A MAGIC WEB

A MAGIC WEB
The Forest of Barro Colorado Island

PHOTOGRAPHS BY CHRISTIAN ZIEGLER
TEXT BY EGBERT GILES LEIGH, JR.

OXFORD
UNIVERSITY PRESS
2002

OXFORD
UNIVERSITY PRESS

Oxford New York

Auckland Bangkok Buenos Aires Cape Town
Chennai Dar es Salaam Delhi Hong Kong Istanbul Karachi Kolkata
Kuala Lumpur Madrid Melbourne Mexico City Mumbai Nairobi
São Paulo Shanghai Singapore Taipei Tokyo Toronto
and an associated company in Berlin

Published by Oxford University Press, Inc.
198 Madison Avenue, New York, New York 10016

Oxford is a registered trademark of Oxford University Press

Library of Congress Cataloging-in-Publication Data
Ziegler, Christian.
A magic web: the forest of Barro Colorado Island/
photographs by Christian Ziegler;
text by Egbert Giles Leigh, Jr.
p. cm. Includes bibliographical references.
ISBN 0-19-514328-0
1. Forest ecology—Panama—Barro Colorado Island.
I. Title.
QH108.P3 L44 2002 577.3'097287'32—dc21 2001055455

9 8 7 6 5 4 3 2 1

Printed in Hong Kong
on acid-free paper

To Our Parents

May this book meet their standards of clear and agreeable discourse

CONTENTS

PHOTOGRAPHER'S PREFACE

Ever since my first visit to a rain forest, I have been fascinated by those amazing ecosystems. My university studies in tropical biology gave me the privilege of visiting rain forests in Asia, Africa, and Central America, and learning about their biology and their unique charm and beauty. I developed my photography as a tool to share my appreciation of tropical nature, and started to think about constructing a picture book on rain forests that would enable the reader to learn the basics of the ecology of tropical forests. When I first visited Barro Colorado Island, I realized it would be the perfect setting for such a book.

Egbert Leigh and I set out to reveal, through science and photography, the different layers of the rain forest, from its complexity to its stunning aesthetic. We hope to reach a broad audience: scientists, naturalists, and people who simply seek a general understanding of tropical forests.

The forest of Barro Colorado Island is home to tens of thousands of different kinds of organisms, each with its individual traits that define its role in the system. This forest is a vivid web, woven from thousands of bizarre activities, a stunning variety of ways of living that together make the forest function as a whole. Most of these activities happen secretly and quietly, hidden by a thick green curtain or by their miniature scale. Taking advantage of the knowledge of generations of researchers, using modern camera techniques, and being patient (and in many cases, lucky), I have tried to lift the green curtain for brief moments to obtain glimpses of the processes that shape the forest of Barro Colorado.

For me, the fifteen months of fieldwork became an exciting journey, one that enabled me to go beneath the surface in many cases, tracking individual animals and observing developments and changes in the forest as they unfolded over time.

For each of the pictures shown in the book, another dozen didn't work: hours and days of waiting for the right animal or the right light, pouring rain resulting in failures of the equipment or the photographer, the wrong film or the flash not recharging fast enough—there were a thousand ways to miss the crucial moment. Yet it was well worth the effort. Many of the images result from touching moments, close encounters with the forest and its creatures, that I feel privileged to have witnessed. They easily made up for the disappointments that are always part of nature photography. Some memorable moments come to mind: the intimacy of colorful toucans and motmots feeding their chicks, a million army ants swarming through the forest, an endless line of leaf-cutter ants harvesting leaves, encounters with such rarely seen creatures of the forest as silky anteaters and tree porcupines, watching fishing bats skimming food from the lake's surface at night, the excitement of finding ocelot tracks close to my remote camera system.

We hope we have conveyed our fascination with tropical forests, and the complexity of the system as well as its beauty. Most of all, we hope this book is

enjoyable and entertaining. We also hope we can help raise awareness about the state of these systems at the beginning of the twenty-first century. Tropical forests all around the globe are disappearing at increasing rates. Some of the animals shown in this book are in peril from habitat loss and poaching. It would be tragic if all that remained of these forests were picture books like this. We hope our readers will share these concerns and find their own ways to support conservation efforts for tropical forests.

CHRISTIAN ZIEGLER

Barro Colorado Island, December 2001

AUTHOR'S PREFACE

In early 1999, a student came to see me about the possibility of doing a photographic essay about Barro Colorado Island. He clearly knew how to take pictures. Equally clearly, he could get the support he needed from the Smithsonian Tropical Research Institute only if I wrote the text.

The opportunity to work with a first-rate photographer to convey the beauty of a tropical forest and an understanding of how it works does not come knocking every day. How should such an opportunity be used?

Robert Paine, of the University of Washington, introduced me to the marine life of the storm-beaten, rocky shores of Tatoosh Island, off the tip of Washington's Olympic Peninsula in the northeastern Pacific. He showed me how the distribution, the zonation, of mussels, starfish, sea urchins, coralline algae, and kelps revealed (to the eye educated by appropriate experiments!) the factors that shaped their zonation—how the starfish kept the bed of mussels from spreading like a glacier down among the kelps and displacing them, how the pounding waves kept sea urchins close to their shelters, preventing them from grazing down the kelps, and so forth. Surely a photographic essay could do likewise for the tropical forest on another island. It is easy to illustrate the intensity of plants' struggle for light, the impact of herbivores, the ever-present danger of predators, and the ways in which different animals cope with this danger. It is a subtler business to show that different plants are damaged in different ways, by different agents, but this demonstration shows why plants kept rare by their pests must employ animals to convey their pollen and, often, other animals to disperse their seeds. Could we also show how the struggle for life elaborated, without conscious effort or design, a luxuriant, diverse community of mutually dependent plants, animals, and fungi?

Any book is an homage, conscious or unconscious, to those who shaped its author's education. This book owes a lot to Robert Paine's and Robert MacArthur's interest in how to read the book of nature, Elisabeth Kalko's interest in bats, Alfred Fischer's interest in how to use the fossil record to interpret the present, Robert Stallard's interest in runoff, soil, erosion, and global change, and, not least, Michael Robinson's writings, which are models of how to communicate the wonders of tropical nature simply and joyfully.

I wish to thank the Smithsonian Tropical Research Institute, especially the director, Ira Rubinoff, and his deputy, Cristian Samper; and Kirk Jensen, of Oxford University Press, New York, for betting on this project; and Helen Mules of the same press, for the care she lavished on this book.

I also wish to thank Jacalyn Giacalone, Elizabeth King, Fernando Santos-Granero, John Murray Leigh, and Ira Rubinoff for commenting on drafts of the text, John Murray Leigh for providing the graphs, and Elisabeth Kalko, Annette Aiello, Marcel and Annette Hladik, Ricardo Moreno, Robert Stallard, and Janeene Touchton for reading relevant parts of the text, viewing slides,

identifying organisms therein pictured, commenting on their captions, or supplying unpublished data.

Finally, I thank Laura Flores for her help with this project. Her background is in business administration, and this project did not obey the ordinary rules of business initiatives. Faced with a photographer who consumed film the way an antarctic whale eats krill, and an author in no way inclined to restrain this consumption, she somehow managed to cope, and this project has survived as a witness against economic determinism, which is not the least of the dangers to tropical rain forests.

EGBERT GILES LEIGH, JR.
Barro Colorado Island,
Feast of St. Thomas the Apostle, 2001

A MAGIC WEB

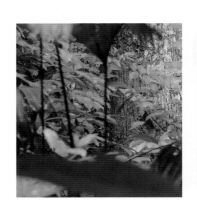 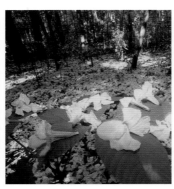 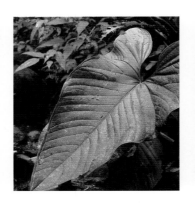 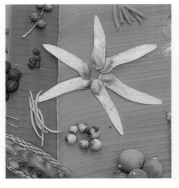

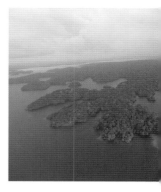

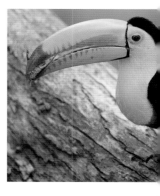

Introduction
A First Impression

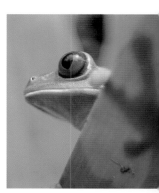

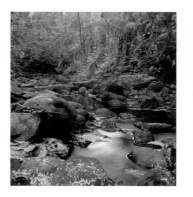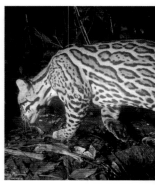

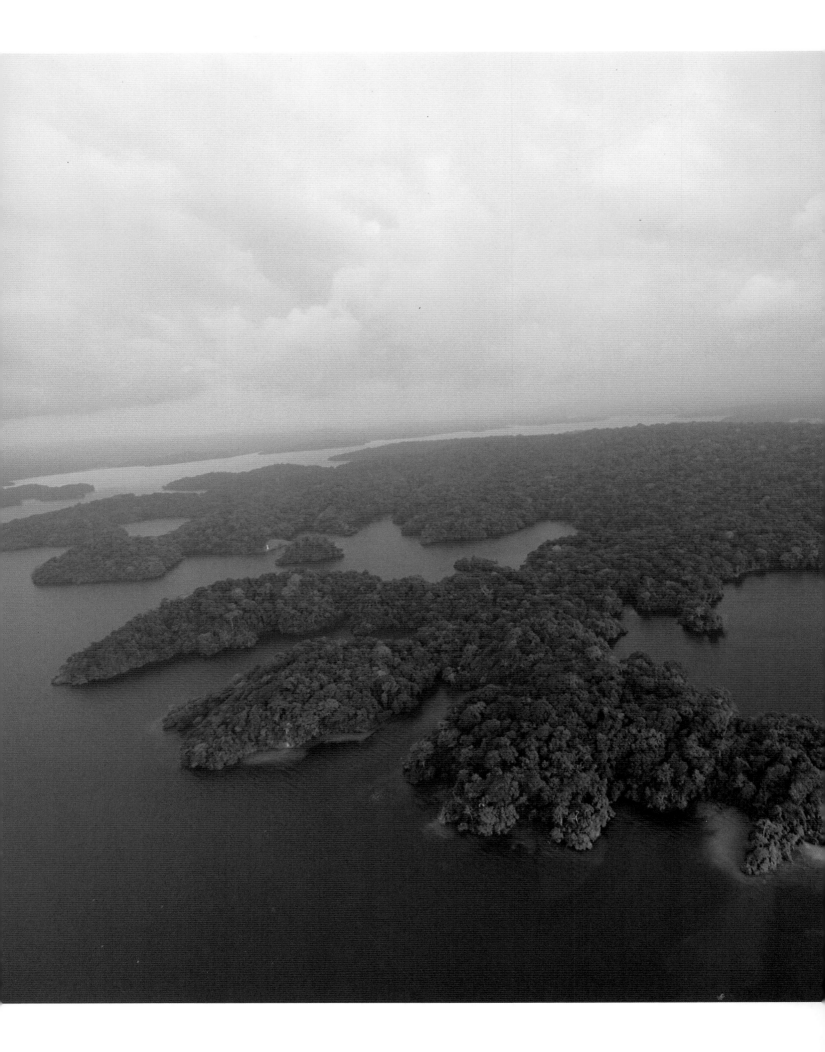

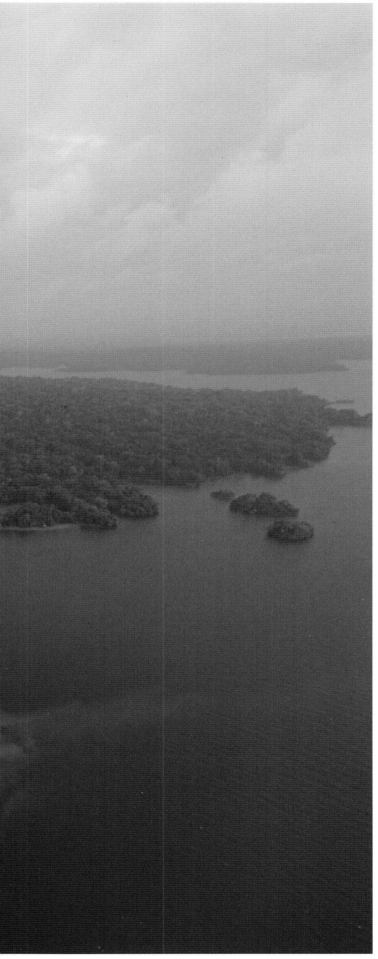

To many, the phrase "tropical forest" suggests an exotic setting, full of bizarrely shaped plants, with occasional huge, garishly colored flowers, and at least a hint of danger, as in Henri Rousseau's paintings. Indeed, the painter Rousseau and many others view the tropical forest as an exuberant, mysteriously perilous world whose atmosphere is rather like that experienced by many of E. M. Forster's English visitors to Italy.

A tropical forest is indeed a different world, a hot and often sticky one (although in summertime, Washington, D.C., can be far more disagreeably hot and sticky). Barro Colorado, an island in Gatun Lake, Panama, set aside for studying tropical nature, is also an isolated world, accessible only by boat (fig. 1). This world is not easily comprehended: a visitor's first impression is usually dominated by an overwhelmingly confusing superabundance of undifferentiated greenery (figs. 5, 6, 7). Barro Colorado's scene is dominated by the luxuriance, and the variety, of its plant life. A resolute effort is often needed to bring this blur of plant profusion into focus and resolve it into its several elements. An occasional great tree, its trunk three to six feet thick, buttressed at the base by great flaring flanges, its first branches eighty or more feet above the ground, thrusts its crown above the confusion of a tropical canopy (fig. 2). Slender palms supported on stilts (fig. 3); leaves often lost in the canopy; little vines with leaves plastered in neat rows on rocks or tree trunks; huge woody vines thicker than a boxer's arm, hanging from tree branches a hundred feet high; trees whose trunks are embraced tightly by the braided strands of the incipient trunk of a strangler fig—all contribute to this extraordinary variety. Shady tracts of tall forest, easy to walk through, alternate with "light gaps" opened by

Barro Colorado, blanketed with lush forest, in a quiet Gatun Lake one afternoon late in the rainy season.

the fall of a forest giant, often already choked with saplings competing to replace the fallen tree. Some great trees have branches festooned with ferns, orchids, bromeliads, even cacti. Getting one's leaves into the sun must be a central theme of tropical plants' lives: plants have so many ways of doing so.

Bright colors are not prevalent in tropical forests. One may see a brightly colored fruit inviting animals to eat it and disperse its seeds. Normally, however, bright colors betoken either sex, as when dazzling male birds seek mates (fig. 31) or a blaze of flowers calls for pollinators (fig. 8), or danger, as in the red, yellow, and black of the exceedingly venomous coral snake, or in the gorgeous wings of butterflies advertising their distastefulness. Leaves of a few of Barro Colorado's trees turn scarlet before falling, but the full glory of fall colors is found in Vermont or Virginia, or in a forest of Japanese maples, not in Panama.

In the right season, a visitor on the boat to Barro Colorado sees scattered trees or vines ablaze with flowers: in the forest what one usually finds is just a carpet of flowers on the ground, fallen from a tree crown one cannot see (fig. 4). There are other flashes of color. One might happen upon a bird in its mating plumage (although the most brightly colored birds are seen in gardens or at the forest's edge). A male giant damselfly nearly four inches long may be hovering in a light gap, its fluttering wings, splashed with dark blue and white, looking for all the world like a pulsating blue-and-white beacon, calling females and warning off rival males.

Tropical forests are home to other strange sights and sounds. One often hears howler monkeys roaring in the distance (fig. 14), like African lions, or the insistent sounds, rather like high-pitched buzz saws, of cicadas seeking mates. Monkeys may be heard, or even seen, moving about overhead. One may happen upon an insect curiously disguised as a twig or a leaf. A swarm of ants in their hundreds of thousands may cross one's trail, scaring up insects and pouring down ant nests to take the larvae as food for their own: birds hover about the front of the swarm, snatching at the escaping insects. A different parade of ants (fig. 11) may be carrying leaves or flowers back to a huge nest. Night has its own strange sights and sounds.

Many of these sights have no parallel in temperate-zone forests. They each have a story to tell about the problems of living in a tropical forest: one sees plants struggling for a place in the sun, flowers attracting pollinators, animals looking for food or trying to avoid becoming food, sometimes individually, sometimes in marvelously organized cooperative groups. Barro Colorado's animals and plants have been the object of research since the First World War. This research has helped us understand how a tropical forest manages to stay green despite a diverse multitude of leaf-eating sloths, porcupines, iguanas, and monkeys, not to mention a legion of insect pests; why this forest has so many kinds of plants and animals; and what sort of world these plants and animals have built. A photographer has spent a year on Barro Colorado to obtain pictures of some of its sights—both everyday and extraordinary—for this book. A biologist has drawn on thirty years of experience on

Barro Colorado and elsewhere in the tropics, and thirty years of conversations with students of many a rain forest, to weave the messages of these pictures into a story about the life of the forest. Together we have tried to show how to read these pictures to learn what basic problems the animals and plants of Barro Colorado face, and how their responses to these problems shape the balance of nature there.

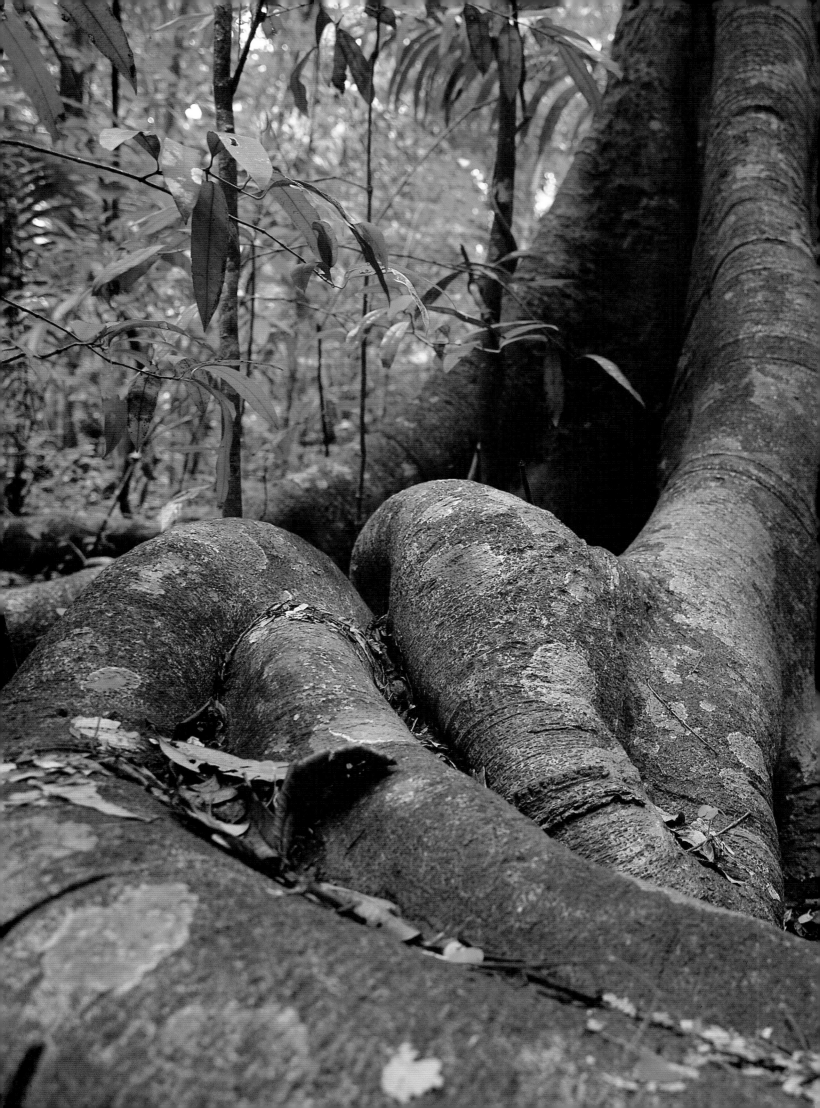

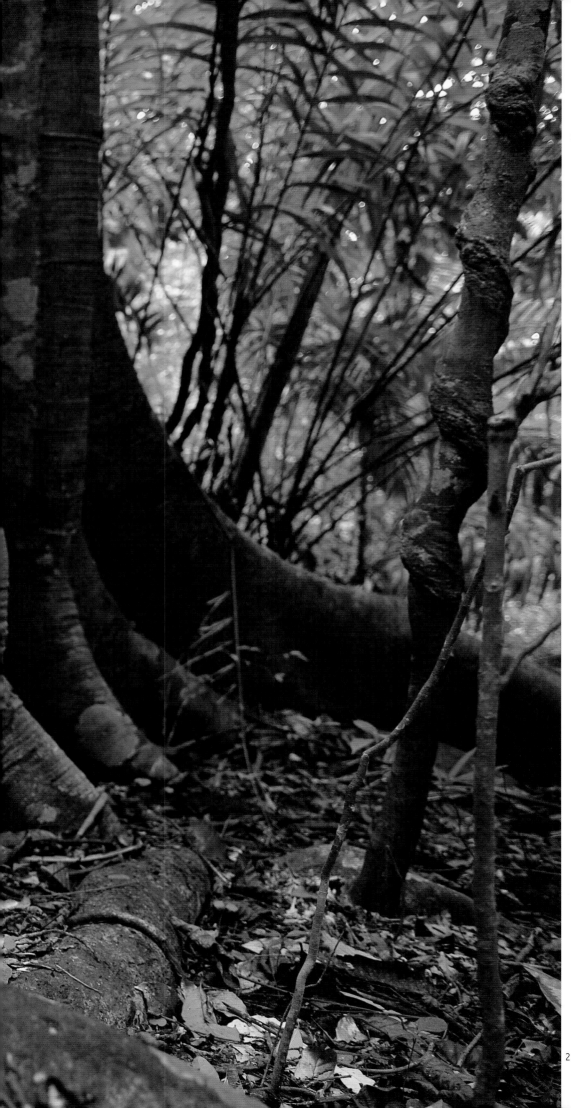

This giant fig tree, *Ficus insipida,* lives in the old forest on the island's south side. Many rain-forest trees live for hundreds of years and begin to reproduce only after they are a few decades old.

A dreamlike impression during a morning walk in the dry season: sparkles of green and blue light fly by while one passes a stilt root of a walking palm *(Socratea exorrhiza)*.

OVERLEAF: As yellow as it gets. A dry-season rain can trigger a syn-chronized mass flowering of *Tabebuia guayacan,* perhaps the most impressive episode of flow-ering on Barro Colorado. After two days, the trees drop their petals, creating a spectacular flower car-pet on the forest floor (fig. 4).

3

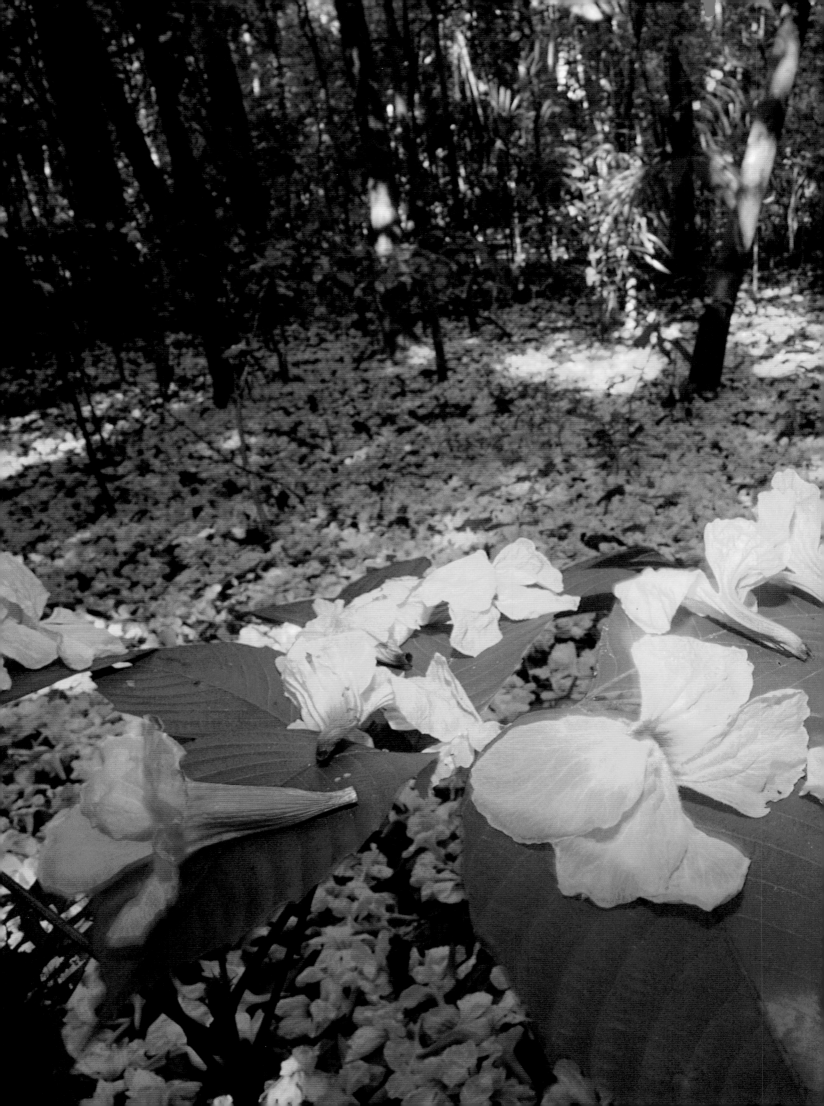

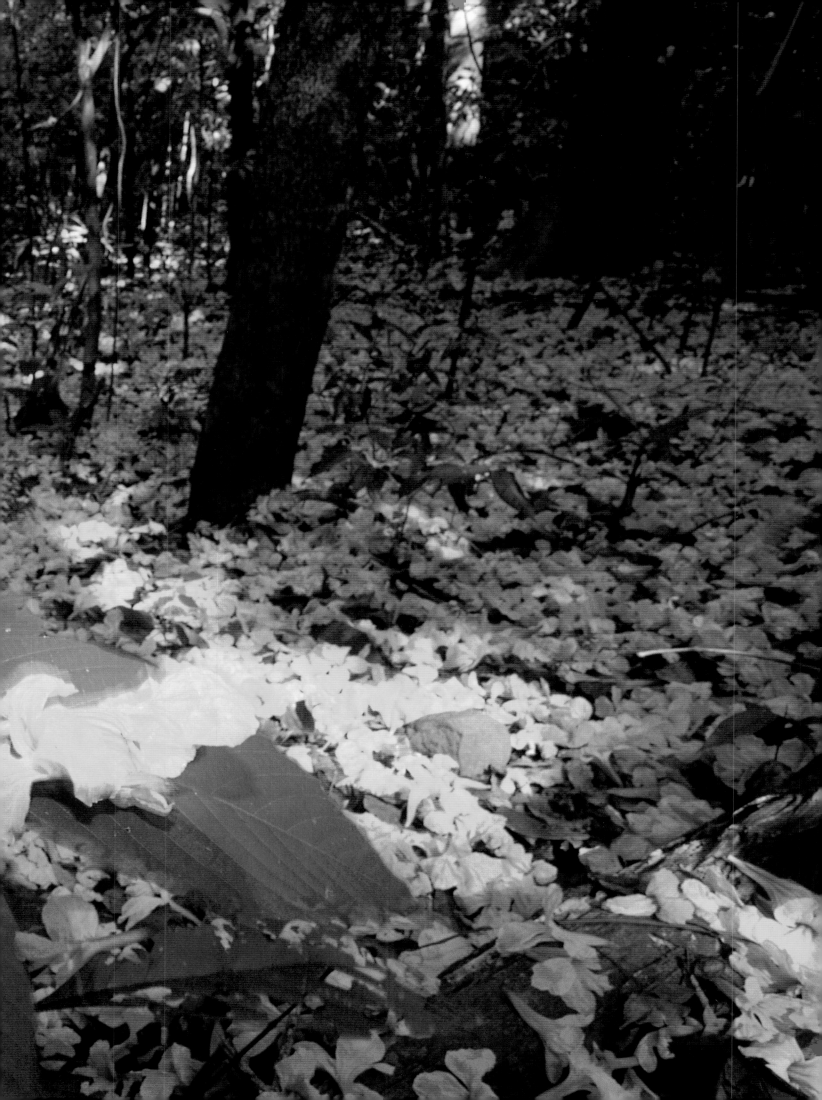

Impressions of the forest landscape: a tree trunk

seen through the understory vegetation . . .

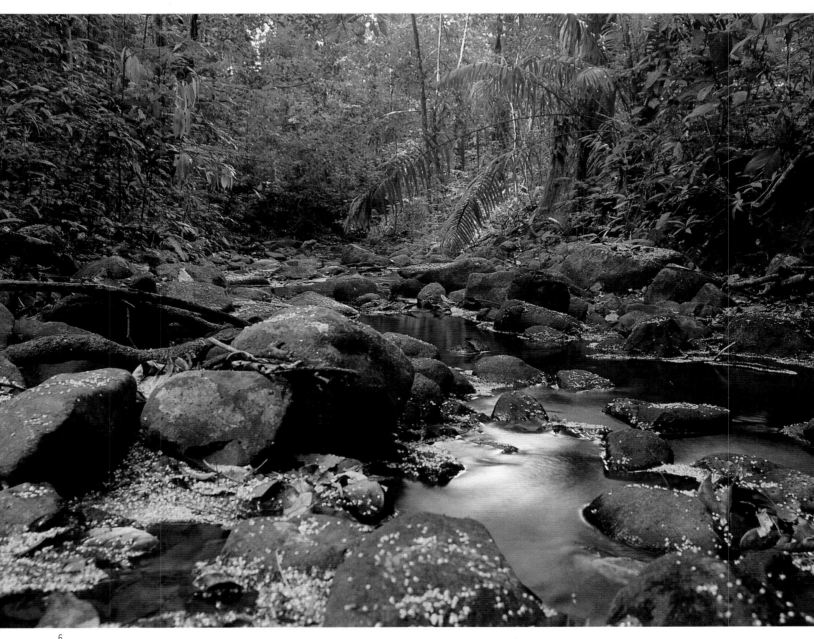

. . . . and a small creek in the middle of the island.

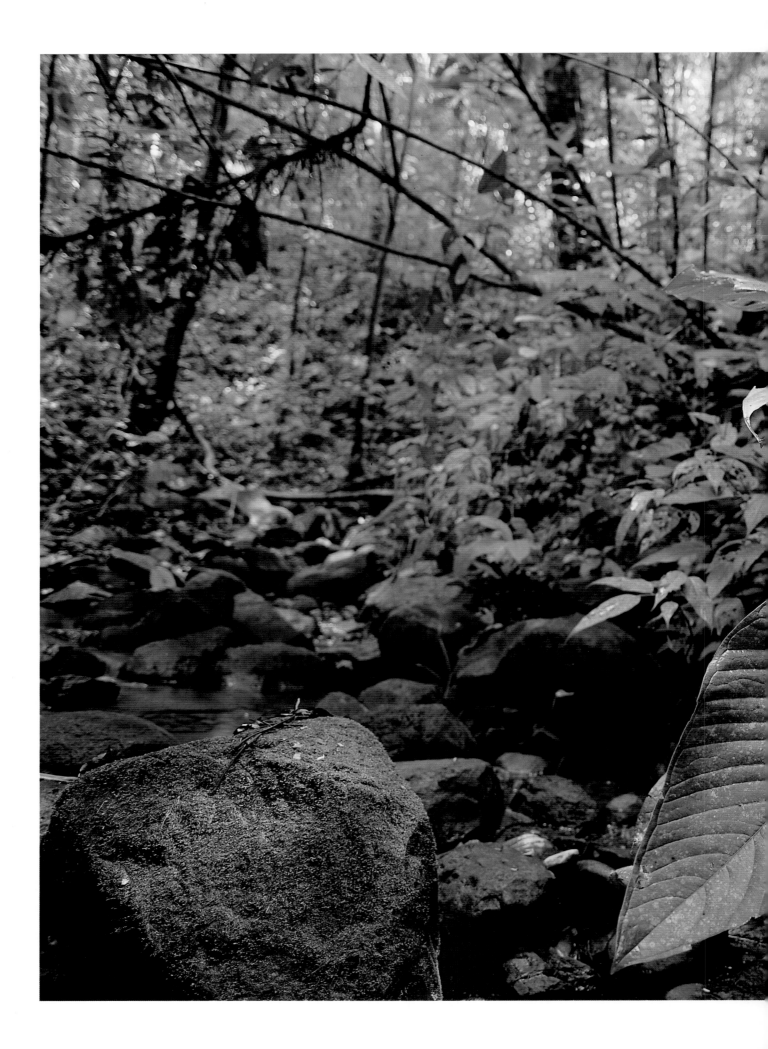

Shade plants with their large leaves cover the banks of this small forest creek.

OVERLEAF: This enormous flower belongs to *Aechmea magdalenae,* a large ground-living species of the Bromeliaceae, the pineapple family (fig. 8).

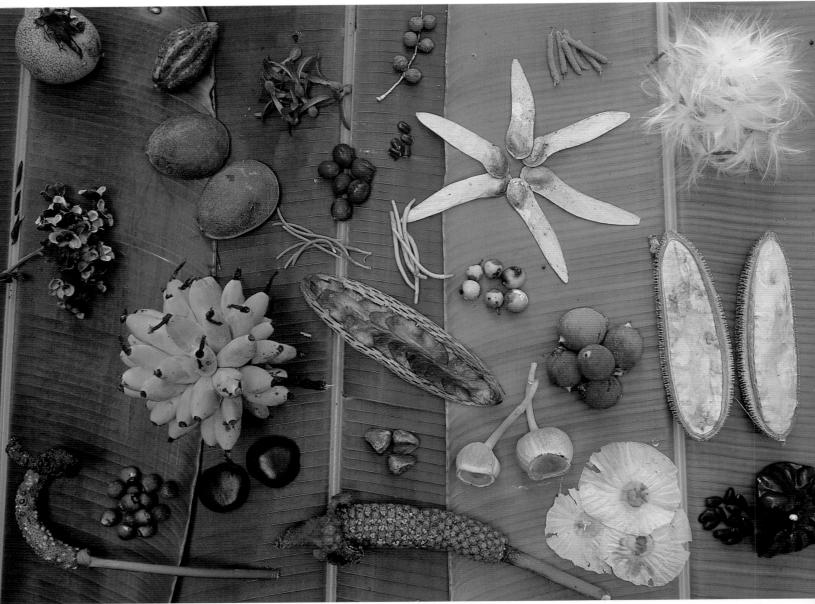

Varied seeds and fruits from nearly
thirty plant species, collected on Barro
Colorado in late April, near the end of
the dry season.

A red-eyed tree frog *(Agalychnis cal-lidryas)* resting in a big bromeliad. This gorgeous animal has become a symbol for biodiversity and now serves as ambassador for a whole habitat under threat of disappearance: the rain forests of Central America.

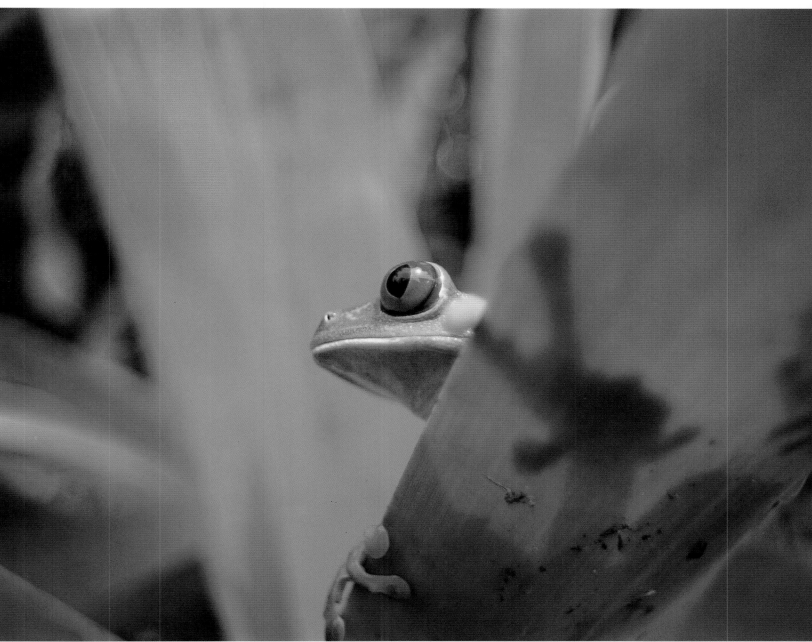

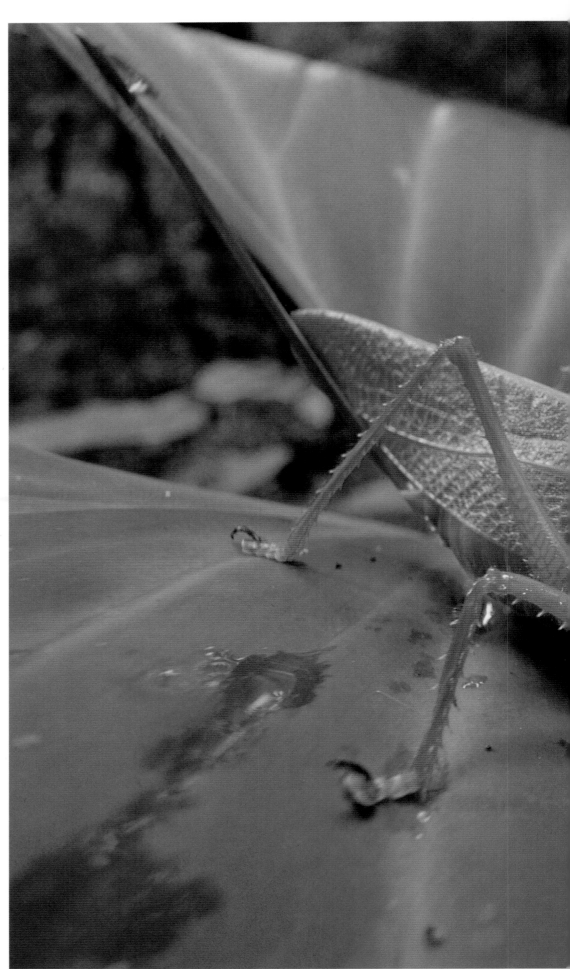

PREVIOUS PAGES: Enormous colonies of millions of leaf-cutter ants *(Atta colombica)* cultivate and protect a fungus, which they eat (fig. 11).

RIGHT: This surreal orange katydid *(Copiphora* sp.), unlike most of its relatives, is carnivorous. It is one of the tens of thousands of insect species for which the forest of Barro Colorado Island is home.

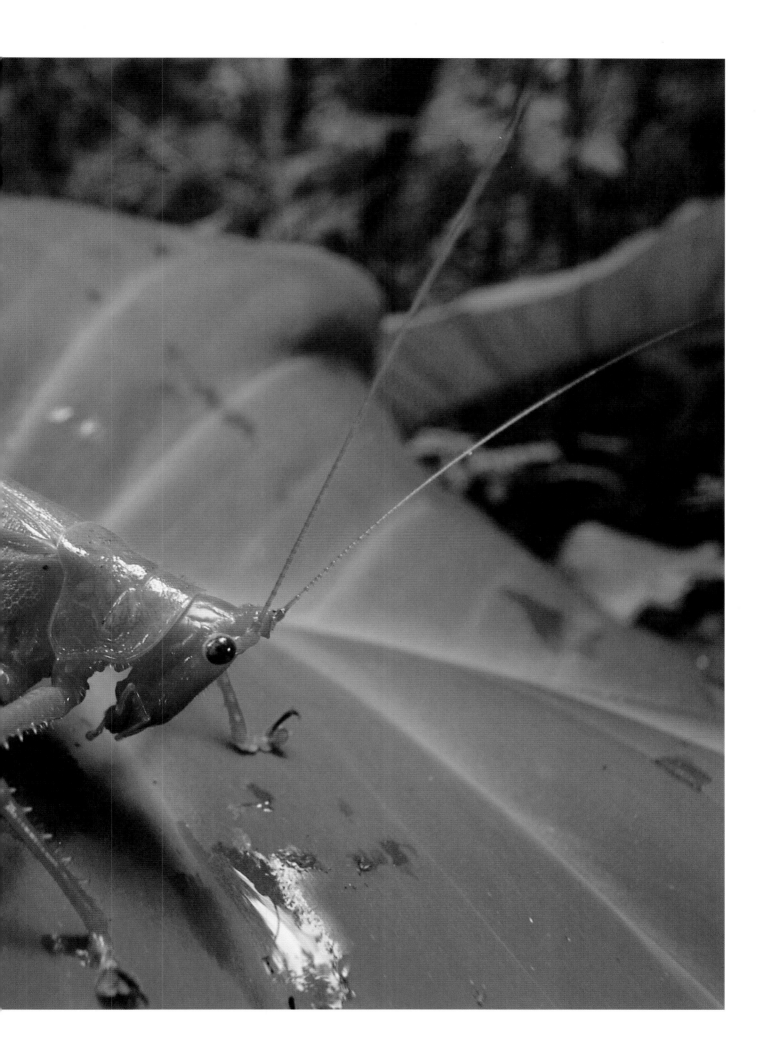

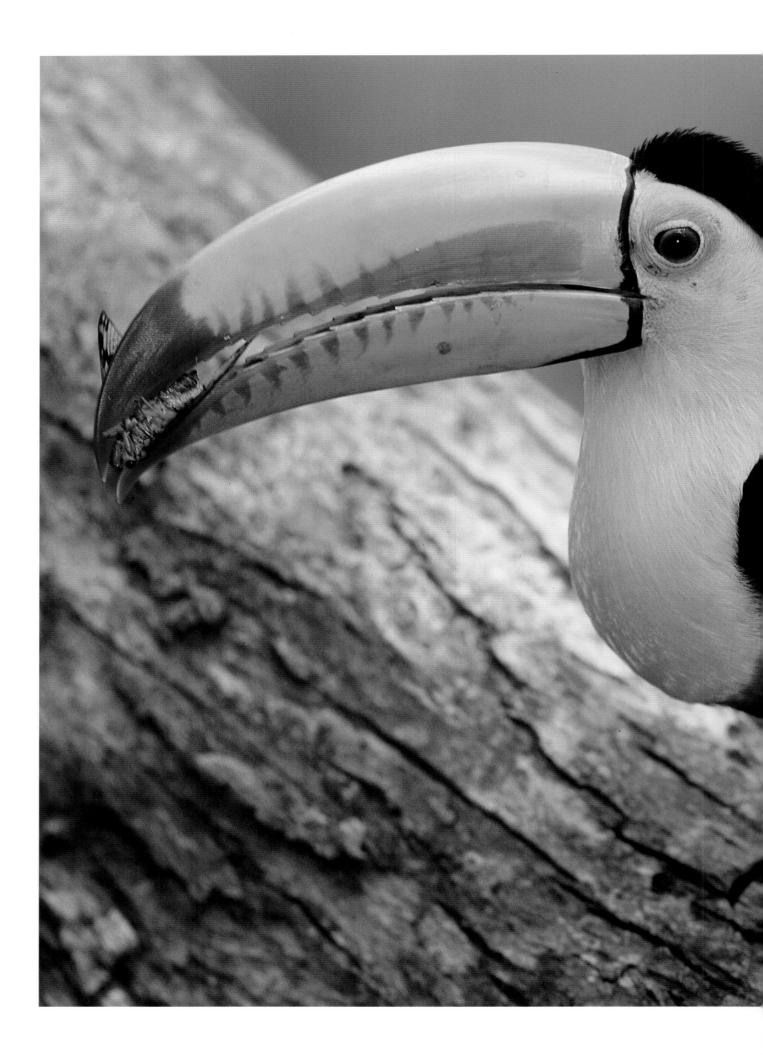

Keel-billed toucans, *Ramphastos sulfuratus,* often flock together in trees with rich fruit crops. They are important dispersers of seeds: some tree species, such as the wild nutmeg, appear to depend nearly entirely on toucans for dispersal of their seeds. Toucans also play another role. These birds mainly eat fruit, but they feed insects to their young, thereby helping restrict insect herbivory in the forest. Here, an adult returns to the nest with a cicada in its bill.

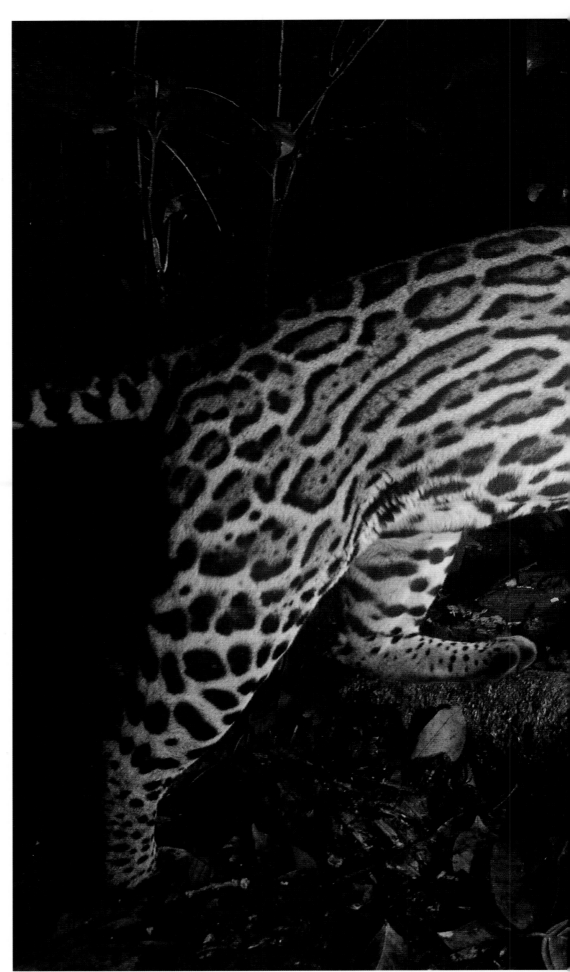

PREVIOUS PAGES: Howler monkeys *(Alouatta palliata)* are by far the most common monkey species on Barro Colorado; there are some thirteen hundred of them. Their impressive roars are among the most characteristic and memorable sounds of the island's forest (fig. 14).

RIGHT: A rare sighting at night. Ocelots *(Felis pardalis)* are top predators. This male is strolling near a fruiting tree, where a good meal, such as a paca or opossum, may come within reach.

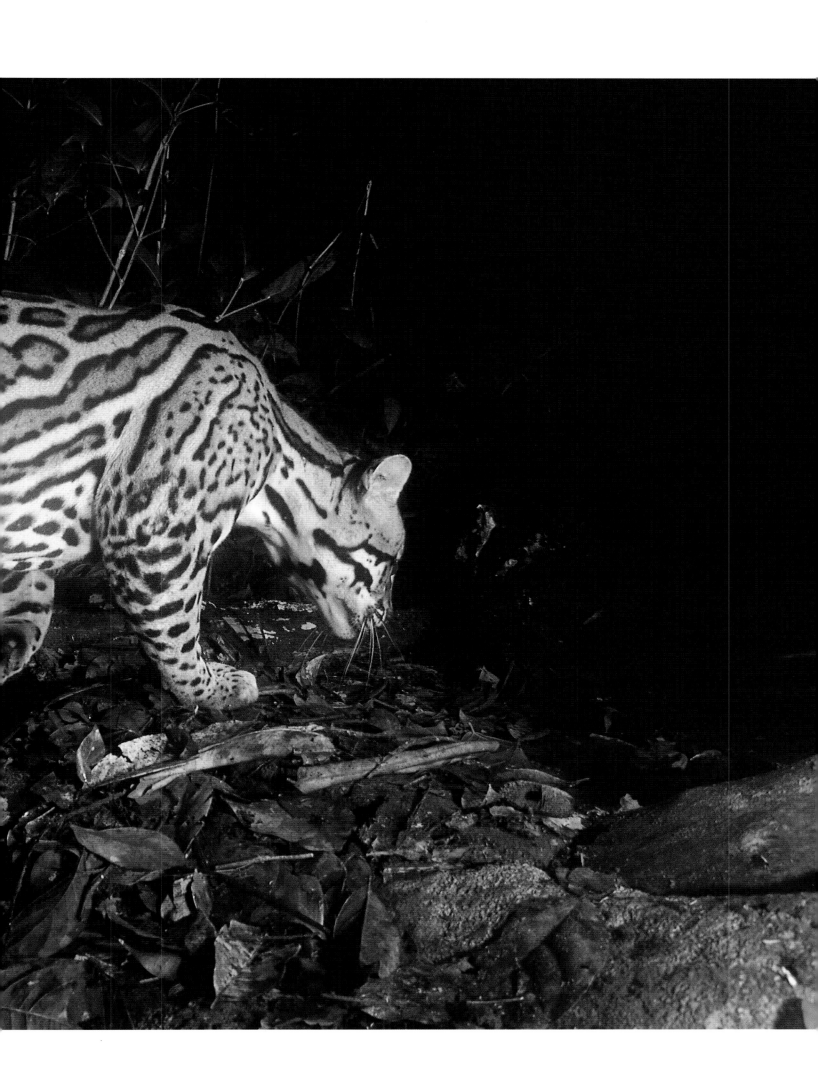

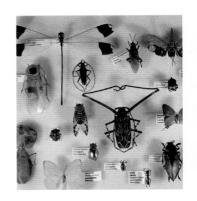 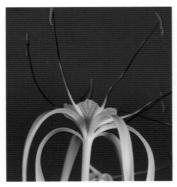 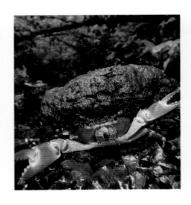 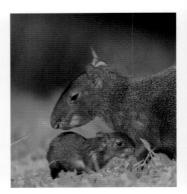

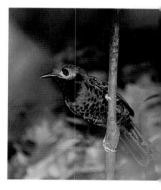
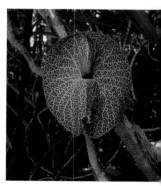

1

What Is Special about Tropical Forests?

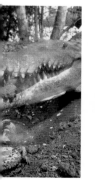
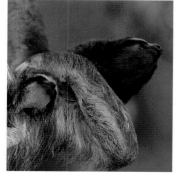
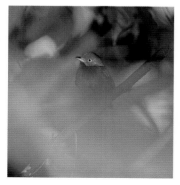

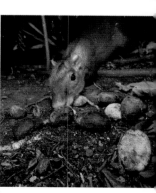

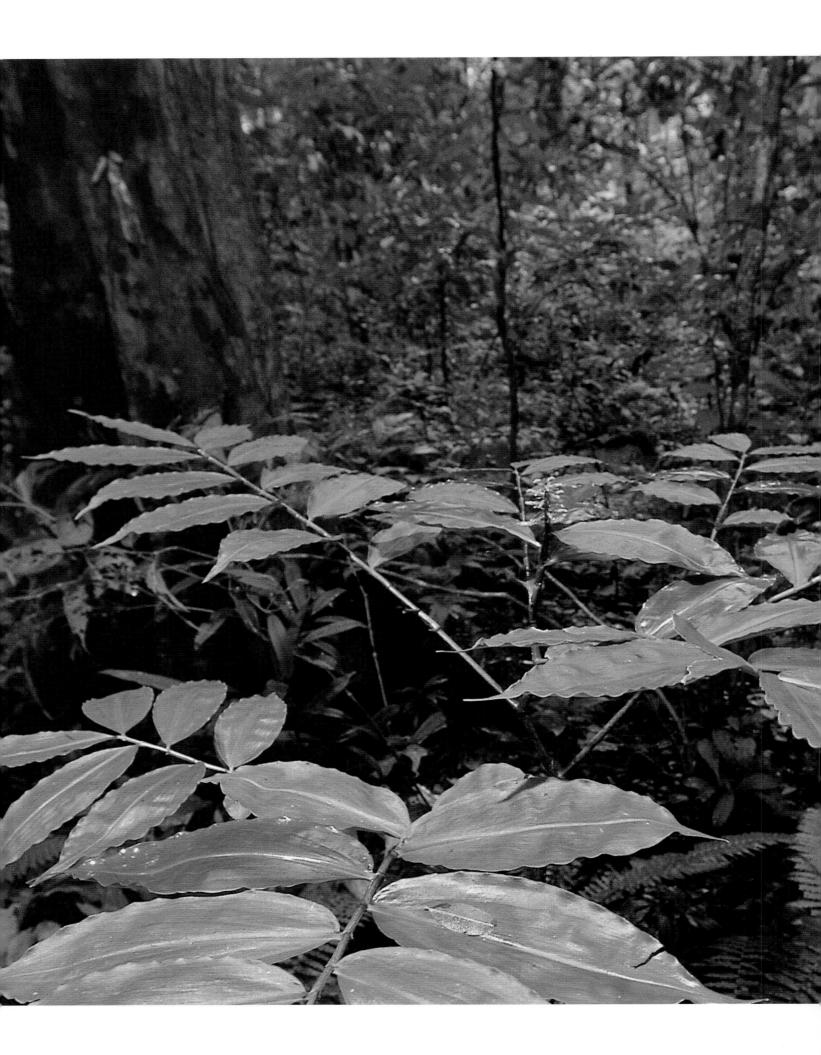

T ropical forests have wide appeal. They have fascinated artists as different as Frederick Church and Henri Rousseau, and attracted biologists of the stature of Charles Darwin and Alfred Russel Wallace. Today, many graduate students, following in their footsteps, sacrifice income and comfort to work in these beautiful forests. In the New World, as in Madagascar, the grim and devastating trade in endangered species is fueled by fascination with the wonders of tropical nature: orchids with their many colors, shapes, and perfumes; guppies, piranhas, and other strange fishes of tropical rivers; chameleons, diverse in shape and changeable in color; spotted cats; macaws splashed with garish hues; and amiable, furry lemurs and monkeys, so full of personality and designing intelligence.

The Enormous Variety of Tropical Organisms

For biologists, the most striking feature of tropical forests is that they have so many more kinds of plants and animals than do forests of the temperate zone. A hectare—a 100-by-100-meter (328-by-328-foot) square—of broadleaf forest at least 120 years old, near Annapolis, Maryland, includes 16 species among its 351 trees over ten centimeters (about four inches) in trunk diameter. A hectare of mature forest on Barro Colorado includes 91 species among 425 such trees. By tropical standards, Barro Colorado's tree diversity is mediocre. A 120-by-80-meter rectangle of rain forest in Brunei, on the northwest coast of Borneo, contained 256 species among 596 such trees, more than twice the number of tree species in the north half of Europe; a hectare of rain forest in eastern Ecuador included 307 species among 693 such trees. Comparing larger plots, or geographical regions, reveals equally striking differences between tropical and temperate-zone settings in number of tree species (table 1.1).

A first-time visitor to a tropical forest, however, is usually too overwhelmed by the simple mass of greenery to become fully aware of the diversity of plants involved. The diversity of tropical animals is more evident. For example, 60 species of butterfly (excluding skippers) are known to live in the fifty-thousand-hectare H. J. Andrews Experimental Forest in western Oregon; Barro Colorado's fifteen hundred hectares shelter about 270 species. Again, this is mediocre diversity by tropical standards: 850 species of butter-

TABLE 1.1

Tree Diversity in the Tropics and the Temperate Zone

Tree Diversity in Selected Sample Plots

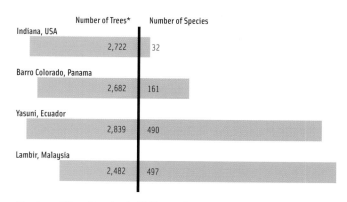

Number of Tree Species in Different Regions

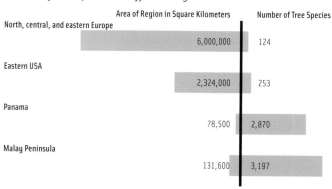

* Trees of at least 10cm trunk diameter in plots chosen to make tree numbers similar (between 4 and 8 ha)

Fruits come in all shapes, colors, and sizes, according to how they are dispersed. This fruit of an understory herb has an unusual coloration of green and purple, probably meant to attract birds.

OVERLEAF: Fungi play a key role as decomposers, particularly of dead leaves and wood. From an ant's perspective, these orange fungi, *Xeromphalina* sp., are large umbrellas under which it can walk (fig. 17).

16

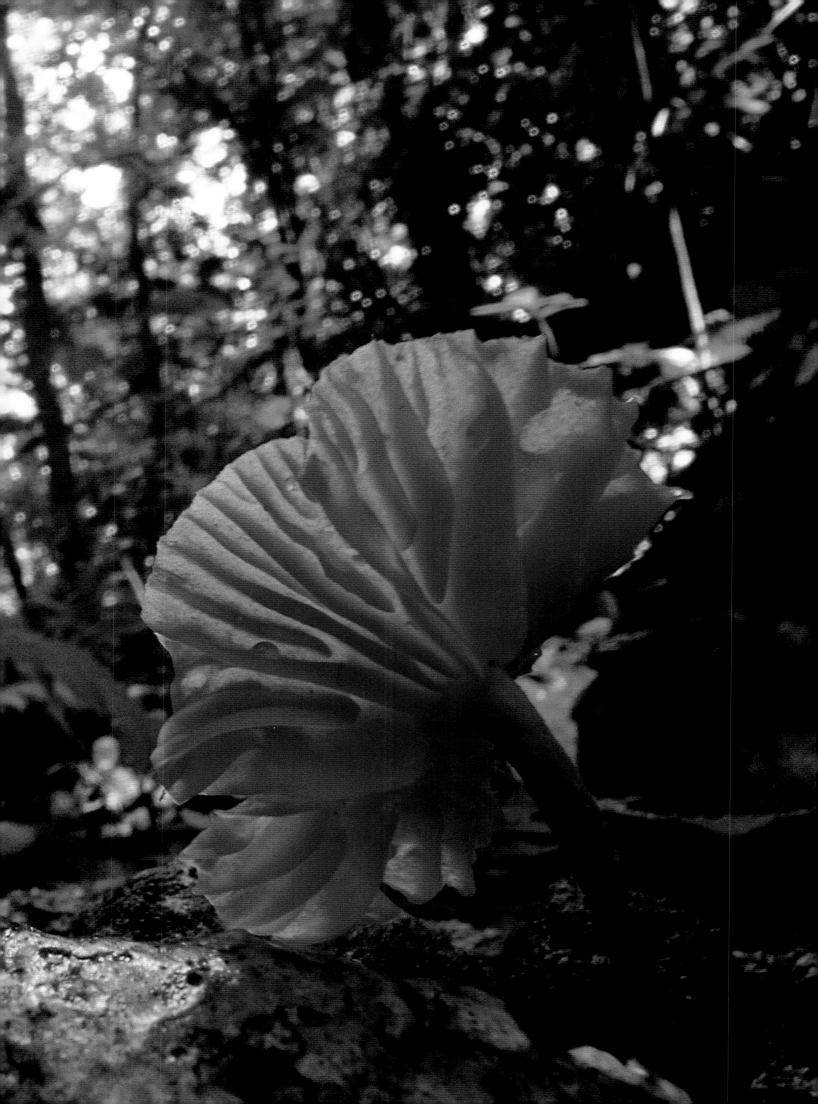

fly live in the four thousand hectares of tropical forest near the mouth of the Rio Manu, at Pakitza in southeastern Peru. Birds are also more diverse in the tropics than farther north (or south). The Congaree Forest, a magnificent stand of old forest upriver from Columbia, South Carolina, harbors 40 species of resident, land-dwelling bird; Barro Colorado has about 140, and the tropical forest around Cocha Cashu, in the valley of the Rio Manu, has more than 200. The high diversity of tropical organisms is not limited to forest dwellers: indeed, the increase in species diversity toward the tropics was first documented for seashells along the Pacific coast of North and Central America.

Why Does the World Have So Many Kinds of Animals and Plants?

Why are there so many kinds of animals and plants in tropical forests? To answer this question, we must learn what factors allow different species to live together in any ecological community.

Ecological communities are competitive worlds. To see how this competition shapes a community, imagine several species, living in the same place, whose populations are limited by the availability of the same kind of food. As long as there is food enough, these species multiply until they begin to deplete the food supply. The abundance of food continues to decline until the only species left is the one needing the least abundance of this food to maintain its numbers. By depleting the food supply to a level where only it can survive, this species has excluded its less successful competitors from its niche. This schematic example illustrates the principle of competitive exclusion: no two species can make their living in the same way, in the same place, for the one that is better at it will replace the other. Similarly, if two airlines fly the same routes, competing for the same market, the more efficient or effective will be able to expand until no business is left for the other. In sum, competition reduces diversity unless the competing species make their livings in different ways.

There are, however, many ways for organisms to make livings. No one species can be best at them all: as the proverb says, "the jack-of-all-trades is master of none." In business, the incompatibility, the trade-off, between keeping fares low and offering reliable, luxurious service means that two airlines flying the same routes can coexist if one attracts passengers who wish to travel cheaply, the other, passengers preferring comfort or insistent upon arriving on time. In the plant world, the abundant photosynthetic machinery a plant needs to take full advantage of bright light is incompatible with the need of deeply shaded plants to minimize maintenance costs by keeping only enough of this machinery to use the scarce light available. Therefore, as long as the death of forest giants continually opens large, sunny gaps, light-demanding and shade-tolerant species of plants can coexist in the same community. The trade-off between speedier growth in high light and higher survival in shade prevents species that grow fast in high light from displacing

shade-adapted understory trees from their shady niche, and vice versa. Likewise, some insects, such as beetles or caterpillars, have mouths designed to chew leaves, while others, such as aphids, cicadas, and leafhoppers, have mouths designed as sharp-edged tubes that can pierce leaves or stems to suck sap: no one mouth can do both jobs well.

Moreover, just as a business creates opportunities for other kinds of business to manufacture tools and provide services needed by the first, and (however inadvertently) opportunities for thieves to steal some of the goods or money thus accumulated, organisms provide livings for other organisms. Canopy trees create a habitat for shade-tolerant understory trees and herbs. Canopy trees also provide supports on which lianas (woody vines) can climb and epiphytes, plants that grow on other plants, can sit to place their leaves in the sun. When trees die, their wood and leaves feed a host of fungi (fig. 17), bacteria, and even animals, the decomposers that live on dead matter and release its mineral nutrients for reuse by other plants. Dead matter is usually found in deep shade or even the airless dark: organisms that decompose dead matter rarely get enough light to combine water and carbon dioxide into sugar. Even where they do, it is rarely economical for decomposers to equip themselves for photosynthesis as well. Plants are also food for fungal blights and herbivorous animals, which consume the materials plants make rather than using light to make their own. But plants also provide livings for other fungi, mycorrhizae, that live on or in plant roots and help them take up mineral nutrients from the soil in return for some of their host plants' sugars. The mobility that enables certain animals to seek and find suitable parts of plants to eat also makes it profitable for plants to entice them into pollinating their flowers (fig. 18) and dispersing their seeds (fig. 9), thereby creating a world where, in E. J. H. Corner's phrase, animals help plants as well as helping themselves to them. Pollinators, however, also provide a new way by which a disease can spread from one plant to another. Finally, herbivorous animals provide livings for carnivores adapted to chase or surprise, and to overcome, mobile prey. In sum, organisms usually provide opportunities for other organisms of different kinds: biotic diversity makes possible more biotic diversity.

Why Are There So Many More Species in Tropical Than in Temperate-Zone Forests?

There are so many more kinds of animals and plants in tropical forests because their warm, wet climate, and the lack of winter, make possible an ample, continuous production of vegetable matter. Harvard Forest, in Massachusetts, is productive for less than half the year. In wintertime, that forest offers no nectar, fresh fruit, or tender young leaves that animals can eat, and it is too cold for bats or hummingbirds to fly, even if there were food for them. Thanks to its winter, the leaves of Harvard Forest only produce the equivalent of twenty-eight tons of sugar per hectare per year, while the leaves of the Amazonian forest, which functions all year long, produce seventy-five. Barro Col-

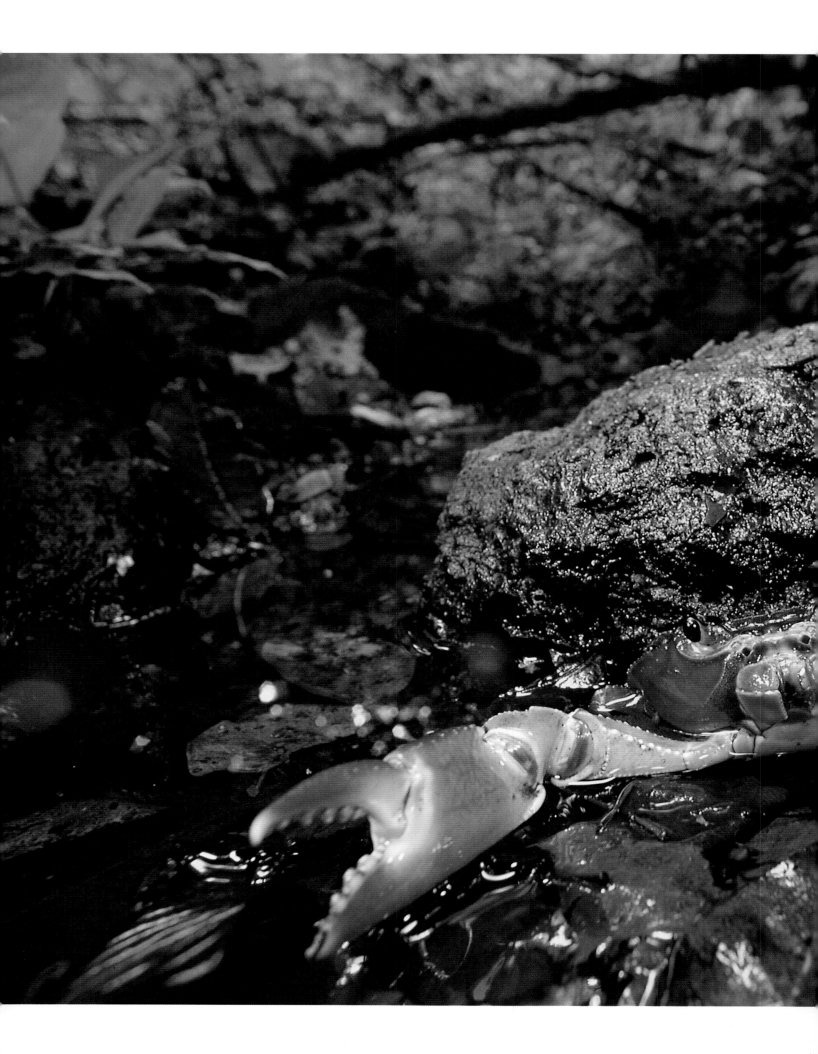

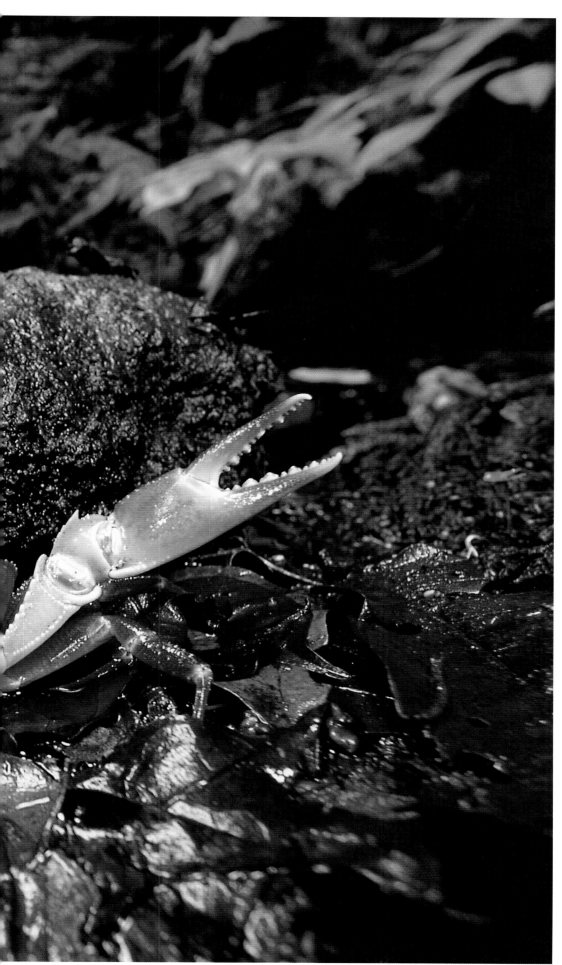

PREVIOUS PAGES: Plants display flowers meant to attract specific pollinators. This forest lily, *Hymenocallis pedalis,* is pollinated by nocturnal hawk moths. It opens its flowers in late afternoon, and releases a lovely sweet scent soon after sunset to attract the moths that pollinate it (fig. 18).

Besides insects, Barro Colorado has several other groups of arthropods, including the Crustacea, to which this land crab, *Potamocarcinus richmondi,* belongs. With its pincers, it can open tough seedpods and inflict painful bites on animals that molest it.

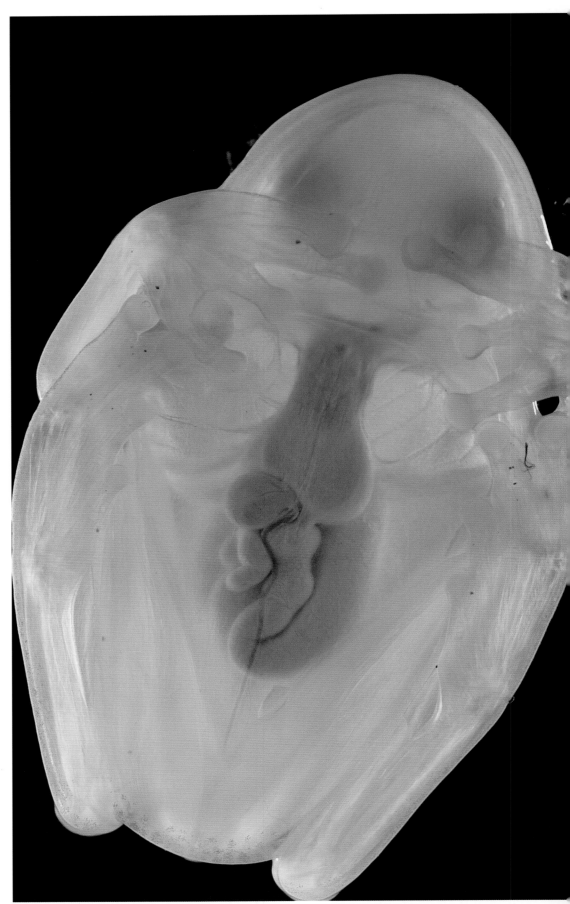

Among the fifty-three species of amphibians on Barro Colorado Island, one of the most amazing is the glass frog, *Centrolenella colymbiphyllum*. During the day it rests under a leaf. The whole animal (including the bones) is nearly transparent.

OVERLEAF: Mother crocodiles (Crocodilus acutus) care for their young. Females bury their eggs, and guard them for nearly two months until the babies hatch. When they hatch, they call for their mother to dig them out and carry them to the water (fig. 21).

orado is probably more productive than Amazonia. Even though the dry season grips Barro Colorado for four or five months a year, when the forest receives only a quarter of the rain it can use and the ground bakes and cracks, most canopy trees have reliable access to groundwater all year long. In any moist or wet tropical forest, it is always warm enough for animals to be out in the open air. Moreover, at any time of year, most trees are in full leaf, and some trees can be found in fruit, others in flower, and yet others flushing tender, nutritious young leaves. Thus tropical forests provide ample, full-time livings for many kinds of animals that could function only as migrant workers in Harvard Forest, if they could afford to migrate there at all.

The vastly more stable climate and food supply of tropical habitats are what most enhance tropical-forest diversity. The continual availability of at least some fruit and flowers provides livings for many animals unknown to Harvard Forest: fruit-eating monkeys and kinkajous in the trees; coatis, peccaries, agoutis, pacas, and spiny rats on the ground; a remarkable diversity of fruit-eating bats (table 1.2) and birds, as well as hummingbirds (fig. 22) and bats specialized to suck nectar from flowers. Similarly, the continual availability of leaves provides livings for leaf-eating sloths in the trees (fig. 23), browsing tapirs on the ground, hordes of herbivorous insects (larval and adult beetles [fig. 25], caterpillars of butterflies and moths, most of whose adults live on flower nectar, sap-sucking aphids, cicadas, leafhoppers, and so forth [fig. 24]), and multitudes of bats, birds, spiders, wasps, robberflies, assassin-bugs, and the like to eat the leaf-eating insects. None of these could survive a Massachusetts winter, and few could be redesigned to do so without fundamentally changing their ways of life.

Because a jack-of-all-trades is master of none, appropriate specialization allows members of a species to exploit or defend their favored food or habitat more effectively, making them less liable to displacement by superior competitors. Specialization is advantageous if the species faces abundant competition and the food or habitat to which the species is specialized is reliably available. Specialization is the engine driving tropical diversity. Where the amount and composition of the food supply are more stable, each species can specialize further without risking extinction from the disappearance of the particular food it depends on, so a given range of foods supports more species.

TABLE 1.2

Bat Species in Different Feeding Guilds, at Different Sites

	Barro Colorado	Indiana	Eastern Germany
Hawkers of Flying Insects	32	10	11
Gleaners of Walking Prey, Mostly Insects	11	2	6
Carnivores	2	0	0
Vampires	2	0	0
Fruit and Nectar Eaters	25	0	0
Total (All Species Combined)	72	12	17

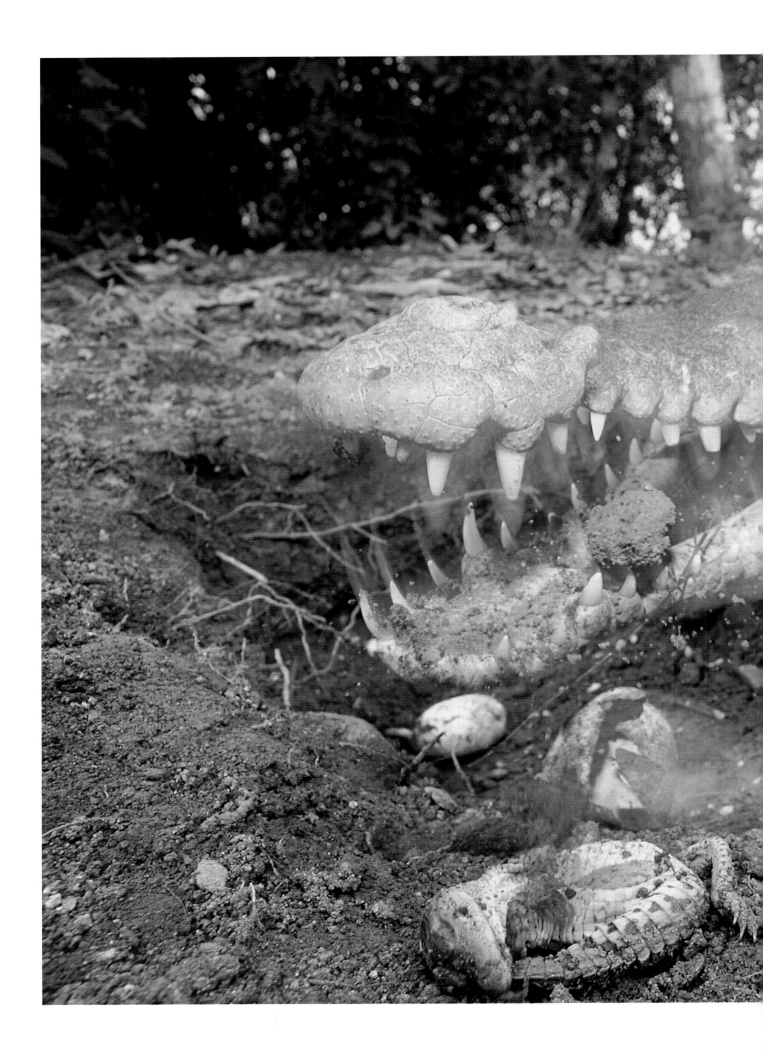

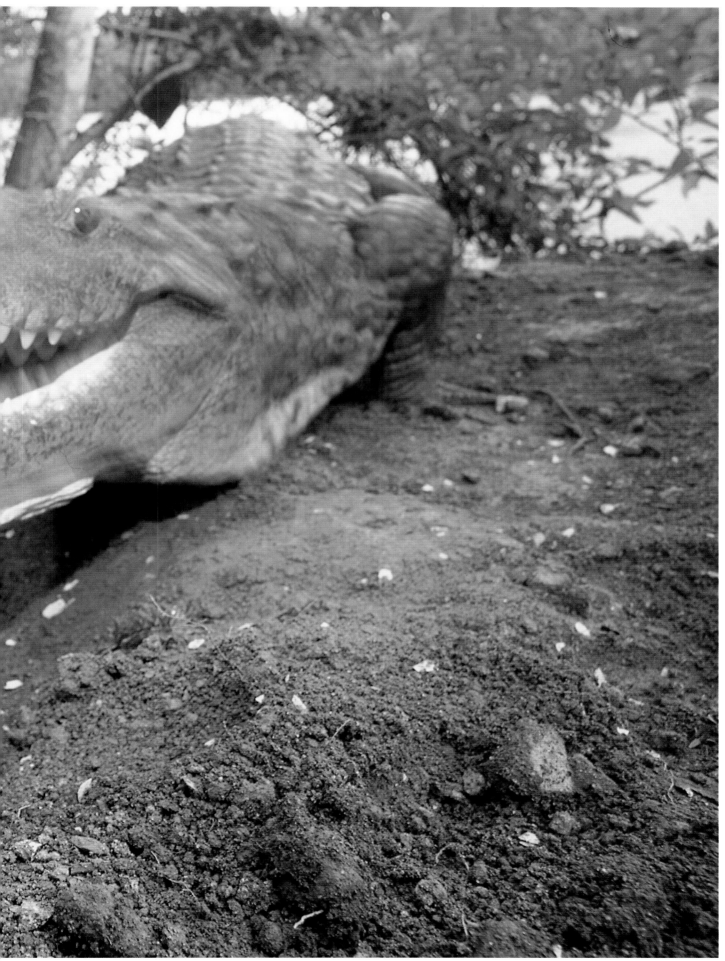

Pest Pressure and Tree Diversity

Why are there so many kinds of tropical trees? All green plants use light to transform carbon dioxide and water into sugar and oxygen, and all trees do so in the same way. Different tree species can and do specialize to different levels of the forest. However, the canopy trees on a hectare usually have equal access to light, and to the soil with its nutrients and water. How can there be more than one best way to be a canopy tree on that hectare?

Living in different habitats and specializing to different light levels are not the only ways by which different plant species coexist. In tropical forests, pests and pathogens usually prevent any one tree species from taking over the forest. Even in the temperate zone, trees in plantations and forestry reserves suffer severely from fungal blights such as root rots, and insect pests such as gypsy moths and spruce budworms, some of which have distressingly catholic tastes. American chestnuts were nearly all killed by chestnut blight, and American elms by Dutch elm disease. In tropical forests, no winter depresses pest populations. Ultraviolet-light traps on Barro Colorado catch leafhoppers and other plant-eating insects all through the year (fig. 26), whereas in Maryland, light traps would never catch such insects in the wintertime. Because of the ever-present insect pests, leaves of tropical trees contain such varied poisons that jacks-of-all-trades feeding on many kinds of trees cannot devastate the tropical forest. John Barone, a graduate student at the University of Utah working on Barro Colorado, found instead that tropical saplings suffer most of their damage (fig. 27) from pests specialized to handle the poisons in the sufferer's species, and perhaps a few close relatives.

Even in natural tropical forests, where trees of each kind are scattered among a multitude of others, young leaves are much more heavily eaten, despite being much more poisonous, than young leaves of deciduous temperate-zone trees. Plant trees of one species together in an extensive tropical plantation and their pests will spread quickly from one tree to the next, defoliating them, or devouring their seeds or seedlings, just as diseases spread through an overcrowded refugee camp. In short, it appears that natural tropical forests have so many kinds of trees because each is kept rare by the pests that are specialized to it.

Are warmer winters really what enhance pest pressure in the tropics? About fifty-four million years ago, the average annual temperature in southern Wyoming rose by 7 degrees Celsius, making the winters frost free. Well-preserved fossil leaves have been found from soon before and soon after the warming. Peter Wilf and Conrad Labandeira, of the Smithsonian's Natural History Museum, learned from these fossils that, after the warming, insect damage to the leaves was greater, as was the diversity of insect pests per plant species, even though plant diversity had also increased after the warming. Leaves of common species were the most heavily damaged, as would be expected if insect pests were hammering common plants hard enough to make room for other species, thereby enhancing plant diversity.

The dry season also depresses pest populations, although far less markedly

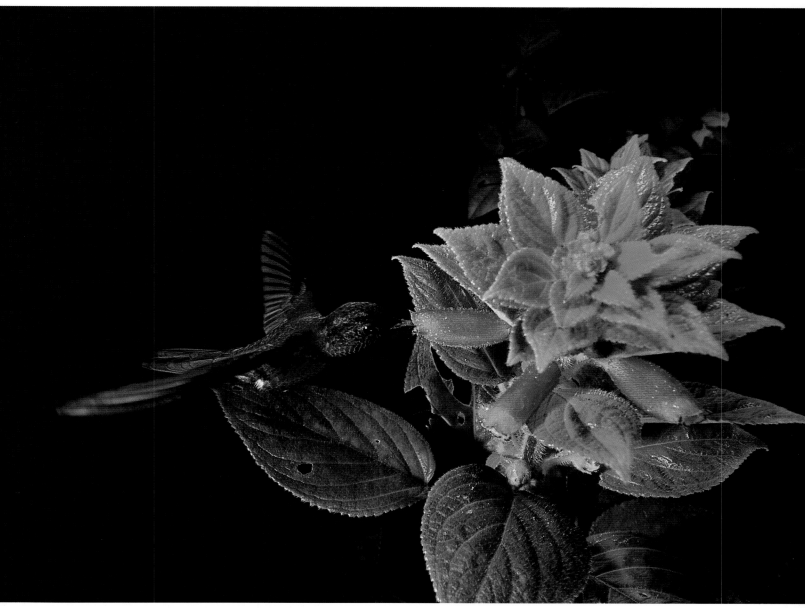

A violet-bellied hummingbird, *Damophila julie panamensis,* drinking nectar
from a gesneriad, *Kohleria tubiflora.* Nectar-eating birds live mainly in trop-
ical and subtropical habitats, where flowers are available all through the
year. This is one of several guilds—groups of animals that make their living in
a similar way—that contribute to the higher diversity of the tropics compared
to temperate-zone settings. Tropical rain forests have many kinds of nectar-
eating birds that plant species need to pollinate their flowers.

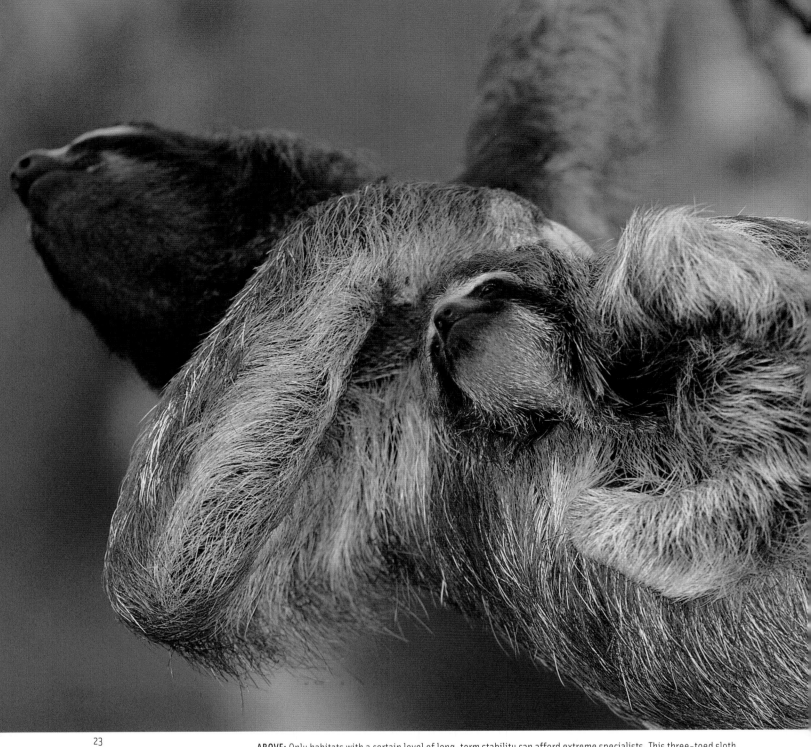

23

ABOVE: Only habitats with a certain level of long-term stability can afford extreme specialists. This three-toed sloth, *Bradypus infuscatus,* eats only leaves. Leaves are difficult to digest, allowing only a reptilian rate of metabolism and a low level of activity.

OPPOSITE, TOP: Insects are by far the most diverse group of animals. Tens of thousands of insect species live on Barro Colorado. Even after eighty years of research on this island, we cannot be more precise about this number. This shot from the Smithsonian Tropical Research Institute's scientific collection features representative species of important insect groups in Barro Colorado's forest. At the top left is a giant damselfly, *Megaloprepus coerulatus*; the huge beetle with long forearms below it to its right is a harlequin beetle, *Acroncinus longimanus* (fig. 24).

OPPOSITE, BOTTOM: Specialized pests appear to play an important role in maintaining plant diversity by keeping any one plant species from becoming common enough to crowd out others. Beetles of the family Bruchidae are specialized seed predators that destroy nearly all seeds of their favored species that agoutis leave unburied. Here, a bruchid beetle, *Speciomerus giganteus,* emerges from a seed of the palm *Attalea butyracea* (fig. 25).

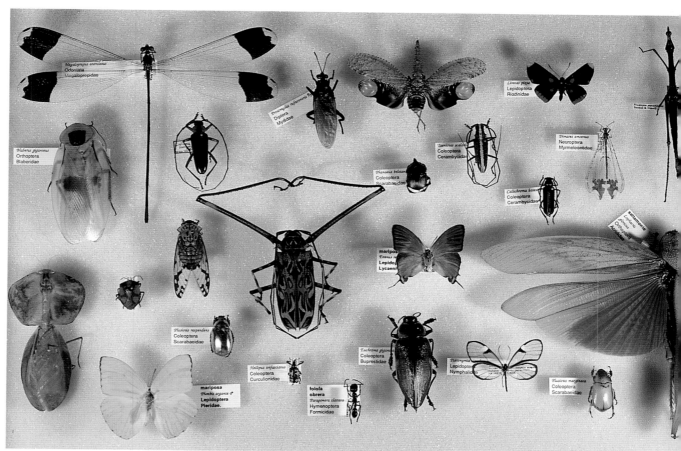

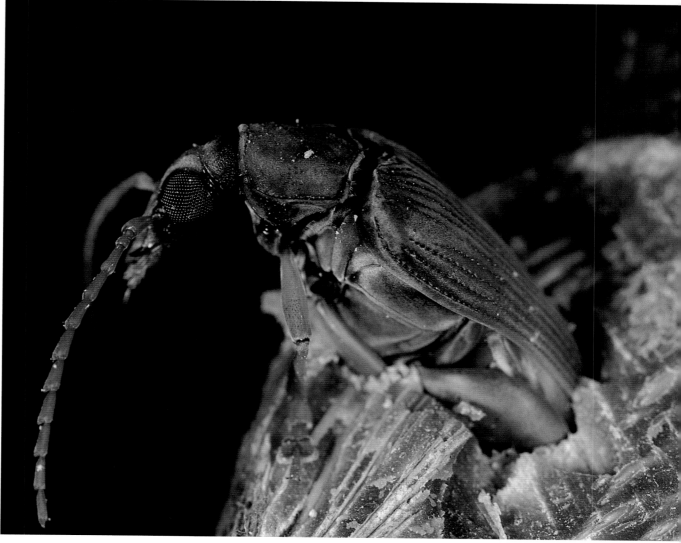

Light with high ultraviolet content draws insects of many different kinds. Scientists attract insects to white sheets by illuminating them with ultraviolet light. This picture shows the many insects thereby drawn to the sheet.

26

than winter does. Where the dry season is severe, as in the deciduous forests of south India, canopy trees reduce insect damage by flushing young leaves just before the rains come. A few trees do likewise on Barro Colorado. In a montane forest with no dry season in western Panama, catches of herbivorous insects at light traps vary less through the year than they do on Barro Colorado Island. Presumably because of the steadier, heavier pest pressure, a hectare of everwet forest, Nusagandi, a hundred kilometers east of Barro Colorado, contains more than twice as many tree species as a hectare on Barro Colorado itself. Correspondingly, tree diversity is lower where the dry season is harsher (table 1.3).

Unlike deserts, where plants defend themselves with a visible abundance of spines, and where the perfumes of their defenses can pervade the air in the evening, the defenses of most tropical leaves are neither visible nor easily smelled. After all, conspicuous leaves are easier for specialized pests to find. The clearest signs of pest pressure are the adaptations by which plants attract pollen from faraway neighbors of their species and arrange for the dispersal

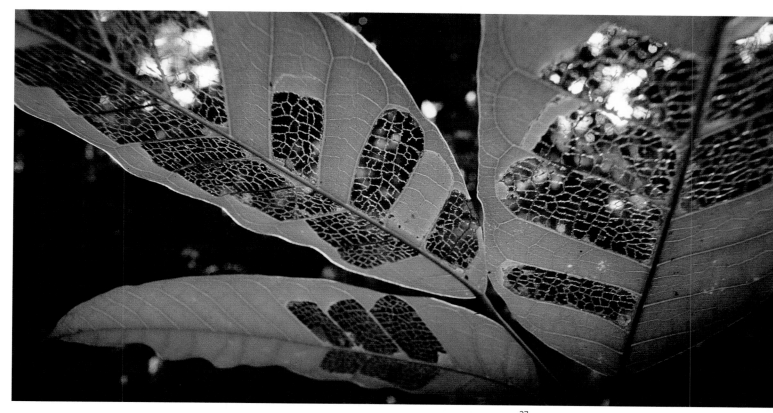

27 Young leaves are eaten much more rapidly in tropical than in temperate-zone forests. Herbivory helps maintain the diversity of tropical plants. The pattern of damage on this *Protium* leaf reflects a particular insect herbivore's work.

of their seeds. Flowers suggest the importance of attracting those particular animals most likely to bring pollen to and from other plants of their species. Fruits designed to ride the wind or seduce animals into eating them and dispersing their seeds testify to the urgency of removing seeds far from their parent plant and the specialist pests living on it. The more nearly everwet a tropical forest's climate, and the more evenly year-round its pest pressure, the higher the proportion of tree species therein that employ animals to disperse their seeds (table 1.4; figs. 28, 29). Animals may leave more fruit uneaten below the tree, but they carry more seeds far away than the wind does.

TABLE 1.3

Tree Diversity in One-Hectare Plots under Different Rainfall Regimes

Site	Santa Rosa, Costa Rica	Barro Colorado, Panama	Nusagandi, Panama
Vegetation	Dry Forest	Moist Forest	Rain Forest
Annual Rainfall, mm	1,614	2,600	3,324
Rainfall, Driest Two Months, mm	0	60	123
Number of Trees ≥ 10 cm dbh*	354	429	559
Number of Species ≥ 10 cm dbh*	56	91	191

* Diameter at chest height

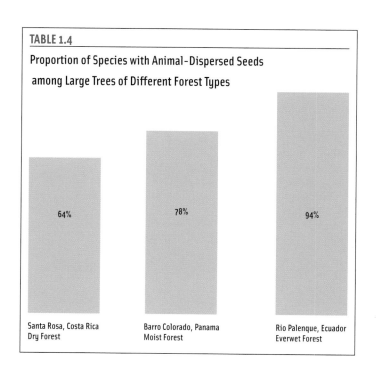

TABLE 1.4

Proportion of Species with Animal-Dispersed Seeds among Large Trees of Different Forest Types

Santa Rosa, Costa Rica Dry Forest	Barro Colorado, Panama Moist Forest	Rio Palenque, Ecuador Everwet Forest
64%	78%	94%

By keeping their host trees rare, specialized pests make room for other kinds of trees afflicted by different pests (fig. 25). In turn, these pests provide livings for hosts of insect eaters: birds, bats, capuchin monkeys, tamarins, lizards, spiders, predatory ants and wasps, parasitoids (insects that lay their eggs on, and whose larvae live within, their insect victims), and the like. The more diverse the pests, the more diverse their predators. But just as pests enhance plant diversity, so their predators enhance pest diversity. A pest may be specialized to a particular tree's leaves for many reasons. Even without predators, the pest must be able to live on those leaves. Moreover, of several kinds of leaves the pest could live on, these leaves might be the one kind its mother could reliably single out from the forest's confusing riot of greenery. Where predators are present, pests may prefer leaves that contain poisons that they can incorporate into their own bodies to make themselves too distasteful or poisonous to be eaten. Or their favored leaves may be on a kind of plant where the pests are less likely to be found or eaten by predators. The impact of predators may be gauged by the many ways in which insects disguise themselves, or other insects render themselves difficult, unpleasant, or dangerous to eat, and by the striking colors with which distasteful insects or

Agoutis (*Dasyprocta punctata*) are considered keystone species for the maintenance of tree diversity in the forests they inhabit, because they protect seeds of many different plant species from insect attack by burying them.

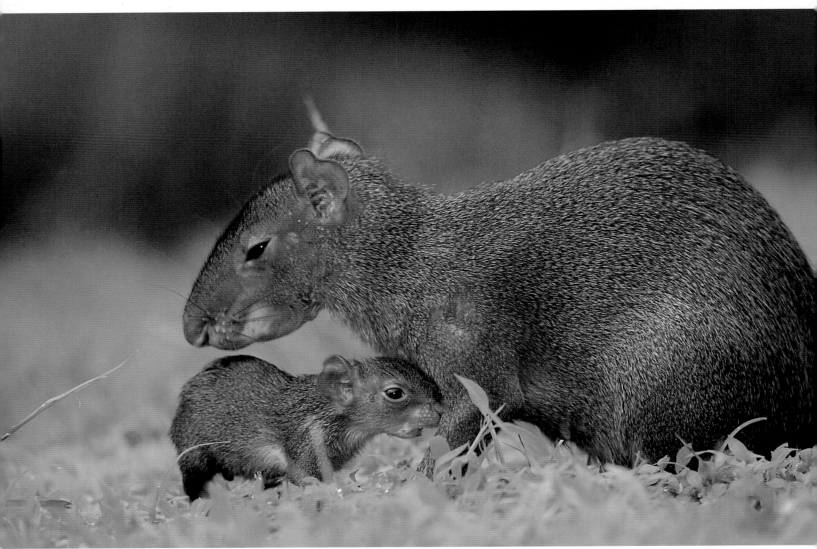

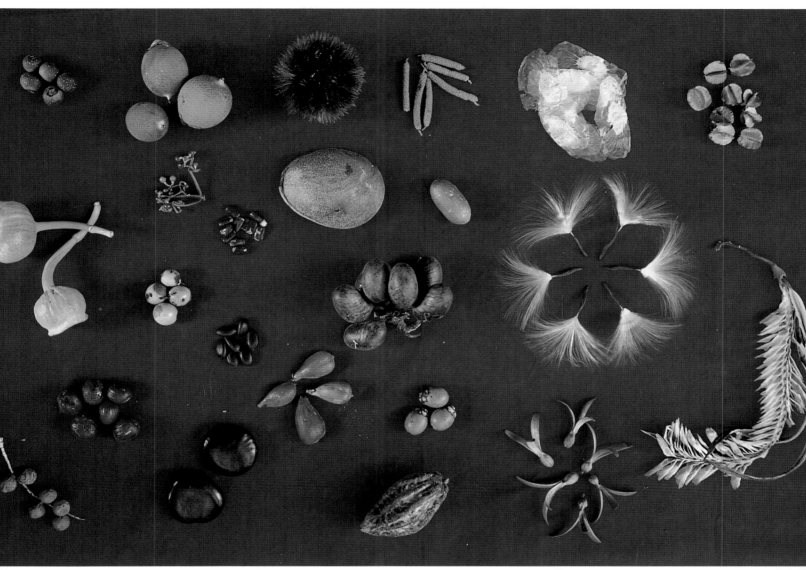

their edible mimics warn predators of their supposed undesirability. In sum, plant diversity enhances pest diversity, which enhances the diversity of the animals that eat the pests, which further enhances pest diversity, which further enhances plant diversity—a wonderful example of a circular causal process in ecology.

The Origin of Species and Selection in Relation to Sex

Understanding diversity means understanding how species coexist and how one species becomes two. One species of animal has become two when it has become divided into two populations whose members no longer mate with members of the other population. Thus the origin of animal species is intimately connected to changes in how animals choose mates.

How do animals attract mates, and how do they choose? Males of many species attract females by calls peculiar to their species. The buzz-saw "songs" of cicadas that sometimes fill the forest, bird songs, and the nighttime sounds of

29 Because many pests (insects eating leaves or seeds, disease-causing microbes, and fungi) are specialized to particular plant species, a seed landing closer to its mother tree is more likely to be killed by its mother's pests. Therefore, plants must find ways to disperse seeds far from their parents. Many employ animals to do so. Four-fifths of the seeds in this picture, which were all collected in April, are of animal-dispersed species, mirroring the proportion of species of large trees on Barro Colorado with animal-dispersed seeds.

frogs, crickets, and katydids are all meant to attract or retain mates. Bird songs also warn off rival males, but their role in courtship is the focus here. Not only do these calls identify the caller's species, they advertise his relative attractiveness as a mate. A female tungara frog prefers males with deeper, lower calls, because these males are probably larger and more likely to fertilize all her eggs.

Other males attract females by visual displays, as do the peacock with his gorgeous tail, birds of paradise with their bright colors and curiously shaped feathers, bowerbirds with their laboriously constructed "bowers," and quetzals with their long, bright tail feathers (fig. 30). In the rainy season, a morning's walk may take a visitor by a male giant damselfly, *Megaloprepus* (fig. 24), hovering in a gap where a tree has fallen, plainly visible thanks to the fluttering of his blue-and-white wingtips. He is advertising a water-filled hole in a nearby tree trunk—a good place for a female to lay her eggs, because it is a good place for larval giant damselflies to grow. He is also warning females that they must let him fertilize their eggs before laying them in "his" tree hole. During the dry season, a visitor may hear curious whirrings and snappings made by a small black bird with a bright red spot capping his head. This is one of a group of male red-capped manakins (fig. 31) whose displays jointly attract the occasional female. In such displays, each male tries to outdo the others to win her favor.

In some species, male calls and displays enable females to choose males of higher "quality"—those that are larger, healthier, or possessed of enough stamina to keep displaying long enough to be convincing. Is this always true? Or do females sometimes fall for stimuli that bear no more relation to mate quality than the clothing displayed nowadays at a Paris fashion show?

Studies of courtship and mating in insects, many by William Eberhard, a biologist at the Smithsonian Tropical Research Institute (STRI), show that in isolated populations, female choice drives remorseless change in the traits and displays by which males attract females, and vice versa. Martin Moynihan, the institute's founder, described an analogous circumstance in certain human signals: "A particularly 'strong' word or phrase, e.g., an obscenity or striking new technical term, is apt to be very impressive and effective when it first begins to be used. Simply because it is effective, it tends to be used more and more frequently. And, unless it is constantly reinforced by new variations or further elaboration, it eventually becomes essentially meaningless." These changes in the characteristics under sexual selection are hardly more predictable than changes in fashions today. If a population is sundered into two isolated fragments, criteria in mate choice may diverge until neither population recognizes members of the other as suitable mates, at which point they have become separate species.

Studies of fish in East Africa's Lake Victoria by students from Holland's University of Leiden suggest that divergent sexual selection can rapidly transform one species into two, and that only after these two populations have ceased to interbreed do they evolve enough differences in habitat or food choice for them to be able to coexist. Darwin commented that related species differ most in the characteristics meant to attract mates, which implies that sexual selection often plays a crucial role in the origin of new species.

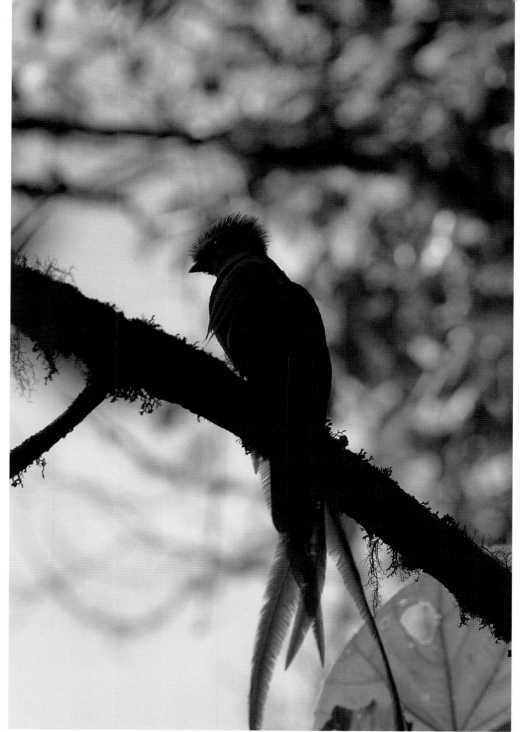

LEFT: Sexual selection is thought to be one of the driving forces of speciation. Male ornaments are often important for recognizing appropriate partners. A famous and beautiful example of such a male ornament is the long tail feathers of quetzals (*Pharomachrus mocinno costaricensis*), birds of Central American mountains. This one is in a cloud forest in the Volcan Baru National Park.

BELOW: A male red-capped manakin, *Pipra mentalis ignifera*. These males assemble in groups called "leks" to attract females, for whose favors they compete.

Interdependence: The Many Ways
Different Species Depend on One Another

Forests, like other ecological communities, are webs of interdependence. Animals depend on green plants for the food and oxygen created by photosynthesis. Plants depend on a great variety of animals, ranging from termites and earthworms to minute mites, insects, fungi, and bacteria, to consume dead plant matter and break it down by successive stages—one guild of organisms consuming what has been fragmented or passed through the gut of another—until the mineral nutrients contained therein are released to fertilize other plants. In his last book, Charles Darwin showed how much British plants depend on earthworms to aerate their soil and to enhance its penetrability by roots, its fertility, and its water-holding capacity. Indeed, in tropical forests, as in Britain, a whole host of microorganisms helps earthworms preserve the structure and fertility of the soil. Plants also depend on birds, bats, spiders, wasps, and other animals for help in controlling their insect pests.

The stability of tropical environments promotes more complex interdependences. Because swarms of army ants are always marching across the forest floor, flushing insects as they go, one guild of birds makes a living by specializing on the insects flushed by these ants. Agoutis bury seeds of suitable sizes, scattered over their territories, as a food reserve against a time of fruit shortage. Where agoutis live, several trees with large seeds depend on these agoutis to bury their seeds and thereby protect them from would-be consumers. Because predators are an ever-present threat in tropical forests, many birds of the forest understory join with birds of other species, which eat different things, or feed in different ways, to form "mixed flocks" or "mixed-bird parties." These birds seldom help each other find food: indeed, each species is represented in a flock by no more than one pair with attendant young, as if the flock's members were chosen to minimize competition among them for food. These birds flock because the more birds there are to notice predators, the more time each bird can spend feeding. Such mixed-bird parties are a characteristic feature of lowland tropical forests, in Borneo and New Guinea as in Panama.

In many cases, this interdependence arises when organisms pool complementary abilities. Plants are good at making food; other organisms are good at decomposing dead plants, moving and burying live seeds, and so forth. Indeed, all species alive today depend on services that appear to be automatic consequences or by-products of the ways other species make their livings. Animals depend on plants for their oxygen; plants depend largely on the organisms that eat or rot them for their carbon dioxide, and so forth. Although decomposers are ultimately dependent upon the plants whose dead matter they rot, a decomposer derives no more advantage over its neighbors by enhancing its usefulness to plants than someone would by cleaning the air around him in Times Square. In both cases, the benefits of these activities diffuse too widely to profit the agent differentially.

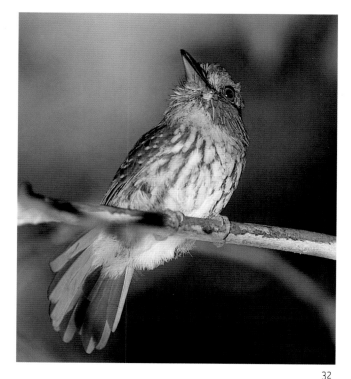

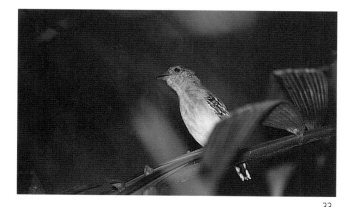

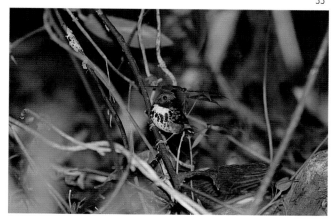

33

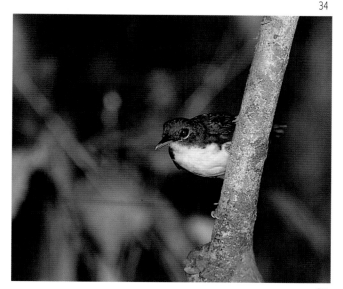

34

32

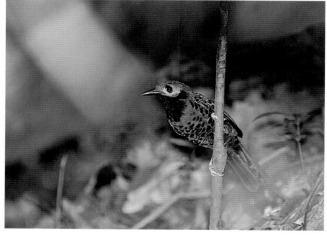

35

37

Another famous phenomenon of tropical forests is mixed-species bird flocks. These flocks can consist of up to ten different species foraging together. In the Neotropics, ant-following ant-birds of several different species flock together to follow raiding swarms of army ants and eat the insects trying to escape the ants. Figs. 32–37 show six species that at least occasionally join ant-bird flocks. **CLOCKWISE FROM UPPER LEFT:** White-whiskered puffbird *(Malacoptila m. panamensis)*, a rare visitor to ant swarms. A male slaty ant-shrike, *Thamnophilus punctatus:* another rare visitor to ant swarms. A male spotted ant-bird, *Hylophylax naevioides,* a mainstay of ant-following flocks. A bicolored ant-bird *Gymnopithys leucaspis,* a professional ant-follower. An ocellated ant-bird, *Phaenostictus mcleannani,* on the mainland near Barro Colorado. This professional ant-follower is now extinct from Barro Colorado. Last, a plain brown woodcreeper *(Dendrocincla fuliginosa).* See discussion on p. 209.

36

Mutualisms

Sometimes, however, complementary functions cause two species, or two groups of species, to become partners in a mutualism. In a mutualism, members of each species exploit activities of the other to their mutual benefit. Mutualisms are relationships that serve the common good of the partners involved. Accordingly, a species often evolves in some way to accommodate its partner in mutualism, in order to derive more profit from the relationship.

Many plants have nectaries on their petioles or leaves that, at least when the leaves are young, secrete a fluid attracting predaceous ants, which kill some leaf-eating caterpillars and frighten away or chase off some other leaf-eating insects. These ants do not nest on the plant, and they show little dedication in defending it. These plants pay a small price in carbohydrates, which they specialize in manufacturing, to obtain a degree of protection from the mobility and aggressiveness of the ants they attract. One such plant is *Croton billbergianus;* each leaf has a nectary, a small circular area on the leafstalk, just where the stalk joins the base of the heart-shaped leaf. Usually, ants are found only on the youngest leaves.

In such catch-as-catch-can relationships, animals may take the bribe without protecting the plant, which cannot retaliate. Herbivores may even outbid the plants for the ants' protection. Caterpillars of the butterfly *Thisbe irenea* eat only *Croton* leaves. In 1985, Philip DeVries, a graduate student at the University of Texas, came to Barro Colorado on a Smithsonian predoctoral fellowship to learn how *Thisbe* caterpillars subvert *Croton*'s ants (fig. 38). These caterpillars drink from *Croton*'s leaf-base nectaries and transform this fluid into something much more nutritious, which the ants greatly prefer. The caterpillars offer this fluid in nectaries on their bodies. *Thisbe* caterpillars also use other means to transform *Croton*'s ants from indolent protectors of leaves to energetic bodyguards of caterpillars, which, indeed, are likely to die unless ants protect them. The caterpillars can call forth ant defenders by releasing chemicals that the ants mistake for fellow ants' alarm signals, and by using structures on their bodies to call ants "ultrasonically." *Thisbe* and its ants are an unusually elaborate example of the many mutualisms in which aggressive ants protect tender, sluggish insect herbivores such as aphids or caterpillars in return for a reliably copious supply of honeydew (fig. 40).

Some plants offer shelter and food designed to attract specific kinds of ants, which, in return, defend their plants aggressively and comprehensively. Here, the complementation of functions has been refined to the mutual benefit of plants and ants. The prickly stemmed sprawler *Acacia hayesii* has extrafloral nectaries that attract halfhearted ant protectors for its young leaves. Barro Colorado also has a few swollen-thorn acacias *(Acacia melanoceros),* trees with nectaries on their leaves, and nesting sites—great bulbous hollow thorns—that attract ants justly named *Pseudomyrmex satanica* for their obnoxious stings and their readiness to use them. These ants chew off the tips of vines touching their plant, repel herbivores, and maintain a clearing around their plant's base. On Barro Colorado, a more familiar ant-plant is

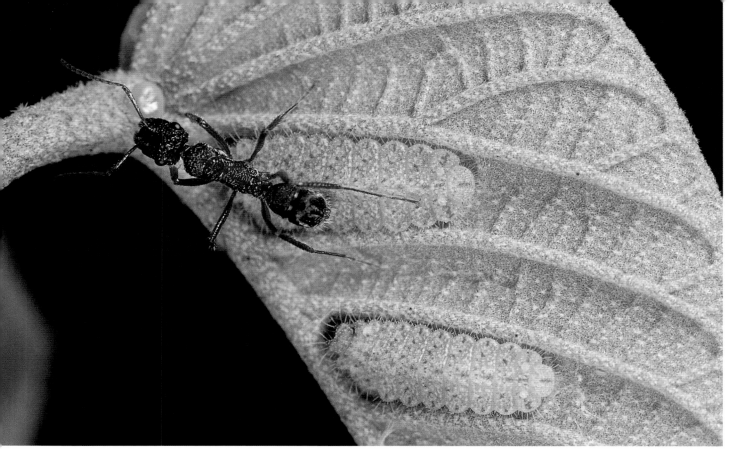

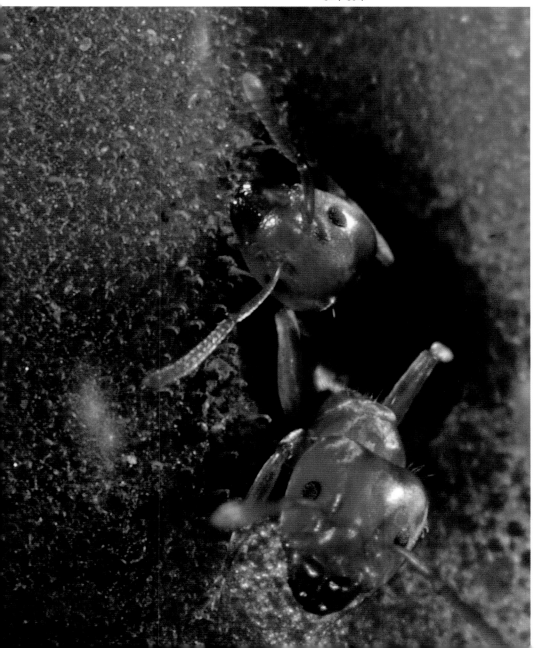

ABOVE: Many plants, including *Croton billbergianus,* have nectaries on their young leaves that attract ants. These ants are expected to scare off some potential herbivores. In this *Croton*'s case, however, the caterpillar *Thisbe irenea* drinks the plant's nectar and transforms it into a liquid the ants like better. The ants accordingly let the caterpillars devour *Croton*'s leaves at will, and defend the caterpillars against some of their enemies.

LEFT: Plants of the genus *Cecropia* have developed a close relationship with ants. As pioneer species, they must grow rap-idly and cannot afford to invest much energy repelling herbivores. For this reason, *Cecropia* plants offer ants room and board in exchange for protection against herbivores. *Cecropia* stems are hollow and chambered, providing perfect ant houses for many small ant species. The plant also offers the ants small food bodies at the base of its young leaves. The plant benefits because the ants defend their source of food, attacking any animal that tries to eat their plant's leaves. Here, ants, *Azteca* sp., are com-ing out of a hole in the stem.

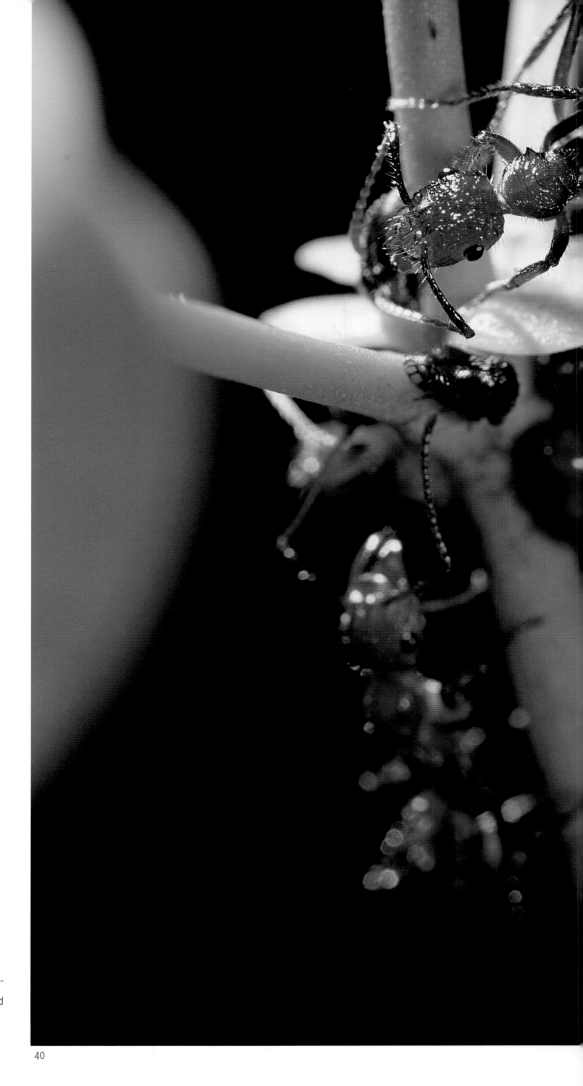

Insects that suck sap from plants often consume more sugar than they can use, so they offer honeydew to ants, which care for their food suppliers by scaring off potential predators. Here, ants of the genus *Ectatomma* tend sap-sucking membracines, relatives of cicadas.

the light-gap tree *Cecropia.* This tree has hollow stems where *Azteca* ants nest, and glycogen-rich bodies on hairy platforms at the bases of their leaf-stalks for ants to eat and to feed to their larvae. *Cecropia*'s ants repel encroaching vines as well as herbivores (fig. 39).

A distinct group of ants collects insect corpses, dung, or dead vegetation, on which the ants raise a fungus to feed their larvae. The mobile ants concentrate resources appropriate to their fungi, which digest them for their own and the ants' benefit. These colonies are mostly small, with a hundred to a few thousand workers. However, some fungus-growing ants, the leaf-cutters, farm a "superfungus" that digests freshly cut leaf fragments from an extraordinary variety of plant species (fig. 41–45). This superfungus is truly a master of many trades. There are forty-five leaf-cutter nests in the seventy-five hectares surrounding Barro Colorado's laboratory, and very few farther away. Each nest is a system of underground caves housing a few million ants and their fungus gardens. On Barro Colorado, most nests are marked by workings of red earth several meters wide, often with a dump where used leaf fragments are steadily deposited, day and night. Ant highways radiate out a hundred feet or more from the nest, many filled with lines of ants carrying leaf fragments, often cut from the crowns of tall trees, into their nest's fungus gardens. A nest consumes over half a ton of fresh leaves per year.

Leaf-cutter ants jealously guard the purity of their fungus culture. Each new leaf-cutter ant queen carries a piece of fungus from her mother's nest to start her garden. This piece of fungus contains *Streptomyces* bacteria, whose antibiotic secretions keep the culture free of contamination by the most dangerous species of parasitic fungus. The ants eat what would become the fungus's reproductive parts. Thus the fungus can reproduce only when ants carry it to new nests. The reproductive prospects of the fungus are therefore governed by how well it serves its ants.

Pollination and Seed Dispersal

The most familiar mutualisms are those by which plants attract animals to pollinate their flowers or disperse their seeds. Plants supply carbohydrates, or feign the presence of that or some other attraction, advertising their bait by brightly colored or curiously constructed flowers to entice mobile animals to move their pollen or seeds. Animals sometimes accept, or destructively steal, the bait without delivering the service required. A hummingbird, which readily pollinates one kind of red tube-flower, may find it easier to reach another's nectar by stabbing through its base than by inserting its bill into the flower in the normal manner that dusts the bird with pollen. Likewise, a bee might bite through the base of a flower to get its nectar. Parrots routinely smash and digest the seeds in fruits they eat.

To attract the most appropriate and most trustworthy pollinators, plants use an extraordinary variety of means. Indeed, there seems to be a premium on finding new ways to be pollinated. The bright yellow flowers of the guayacan are

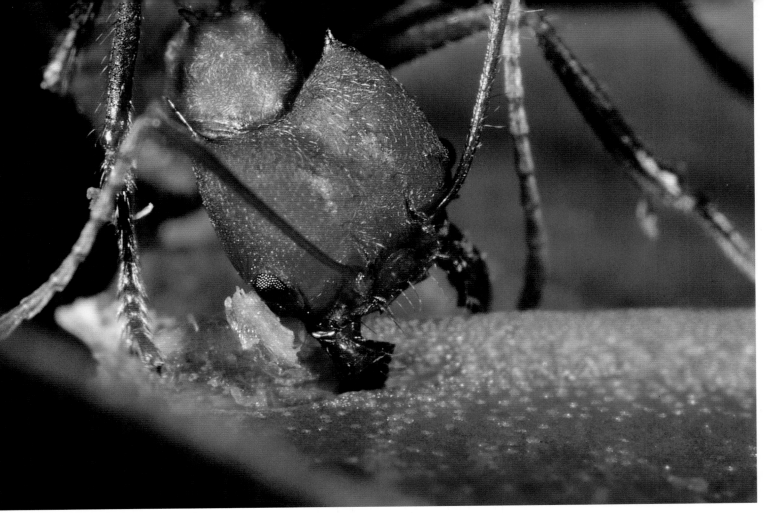

41 Leaf-cutter ants (*Atta colombica*) are among the most sophisticated ant species on our planet. Their enormous colonies, with up to several million ants, cultivate a particular fungus to digest the leaf fragments they bring from the rain-forest canopy. Ants first employed fungi as external digestive organs about fifty million years ago. Fungus-taming has transformed some species of leaf-cutting ants into abundant, versatile herbivores—major pests of human agriculture. With their specially designed mandibles (fig. 41), ant workers cut little pieces out of leaves (fig. 43) and carry these (fig. 44) along trails up to two hundred meters long back to their underground nests. Ants often harvest flowers and fruit as well as leaves. In the nest, specialized "fungus garden

42

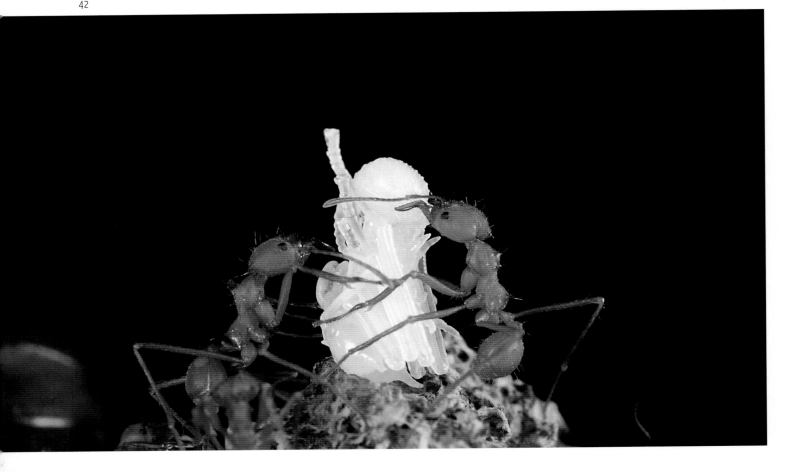

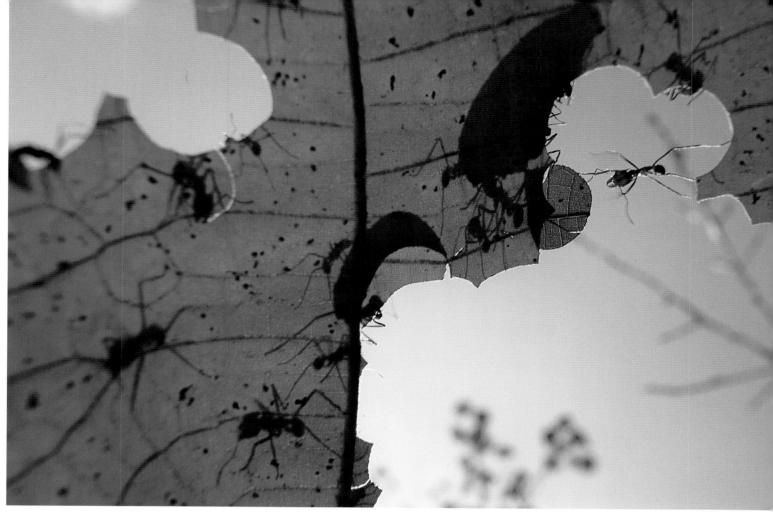

workers" cut the leaf pieces smaller and chew them together with bits of fungus from the fungus garden, which resembles a bath sponge (fig. 42). The fungus "digests" the plant material, coping with its many poisons, which protect these leaves from other herbivores. The ant larvae eat the nutritious fruiting bodies of the fungus. Here, two workers tend a larva on the fungus garden.

THIS PAGE AND NEXT: Leaf-cutter cutting *Ochroma* leaves (fig. 43); a crowded ant highway (fig. 44); a worker carrying a freshly cut leaf fragment (fig. 45, overleaf).

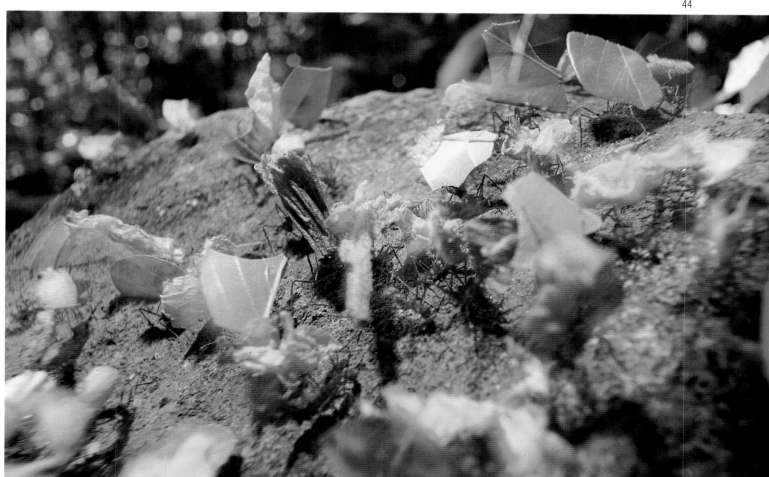

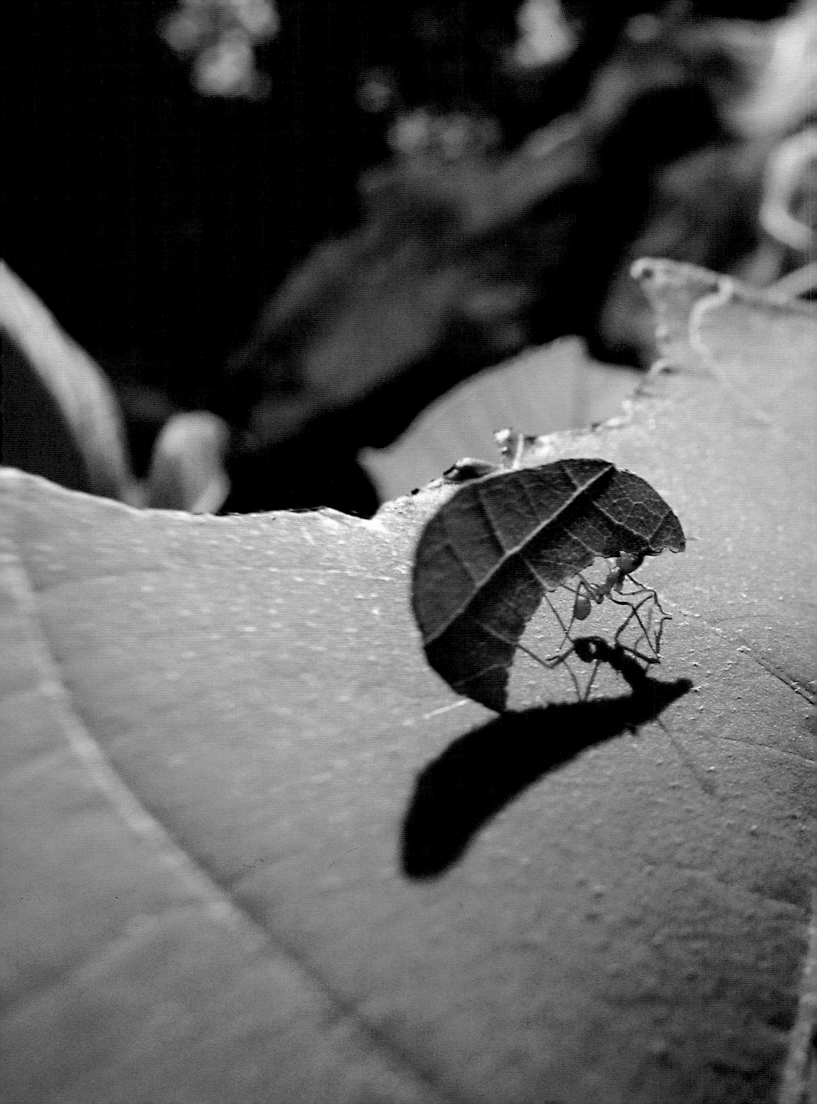

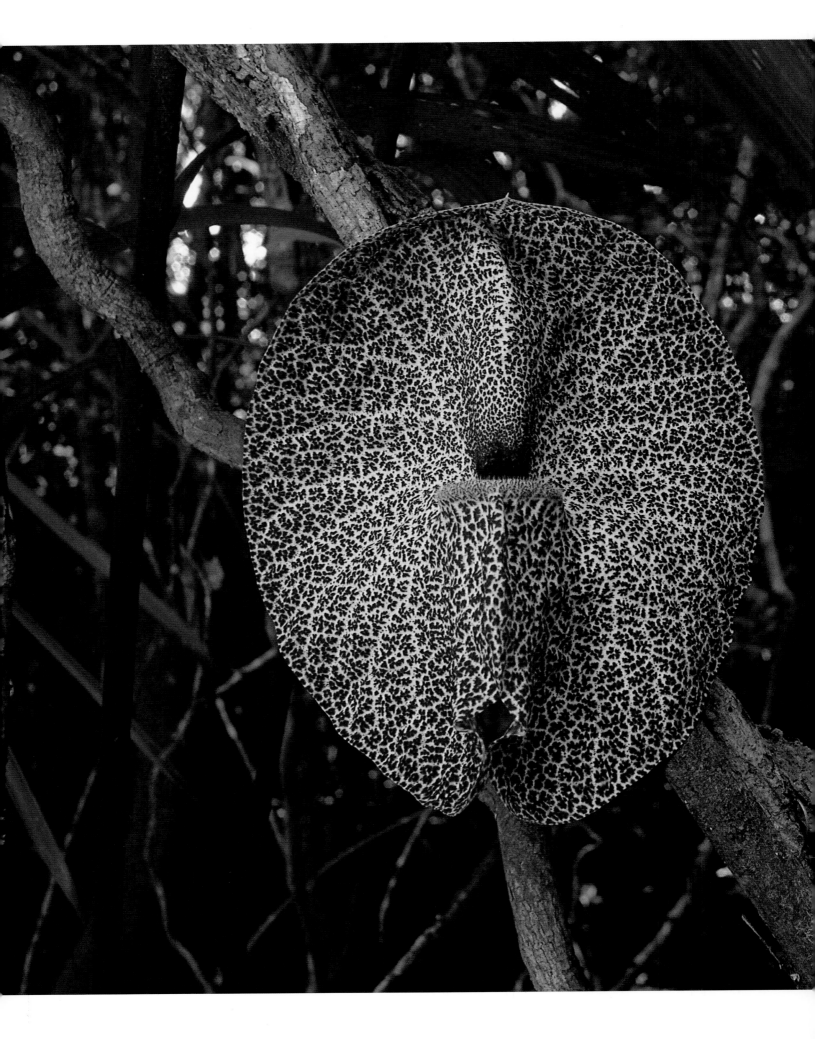

Some plants attract pollinating insects by deceptive advertising. Among these are flowers, like that of the vine *Aristolochia gigantea* illustrated here, that imitate the scent of a carcass to attract dung beetles and flies as pollinators.

designed to attract a variety of large bees, while an orchid's flower may be designed to attract one kind of orchid bee (fig. 47). Long-tubed red flowers are meant for hummingbirds. The flowers of some *Aristolochia* resemble, and often smell like, cavities in a carcass, to attract carrion flies (fig. 46). Some aroid flowers heat up at evening to spread an odor that attracts a particular kind of beetle and imprisons the beetles thus attracted overnight to enhance the effectiveness of pollination.

Similarly, some fig trees attract an indiscriminate variety of monkeys, bats, kinkajous, and the like to eat their fruit, while the fruits of wild nutmeg, whose large seeds must be carried far from the parent to escape its pests, attract mainly toucans. Plants use varied means to attract these dispersers—bright berries for little birds; large, hard seeds for agoutis; greenish fruits for bats; various sugary or oily fruits for other mammals and larger birds. Interdependence ramifies far beyond a plant and its pollinators and dispersers. A plant depending on certain birds to disperse its seeds depends on other plants to feed these birds when it has no fruit, and sometimes on other forests to feed them when its own has little fruit. Many trees also depend on predators that lurk in their crowns at fruiting time to frighten dispersers into carrying fruit far away before eating it and dropping its seeds.

If an animal is sufficiently attracted by a particular plant's nectar, it will search out and pollinate other plants of the same species even if they are widely scattered. If a species-specific pest thins out this plant's population, its flowers will still be pollinated. Thus animal pollination allows this plant species to be rarer and more widely scattered without risking extinction. A species of plant that can survive when rare enough to escape its pests need invest less in antiherbivore defense than others whose members are close enough together for pests to move easily from one to the next. The animal-pollinated plant can invest instead in growing faster and reproducing sooner. Plants capable of attracting pollinators faithful to their species—weeds that live in open places where fast growth is at a premium—first evolved more than a hundred million years ago. Their descendants diversified rapidly, filling tree-fall gaps and colonizing riverbanks and other disturbed areas. After dinosaurs died and mammals came into their own, flowering trees could count on mammals to disperse their large seeds (fig. 48). These seeds could germinate and grow in the deep shade of mature forest, far from others of their species. Trees with animal-dispersed seeds diversified to make the tropical forest we know today. The diversity and luxuriance of tropical forests are a gift of animal pollinators and seed dispersers. Beautiful flowers and tasty fruit attract the pollinators and seed dispersers that allow each kind of tropical plant to escape its pests by hiding among a multitude of other plants their own pests cannot eat, rather than defending themselves with heavy, growth-slowing loads of antiherbivore toxins.

OPPOSITE: Plants offer animals nectar to entice them to serve as pollinators. Here, an aroid has attracted two orchid bees (euglossines), a small *Euglossa* and a large *Exaerete,* a parasitic orchid bee that lays eggs in the nests of other orchid bees. Orchid bees can carry pollen long distances. Many plants, such as orchids and aroids, rely solely on orchid bees for pollination, and produce very flowery, sweet scents to attract the bees from far away (fig. 47).

OVERLEAF: Agoutis *(Dasyprocta punctata),* like the one here, are among the few animals that can open the hard shell of a *Dipteryx panamensis* fruit to reach the nutritious seed inside. They are major consumers of *Dipteryx* fruit. They also bury large numbers of *Dipteryx* seeds for later use, hiding them from other seed-eaters, as jays bury acorns in North America. Forgotten seeds sprout, replenishing their species (fig. 48).

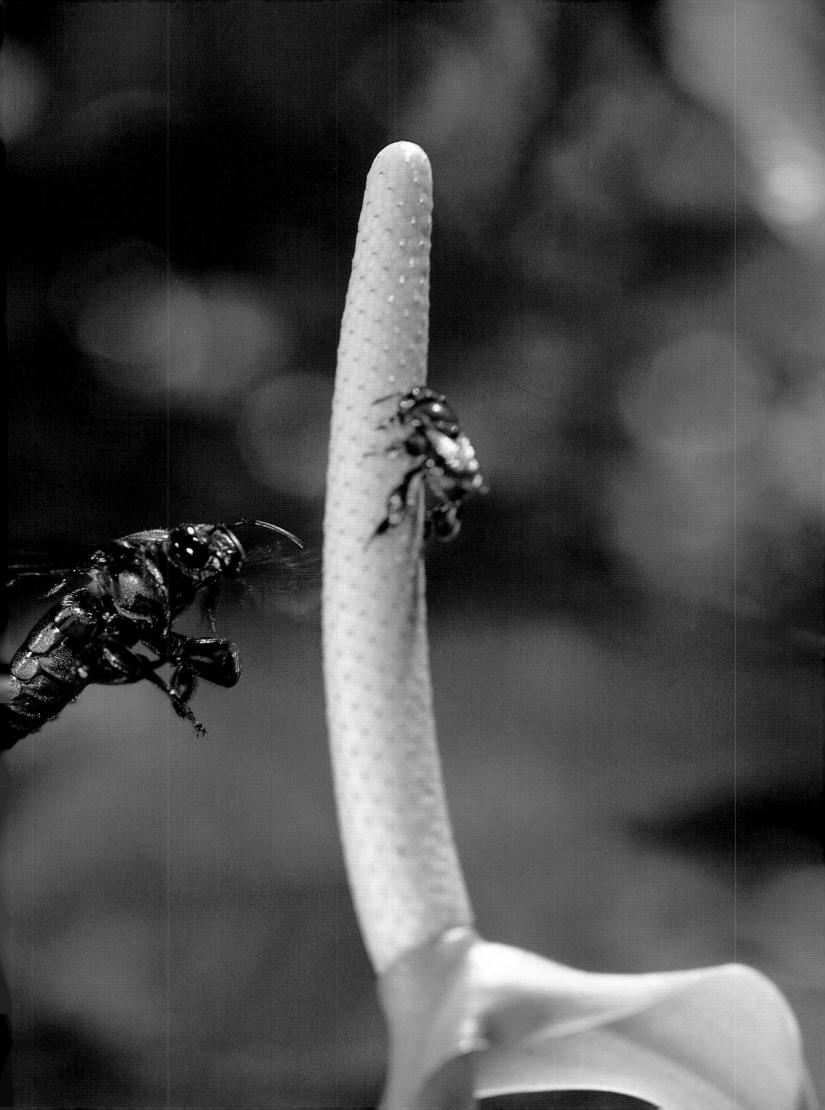

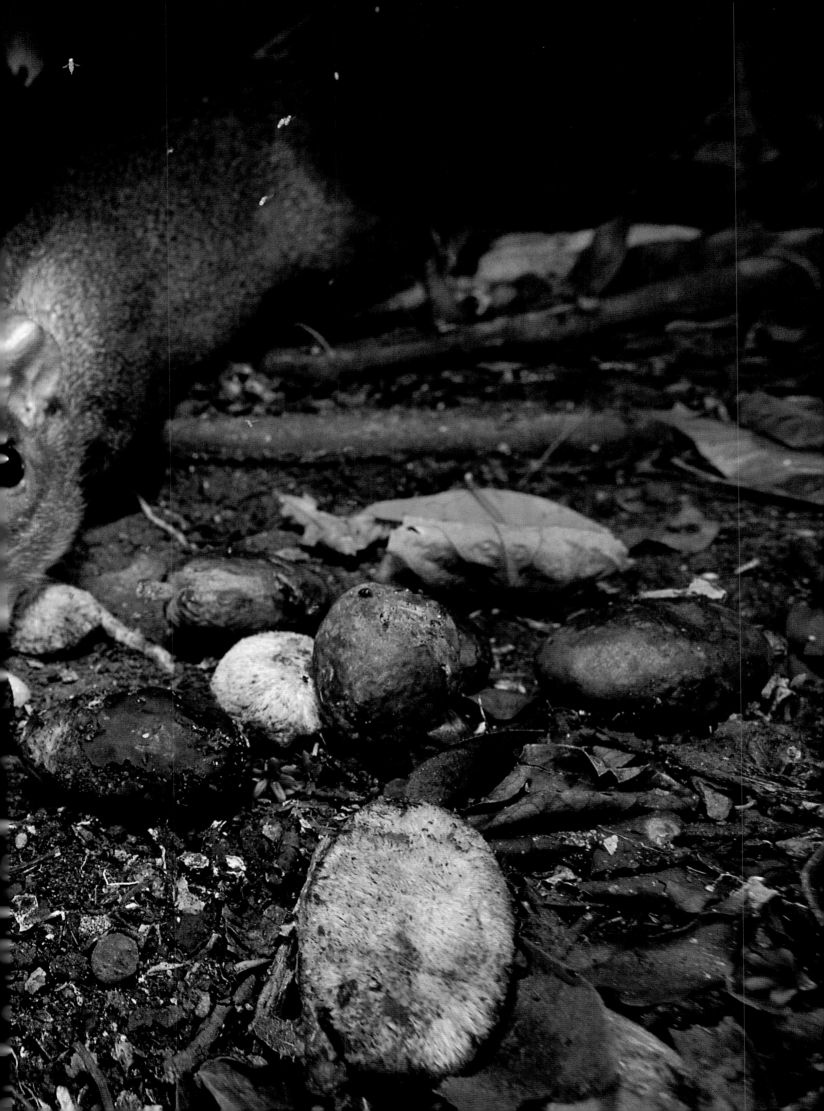

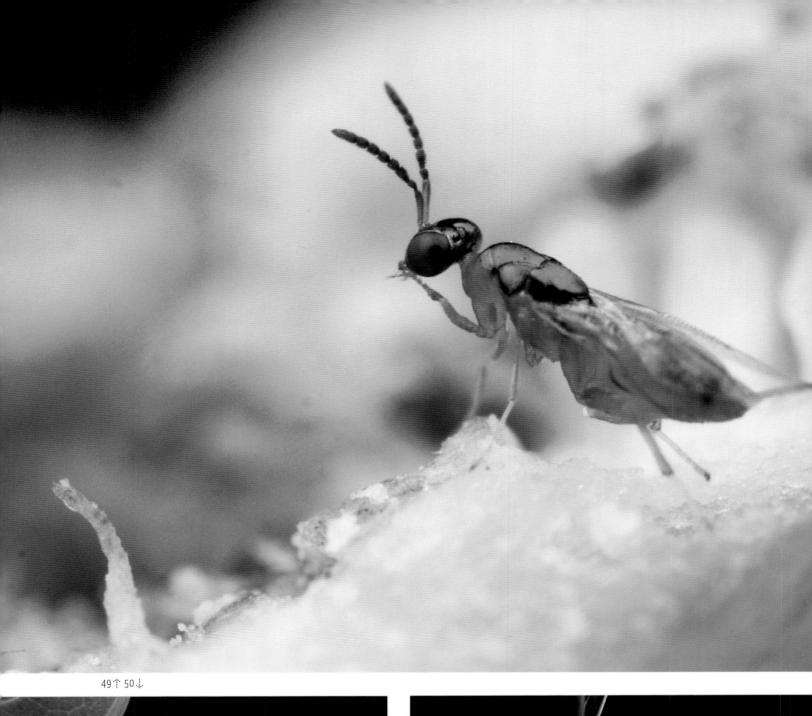

49 ↑ 50 ↓

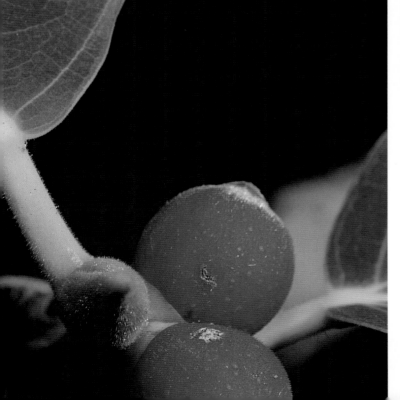

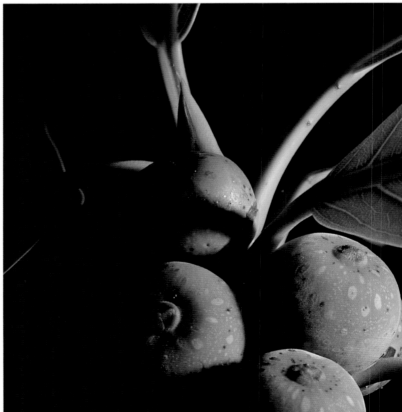

The Ultimate Pollinators: The Wasps That Pollinate Fig Trees

Most pollinators depend for their living on several species of plants. A spectacular exception is the pollinators of fig trees. Barro Colorado has eighteen of the world's seven hundred species of fig tree. Each one of these seven hundred species has its own species of pollinating wasp. A fig "fruit" is a flower head turned outside in to form a ball, or syconium, with a hole at one end, lined on the inside with flowers. When a tree's flowers are ready to be pollinated, a special odor attracts pollen-bearing wasps. One or more enter each syconium, fertilize its flowers, and lay eggs in about half of them. Each wasp larva matures within the confines of a single seed; no seed gets more than one wasp. When adult wasps emerge from their seeds, they mate among themselves, and the males chew a hole in the syconium's wall through which the females will leave. The fertilized females, dusting themselves with the pollen that the flowers are only now producing, fly off in search of new trees to pollinate (figs. 49–55).

Fig trees are designed to ensure cross-fertilization. When a syconium's flowers finally produce pollen, they can no longer be fertilized by it. In most fig species, a fig's syconia develop so synchronously that when the earliest release pollen-bearing wasps, the tree has no more syconia wait-

Fig trees and their pollinator wasps represent one of the most specialized mutualistic relationships between plants and animals. Neither figs nor wasps can survive without their partners. This intricate partnership evolved when dinosaurs walked the earth. There are more than seven hundred species of figs worldwide. At least nineteen species grow on or near Barro Colorado Island. Each has one or more species of pollinating wasp of its own. Each wasp larva matures within the confines of a single fig seed. When the adults hatch (fig. 55), they mate with the others in their fruit. Mated females pick up some pollen, leave the fruit, and fly off in search of a flowering fig tree of the same species. The one they find may be more than ten kilometers away. There, one or more female wasps enter a developing fig fruit (now a ball lined on the inside with flowers), pollinate the flowers, and lay eggs in some of the seeds. Overall, about half a fig tree's seeds produce wasps; the others are capable of becoming new fig trees. Other wasps specialize in parasitizing the pollination mutualism. They have long ovipositors, and lay eggs from outside the fruit without pollinating any flowers (fig. 49). Figs rely on other animals to eat their ripe fruit (figs. 50, 51) and disperse their seeds. Figs with red fruits (fig. 50) are dispersed mainly by birds, which are attracted to the color red. Fig species with green fruit (fig. 51) are eaten and dispersed mainly by fruit-eating bats, which they attract during the night with a special scent. Fig. 54 shows a fruiting fig tree in the early evening and a little bat, probably *Vampyressa nymphea,* about to take a fruit. The adult trees of many fig species are impressive, with intricately convoluted trunks (fig. 53). About half of the world's fig species are stranglers that start their lives as epiphytes on other trees and then send roots down to the ground. In many of these species, the fig encloses its host tree so tightly that the tree dies sooner or later, leaving a hollow in the fig's trunk (fig. 52).

OPPOSITE, TOP: Parasitic fig wasp (*Idarnes* sp.) with long ovipositor (fig. 49); **OPPOSITE, BOTTOM LEFT AND RIGHT:** Red fruits of a fig tree, *Ficus* sp., on the mainland, whose seeds are dispersed by birds (fig. 50); green fruit fig of the *Ficus obtusifolia* (fig. 51), whose seeds are dispersed by bats.

OVERLEAF: Left: Freestanding fig tree, detail from inside (fig. 52). Right: Strangler fig tree (fig. 53).

51

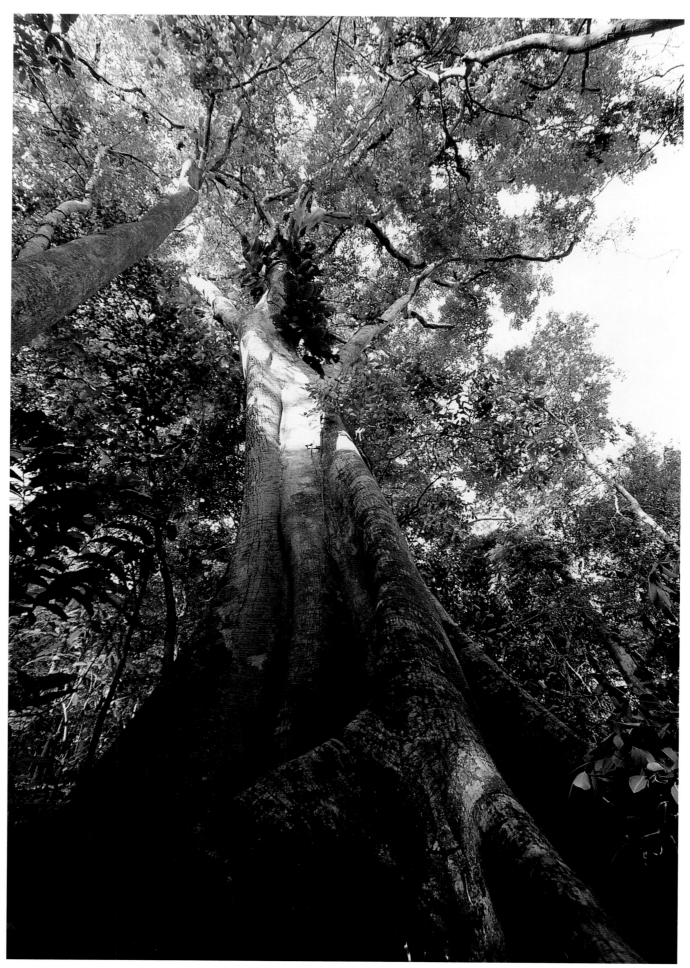

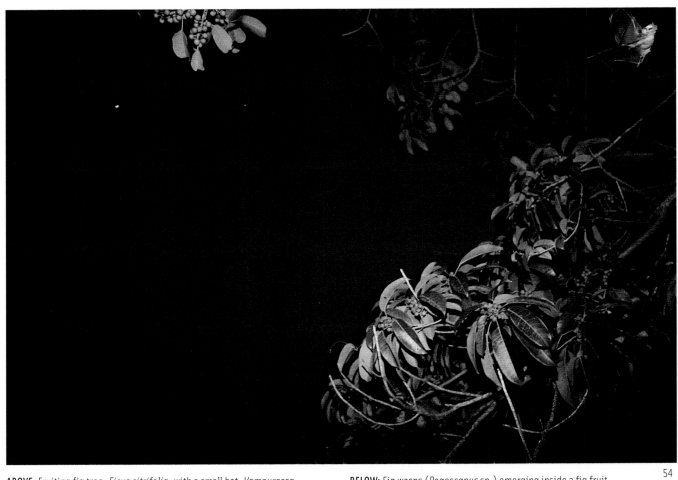

ABOVE: Fruiting fig tree, *Ficus citrifolia,* with a small bat, *Vampyressa nymphaea,* coming in from the upper right.

BELOW: Fig wasps (*Pegoscapus* sp.) emerging inside a fig fruit

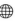

ing to be pollinated. These wasps must find another tree to pollinate. Although the adult wasps die within a few days, they can pollinate trees several kilometers away. Indeed, a tree can attract wasps from a hundred or more square kilometers of forest (table 1.5).

John Nason, then a graduate student at the University of Iowa, was the first to learn how far fig wasps travel. By growing seedlings from a "singly sired" fruit, a fruit pollinated by a single wasp, and establishing their genotype, he could use methods analogous to paternity analysis in humans to infer the genotypes of both the seed and the pollen parents of these seedlings. Thus, given a set of singly sired fruits from a single tree's fruit crop, he could tell how many trees contributed wasps to pollinate these fruit. At most, one of every fourteen trees could have supplied wasps at a time allowing them to pollinate this fruit crop. The number of hectares supplying the wasps to pollinate this tree's fruit crop is at least fourteen times the number of hectares per adult tree of this species times the number of trees supplying pollen to the singly sired fruit whose seedlings John Nason genotyped.

Fig-pollinating wasps are expensive to maintain. To feed its pollinators, a species of fig tree must always have some trees with fruit ready to pollinate, regardless of whether the season is propitious for fig seedlings. Moreover, the wasps die if overheated. Therefore, trees with larger fruit, which is more likely to overheat when in the sun, must evaporate a steady stream of water during the day to keep their fruit cool. Fig trees with large fruit must therefore have reliable access to soil water.

These fabulous pollinators, however, allow even rare species of fig tree to maintain high genetic diversity. Moreover, fig trees need not invest heavily in antiherbivore defenses; they grow fast, die quickly, rot quickly when dead, and produce an abundance of nutritious foliage and fruit. A square meter of a fig tree's sun-leaves produce more sugar per day than a square meter of sun-leaves of any other tree yet known: twenty grams, compared to eight grams in the average canopy tree. Some fig trees colonize abandoned fields and newly accreting riverbanks; others start life growing on the branches of other plants, and drop roots to the ground that eventually encircle the host's trunk, strangling the host.

Thanks to their steady, reliable supply of fruit and their nutritious leaves, fig trees are "keystone species"—species that are disproportionately important to the maintenance of other species—in many tropical forests of both the New World and Asia. A special guild of several bat species eats their fruit and disperses their seeds. Many other animals depend on their fruit during the season of forestwide fruit shortage. Moreover, a diverse and busy collection of insects specializes in consuming the wood of dead fig trees.

TABLE 1.5

Areas from Which Different Fig Trees Call Pollinators

	obtusifolia	dugandii
Number of Singly Sired Fruit Collected	28	15
Number of Trees Supplying Pollen to This Set of Fruit	22	11
Area per Adult Tree of This Species	14 ha	250 ha
Area per Tree Releasing Wasps at the Right Time to Pollinate These Fruit	196 (14 x 14) ha	3,500 (250 x 14) ha
Area of Forest Supplying Pollinators for These Fruit	4,300 (196 x 22) ha	38,500 (3,500 x 11) ha

Note: Figures based on a single fruit crop from one tree of each species.

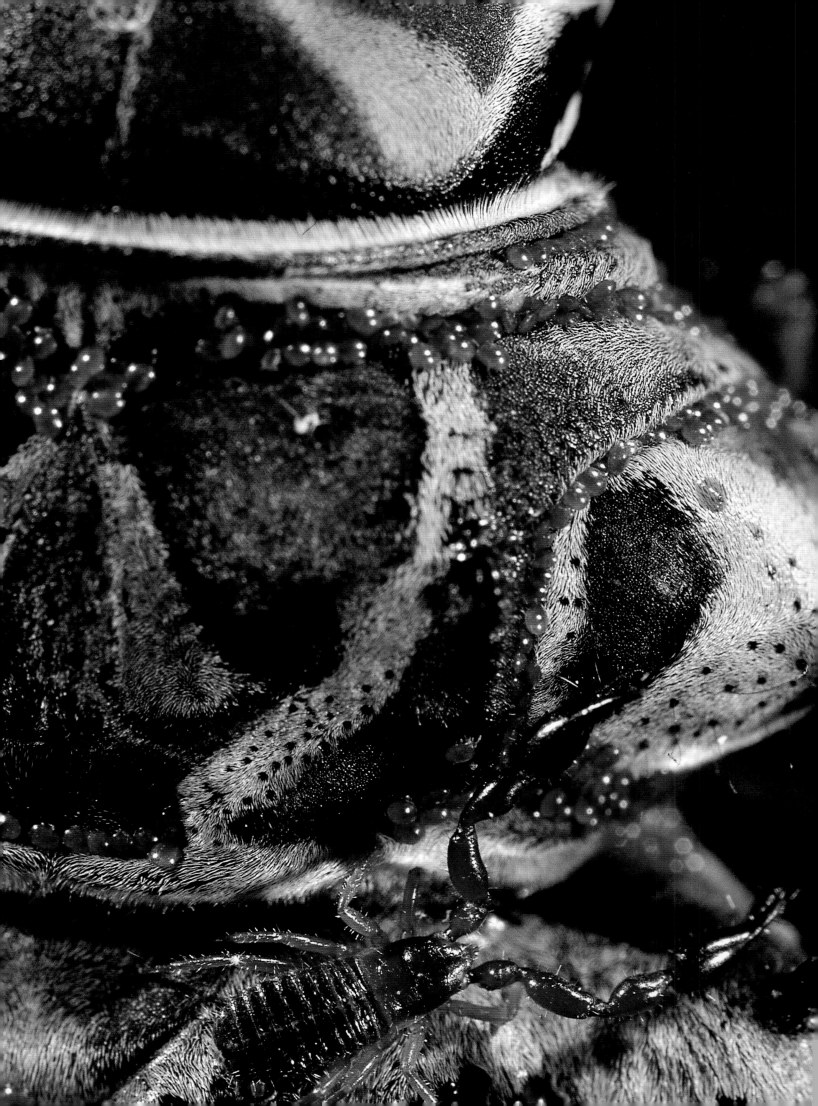

Are Ecological Communities Commonwealths for Their Member Species?

The luxuriance and diversity of the tropical forest on Barro Colorado and nearby protected areas contrast strikingly with the sterile tracts of paja grass, *Saccharum spontaneum,* a southeast Asian grass introduced to Panama about 1970 that invades many abandoned clearings near the Panama Canal. Paja grasslands can be quite productive. On the other hand, paja grass crowds out other plants. During the dry season, this grass dries out, providing fuel for fires that destroy its competitors (fig. 57). This grassland supports few mammals or birds, and is far less useful to human beings than the forest that formerly grew in its place.

Long before "civilization," human beings caused ecological disasters worse than this grass has yet become. A grassland supporting mammoths and other large animals covered eastern Siberia during the Ice Ages. Trampling by their huge feet prevented mosses from replacing the grasses the animals ate. Grassland is much more productive than moss tundra, and transfers much more water from soil to air than mosses do, keeping the soil dry enough for grasses to keep growing there. When hunters exterminated the mammoths twelve thousand years ago, moss tundra replaced the grass, leading to water-logged soil and causing a catastrophic drop in the production of vegetable matter.

Paja grassland and moss tundra are extreme examples of the rule that humans' disturbance of natural communities they do not understand or care for usually reduces the productivity of these communities and the diversity of organisms they support. Organisms are organized to survive and multiply. One of Aristotle's arguments for this proposition was that mutant organisms, organisms whose designs have suffered random change, do so less well than their normal counterparts. Does the sensitivity of ecological communities (ecosystems) to disruptions with no natural parallel mean that they are organized in ways that enhance their productivity and the number of species they support? If so, what processes organize them? What are they organized for?

Ecosystems, like economies, are webs of interdependence. Each species depends in many ways on the ecological context in which it evolved, just as a business firm depends on its economic or social context. Disrupt the context, and most suffer. But is this interdependence higgledy-piggledy, or is it somehow organized to enhance the common good of the species involved?

Indeed, ecosystems resemble economies more than they do organisms. Like economies, ecosystems are both arenas of competition and conflict, and functional systems with a mutually beneficial division of labor among their participants. Not only is there division of labor among producers, consumers, and decomposers; there is division of labor among producers adapted to different stations in the forest—canopy trees, understory trees, ground-herbs, and so forth. Likewise, there is division of labor among organisms that decompose dead matter of different kinds—indeed, among those involved in different stages of decomposing each kind. Pollinators and seed dispersers maintain a

OPPOSITE: Free transportation. Many small arthropods ride on bigger animals from one spot to another to find food or mates. Here a pseudoscorpion crawls around on the back of a huge harlequin beetle, *Acrocinus longimanus,* with an abundance of red mites. These pseudoscorpions often hide under the wings of harlequin beetles in hopes of a ride to a freshly rotting fig tree in which to live (fig. 56).

tropical forest's productivity by allowing its trees to escape excessive herbivory without overloading themselves with growth-reducing antiherbivore toxins. Such diversity of function does enhance the forest's productivity.

Competition is the driving force behind this division of labor. A species that exploits a source of energy available to a community better than any already present can establish itself if it reaches that community. Competition, however, is sometimes destructive. Paja grass spreads by providing fuel for fires that burn up its competitors. On the other hand, the success of destructive competition may be ephemeral. If destructive competition leaves resources grossly underused, something will evolve to exploit them. More generally, a species that makes its living in ways that benefit the most other species and harm the fewest, is least liable to the evolution of countermeasures by adversely affected species. Do these processes suffice to make ecosystems productive commonwealths with livings for many species?

The Need to Understand Tropical Nature
in Order to Work with, Not Against, It

Tropical forests are useful to many people—vastly more useful than most of what eventually replaces them. We therefore need to learn how tropical forests function, how they maintain their high productivity and diversity. Although tropical nature is degraded daily by the activities of people who do not understand the habitat or lack the interest or incentive to care for it, tropical forests can be used sustainably to grow timber and other products by working with, not against, nature. Enlightened foresters in both the tropics and the temperate zone are trying to make harvesting timber more like the natural disturbances from which these forests are designed to recover. Farmers also benefit by learning how to work with nature. People are most likely to care for the land if they profit by doing so; thus, reliable land tenure of a type that allows farmers to profit from their improvements is essential to careful and sustainable land use. Moreover, working with nature presupposes an understanding and a genuine love of the land. One can work with tropical nature only if one understands how tropical nature works.

OPPOSITE: Fire burning through paja grass, *Saccharum spontaneum*. This aggressive grass, native to southeast Asia, now colonizes abandoned pastures and other cleared landscapes. Fires prevent trees from replacing this grass.

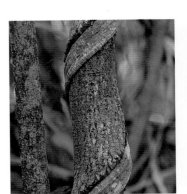 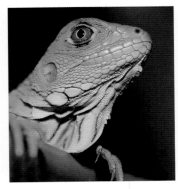

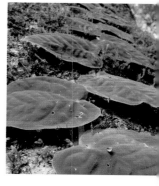

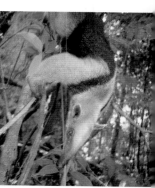

2

The Life of Plants

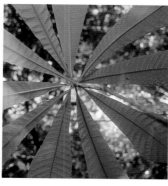

Green plants are the forest's primary producers. In the process called photosynthesis, their leaves use energy from sunlight to make sugar from water drawn from the soil and carbon dioxide drawn from the air. This process provides food for the whole forest community.

Almost all other organisms on this earth are guests of its green plants. Photosynthesis—the process by which plants combine carbon dioxide and water to make carbohydrates and oxygen—provides the energy that makes possible the continued existence of life on this planet (fig. 58). Even a carnivore that disdains any form of vegetable food eats either herbivores, animals that eat herbivores, or animals that eat animals that eat herbivores. Such food chains have relatively few links because, at each level, it takes about ten pounds of food to make a pound of animal. Animals too high up the food chain are thus too rare to be a reliable food supply. To grow a half-ounce bat, *Micronycteris hirsuta,* that gleans resting giant damselflies from the foliage at night, which in turn eat web-building spiders that eat wasps that eat leaf-eating caterpillars, requires five ounces of giant damselflies, which in turn would have eaten three pounds of spiders, which would have eaten thirty pounds of wasps, which would have eaten three hundred pounds of caterpillars, which would have had to devour a ton-and-a-half of leaves. In fact, few of this bat's calories are laundered through so many transformations of vegetable matter. This bat also eats vegetarian caterpillars and katydids, just as, further down the food chain, the spiders eaten by giant damselflies snared vegetarian insects as well as predaceous wasps.

A hectare of tropical forest carries six to eight hectares of leaves. In other words, it has a "leaf area index" (LAI) of between six and eight (fig. 59). How do we know this? On Barro Colorado, every week I collected the leaves that fell into a known area of litter traps during that week, measured their area, and calculated that the forest annually drops about seven hectares of leaves per hectare of ground. If leaf lifetime on Barro Colorado averages one year, LAI there is about seven. In Malaysia's Pasoh Reserve, a Japanese team led by Ryosuke Kato felled all the trees on a two-thousand-square-meter plot of rain forest and measured the areas of their leaves. The felled

OPPOSITE PAGE, TOP: Plants not only feed the forest community, they also structure its habitats and provide its highways and byways. Lianas link the tree crowns, providing paths for many tree dwellers such as monkeys, squirrels, and smaller creatures such as ants and termites (fig. 60).

OPPOSITE PAGE, BELOW: A microhabitat such as this water-filled tree hole in the buttress of a huge *Ceiba* tree provides a home for a specific group of animals. It may contain a whole community in microcosm, with one-celled organisms that break down the leaflitter and decompose the corpses, and larvae of different insects, tadpoles, and frogs, which eat the decomposers and each other (fig. 61).

BOTTOM: Leaf density in a forest is measured by how many square meters of leaves there are per square meter of forest floor, a ratio known as the leaf area index. On Barro Colorado, the leaf area index is about seven, meaning that there are about seven square meters of leaves per square meter of forest floor. Looking down from the canopy tower on the island gives one a rough idea of how many different layers of leaves there are.

trees carried sixteen thousand square meters of leaves, eight times the area of the plot their trees occupied; that plot's LAI was eight.

A tropical forest would not benefit by adding more leaves. Kyoji Yoda, another member of the Japanese productivity team at Pasoh, found that in a hectare of forest, each hectare of leaves intercepts about half the light it receives. Half the light from the sun passes through the top hectare of leaves, one quarter passes through the top two hectares, and 1/256, or 0.4 percent, passes through all eight hectares of leaves to the forest floor. Too little light reaches the forest floor to support more plant growth there. On the other hand, decreasing the forest's LAI from eight to six would let four times as much light reach the

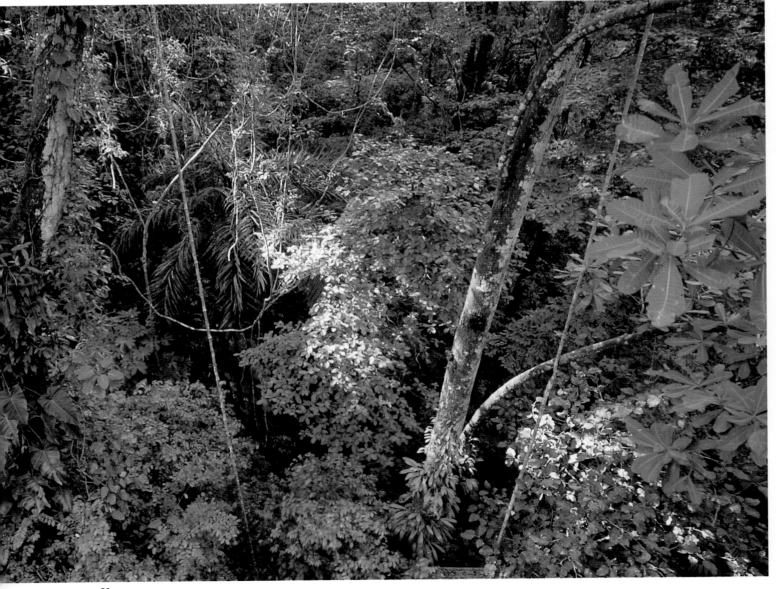

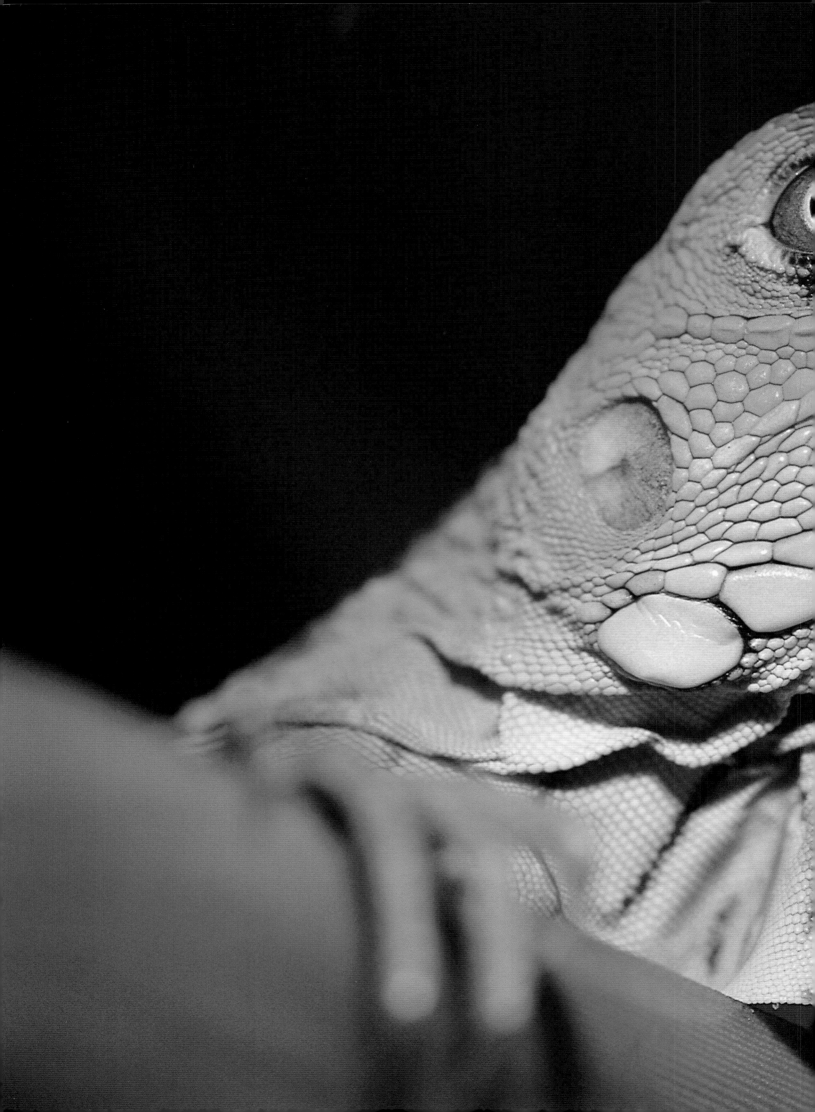

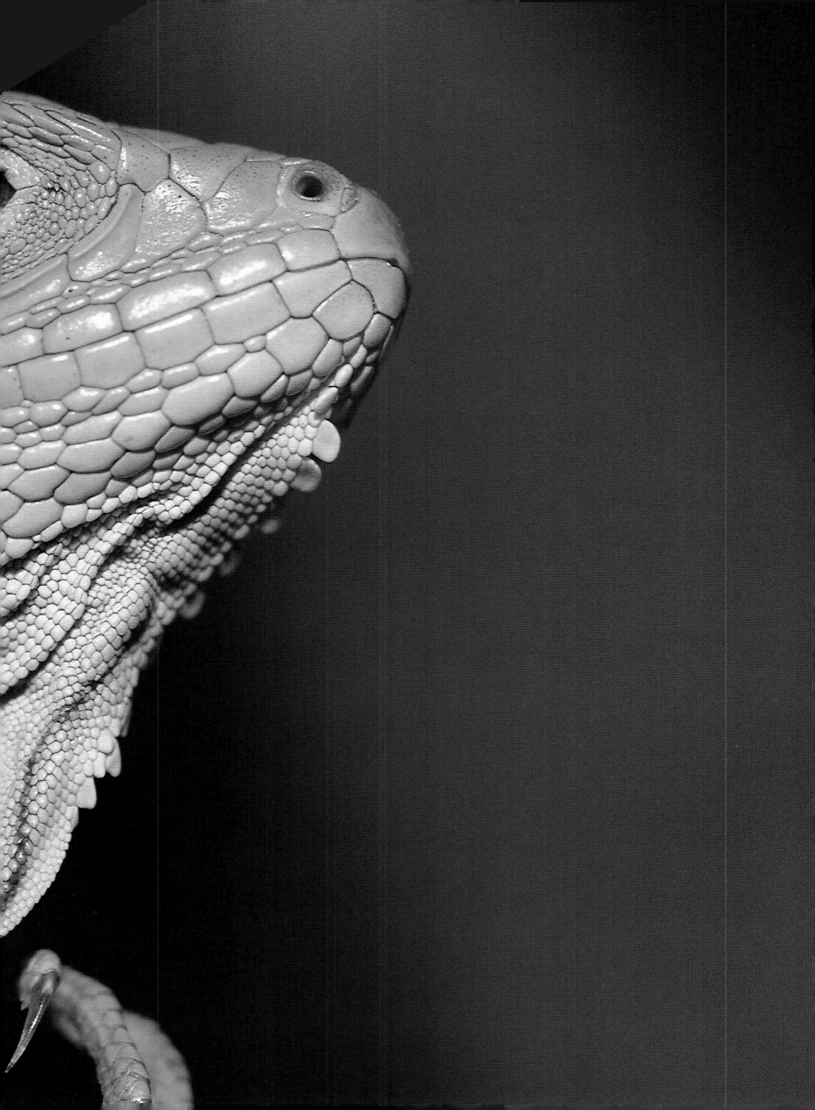

forest floor, quite enough to give seedlings and ground-herbs a good start in life. In most mature stands of tropical forest, roughly 1 percent of the incoming light reaches the forest floor, too little to support more leaves.

How much energy do a forest's leaves provide? At the Smithsonian Tropical Research Institute, a graduate student, Gerhard Zotz, and his professor, Klaus Winter, discovered that a canopy sun-leaf's total daily photosynthesis amounts to roughly six hours of photosynthesis at the leaf's maximum rate. At full blast, photosynthesis in a square meter of typical mature-forest sun-leaves is 1.3 grams of sugar per hour. On the average, this square meter of leaves produces 8 grams of sugar per day, fuel for a power output of 129,600 joules per day, or 1.5 watts (1.5 joules per second), one-fortieth of the power required to keep a sixty-watt lightbulb lit.

We can estimate the photosynthesis of a hectare of forest if we suppose that the next-lower hectare of leaves receives half as much light as the top layer, and so forth, and calculate the photosynthesis of each hectare of leaves for each half hour of the day from the amount of light it receives then. Such calculations suggest that a square meter of forest at Barro Colorado, like a square meter of forest in Pasoh Reserve, Malaysia, produces twenty-four grams of sugar per day, fuel sufficient to maintain an average power supply of four-and-a-half watts. Others have measured a forest's total photosynthesis empirically by measuring how fast the forest uses carbon dioxide, relative to its nocturnal rate of basal respiration, at different levels of incoming light, and adding the photosynthesis appropriate to the average light level of each half hour of the day. This method suggests that a square meter of forest in Amazonia near Manaus produces twenty-one grams of sugar per day, so that a hectare produces seventy-five tons of sugar per year. The same method shows that a hectare of Harvard Forest in Massachusetts produces 37 percent as much sugar in a year. Tropical habitats are indeed more productive than those of the temperate zone.

Plants not only feed the world; they provide the oxygen that makes efficient animal life possible. They also shape many of its habitats. In tropical forests, plants create the scene the visitor admires: animals appear as relatively rare ornaments of it. Trees and lianas form the walkways, crawlways, monkey-ladders, and other passageways by which nonflying mammals move about above ground (fig. 60). Plants also provide nesting sites and resting places for all sorts and sizes of animals. Shelters, little cavities one millimeter wide, along the midrib on the undersides of leaves of the shrub *Psychotria marginata* house leaf-protecting mites. Monkeys sleep on tree branches, relatively safe from jaguars. Cavities and hollows of trees provide sites where some birds nest and some bats roost. Some tree holes collect water, forming arboreal aquaria hosting minute ecosystems of their own (fig. 61).

When plants open their stomates—minute "mouths" in their leaves—to let in carbon dioxide, water in their leaves evaporates through these stomates. This process, called transpiration, cools the forest in the same way that sweat cools us. In the days before every hotel room had a refrigerator, Egyptian hotels provided water in porous clay pitchers: the evaporation of some of the

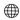

water through the porous clay kept the rest marvelously cool. These pitchers show how we keep cool by sweating. Likewise, transpiration "air-conditions" the forest. The forest's temperature is steamier than most people other than greenhouse keepers would choose, but tropical forests avoid the extremes of hot and cold so typical of desert climates. As long as there is enough water in the soil, the hotter and sunnier the weather, the more the forest transpires, whereas when the transpired vapor creates clouds, transpiration slows. The warmer the weather, the more carbon dioxide plants use, drawing down the atmosphere's supply of this greenhouse gas and cooling the atmosphere. A cooler atmosphere reduces photosynthesis, allowing carbon dioxide levels to increase until balance is restored. More than three hundred million years ago, however, when forests first evolved, no termites were around to break down dead wood, so these forests tied up enough carbon to cause substantial global cooling.

How much water does a tropical rain forest use? In a truly watertight drainage basin, or catchment, water entering as rainfall evaporates, leaves as runoff in the stream draining the catchment, or is stored in the soil. The amount of water stored in the soil is much the same at the end of every dry season, when plants have sucked out all they easily can. The amount of water a forest uses during a "water year" (extending from the end of one year's dry season to the end of the next) is the volume of water entering the catchment as rain, less the volume leaving as runoff. Tropical forests receiving more than 1.7 meters of rain a year use about 1.4 of these 1.7 meters, mostly for transpiration (table 2.1). On Barro Colorado's Conrad Catchment, the difference

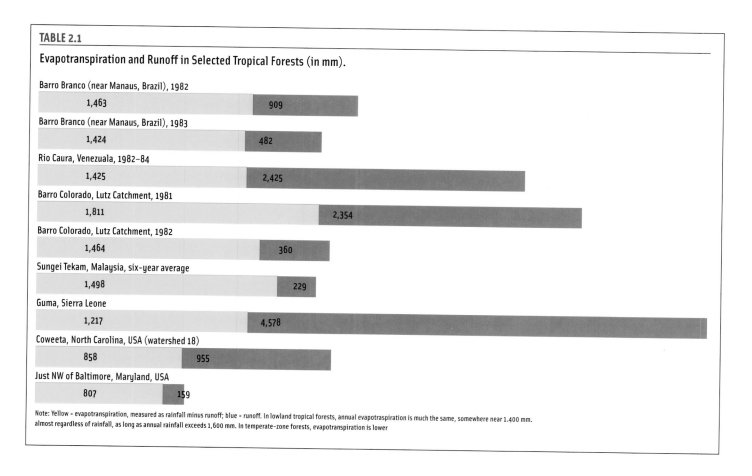

TABLE 2.1

Evapotranspiration and Runoff in Selected Tropical Forests (in mm).

Barro Branco (near Manaus, Brazil), 1982
| 1,463 | 909 |

Barro Branco (near Manaus, Brazil), 1983
| 1,424 | 482 |

Rio Caura, Venezuala, 1982–84
| 1,425 | 2,425 |

Barro Colorado, Lutz Catchment, 1981
| 1,811 | 2,354 |

Barro Colorado, Lutz Catchment, 1982
| 1,464 | 360 |

Sungei Tekam, Malaysia, six-year average
| 1,498 | 229 |

Guma, Sierra Leone
| 1,217 | 4,578 |

Coweeta, North Carolina, USA (watershed 18)
| 858 | 955 |

Just NW of Baltimore, Maryland, USA
| 807 | 159 |

Note: Yellow = evapotranspiration, measured as rainfall minus runoff; blue = runoff. In lowland tropical forests, annual evapotraspiration is much the same, somewhere near 1.400 mm. almost regardless of rainfall, as long as annual rainfall exceeds 1,600 mm. In temperate-zone forests, evapotranspiration is lower

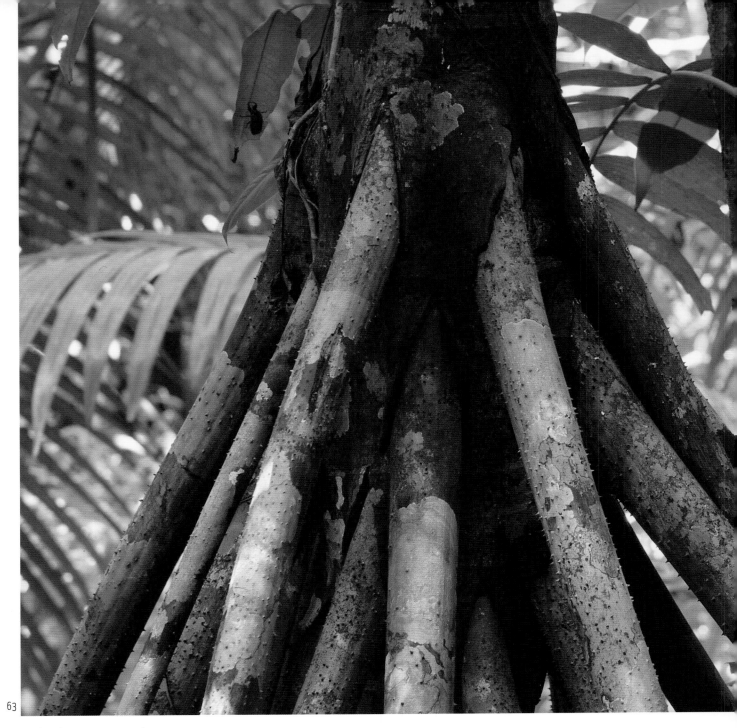

Roots must reach and transport water and nutrients. They must also stabilize the tree. Stabilizing a tree 150 feet tall, with a huge crown, heavy with rainwater and buffeted by the strong winds of a squall, must be quite a challenge. Tropical trees use various root forms to stabilize themselves that are rarely, if ever, seen in the temperate zone, such as the stilt roots of the "walking palm" *Socratea exorrhiza,* in fig. 63, the prop roots of the tree *Cecropia* sp.) in fig. 64, and the buttress roots of the *Tachigalia versicolor* in fig. 65 (overleaf).

between rainfall and runoff is unusually high, about two meters; it seems as if some water is leaking out of the catchment underground. The geologist Robert Stallard thinks that even in Lutz Catchment, perhaps 10 percent of the rainfall flows out underground.

Much of the water thus evaporated is recycled to the forest in convective storms; as the tropical botanist E.J.H. Corner remarked, evapotranspiration "becomes the overwhelming activity of the forest, which through plenteous evaporation engenders its own storms."

An annual evapotranspiration of 1.4 meters implies the annual evaporation of 1.4 tons of water per square meter of forest. A square meter of forest thus "sweats" four kilograms of water per day, or one gram every eleven seconds of daylight. Evaporating water at this rate consumes more than one hundred of the two hundred (plus or minus fifty) watts of power that a square meter of forest receives, on annual average, from the sun. Evapotranspiration thus consumes more than twenty times the forest's power output from photosyn-

thesis. When the atmosphere was richer in carbon dioxide, plants had fewer stomates per square centimeter of leaf, which suggests that stomates open to let in carbon dioxide, not to cool the forest.

Plants must grow upward to obtain the light they need for photosynthesis. They must grow roots to obtain water and nutrients from the soil. They must survive to reproduce, and not be killed by a storm or destroyed by pests or disease beforehand. These demands compete for the profits of photosynthesis. How should a plant apportion its resources among reproducing, defending itself against herbivores, growing the wood needed to keep neighbors from shading its leaves, and growing the roots needed to ensure an adequate supply of water and to snabble up mineral nutrients before the neighbors grab them? Let us consider these choices more closely.

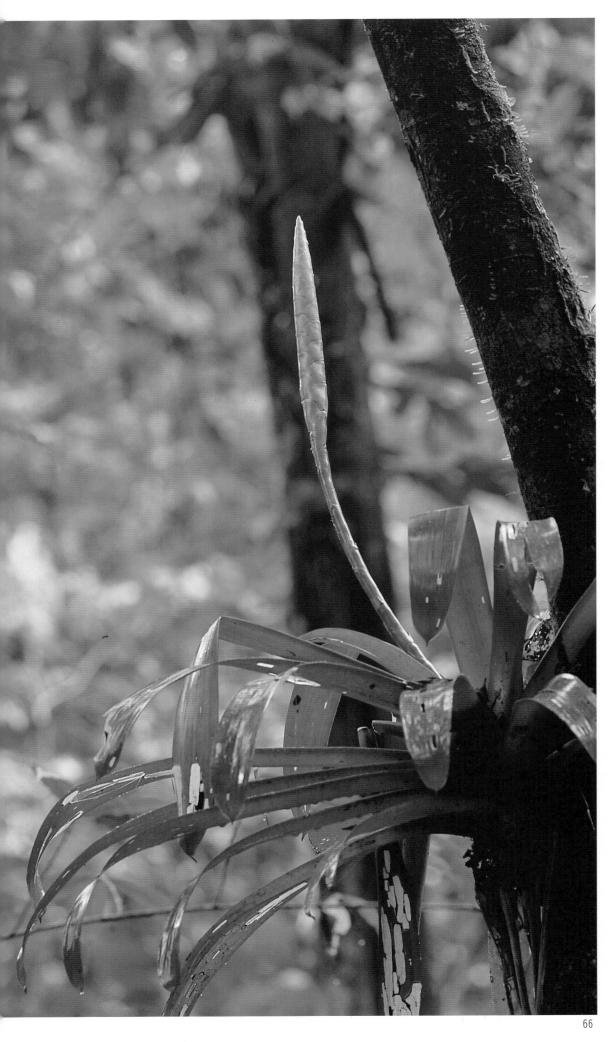

Most canopy trees raise crowns of leaves toward the light on their own trunks. In tropical forests, however, the struggle for light is particularly intense, so some plants—climbers, epiphytes, and hemi-epiphytes—take advantage of other trees' wood to place their own leaves in the sun. By using the wood of self-supporting trees, these plants can reduce their investment in nonphotosynthetic support structures. They have much less wood per square meter of leaves than trees do.

Frequent rainfall and freedom from frost favor the abundance and diversity of vascular epiphytes, including many orchids, aroids, bromeliads, and ferns, in tropical rain forests. Epiphytes, however, make substantial sacrifices for their place in the sun. They have no access to soil, with its relatively stable supply of water and nutrients, and must satisfy their needs elsewhere. Some bromeliads (members of the pineapple family), such as this *Vriesia gladioliflora* (left), arrange their leaves to form a central tank where water, trash, and dead leaves collect. The rotting litter releases nutrients that the plant absorbs through special structures at the bases of its leaves.

Some hemi-epiphytes, including many aroids, start life as climbers and sever their connection to the ground later in life. Those aroids, like normal epiphytes, harm their host tree only by increasing the weight it bears. Other hemi-epiphytes, like this fig, start as epiphytes and later sink roots to the ground to secure a more stable supply of water and nutrients. Strangler figs have perfected the second strategy. A strangler's roots eventually enclose its host's trunk, leaving the host no room to grow or to produce replacements for the trunk's transport vessels through which water and nutrients reach the leaves. When the host tree dies, the strangler, whose trunk can now carry the weight of its leafy crown, inherits the host's place in the canopy.

Finding Light

The struggle for light gives a forest its structure, and thus the beauty of high canopy supported by columnar tree trunks. A tree's trunk and branches are its means of raising its leaves above as many neighbors as possible. A hectare of tropical forest has seven or eight hectares of leaves that, when dried, weigh as many tons. A typical tropical forest uses three hundred tons dry weight of wood per hectare to support its leaves—about forty tons of wood for each ton of leaves.

Placing Leaves in the Sun and Supporting Tree Trunks

How does leaf production compare with wood production? Litterfall, the weight of leaves, twigs, flowers, fruit, and so forth falling to the forest floor each year, has been measured in many tropical forests. On Barro Colorado, about seven tons dry weight of leaves fall per hectare per year, representing an annual leaf production of eight tons per hectare. In other lowland tropical forests,

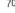

annual leaf-fall varies between five-and-a-half and eight tons dry weight per hectare: leaf-fall is lowest on poor soils. A tree's leaves provide fuel for all its other activities, so ensuring an adequate supply of leaves has first call on any plant's resources. On the other hand, different lowland rain forests maintain LAIs between six and eight, which probably explains the narrow range in leaf litterfall.

To measure wood production directly, one must measure the increase in height and diameter of all the trees on a plot, which is a difficult and uncertain business. However, wood production can be measured indirectly. A fifty-hectare Forest Dynamics Plot was established on Barro Colorado, where every nonliana stem more than one centimeter in diameter was mapped and identified, and its diameter measured, in 1982 and every five years from 1985 onward. The death rate of stems of all diameters from five to eighty centimeters on this plot was about 2 percent per year from 1985 through 1995. The densities of trees of different sizes changed little during this period. This plot has about 270 tons dry weight of wood per hectare. Its annual wood production must therefore be about 2 percent of this, or about 5.4 tons dry weight per hectare. This wood production does not include small twigs, which are quickly replaced. On Barro Colorado, litter collectors annually catch about 1.75 tons dry weight of fallen twigs per hectare. These twigs are about 50 percent decomposed, so the forest's annual production of twig matter must be 3.5 tons dry weight per hectare. If we add twig production to wood production, we find that Barro Colorado's forest spends more to place its leaves in the light than to make

OPPOSITE, TOP: Lianas—woody vines—can become quite large. On Barro Colorado, one big liana spread through the crowns of forty-nine trees and covered half a hectare. Lianas have evolved in many different plant families. Barro Colorado has 171 species of woody climber, nearly as many as its 211 species of tree able to grow ten meters tall. Lianas contribute about 15 percent of Barro Colorado's one hundred square kilometers of leaves. Different lianas use different methods to climb (fig. 68).

OPPOSITE, BOTTOM: The main stem of a twiner winds around its support. Few twiners climb stems more than ten centimeters thick. One often sees saplings whose growth has snapped and killed a constraining twiner, after the twiner created a characteristic spiral channel in the host's trunk (fig. 69).

ABOVE: Tendril climbers twine modified leaves, leaflets, and the like around their supports to stay upright. This is the cheapest way to climb. Tendrils, however, are rarely more than ten centimeters long, so the climber must find supports narrow enough (rarely more than five centimeters thick) to coil their tendrils around (fig. 70).

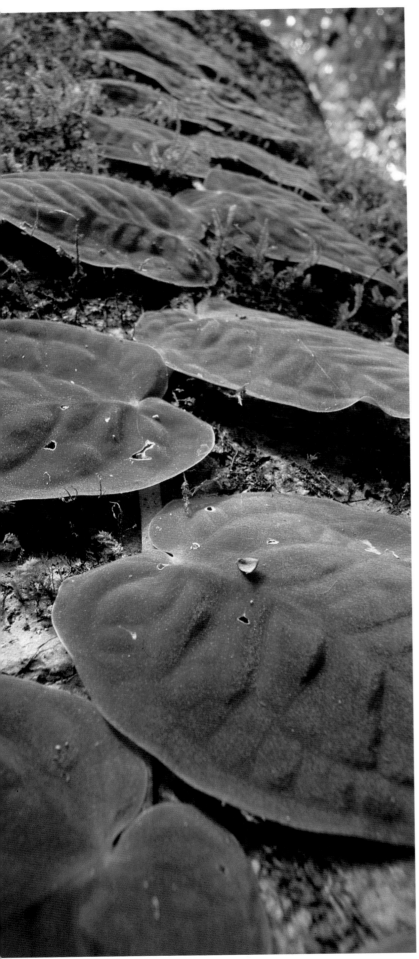

71

them. Mature forests near Amazonia, which are taller, use about 350 tons dry weight of wood to support their leaves. There, annual tree mortality is 1.13 percent, so annual wood production (excluding twigs) should be roughly 4 tons per hectare.

These tall trunks sometimes need special structures to keep them upright. Palms such as *Socratea exorrhiza* support their trunks on stilts (fig. 63). A fallen palm of this type has usually snapped just above where the stilts unite to form its trunk: the stilts themselves offer strong support. Other trees, such as *Protium panamensis*, and the various species of *Cecropia* that spring up in large tree-fall gaps, support their trunks with prop roots, miniature flying buttresses (fig. 64). Many trees buttress their trunks with great basal flanges, sometimes straight, sometimes sinuous. These flanges are what tropical biologists call buttresses (fig. 65). The buttresses of *Ceiba pentandra* are truly spectacular. Tree buttresses are usually best developed on the side of the tree facing the wind; they function as guy wires to prevent their trees from falling before the wind.

Parasitizing Others' Wood: Epiphytes and Lianas

The struggle for light is so intense that some plants exploit the wood of others to place their own leaves in the sun. Epiphytes, or "air plants," find places in the sun by sitting on tree branches (fig. 66). Epiphytes use their hosts only for support. Their life is difficult, especially in lowland forests, where a long time can elapse between successive rains, for the epiphytes draw neither nutrients nor water from the trees on which they sit.

How do epiphytes get their water and nutrients? Many bromeliads accumulate water and detritus at the bases of their tight rosettes of inclined leaves (fig. 66). This water attracts aquatic insects and tadpoles whose feces and corpses fertilize this detritus. The bromeliad sends roots into the humus trapped among its leaf bases to tap the water and nutrients contained therein. A graduate student on Barro Col-

orado, José Luis Andrade, asked how other epiphytes secured their water and nutrients. He found that an epiphytic fern solves this problem by catching dust and detritus in a basket of roots to make a rich, water-holding soil. Epiphytic cacti, on the other hand, do not make root baskets, so they must root in cavities already stocked with rich soil. Such sites are relatively few and far between, but an epiphytic cactus rooted in such a site can grow much faster than an epiphytic fern that invests in making a root basket.

Epiphytes have rarely been counted. When Yamakura's team felled its eighth of a hectare of rain forest at Sebulu, in Indonesian Borneo, to measure the leaf area and wood weight of felled trees and lianas, it also measured the leaf area of the epiphytes, dried their support tissue, and weighed it. This was a big, tiring, expensive job. Judging by their sample, a hectare of their forest has 680 square meters of epiphyte leaves, supported by 236 kilograms dry weight of roots and stems. These epiphytes used 350 grams dry weight of vegetable matter to support a square meter of leaves. On this same hectare, trees used more than eight hundred tons dry weight of wood to carry nearly seven hectares of leaves, more than twelve kilograms of dry weight of wood per square meter of leaf. The trees there used thirty-five times as much dry matter to support a square meter of leaves as did the epiphytes. Despite this enormous advantage, epiphytes contributed less than 1 percent of the leaf area of this lowland forest.

Strangler figs and some other plants start life as epiphytes, then drop roots to the ground. Such plants are called hemi-epiphytes. A strangler fig constructs its own trunk around that of its host—a much quicker process than growing a trunk of that size unaided. When the strangler has completely surrounded the host's trunk, its trunk kills the host's by stifling its growth, so the strangler inherits its host's place in the forest canopy (fig. 67). To take over its

OPPOSITE PAGE: Adhesive climbers like this *Monstera* glue or otherwise attach themselves to their host's trunk. Adhesive climbers can climb trunks of any size, but theirs is the most expensive of the various ways to climb (fig. 71).

BELOW: Gaps in the forest canopy opened by fallen trees pace tree growth in tropical forests. Light-demanding pioneer species colonize a gap soon after it opens (fig. 67).

72

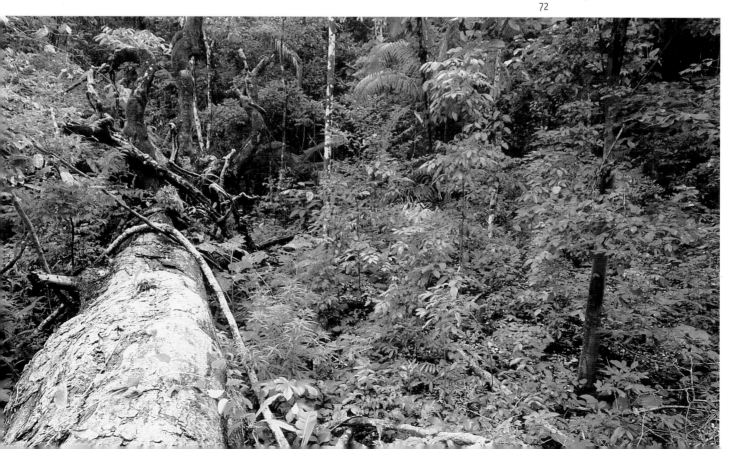

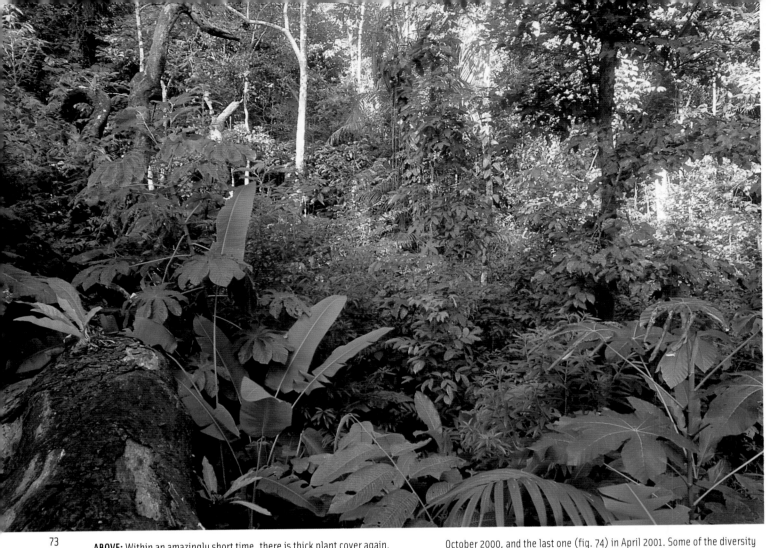

73

ABOVE: Within an amazingly short time, there is thick plant cover again.

BELOW: Over decades, in a process called succession, more shade-tolerant tree species of the old forest will come in, eventually replacing the short-lived pioneers. This gap was created by a huge tree-fall in April 2000. The first picture (fig. 72) was taken in June 2000, the second one (fig. 73) in October 2000, and the last one (fig. 74) in April 2001. Some of the diversity of trees in tropical forests is maintained because the forest is a patchwork of different stages of succession, each of which provides optimal conditions for a different set of tree species.

74

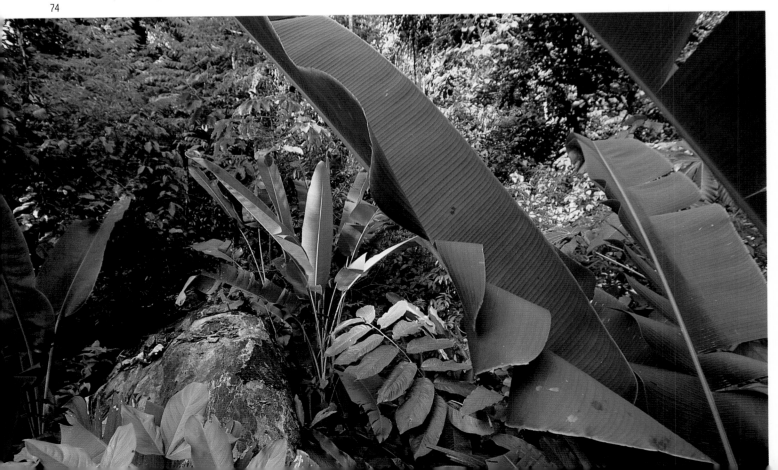

Before and after a Tree-Fall: How Light Conditions Change. **ABOVE:** The avail-ability of light changes drastically after a tree-fall, as in the case of this big strangler fig that fell over soon after this shot was taken, starting a race between the thousands of seedlings and saplings that . . .

BELOW: . . . have been standing in the shade of the fig tree, waiting for enough light to start growing toward the canopy. In the end only one tree will replace the fig, closing the canopy again many decades from now.

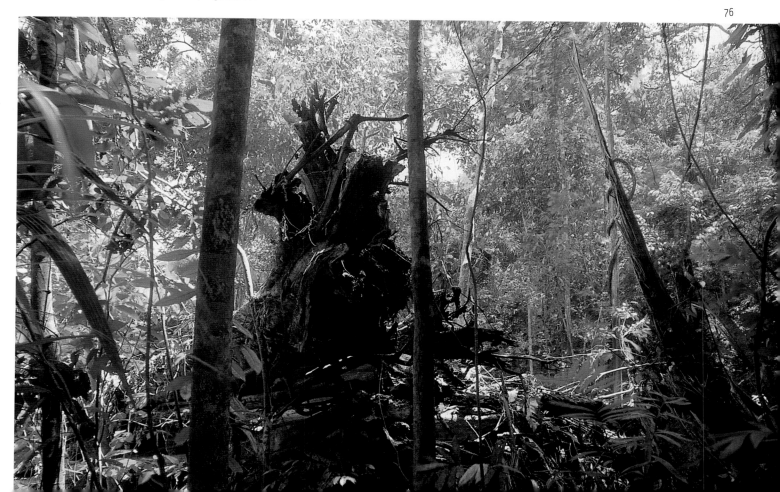

77

78

79 ↑ 80 ↓

Understory leaf arrangements: Only 1 percent of the light above the canopy reaches the forest floor. Thus understory plants, including the seedlings and saplings of shade-tolerant trees, must arrange leaves to catch as much light as possible on each square centimeter of leaf. They hold their leaves horizontal, perpendicular to the incoming light, arranged so they do not shade each other. Understory plants achieve this end in many ways.

The aroid, *Xanthosoma helleboricum,* has a compound leaf with leaflets arranged in a double spiral (fig. 77).

The runners of *Geophila repens* creep along the ground, branching from time to time, and cover a patch of forest floor with their leaves (fig. 78).

The runner of this *Serjania* puts out compound leaves alternately to each side, with leaflets neatly arranged to avoid overlap (fig. 79).

The ground-herb, *Chrysothemis friedrichsthaliana,* arranges its few leaves in a rosette close to the ground. The top pair of large leaves is rotated 90 degrees from the one below to avoid overlap (fig. 80).

This *Virola sebifera* sapling has one layer of leaves. This layer is carried by a close-set spiral of five horizontal branches (fig. 81).

This large *Alseis blackiana* seedling supports a rosette of many long, narrow, flat leaves. Each pair of opposite leaves is rotated about 70 degrees from the one below, which spaces the leaves remarkably evenly around the stem (fig. 82).

A spiral staircase of *Costus pulverulentus* leaves, viewed from above (fig. 83).

The shrub, *Psychotria acuminata,* flowers at the tips of its twigs, after which the twigs fork. The result is an umbrella of leaf rosettes, each one constructed like the rosette of *Chrysothemis friedrichsthaliana* (fig. 87).

Branches of this shrub, *Psychotria chagrensis,* fork asymmetrically to make a horizontal spray of leaf rosettes (fig. 85). Each rosette is constructed like a small-leafed version of *Chrysothemis.*

A *Terminalia amazonica* sapling carries its leaves in layers. Each horizontal branch starts as a twig that turns up to produce a rosette of leaves spiraled about its tip. One or more relay twigs sprout below the rosette, thereby forming a horizontal spray of such rosettes (fig. 86).

OVERLEAF

While the shade leaves of the wild nutmeg, *Virola surinamensis* (fig. 87), are flat and horizontal, the sun leaves of the same tree are drooped horizontal, to spread the light over a larger area of leaf (fig. 88). The sun leaves of the wild cashew, *Anacardium excelsum,* are inclined to their twig, spiraled closely about its tip, for the same purpose (fig. 89).

81

84

82

85

83

86

87

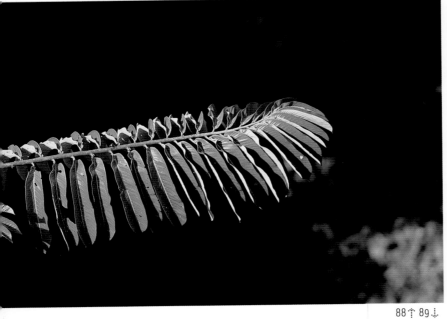

88 ↑ 89 ↓

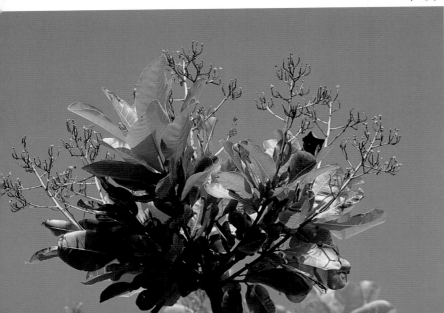

90

A spiral staircase of *Costus pulverulentus* leaves viewed from the side (fig. 90).

host's place in the sun, however, a strangler seedling must have access to an abundance of trapped soil. Ideally, the strangler seedling's roots must be able to reach a rotting, soil-filled hollow within its host. As a rule, such sites are even rarer than suitable sites for epiphytic cacti. Stranglers establish themselves readily on certain palms, however, because the humus that is trapped at the bases of these palms' leaves provides a good start for strangler seedlings.

Lianas are woody vines, some of which exceed ten centimeters in diameter, that reach the light by climbing up the trunks and branches of other trees (fig. 68). Experiments performed by Francis Putz when he was a graduate student on Barro Colorado showed that lianas will grow in the shadiest parts of the forest if they are provided with suitable supports. By climbing up other plants to grow upward, young lianas circumvent limitation by light. Putz also found that where a liana can grow, and how fast it does so, depends on how it clings to its hosts. Indeed, there appears to be a trade-off between how fast a liana can grow when it has an abundance of suitable supports and the range of supports that will allow it to grow at all. Some lianas wind tendrils (modified leaves) around suitable supports (fig. 70). These tendrils are rarely more than ten centimeters long, so the liana's supports cannot be more than a few centimeters in circumference. On the other hand, tendrils are the cheapest means by which lianas can cling to their hosts; where supports of the right size are available, tendril climbers can outgrow other kinds of lianas. Twiners, which wind around the trunks of their hosts, can use thicker supports (fig. 69). Branch twiners, which twine branches around their supports, readily

Pioneer trees, such as this *Cecropia peltata*, use their energy to grow faster than their competitors. They spend little to defend their leaves against herbivores, so their leaves live only a few months. They must be well lit to pay for both their own replacements and their plant's growth.

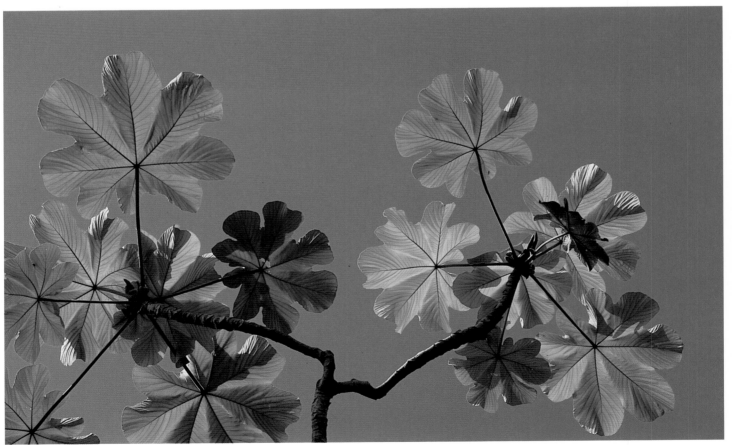

use supports more than ten centimeters thick, which are too big for ordinary twiners to deal with. Adhesive climbers can climb up a trunk of any size if they have enough light to do so (fig. 71). Adhesive climbers have exchanged limitation by shortage of suitable supports for limitation by shortage of light.

When a liana reaches the end of its support, it can go no farther unless it can grasp another within a meter or two of its predecessor. Thus, even though lianas are not limited by light, they grow best on the edges of gaps opened in the canopy by fallen trees, where suitably spaced supports are most readily available.

Less wood is needed to support a square meter of liana leaves than to support a square meter of tree leaves. Evidence for this proposition has not been collected on Barro Colorado, for gathering it involves felling trees. In the few forests where appropriate data are available, trees use an average of 6 to 13 kilograms dry weight of wood to support a square meter of leaves, while lianas use an average of 1.3 to 1.4 kilograms to do so. Lianas are four times less economical of support tissue than epiphytes are, but much more economical than trees are.

Lianas are considered a hallmark of tropical forests, although Francis Putz, the best-known student of lianas, learned from *The Northern Logger* that wood production in some Appalachian forests is severely diminished by a superabundance of woody grapevines. How prevalent are lianas in tropical forests?

As part of his Ph.D. research, Putz assessed the abundance of lianas on Barro Colorado. He found that 22 percent of the plants ten to two hundred centimeters tall on his sample plots were lianas, and that 43 percent of the trees on these plots with trunk diameters of more than twenty centimeters had lianas in their crowns. When he had become a professor, Putz, together with the Sarawak forester Paul Chai, found that in the valley bottoms of the Lambir Hills in Sarawak, 31 percent of the seedlings less than one meter tall were lianas, and 54 percent of the trees more than twenty centimeters in diameter had lianas in their crowns.

To learn what proportion of a forest's leaf-fall comes from lianas requires a botanist who can tell the species of each leaf falling into litter collectors. On Barro Colorado, the botanist Oswaldo Calderón examined the leaves falling into litter collectors scattered over four hectares of mature forest. Of the 7.37 tons dry weight per hectare of leaves falling in 1991, 14 percent was contributed by lianas, and another 2 percent of this weight was unidentified. In a mature, undisturbed rain forest in Sabah, Malaysia, 13 percent of the 6.53 tons falling yearly per hectare came from lianas, while in a logged-over forest, 27 percent of the 6.16 tons dry weight of leaves annually falling per hectare came from lianas.

Although lianas are picturesque, they are nuisances to their forests. They parasitize the ecological commonwealth, offering little in return. On Barro Colorado, as elsewhere, they slow the growth of their host trees, increase their rate of mortality, and swarm so extensively over some tree-fall gaps that they stifle forest regrowth for decades.

Evidence for Light Limitation:
Distinctions Between Life in Sun and in Shade

How sharply the shortage of light limits the growth of forest plants is illustrated by the contrast between the relatively open understory found under intact high canopy and the crush of vegetation where the fall of a canopy tree has allowed an abundance of light to reach the ground (figs. 72-76).

The limiting effects of light shortage are also illustrated by the contrast between the leaf arrangements of plants of the forest understory and those of canopy trees. An understory plant spreads one or more horizontal layers of flat, nonoverlapping leaves to concentrate as much light as possible per square centimeter of leaf. When he was a graduate student at the Université de Paris-6, Patrick Blanc showed how herbs of the shady rain-forest floor exhibited the same spectrum of leaf arrangements in South America, Africa, and Asia. Also, when comparing lowland rain forests around the world, I found that, in each forest, understory saplings and shrubs have much the same variety of leaf arrangements. Many place their leaves along the sides of horizontal branches radiating out from the erect central stem, as do *Virola sebifera* (fig. 81) seedlings. Many others, such as *Alseis blackiana* (fig. 82) seedlings, carry a rosette of leaves around the top of an unbranched stem. A few others create horizontal sprays of leaf-rosettes, each atop a short twig ascending from a horizontal branch system, as do the young *Terminalia* (fig. 86) and the *Psychotria chagrensis* (fig. 85). Others have stems that fork after flowering at the tip, each fork doing likewise, to form an umbrella of leaf-rosettes atop the ultimate twigs, as does *Psychotria acuminata* (fig. 84). Canopy trees, by contrast, spread the superabundant light over as much leaf surface as possible. In contrast to its shade-leaves (fig. 87), the sun-leaves of *Virola surinamensis* (fig. 88) are crowded along the sides of their twigs, drooped and folded about their midribs. Others, such as *Anacardium excelsum* (fig. 89), crowd their inclined leaves around the tips of erect twigs; the leaves are crowded closely enough together to shade each other intermittently.

Some trees change their growth form as they progress from the understory into the light. The branches of *Faramea occidentalis* are decussate about the main stem, each pair attached to opposite sides of the stem, and rotated ninety degrees around from the next pair below. In the understory, these branches extend horizontally, and the petioles of leaves meant to be decussate around an ascending stem are twisted to make the leaves lie horizontally, each pair on opposite sides of their horizontal twig. In a gap, *Faramea*'s branches turn upward, and the leaves are arranged around their branches as the branches are arranged around their stem. On Barro Colorado, other kinds of tree, notably *Garcinia,* change form in the same way when they reach abundant light. Sun-leaves differ radically from shade-leaves in physiology as well as arrangement. Sun-leaves contain more chlorophyll and more of the enzymes needed for photosynthesis, which items confer increased photosynthetic capacity. Maintaining all this photosynthetic equipment, however, entails costs that shade-leaves cannot afford: where profits are likely to be

slim, overhead expenses must be kept as low as possible.

Plants that currently occupy the same station in the forest also differ according to how tall they will be when mature. Sean Thomas, a Harvard graduate student working at Pasoh Reserve, in Malaysia, discovered that even under identical light conditions, a sapling of a canopy-tree species has leaves with greater photosynthetic capacity than a sapling of an understory species. After all, each square meter of leaves of a full-grown canopy tree must support far more in the way of wood and roots than a square meter of understory tree leaves; canopy leaves must be well lit if they are to support their tree. David King, a postdoctoral fellow working in the rain forest at La Selva, Costa Rica, found that saplings of canopy-tree species have slenderer stems and narrower crowns than plants of the same height belonging to understory species.

Moreover, there are at least two basic types of shade-tolerant plants. Thomas Kursar, a professor at the University of Utah working on Barro Colorado, found that some understory plants have tough, long-lived leaves. (Barro Colorado's record leaf lived for fourteen years; such leaves routinely live for four years or more.) Such precious leaves must be protected: their trees must root deeply enough to assure a reliable supply of water. Such leaves can survive the increased exposure to light that occurs when a falling tree opens a large gap overhead, but their photosynthetic capacity can increase only to a limited degree. Other understory plants have cheaper, thinner, more disposable leaves that normally last only a year or two. Such plants can afford to lose many leaves if they suffer an unusual drought, so they need not root so deeply. If a large light gap opens overhead, such plants can afford to replace their leaves with new ones that can photosynthesize much more rapidly. In other words, shade-tolerant plants face a trade-off between adaptedness and adaptability. The response of a plant species to this trade-off links the physiology of its leaves and the nature of its antiherbivore defenses with the way it roots.

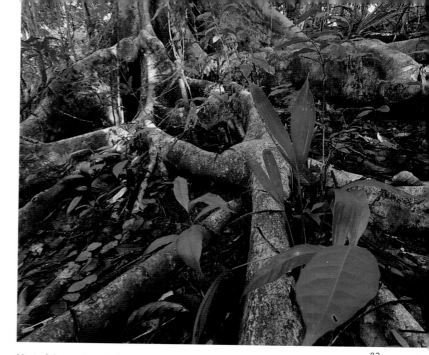

Most of the nutrients in forest soil are located in a thin layer on its surface. Many roots snake along the surface of the forest floor to scavenge nutrients released by decaying litter, rather than plunging underground.

92

To establish a secure source of nutrients and water in a habitat without soil, this *Anthurium*, like many other epiphytes, arranges its leaves so that litter collects among their bases and rots. These "trash baskets" also absorb water as sponges do.

93

A seedling sprouting in a tiny bit of humus on the base of a huge leaf. Even though the seedling will almost certainly die, it grows as if to bet on survival.

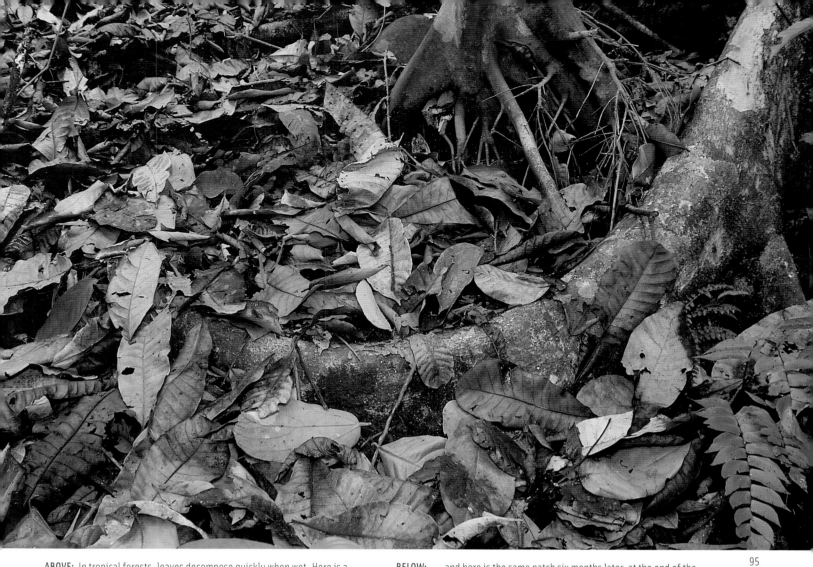

ABOVE: In tropical forests, leaves decompose quickly when wet. Here is a patch of forest floor at the end of a long dry season in late May, covered with dry leaves that have accumulated since the rains stopped . . .

BELOW: . . . and here is the same patch six months later, at the end of the rainy season, when nearly all the dead leaves have decomposed.

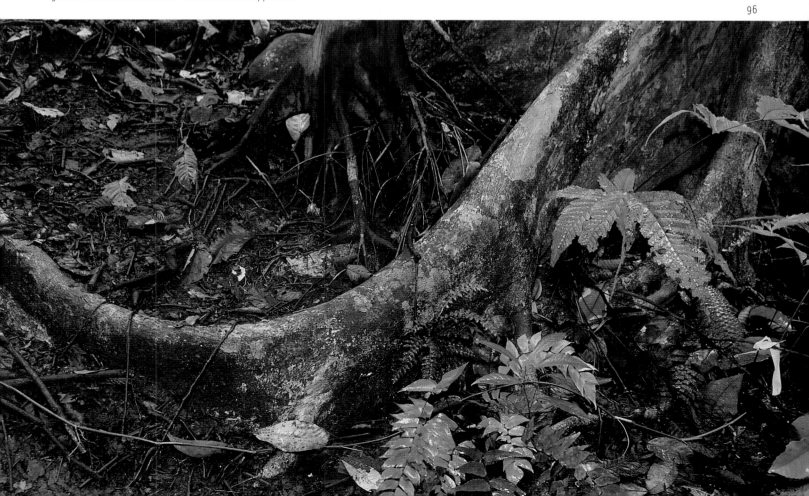

The Trade-off Between Fast Growth in High Light and Survival in Shade

Among plants, there is a fundamental trade-off between being able to grow fast in brightly lit places and being able to survive in the shade. Nicholas Brokaw compared the response of different plants on Barro Colorado to light and shade while he was a graduate student of Robin Foster, the one person who most influenced the goals of research on Barro Colorado. Brokaw asked which plants grow best in light gaps of different sizes. He found that the faster a pioneer tree can grow in a really large gap, the larger the gap it needs to survive to reproductive age (table 2.2). This trade-off between growing fast in large gaps and surviving in shade means that each of the three species in the table has a range of gap sizes in which it can outgrow or outlive its two competitors.

David King came to Barro Colorado on a postdoctoral fellowship to look for characteristics distinguishing light-demanding from shade-tolerant saplings. He analyzed the growth of ten species of saplings, three light-demanders and seven shade-tolerants. A *Cecropia* (fig. 91) was his least shade-tolerant species. Other plants reduce their investment in support tissue relative to new leaves if less light is available, but *Cecropia* is rigidly programmed to invest equally in both, whatever the light level. Moreover, *Cecropia*'s poorly defended leaves live fewer than five months. These leaves thus had to be well enough lit to support their host's growth and to pay for their own replacement in a few months. Thus, to keep its leaf area from shrinking, *Cecropia* had to produce more dry matter per square meter of leaf per week than any other species. On the other hand, at 0.15 grams dry weight per cubic centimeter, *Cecropia*'s wood was half as dense as that of any of the other species King studied. Thus *Cecropia* needed less dry matter to lift a square meter of leaves another meter higher than any other species, so that, even in only 6 percent of full sunlight, *Cecropia* grew seventy-one centimeters a year, nearly twice as fast as any other species of sapling. The other sun-lovers also had lighter-weight stems than their shade-tolerant counterparts, and needed to produce

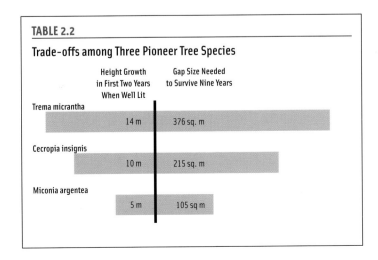

TABLE 2.2

Trade-offs among Three Pioneer Tree Species

	Height Growth in First Two Years When Well Lit	Gap Size Needed to Survive Nine Years
Trema micrantha	14 m	376 sq. m
Cecropia insignis	10 m	215 sq. m
Miconia argentea	5 m	105 sq m

more dry matter per square meter of leaf to maintain their leaf area. As a result, every light-demander needed 4 percent of full sun or more to break even, whereas the shade-tolerants could do so on 3 percent or less.

At about the same time, Kaoru Kitajima, a graduate student at the University of Illinois, whose professor Carol Augspurger had also done her thesis research on Barro Colorado, grew seedlings in the screened growing-house there to analyze the basis of the trade-off between growing fast in high light and surviving in shade. Kitajima studied thirteen species with wind-dispersed seeds, ranging from balsa, *Ochroma pyramidale,* whose seeds germinate only in the sun-heated soil of large light gaps, to the mature-forest species *Aspidosperma cruenta,* which holds Barro Colorado's record leaf lifetime of fourteen years. The species of seedlings that grew fastest in bright sunlight tended to be those that died most rapidly in the shade. It was much more strictly true that species of seedlings growing fastest in high light also grew faster than the others in shade; high mortality in shady conditions, not slow growth, drives the trade-off. The fastest-growing seedling species tended to be those with the highest leaf area per unit dry weight of seedling. Those surviving best in shade tended to be those whose stems were heaviest (those whose stems had the most dry matter per cubic millimeter). Finally, with the exception of *Bombacopsis sessilis,* which had the lowest seedling mortality of all despite investing little in roots, the species of seedlings surviving best in shade had the highest ratios of root weight to aboveground shoot weight. Investing in roots usually enhances shade tolerance. But how do plants compete underground?

Procuring Nutrients and Water

Plants need nutrients and water in order to use light to make vegetable matter and store energy. Plants must draw most of the nutrients and (especially in lowland forests) nearly all the water they need from the soil. Even though they need not grow wood to place their leaves in the sun, epiphytes are clearly cramped by their lack of access to soil. As we have seen, many epiphytes solve this problem by making a soil, or a nutrient-rich muck, of their own to provide a source of the nutrients and water they cannot get from the air. True, the air is full of nitrogen, but most of this nitrogen is molecular nitrogen, N_2, which plants cannot use. Some plants, at least, take up usable nitrogen through their leaves, either nitrogen dioxide, NO_2, from the air, or ammonia manufactured from atmospheric N_2 by lichens on their leaves. Nonetheless, plants of the legume family still find it worthwhile to subsidize rhizobial bacteria on their roots, because these bacteria transform N_2 into ammonia that plants can use, in the soil, from which plants can most conveniently obtain it. Similarly, farmers find it profitable to plant legumes, either among other crops or as one crop in a rotation, to enrich the soil with nitrogen.

OVERLEAF: Fungi, such as these *Favolus brasiliensis,* are a major group of decomposers. They can break down lignin, the toughest and most decay-resistant component of wood (fig. 98).

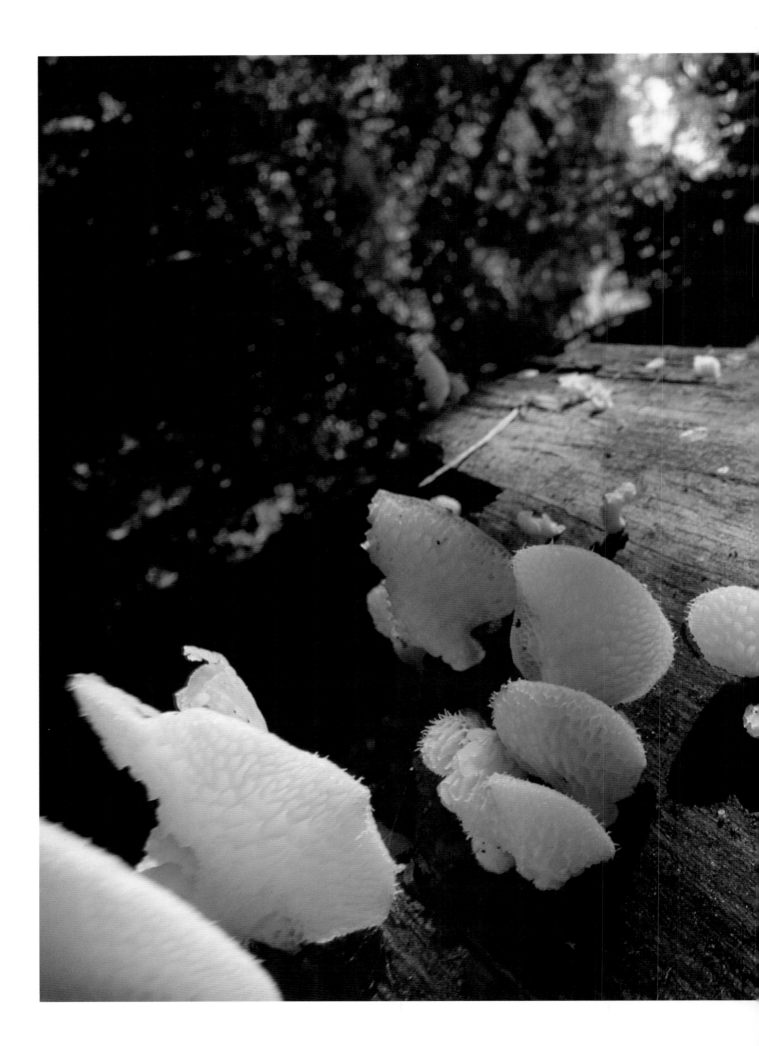

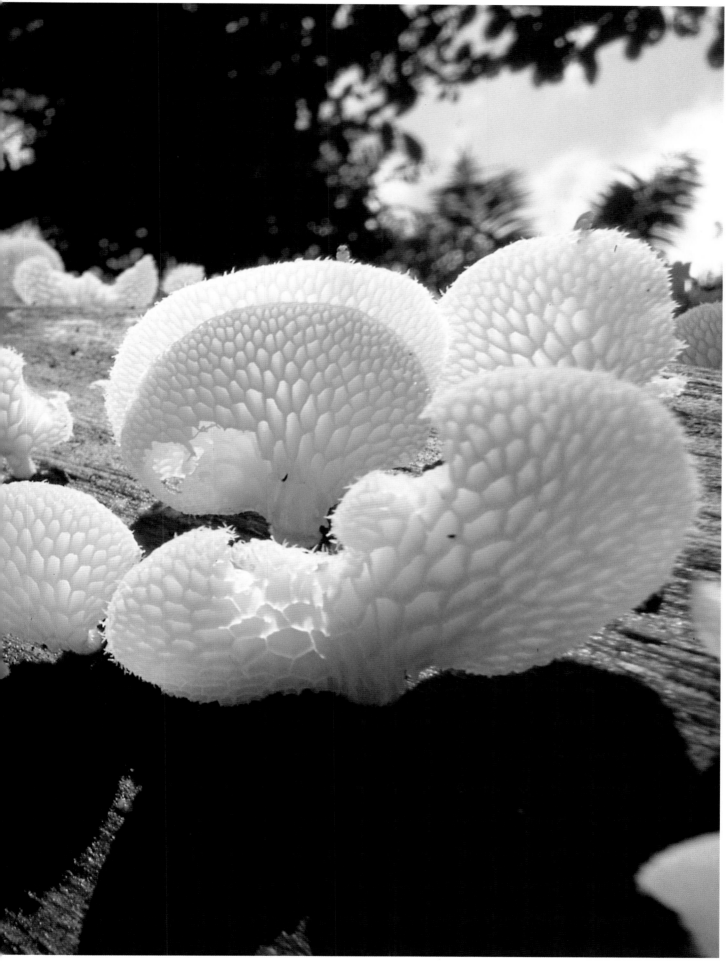

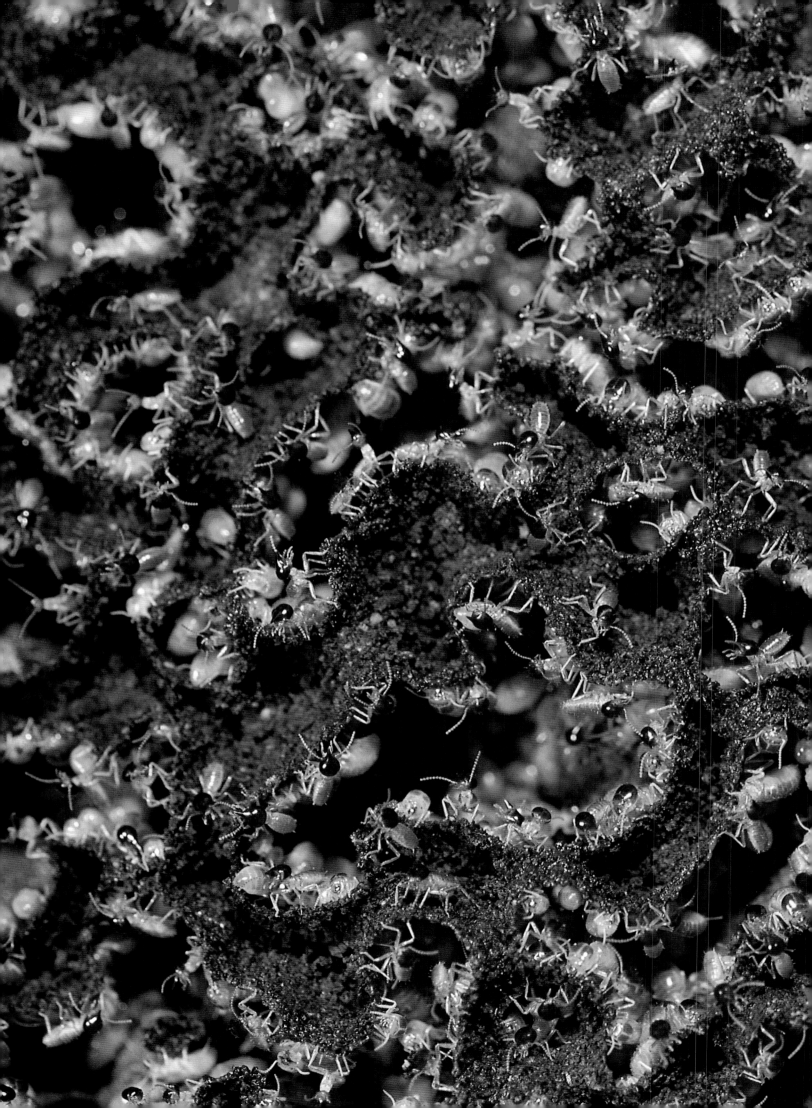

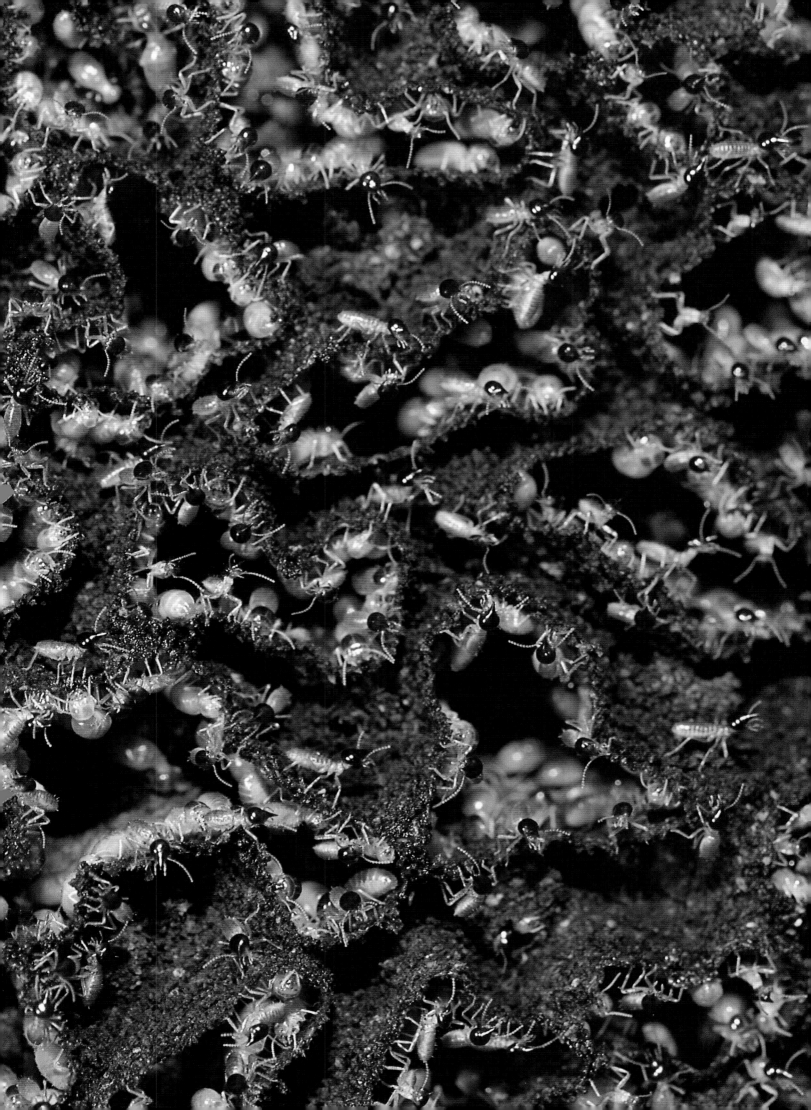

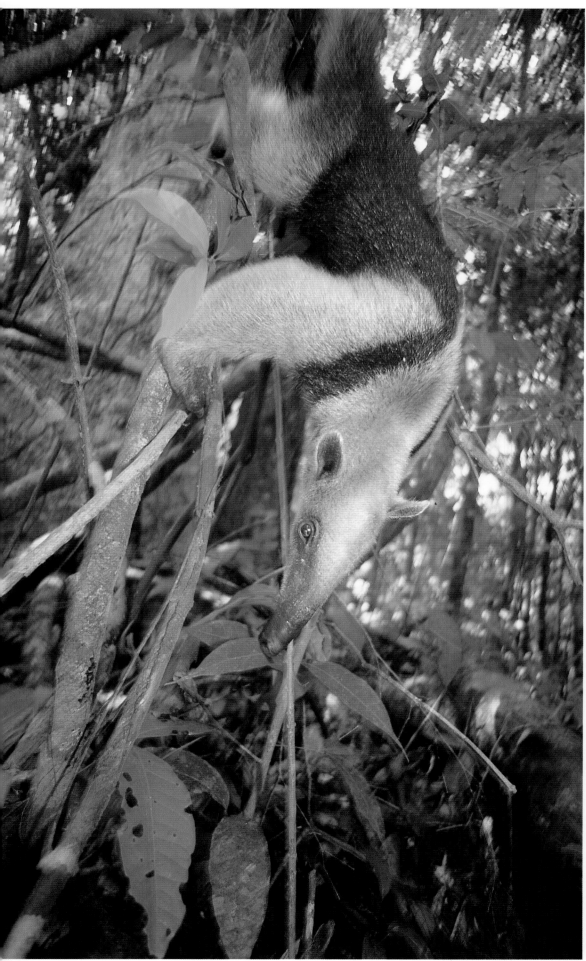

PREVIOUS PAGES: Termites play a key role in breaking down dead plant material, which they digest with the help of symbiotic microbes—bacteria and protozoans—in their intestines. There are many species of termites specializing in dead plant matter such as dead wood and fallen leaves (fig. 99).

LEFT: A tamandua, *Tamandua mexicana*. This anteater is a specialist that breaks open the nests of ants and termites to eat the larvae.

BELOW: This species of assassin bug is another predator of termites. Here, the bug is waiting by an arboreal termite nest for prey to appear (fig. 101).

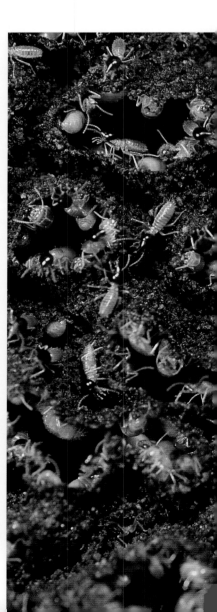

Competing Underground

Plants compete as ruthlessly—and as expensively—for nutrients in the soil as they do for the light that comes from above. Because most roots grow underground, it is hard to see just what they are doing. The signs of competition for nutrients that a visitor to Barro Colorado can actually see are the roots snaking over the forest floor, often in greater abundance, and extending farther from their trees, than do their counterparts in the temperate zone (fig. 92). The visitor may also see roots growing down from the canopy to tap the soil. These roots belong to plants such as strangler figs that begin life as epiphytes in tree crowns. Occasionally, a visitor may happen upon a fallen epiphyte, with the soil it gathered from falling leaves and the dust of the air firmly grasped in the trash basket formed by the bases of its leaves, bearing mute witness to the importance of the struggle for nutrients (fig. 93).

Barro Colorado, however, has relatively fertile soil. In tropical forests on poorer soils, mats of fine roots, meant to gather the nutrients from the leaf-litter as quickly as possible, cover much of the soil. Moreover, these forests have "trash-basket plants" in the understory. Each such plant has a rosette of stiffly inclined leaves surrounding the tip of an unbranched stem, forming a basket that traps leaves and twigs falling from the canopy. Adventitious roots

101

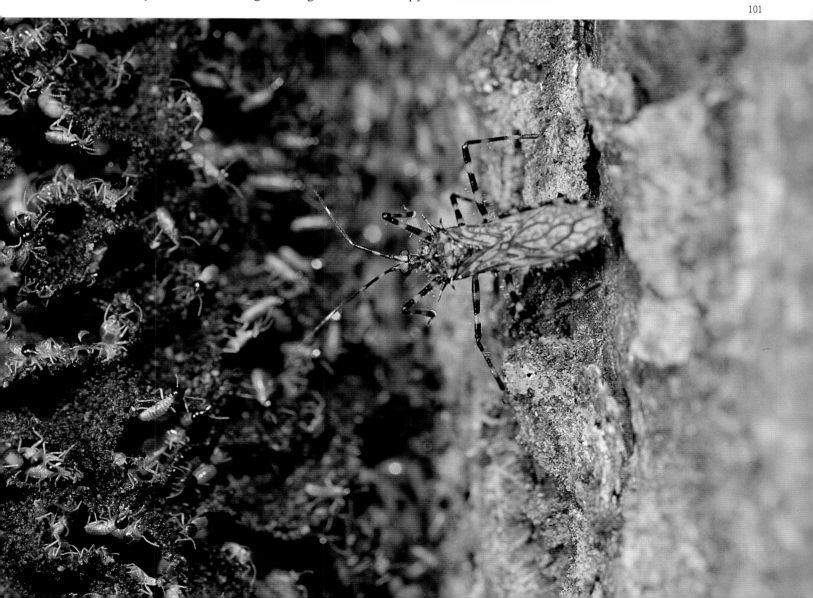

ABOVE: Heavy rain causes erosion at Lutz Creek. A minute forest stream . . .

BELOW: . . . becomes a muddy torrent after a strong rain.

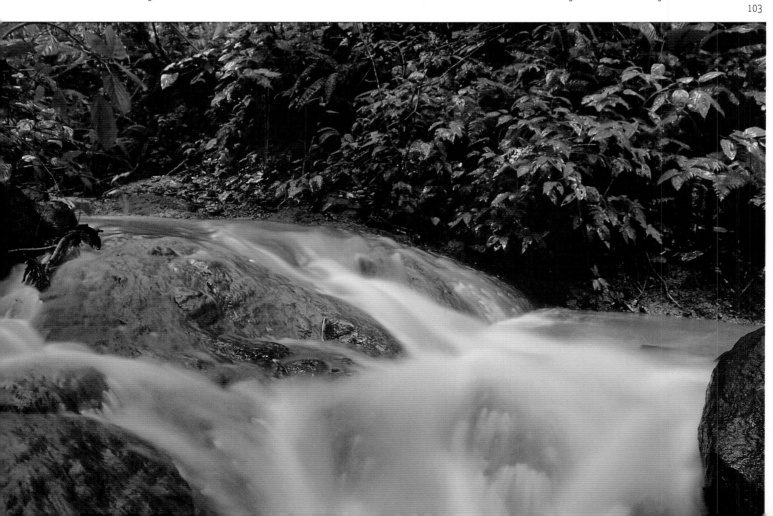

sprout from the apex of the stem, entering this mass of rotting litter to absorb the nutrients it releases. Sometimes roots from nearby trees snake up the stems of trash-basket plants to siphon off the nutrients in their rotting trash. Similarly, many canopy trees sprout adventitious roots to steal nutrients from the soil formed so patiently by their epiphytes.

Biologists have other ways of measuring the intensity of competition among roots. An intrusive, indeed often destructive, approach is to compare the dry weight of roots per hectare to the dry weight per hectare of above-ground vegetation. At San Carlos de Rio Negro in Venezuela, the ratio of the dry weight of roots per hectare to the dry weight per hectare of aboveground vegetation is lowest in tierra firme forest, which grows on the most fertile of the many infertile soils in this area (table 2.3). As one passes to progressively less-fertile soil, this ratio increases, reaching its maximum in "open bana," a miserable, sparse, tough-leaved scrub on sterile white sand, where nutrients are so scarce that the plants can use little of the incoming light. Likewise, dry forests, receiving seven hundred to a thousand millimeters of rain a year compared to the more than two thousand millimeters typical of rain forests, invest half their stock of vegetable matter in roots to scavenge scarce water more effectively, while rain forests on ordinary soil invest only 15 percent.

A less intrusive way to measure the intensity of competition among roots is to measure soil respiration, the amount of carbon dioxide released from a square meter of soil surface per day at different times of the year. Among other organisms, as among human beings, the rate at which carbon dioxide is released measures the rate of fuel use, that is, energy expenditure. Thus soil respiration measures the rate at which energy is being spent underground. Some of the soil respiration reflects the breakdown, the metabolism, of litter fallen from above the soil. All the metabolism represented by soil respiration, however, must derive from the decay of fallen litter, the production of new roots, the decay of old ones, or the maintenance and function of roots and

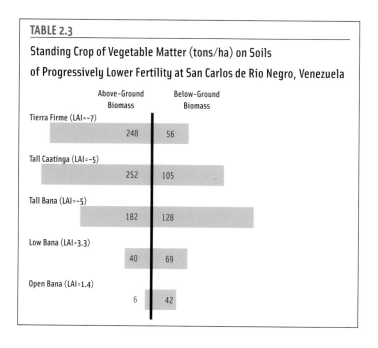

TABLE 2.3

Standing Crop of Vegetable Matter (tons/ha) on Soils of Progressively Lower Fertility at San Carlos de Rio Negro, Venezuela

	Above-Ground Biomass	Below-Ground Biomass
Tierra Firme (LAI=~7)	248	56
Tall Caatinga (LAI=~5)	252	105
Tall Bana (LAI=~5)	182	128
Low Bana (LAI=3.3)	40	69
Open Bana (LAI=1.4)	6	42

their fungal or microbial symbionts, for green leaves are the ultimate source of all usable energy in the forest. By measuring litterfall and determining the total weight of the carbon atoms in this litter, one can calculate how much CO_2 the metabolism of this litter will produce, because complete metabolism of the litter produces one molecule of carbon dioxide for every carbon atom in the litter, or forty-four grams of carbon dioxide for every twelve grams of carbon in the litter. The excess carbon dioxide released from the soil over that accounted for by the rate of litterfall must reflect metabolic expenditures associated with the growth of large roots, which help support the tree, and underground competition among plants for water and nutrients. On Barro Colorado, Thomas Kursar, a researcher from the University of Utah, measured soil respiration at a variety of sites at different times of the year. In central Amazonia, where soils are poorer, soil respiration was measured as part of a large-scale study of ecosystem productivity. Litterfall has been measured at both sites; one can therefore compare litter metabolism with root metabolism at these two sites. Root metabolism is twice as high, and litter metabolism markedly lower, in Amazonia compared to Barro Colorado Island (table 2.4). Where nutrients are readily available it pays trees better to try to outgrow their neighbors than to corner their neighbors' nutrients.

Even so, soil respiration cannot reveal whose roots are doing what. We can learn, however, where trees get their water. A few of the hydrogen atoms in water weigh twice as much as the others. The heavy atoms are deuterium atoms. When water evaporates, the deuterium atoms tend to be left behind. Thus, during the dry season, the concentration of deuterium atoms in the water is lower deeper in the soil, where there is little evaporation. By analyzing the deuterium content of the water in a tree's rising sap, one can tell where in the soil it came from. Studies on Barro Colorado tell us that during the dry season, trees twenty to forty centimeters in trunk diameter tend to get their water from deeper in the soil, where it is more readily available, than big trees more than sixty centimeters in diameter. Really big trees get most of their water from the dry but relatively fertile topsoil, where their roots spread widely. Even in the dry season, trees on Barro Colorado seem to compete more intensely for nutrients than for water.

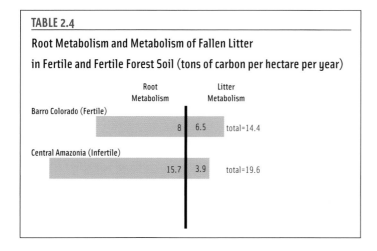

TABLE 2.4

Root Metabolism and Metabolism of Fallen Litter

in Fertile and Fertile Forest Soil (tons of carbon per hectare per year)

	Root Metabolism	Litter Metabolism	
Barro Colorado (Fertile)	8	6.5	total=14.4
Central Amazonia (Infertile)	15.7	3.9	total=19.6

The Community of Decomposers

Most plant matter dies before herbivores eat it. Fallen leaves cover much of the forest floor, and fallen logs are a rather frequent sight. On the other hand, one does not often see trees or shrubs that have had most of their leaves devoured by insects. Moreover, the plants that are defoliated are usually those with newly flushed leaves, which are uncommonly tender and nutritious. Most plant matter escapes being eaten because it is unpalatable, indigestible, or less than adequately nutritious. In forests (unlike the great grasslands of east Africa), most of the nutrients in plant leaves are recycled by decomposers, not eaten by herbivores (figs. 95, 96).

Breaking down the plant matter that herbivores do not eat requires special skills. Today, the community of decomposers includes fungi (fig. 98), termites (fig. 99), the larvae of wood-boring beetles and other insects, earthworms, and a whole host of litter arthropods. This guild of specialists did not evolve as soon as forests did. The great coal deposits of Carboniferous times were laid down before decomposers could catch up with the supply of dead wood from the forests that had evolved not long before.

One cannot see the symbiotic protozoans that break down the cellulose in termite guts, thereby enabling these termites to consume fallen logs or litter leaves. What is visible are large termite nests seated on the trees, about fifty of them per hectare on Barro Colorado. These nests are signs of the complex social organization and elaborate division of labor required of the insects that would win the race with the many fungal rots for the consumption of fallen logs. The division of labor in a termite colony is as complex as that which enables a honeybee colony to locate and exploit different plants at the times and places when and where they come into flower, before other insects take their nectar or pollen.

Unlike termites, most decomposers are essentially invisible. The business end of a fungus is a mat of threads extending through the decomposing object. Many fungi reveal themselves only by mushrooms or other structures they use to disperse their spores, which suddenly sprout from a rotting log and disappear with equal suddenness. Decomposers, however, support a large, visible animal community—consumers of detritus, partly decomposed plant matter, predators on decomposers (figs. 100, 101), their predators, and so forth. Many ants nest in leaflitter or the ground just below; some frogs and toads specialize on eating these ants, or termites; small lizards live on litter insects; coatis spend much of their time searching the litter of the forest floor for lizards and large invertebrates. A nocturnal visitor may find an armadillo snuffling through the litter or digging through the upper soil for decomposers or their predators. During the day a visitor might see a tamandua breaking open a termite nest. Perhaps the most spectacular consumer in the community supported by decomposers is a swarm of army ants, sweeping across the forest floor, eating the brood of ants nesting in the litter or just below ground and the other insects they can catch, or carrying this prey home to their own larvae. Meanwhile, birds hover about these ants, snatching the insects that fly up to escape the oncoming swarm.

The last stage of decay of plant matter is when it becomes soil organic matter. E. F. Bruenig remarked that this matter serves "as sources of nutrients for the roots of living trees and as food and nutrients for soil organisms; as aggregate-stabilizing substances in the soil improving soil stability, crumb cohesion, porosity and aeration, and thereby rootability; and as an absorption and exchange complex for water, mineral nutrients and trace elements." How plant matter decomposes, and what organisms are involved, thus influence crucial aspects of the soil: how well the soil holds water and nutrients before plants take them up, how readily atmospheric oxygen penetrates the soil and carbon dioxide leaves it, how easily plant roots grow through the soil, and the like.

The Common Interest of Plants in Their Soil's Quality

In most tropical forests, plants help protect and improve their soil. Trees work together to improve the arena where their roots compete so ruthlessly, like knights preparing a tournament ground so they can joust more effectively. Soil, however, is an achievement far more remarkable than a level playing field. Soil must satisfy many conflicting requirements. It must be soft enough for roots to penetrate, porous enough for oxygen and carbon dioxide to move through, yet cohesive enough to stay put. Soil must be so structured that it holds the nutrients and water it receives tightly enough to keep them from

Heavy rains erode the soil where plants do not protect it. Here, this effect is shown in microcosm: small particles of leaf protect the soil under them, creating tiny pyramids of protected soil.

draining or leaching away, yet loosely enough so that plant roots can suck them out.

Especially in rugged country, a heavy rain can suddenly transform a clear tropical stream into a raging, muddy torrent (figs. 102, 103). Soil therefore needs protection. Plants share an interest in preventing their soil, and themselves, from washing away.

A tropical forest does protect its soil. The forested Amazon basin receives more than twenty times as much rainfall per year as the largely deforested basin of China's Huang Ho, yet the Huang Ho carries more sediment to the sea. True, deforestation need not be so destructive. Careful cultivation of cleared land can avoid most of its adverse effects. The central point, however, is that care must be taken to replace the services formerly offered by the forest. Such careful cultivation presupposes an understanding of the land, a security of land tenure, an assurance of a reasonable share of the benefits from careful husbandry, and an enduring satisfaction with a farmer's way of life. This combination of circumstances is seldom encountered in this age of mobile labor and often ruthless market economics, so seldom that in most tropical settings we can learn what forests do for their soils by considering the effects of deforestation.

The sediment a river carries away is sometimes an inadequate measure of the impact of deforestation. In Puerto Rico, for example, geologists have compared erosion in two nearby catchments with identical bedrock, the forested Icacos basin and the largely deforested Cayaguas basin. Although runoff from the forested Icacos basin is three times higher, the Cayaguas basin loses more sediment per hectare (table 2.5). This comparison, however, grossly understates the increase in erosion caused by deforestation and careless land use. Landslides are the principal engine of erosion in these steep basins, and the total volume of landslide scars per hectare is two hundred times as high in the deforested Cayaguas basin.

Sediment outflow measures the erosion rate reasonably accurately only where the vegetation has long been undisturbed. The contrast in landslide volume per hectare between the two catchments is so much greater than the contrast in sediment outflow because the debris from a landslide does not leave its catchment immediately. Instead, it piles up at the bottom of the slope it slid

TABLE 2.5

Effect of Deforestation on Erosion Rate and Landslide Volume

Catchment	Sediment Loss per Year	Density of Landslide Scars	Volume per Landslide Scar	Volume of Scars per Hectare
Icacos (Forested)	9.5 tons per hectare	1 per 16 hectares	300 m³	18 m³ per hectare
Cayaguas (Cleared)	11.6 tons per hectare	0.8 per hectare	4714 m³	3771 m³ per hectare

down, and is shifted farther downstream only in stages, by later cloudbursts. When a catchment is cleared, it takes hundreds of years for the sediment outflow to balance the erosion rate.

To learn how much water Barro Colorado's forest uses and how well its soil holds water and keeps nutrients and soil from washing away, Benjamin Morgan installed a "V-notch weir," a dam with a wide-angle V-notch cut in it, on Lutz Creek near the laboratory clearing in 1971 (fig. 105). The water flowing over the weir drains from a 9.7-hectare catchment in rugged country where the average slope is fifteen degrees. If we know the height above the V-notch's base of the water in the "stilling pond" behind the weir, we can calculate how fast water is flowing across it. The automatic record kept of the stilling pond's water level thus makes possible a record of outflow. An appropriate sampling of the creek water above the stilling pond allows us to learn how its chemistry and sediment content vary with the time of year and the flow rate. A weir thus allows us to measure runoff, and the outflow of nutrients, dissolved solids, and suspended solids from its catchment.

The ruggedness of the terrain influences a soil's ability to hold water and keep nutrients from washing away. To learn about this influence, Robert Stallard, a geologist with the Water Resources Division of the United States Geological Survey, installed a second V-notch weir on Conrad Creek, which drains a 40.6-hectare catchment on the level plateau capping the island. Stallard's aim was to compare the chemistry and sediment content of stream water, and

When rain falls, streams rise and get muddier. This weir was built to measure the rate of water flow in Lutz Creek. The water level in the pond behind the weir governs how fast water crosses the weir. The continuous record the Smithsonian Tropical Research Institute keeps of this pond's water level and this water's mud content, and a synchronized record of rainfall near the weir, tell us how rapidly the stream rises after a storm begins, and how much erosion is caused by storms of different sizes.

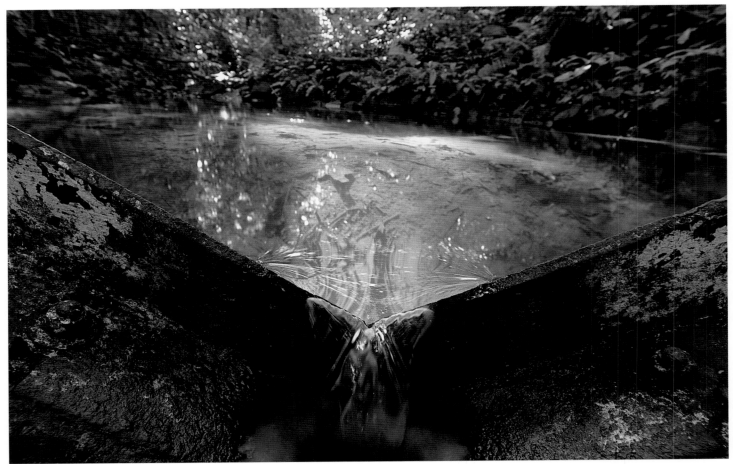

the pattern of its flow, from the relatively flat Conrad Catchment with that from the rugged Lutz Catchment. As one would expect, erosion was about twenty-five times as rapid at Lutz as at Conrad (table 2.6). The equivalent of a layer of bedrock 0.188 millimeters thick erodes from Lutz each year, compared to .008 millimeters per year at Conrad.

The topography of a catchment governs the thickness of its soil and affects the speed with which its stream rises in response to heavy rainfall. In Lutz Catchment, erosion keeps pace with the weathering of bedrock, so the soil is thin and cannot hold much water. Late in the rainy season, when soils are soaked, Lutz Creek starts rising a few minutes after a heavy rain begins; the runoff causing this rise flows through root holes and underground cracks and fissures straight into the stream (figs. 102, 103). Conrad Catchment, however, is too level for erosion to keep pace with the weathering of bedrock, so its soil is much deeper than in the steeper Lutz Catchment. Even though a liter of Conrad Catchment's soil holds less water than a liter of Lutz Catchment's more porous soil, Conrad's deeper soil holds far more water per hectare. Thus Conrad Creek rises much more slowly than Lutz Creek in response to a heavy rain. The rise in Conrad, moreover, is proportionately less substantial. The highest outflows from Lutz have exceeded two cubic meters of water per second. The outflow from Conrad has never attained one cubic meter per second even though Conrad Catchment is four times as large as Lutz. Finally, judging by the lower annual runoff at Conrad, much of Conrad Catchment's water must flow out underground. Soils in both catchments are remarkably effective at keeping nutrients from washing away. When Lutz Creek attains full spate, the chemistry of its water (ignoring sediment) is like that of the rainwater reaching the forest floor. This runoff flows so rapidly from the soil surface to the stream that it has no time to leach nutrients from the soil. Although water spends more time in the deep soil of Conrad Catchment before reaching its stream, Conrad's soil does not let its nutrients wash away. Even though Barro Colorado's plateau is fertile by tropical standards, and the leaflitter falling on the plateau is unusually rich in nitrogen and phosphorus, Conrad

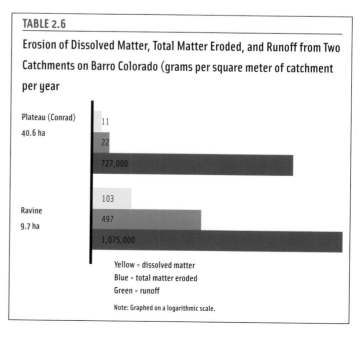

TABLE 2.6

Erosion of Dissolved Matter, Total Matter Eroded, and Runoff from Two Catchments on Barro Colorado (grams per square meter of catchment per year

Plateau (Conrad)
40.6 ha

11
22
727,000

Ravine
9.7 ha

103
497
1,075,000

Yellow = dissolved matter
Blue = total matter eroded
Green = runoff

Note: Graphed on a logarithmic scale.

Creek water is as poor in these nutrients as the streams draining the poor soils of central and eastern Amazonia. Perhaps the most striking evidence of the power of Barro Colorado's soil to hold critical nutrients is that stream water from both Lutz and Conrad is poorer in nitrogen and phosphorus than the rainfall into these catchments.

Many people think that deforestation makes floods more sudden and reduces stream flow during the dry season. To learn whether, and to what extent, this was true in Panama, Stallard compared adjoining catchments of identical ruggedness and bedrock type on the mainland across the Panama Canal from Barro Colorado. One 127-hectare catchment was entirely forested, while 44 percent of the adjoining 169-hectare catchment consisted of pasture and second-growth scrub. In deforested areas, the soil was rather less fertile, much thinner, and far less penetrable by water. When it rained heavily, the stream rose more rapidly and extensively in the deforested catchment than in its forested counterpart (table 2.7). Deforestation also reduced the amount of water used by plants. As a result, the deforested catchment had more runoff per hectare during the rainy season (table 2.8). On the other hand, the forested catchment stored more water during the rainy season, so that more water left it during the following dry season, incidentally benefiting downstream users.

Plants also affect their soil by the chemistry of their litter and roots, which provide the raw material for decomposers and serve as the ultimate sources of organic matter in the soil. In most tropical settings, as on Barro Colorado, most plants benefit more by growing fast than by spending heavily to poison herbivores and competitors. In some infertile sites, however, plants may spread by ruining their competitors. Pines of the New Jersey barrens pile up flammable litter, fueling fires that burn up some competitors and ruin the soil for others, turning it into a bleached sand. Some trees adapted to the poor soils of peat swamps drop leaves that form a raw humus. This humus bleaches the top few centimeters of soil; if trees of these species are planted in better soil, this humus degrades it. Just what circumstances confer effectiveness on the common interest plants have in their soil's fertility is a question that deserves further attention.

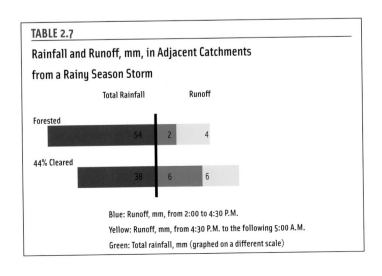

TABLE 2.7

Rainfall and Runoff, mm, in Adjacent Catchments from a Rainy Season Storm

Total Rainfall Runoff

Forested 54 2 4

44% Cleared 38 6 6

Blue: Runoff, mm, from 2:00 to 4:30 P.M.

Yellow: Runoff, mm, from 4:30 P.M. to the following 5:00 A.M.

Green: Total rainfall, mm (graphed on a different scale)

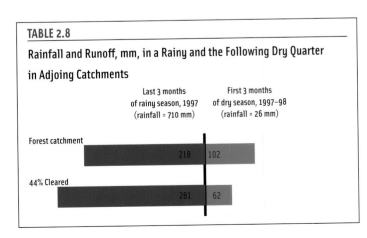

TABLE 2.8

Rainfall and Runoff, mm, in a Rainy and the Following Dry Quarter in Adjoing Catchments

Last 3 months of rainy season, 1997 (rainfall = 710 mm) First 3 months of dry season, 1997–98 (rainfall = 26 mm)

Forest catchment 218 102

44% Cleared 281 62

Seasonal Rhythms and Odd Years

Like many areas in Central and South America, Barro Colorado has a severe dry season. Barro Colorado's dry season usually begins in December and ends between mid-April and mid-May. In the Southern Hemisphere, the dry season begins and ends about six months later. Like winter in the temperate zone, the dry season reflects seasonal changes in day length and in how nearly overhead the sun is at noon. As Barro Colorado's dry season progresses, the soil dries, cracks open in the ground, streams dwindle and dry up, and fallen leaves cover the ground. Some trees lose their leaves.

Although Barro Colorado's annual rainfall averages 2,614 millimeters a year, the average for the year's first quarter, when the dry season is at its height, is 126 millimeters. Indeed, in half the years between 1925 and 1986, less than 100 millimeters of rain fell during the first quarter. In Madagascar, tropical regions that average 125 millimeters of rain per quarter (500 millimeters per year) have vegetation like that of the Sonoran Desert, full of plants resembling cactus and ocotillo. Barro Colorado's dry season is also sunnier, averaging 229 watts of solar radiation per square meter of forest in the year's first quarter, a third more than the 158 watts received between June and November.

The return of the rains is often dramatic. The rain softens the ground, streams begin to flow, and leaflitter begins to decay. The rains bring a renewal of life and activity. A series of plant species bursts into flower, one after another; others drop ripe fruit; throngs of seedlings sprout. The first major rain of the season calls clouds of termites from their nests for their annual mating flights. These flights of termites provide a feast at which insect-eating birds stuff themselves silly without visibly diminishing the abundance of their prey. In early May, when the tender young leaves they require are flushing, baby iguanas hatch and swim ashore from the small, relatively predator-free islands where their eggs were laid. Coatis and other mammals give birth when the rains begin, for fruit is most readily available then for the lactating mothers.

Coping with the Dry Season

Plants deal with the dry season in a variety of ways. Many are evergreen. Evergreen trees keep going by drawing water ever deeper from the soil, where it is more readily available, as the dry season progresses. Others lose their leaves for part of the year. The striking pioneer tree, *Pseudobombax septenatum* (fig. 106), drops its leaves at the turn of the year and flushes new ones in early May, almost regardless of when the dry season begins and ends. *Spondias mombin* drops its leaves, however, only when the upper layers of soil dry. The huge canopy tree *Ceiba pentandra* often drops leaves in October, when skies are cloudiest and the rainy season is reaching its climax. *Ceiba* flushes new leaves in February, thus reducing the damage from insect pests, which dislike dry weather. These new leaves photosynthesize at full blast in the dry season's bright light, as if water were readily available.

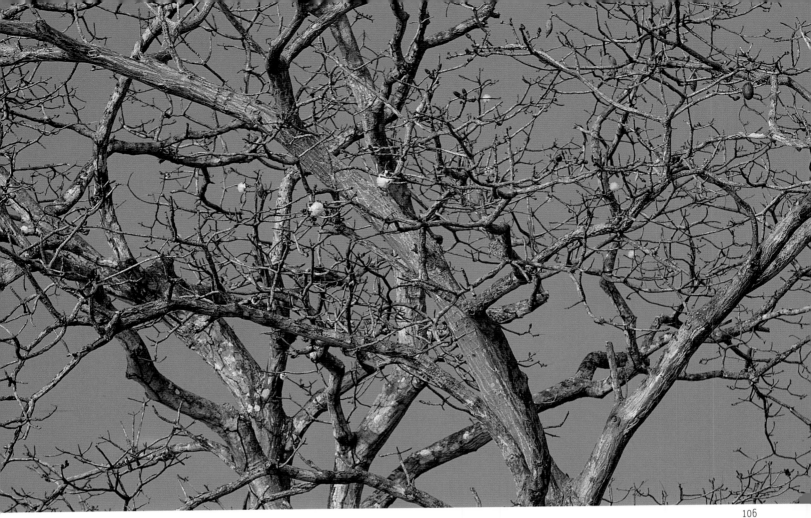

Some of Barro Colorado's trees, such as these *Pseudobombax,* drop leaves in the dry season to reduce water loss from transpiration.

Some plants grow different kinds of leaves for each season. On Barro Colorado, the understory shrub *Psychotria marginata* flushes "rainy-season leaves" in May, as the rains are coming, and "dry-season leaves" in December, as the rains end. Leaves of each kind live for two years, but the youngest leaves should suit their season, as they are most productive and placed in the best light. Leaves of both kinds have equal photosynthetic capacity; they make equal amounts of sugar per unit of leaf area when they have plenty of light and water. Dry-season leaves, however, transpire half the water rainy-season ones do to make a gram of sugar—a useful economy when soils are dry. The water-saving features, however, halve the sugar that dry-season leaves make per quantum of light received when in the deep shade they normally experience during the rainy season.

Do canopy trees make leaves for each season? Alan Smith, of the Smithsonian Tropical Research Institute staff, had a tower crane placed in Panama City's Metropolitan Park. Biologists enter a cage that the crane lifts to the desired point in the forest canopy. It turns out that several species of the park's canopy trees do make leaves for each season. Panama City's dry season is more severe than that of Barro Colorado. Yet in these species, photosynthetic capacity is higher in dry-season leaves. Moreover, these leaves transpire more water at the same relative humidity than rainy-season leaves do. Dry-season leaves of these species are obviously designed to exploit the season's abundant light. Unlike *Psychotria marginata,* these trees can secure plenty of water during the dry season.

Plants pull water from the soil. Transpiration releases vapor through stomates. This water vapor evaporates from the open ends of xylem vessels. These

vessels are pipes, between a tenth and a third of a millimeter wide, carrying water in relays from the roots to the leaves. Evaporation from these vessel-ends pulls the following water upward through these pipes, drawing more water into the roots from the soil to replace it. If the pull is strong enough, however, columns of water begin snapping in their pipes, like overloaded wires. How strong can this pull be?

Transpiring leaves often pull water through a stem more rapidly than a vacuum pump can, suggesting that water in xylem vessels is often under negative pressure. If one puts a leafy twig in a pressure chamber with the twig-end sticking out, the negative pressure, the pull, on the water in this twig's xylem is measured by the positive pressure needed to force water out through the twig's end. Water in a pipe a tenth of a millimeter in diameter can sustain strong pulls if it is free of bubbles. Root membranes and xylem vessels are designed to keep bubbles from entering. A strong pull on a xylem vessel's water creates a powerful suction. If air is somehow sucked into the vessel, the water in it vaporizes (even cold water boils when exposed to a vacuum), snapping the water column and blocking flow through the vessel. The pores in the membranes between one vessel and another are small enough to prevent the spread of bubbles of vapor from one vessel to the next.

Psychotria horizontalis, a common understory shrub on Barro Colorado, can tolerate a pull equivalent to the pressure a diver would feel four hundred meters below the sea surface if the diver could survive there. This shrub's roots are only thirty centimeters deep; in the dry season it must pull hard to get water out of the dry topsoil. In the evergreen pioneer tree *Ochroma pyramidale,* however, a pull less than a quarter this strong would begin snapping water columns and threatening the supply of water to its leaves. Late in the dry season, the pull needed to draw water from the topsoil is often stronger than *Ochroma*'s pipes could bear; this tree must root deeply enough to draw water easily, even at the height of the dry season.

Odd Dry Seasons and Their Consequences

When he was a graduate student from Duke University in 1969, Robin Foster began to record the numbers and kinds of flowers and fruit falling into each of hundreds of green plastic tubs scattered over Barro Colorado. His two-year study told him a lot. Fruit fall peaked in September and October 1969. Then followed a few months of food shortage. His fellow students observed that during the time of fruit shortage, fruit-eating animals were hungry and some, especially young ones, died (fig. 107). Fruit-fall peaked again in April and May 1970, as it did a year later. There was no fruiting peak, however, in September and October 1970. As that rainy season wore on, frugivorous mammals starved and died in such numbers that the forest stank.

What happened? The full two-year record revealed that many of the species that fruited in September and October 1969 flowered after the rains came in 1971 but did not flower in 1970. The dry season in 1970 was weak; its January

was one of the wettest ever. Was that dry season so weak that some trees could not tell when the rainy season came? Earlier studies reported other years when a fruit failure in September and October and a famine among mammals followed a wet dry season.

From his study, Foster inferred that (1) populations of fruit-eating mammals are limited by seasonal shortages of fruit, (2) some plants need a strong dry season to know when to flower, and (3) the normal alternation of dry and rainy seasons is needed to ensure an adequate abundance of fruit through the year. These conclusions took ten years to appear in print. Foster, however, taught a whole generation of students on Barro Colorado how to identify plants, and gave them luminous advice on their research plans. As a result, his work focused much of the research on Barro Colorado toward learning (1) what causes forestwide fruit failures, (2) what limits populations of verte-

107

brate herbivores, and (3) when different kinds of plants flower, fruit, and flush new leaves. These questions occupy the rest of this chapter.

Does Barro Colorado's forest need a strong dry season to ensure normal fruiting in the following September and October? While she was a STRI predoctoral fellow from the University of Michigan, Carol Augspurger showed that a rain caused one species of understory shrub to flower only if that rain were preceded by a strong dry spell. She asked just what makes the shrub, *Hybanthus prunifolius,* flower. These shrubs flower in synchrony after a dry-season rain. In the rainless dry season of 1975, she could make small Hybanthus flower by watering the soil around their roots, if that soil was dry enough. She could also keep them from flowering by watering them continuously after the rains ended. Other plant species also flowered after dry-season rains (fig. 108). On the other hand, a sharp dry season is not a necessary prel-

On Barro Colorado, both fruit and new leaves are in short supply late in the rainy season. This is accordingly a time of higher mortality among the island's vertebrate herbivores. The skeleton of this howler monkey, *Alouatta palliata,* was found in November, when fruit and new leaves are most scarce.

107

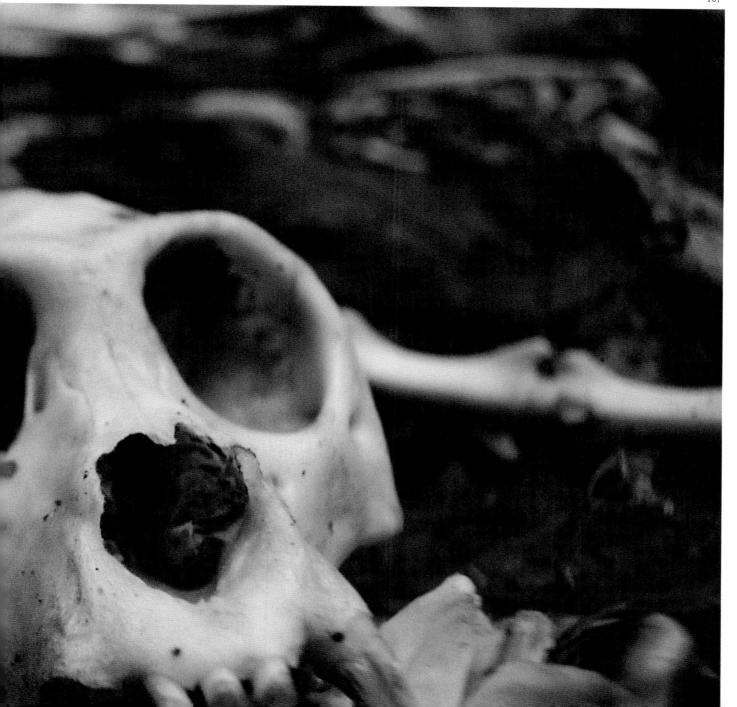

ude to flowering when the rains return. The very wet dry season of 1981 was not followed by the expected fruit failure in the following September and October, nor was there any sign of famine that year among the forest's fruit-eaters.

S. J. Wright, of the STRI staff, deciphered the causes of famine years by examining long-term climate records. He found that famine-causing fruit failure followed a wet dry season only when the year before had an exceptionally severe dry season. Barro Colorado's climate is influenced by a phenomenon called El Niño, a truly global disturbance. A particularly savage El Niño year brings floods to the deserts of coastal Peru, shrinks the Nile's flood, flings storms against the California coast, and brings drought to parts of Indonesia. Severe El Niños also bring Barro Colorado a dry season that is prolonged, severe, or both, and reduce rainfall in the preceding months (fig. 109). An El Niño dry season, however, stimulates unusually heavy fruit-fall. Many tree species that flower when the rains come exhaust their reserves by fruiting heavily, and fail to fruit in the following year. The year following an El Niño often has a wet dry season; this was true for all the famine years Robin Foster read about. Moreover, too wet a dry season causes some trees to miss their flowering when the rains return. A full-scale September-October fruit failure happens, however, only when the preceding dry season is wet and the dry season before that is strong enough to cause unusually heavy fruiting.

BELOW: A heavy rain during the dry season can elicit synchronized flowering among many of the island's *Tabebuia guayacan,* facilitating cross-pollination among these trees.

OVERLEAF: Here, the moon rises over Gatun Lake in April 1998, shining on countless dead tree trunks. These trunks are the remains of the forest flooded when Gatun Lake was created to form the central part of the Panama Canal. Most of these trunks are exposed only when the lake level is low. El Niño, a climatic phenomenon occurring irregularly once every few years, causes droughts in Central America. The 1997–98 El Niño, one of the strongest recorded in Panama, caused Gatun Lake to drop to a historic low, creating the scene shown here (fig. 109).

108

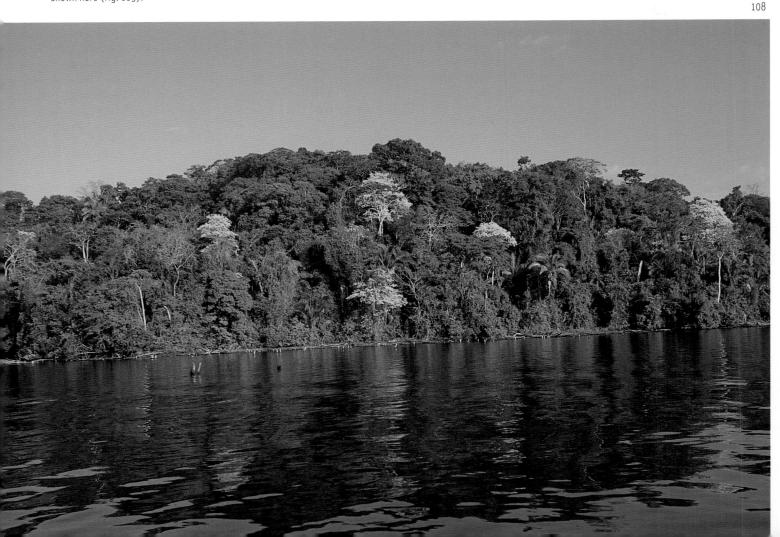

Are Vertebrate Folivores Limited
by Seasonal Shortages of Suitable Food?

Barro Colorado has several species of ground-dwelling mammals that all live on fruit during the season of fruit abundance—peccaries, deer, pacas, agoutis, coatis, and spiny rats. What limits their numbers? In 1966, N. Smythe, a graduate student from the University of Maryland, who later became a member of the STRI staff, first came to Barro Colorado to study agoutis and their relationships with competing species. He measured how much fruit fell to the forest floor, and found that the fall was minimal in December and January. He also found that these mammals entered traps more readily when food was short, that young pacas and agoutis grew more slowly, if at all, during this season, and that during this shortage, animals spent more time looking for food, ranged farther in search of it, and took more risks to obtain it. The young of these animals are more likely to survive if born near the beginning of the season of abundance. Presumably for this reason, coatis bear their young in synchrony at the beginning of the fruiting season. Now that we know roughly how many Barro Colorado has of each kind of fruit-eater, we can apply a physiological formula to estimate how much a mammal eats per day from its body weight to learn how much the ground-dwelling fruit-eaters eat in all. It turns out that in December and January, too little fruit falls to feed these animals. Their populations appear to be limited by seasonal shortages of food. Have the forest's trees cooperated to create the seasonal shortages of fruit in order to control the populations of their frugivores?

It is easier to believe that a seasonal shortage of fruit and new leaves is somehow meant to benefit the trees if it also controls the populations of those vertebrate herbivores that live in tree crowns. Indeed, the story is much the same for canopy-dwelling as for ground-dwelling frugivores. Fruit-eating bats and leaf-eating iguanas time their reproduction to bring forth young when fruit and new leaves are abundant. Students find more dead sloths and howler monkeys (fig. 107) along the trails in the season when fruit and new leaves are scarce. Katharine Milton, who first came to Barro Colorado in 1974 as a graduate student from New York University, and who has since become a professor at the University of California, found that howler monkey troops contested possession of fruiting trees by howling matches more often during the season of shortage. She also found that most howlers that died during the season of shortage did not starve to death; rather, they were so malnourished that screwworms could infect the wounds botflies opened in their skin (fig. 148)—an infestation that was invariably fatal.

Populations of vertebrate herbivores do appear to be limited by seasonal shortages of fruit and new leaves. As a result, when fruit is abundant, dispersed seeds are less likely to be recovered and eaten. The seasonal shortage clearly controls the numbers of leaf-eating vertebrates. Sloths, howler monkeys, and iguanas are Barro Colorado's principal vertebrate leaf-eaters; in total, they eat much less of this forest's foliage than insects do.

Seasonal Rhythms of Leaf Flush, Flowering, and Fruiting

Different kinds of plants flower, ripen fruit, and flush new leaves at different times of the year, manifesting the forest's seasonal rhythm. Why these differences?

Most evergreen trees, and many understory plants, flush leaves at the turn of the year, anticipating the dry season's abundant light. Another, more general wave of leaf flush occurs before and during the onset of the rains. A lesser peak may occur in September. Some plants flush leaves opportunistically. In the rainy season, understory saplings tend to flush leaves after an unusually sunny week, while in the dry season, some tend to flush leaves after a rainy week. Light and water are not the only factors influencing the time of leaf flush. Herbivores relish young leaves. Plants can reduce their "herbivore tax" by flushing leaves when so many others do that herbivores cannot eat them all (fig. 110), or by flushing in the dry season, when insect herbivores are fewer.

Many plants flower in response to the advent of the rainy season, when insect pollinators are most abundant. The flowering of the canopy tree *Dipteryx panamensis* in June and July, which crowns these trees with purple, marks the end of this wave of flowering. The yellow flowers of the pioneer *Cochlospermum vitifolium* are heralds of the dry season, although the rains may still be in full spate when they first appear. Are they responding to the shortening days of December, like the spotted ant-birds that prepare to breed in response to the lengthening days of February and March? Some species, such as the canopy tree *Tabebuia guayacan,* use dry season rains as cues to bring plants of their kind into synchronous flower (fig. 105), making pollination easier.

Many plants ripen fruit when, or just before, the rains begin. Their seeds germinate when the rains come, allowing the seeds as much time as possible to prepare for the coming dry season. Many lianas with wind-dispersed seeds release them late in the dry season, when the trade winds that disperse their seeds are still blowing. Other plants, including many of those flowering after the rains begin, ripen their fruit in September or October. Their seeds, however, remain dormant until the next rainy season begins. North American migrant birds return to their tropical wintering grounds at this time of year. These migrants disperse the seeds of some of the trees fruiting in September and October as they pass through. Understory shrubs unable to make rich fruit tend to fruit well after the rainy season begins, when canopy trees pre-empt fewer of the available seed dispersers.

What Times the Seasonal Rhythms of the Forest? A Gigantic Experiment

To learn how the dry season times the seasonal rhythms of different plants, S. J. Wright arranged an elaborate system of sprinklers to water two 2.25-hectare plots on Barro Colorado for five successive dry seasons. These sprinklers provided the equivalent of six millimeters of rain a day, five days a week, all

through the dry season, enough to make it easy for any plant to draw water from the soil. Wright compared the timing of flowering, fruiting, leaf-fall, and leaf flush in plants on irrigated plots with plants of the same species in unwatered plots nearby.

His first surprise was that most kinds of canopy tree behaved exactly the same whether or not they were watered during the dry season. There were a few exceptions, such as *Tabebuia guayacan,* which clearly respond to changes in the moisture content of the soil. To be sure, the alternation between dry and rainy seasons times the rhythms of all these plants. Most canopy trees, however, are responding to seasonal changes in the atmosphere, not in the water content of the soil. Indeed, these trees have steady and reliable access to soil water all through the year, because water is readily available a meter below the ground. Because watering increases humidity in the understory, but not in the canopy, it is less obvious whether understory plants are responding to changes in atmospheric humidity or in the moisture content of the soil.

The second surprise came from a species of understory shrub, *Psychotria furcata.* Shrubs of this species normally flush leaves in synchrony when the rains come. On irrigated plots, these plants flushed leaves a little earlier, and leaf flush became a little less synchronous, each successive year. It was as if leaf flush in these shrubs was timed by internal clocks for a period of slightly less than a year—as if the clocks were normally reset and synchronized by the onset of the rains. Abolish the time-setting signal and different plants' clocks will diverge more each year.

Young leaves are tender and nutritious. Herbivores greatly prefer them to older, tougher leaves. If enough plants flush leaves in synchrony, they produce such an overabundance of new leaves that herbivores can eat only a small proportion before they mature. Here, trees of two species are flushing young, reddish leaves in synchrony at the beginning of the rainy season.

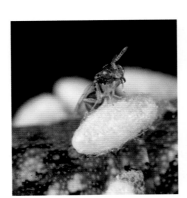 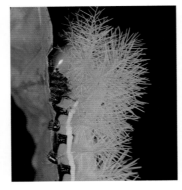

3

Eating and
Being Eaten

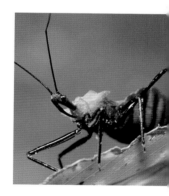

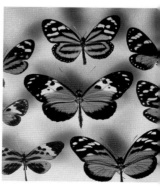

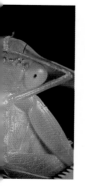

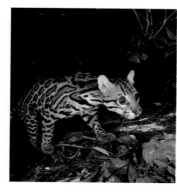

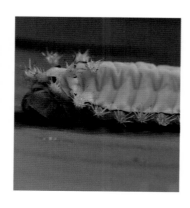

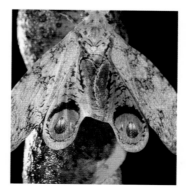

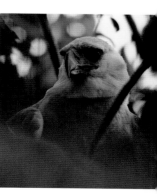

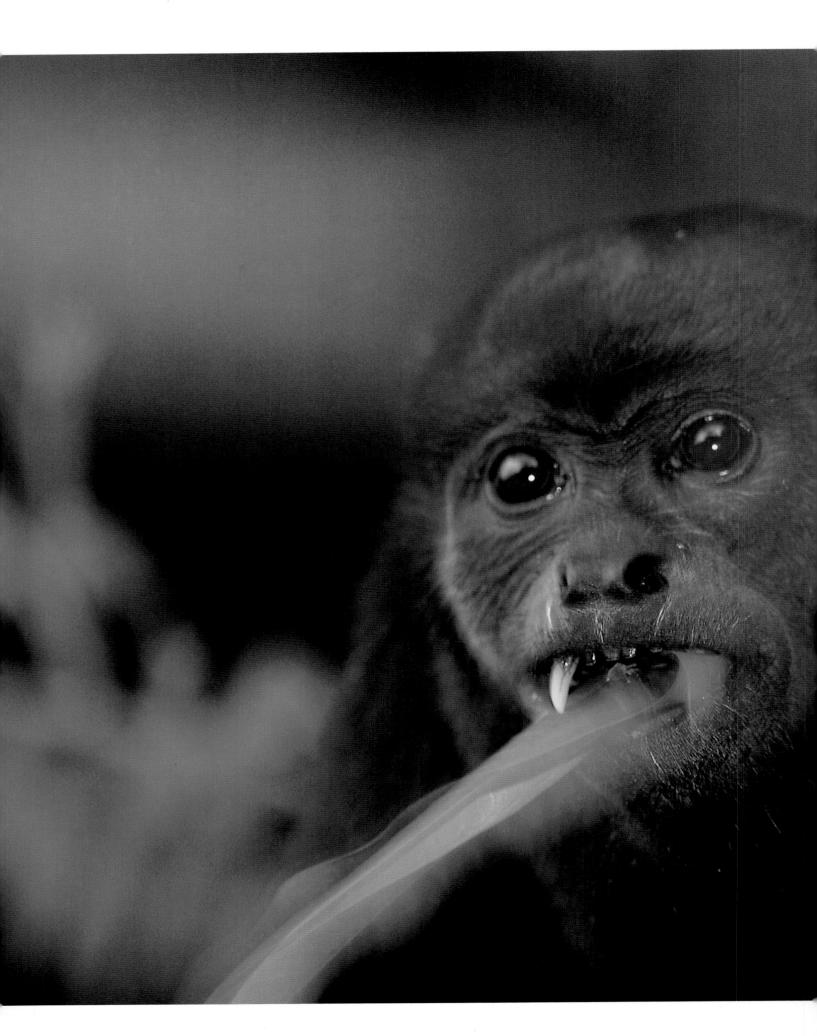

To live, animals must find food they can eat. And because animals must eat to live, plants and animals must all take measures to avoid being eaten.

In any forest, the most abundant fresh food is plants. A visitor, however, may see nothing eating any plant. On Barro Colorado, a lucky visitor might see howler monkeys stuffing young leaves into their mouths (fig. 111), or a caterpillar slowly nibbling away a leaf (fig. 113). Perhaps the walk will bring the visitor to a tree that is dropping a light rain of something more solid than water. A look upward may reveal that this tree's leaves have mostly been eaten. The rain is the frass, the feces, of the leaf-eating caterpillars. True, the visitor will almost certainly see lines of leaf-cutter ants carrying freshly cut leaf fragments down a tree trunk or along an ant highway snaking across the forest floor (figs. 11, 41–45). One rarely sees the ants actually cutting the leaves, however; they are too high overhead.

On the other hand, a careful look at leaves of the shrubbery fringing the laboratory clearing, or the saplings and shrubs along forest trails, reveals abundant evidence of past leaf eating. Some leaves have holes, others ragged edges, where insects have been eating. Hungry caterpillars reduce some leaves to a delicate network of veins (fig. 114); smaller caterpillars "mine" softer matter in other leaves (fig. 116); a disease or blight leaves ugly brown spots on yet others. How much of the foliage is eaten, and the type of damage leaf-eaters inflict, vary according to the kind of plant (fig. 115). Other damage is invisible. Insects such as cicadas (fig. 117), leafhoppers, and aphids, which suck plant juices, apparently slow plant growth every bit as much as leaf-chewers do, but they leave no visible evidence of their depredations.

Phyllis Coley, then a graduate student of Robin Foster's at the University of Chicago, came to Barro Colorado on a Smithsonian predoctoral fellowship to study herbivory. As part of her thesis

About 40 percent of the diet of howler monkeys, *Alouatta palliata,* is leaves, mostly young ones. Barro Colorado's thirteen hundred howlers consume one two-hundredth of the island's leaf production. Howlers use their big canines primarily for defense against howlers of other troops.

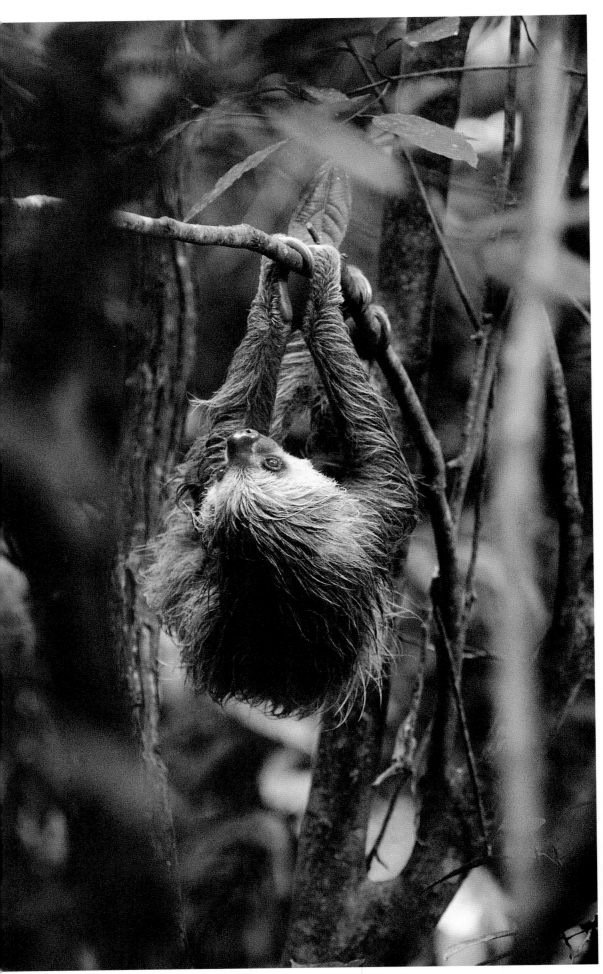

Sloths, such as this two-toed sloth, *Choleopus hoffmanni,* are specialized to eat leaves. Leaves are hard to digest, and support a low metabolic rate, which makes sloths sluggish and slothful.

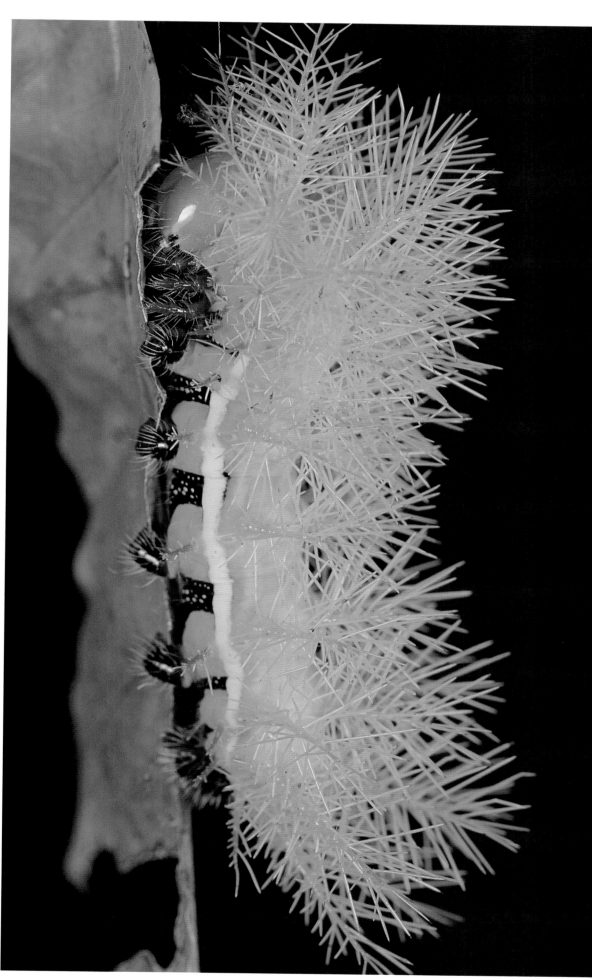

Caterpillars are a diverse, abundant group of leaf eaters. Many caterpillars feed on only a single genus or species of plant. Such specialized pests enhance tree diversity by preventing any one tree species from crowding out others. This caterpillar, of the moth family Limacodidae, has poisonous spines to discourage potential predators such as birds.

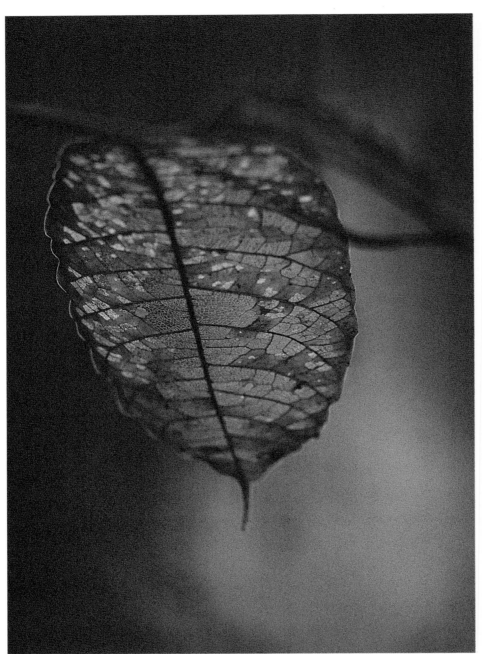

OPPOSITE, TOP: Different kinds of herbivores leave different parts of the leaf. Many herbivores reduce their leaves to a lovely network of veins, which are left uneaten because they are tough and not very nutritious (fig. 114).

LEFT: Other herbivores leave different patterns of damage. The variety of patterns reflects the diversity of ways in which plants are eaten, and the diversity of their consumers. These damaged leaves, shown paired with undamaged counterparts, were collected in March (fig. 115).

ABOVE: Another group of insect larvae with a distinctive way of feeding on plants is leaf-miners. Most of these are larvae of butterflies, beetles, or flies. These small, flat larvae spend their entire larval lives between the two surfaces of a leaf. Many of them are specialized to a single genus or species of plant. The ancestors of some leaf-miners were mining leaves of plants related to their current hosts a hundred million years ago (fig. 116).

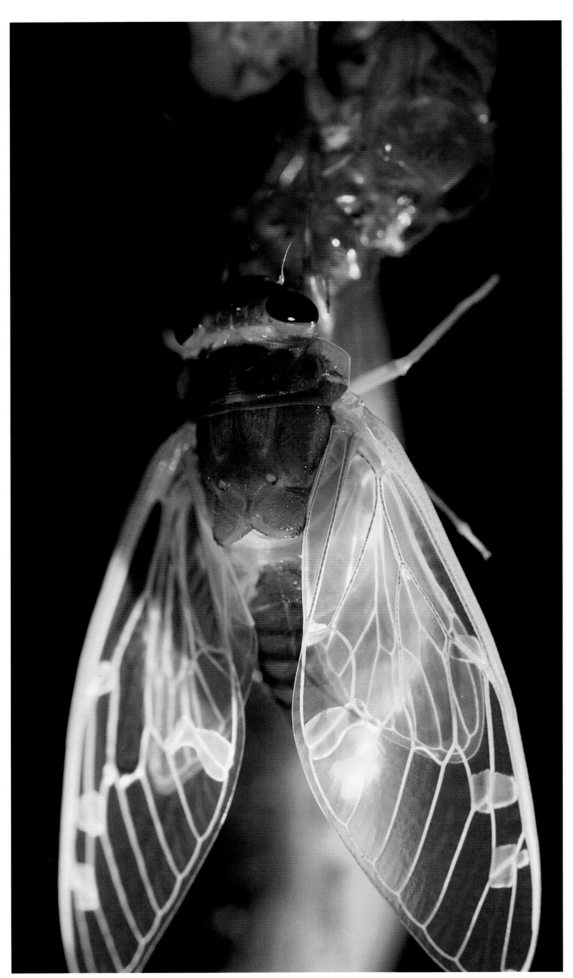

LEFT: Cicadas suck sap from plants. They have long, tubular mouth parts, which they insert into a vessel in a plant's leaf or stem to draw off sap, which contains sugar and some amino acids. The cicada shown here has just emerged from its larval skin after spending years underground as a larva sucking xylem sap from roots. This sap is a diluted food, so the larva grows slowly. This larva crawled out of the ground one night, climbed a plant, and hooked onto it to metamorphose into an adult. This beautiful cicada, freshly transformed, is emerging from its larval skin (fig. 117).

OPPOSITE, TOP: Young leaves are eaten much more rapidly than mature ones, as in this *Calophyllum longifolium* sapling, because they are more tender and nutritious (fig. 118).

OPPOSITE, BOTTOM: To deter herbivores, many plant species attract ants to their leaves by nectar-producing structures called extrafloral nectaries. The ants thus attracted deter or chase off at least some potential herbivores. Here, the plant *Costus pulverulentus* attracts ants, *Ectatomma ruidum,* to nectaries outside its flowers. These ants deter a parasitic fly, whose larvae eat the developing seeds of this plant, from laying eggs on the flower (fig. 119).

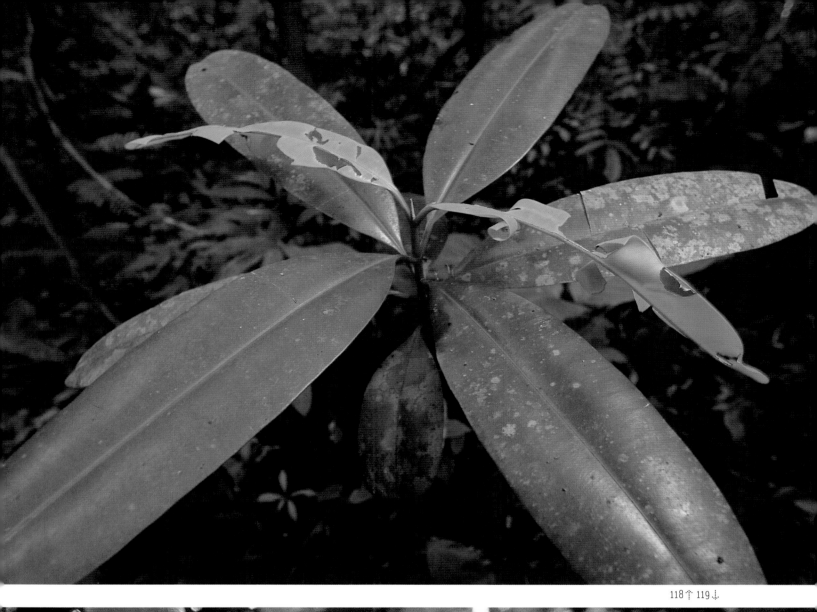

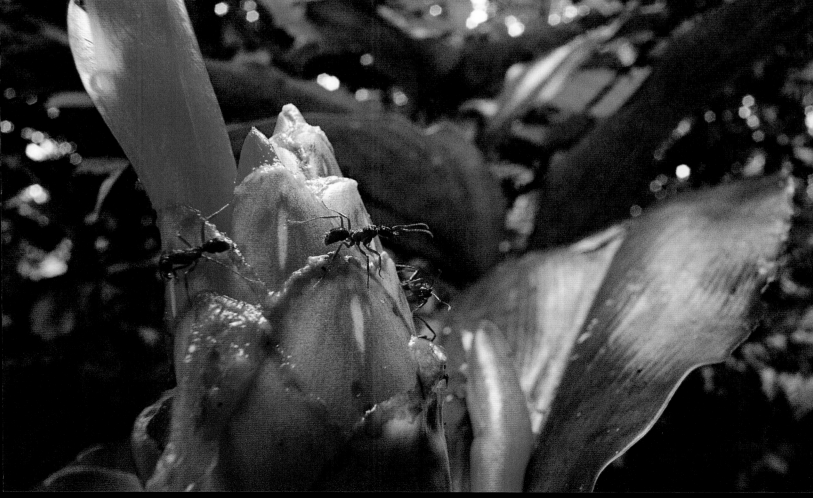

research, she measured the rates at which different plants' leaves are eaten. She measured the proportion of a leaf eaten or damaged at two different times, and calculated what proportion of that leaf was eaten per day. In light gaps, mature leaves of shade-tolerant plants lose an average of 1.3 percent of their area per month; no wonder one so seldom sees herbivores at work! Loss rates differ for different species. Mature leaves of some trees, such as *Calophyllum longifolium,* are eaten at an imperceptible rate, whereas mature leaves of the tree *Alseis blackiana* lose 6.4 percent of their area per month. Herbivores clearly eat some foliage. What keeps them from eating more? Why are some plants more often eaten than others?

Why Don't Herbivores Eat More?

Damage is often most evident on limp, tender young leaves. Just as we prefer young cabbage leaves to old, so most mammals and insects prefer young leaves. One seldom sees howler monkeys eating mature leaves. In seasons when young leaves are in short supply, the monkeys are visibly malnourished, even though they are living in a sea of mature leaves. Leaf-cutter ants also tend to attack trees with young leaves.

Coley found that on shade-tolerant plants, young leaves are eaten twenty times as rapidly as full-grown leaves (fig. 118). On Barro Colorado, the average young leaf loses about 1 percent of its area per day, or 25 percent per month. How do mature leaves protect themselves?

One can see, and often smell, the defenses of desert plants. Cacti and their associates are fearsomely spiny. At dawn or dusk, the smell of these plants' chemical defenses perfumes the desert air. On Barro Colorado, however, spiny stems are rare, and thorny leaves even rarer. A tropical forest may be full of odors, but these are usually either the smell of rotting vegetation or the fragrance of flowers. Some tropical plants have hairy leaves, presumably because the hairs deter some herbivores. Yet hairy leaves are, as a rule, eaten much more quickly than the smooth leaves of other species, which presumably have better defenses. What are these defenses?

On Barro Colorado, Coley found that young leaves are more poisonous than their mature counterparts. In particular, young leaves are more fully stocked with tannins and other phenols that deter or slow down herbivores. Because herbivores prefer young leaves, poisons can rarely be a leaf's best defense. Instead, the toughest leaves, the leaves hardest to bite through, are eaten most slowly, and live longest.

How Do Plants Defend Young Leaves?

Young leaves cannot be tough, because toughness prevents growth. Young leaves lose an average of 25 percent of their area per month, yet take an average of forty days to mature, so growing to maturity is a critically dangerous

120

On Barro Colorado, and in other tropical forests, many young leaves, especially in the shaded understory, are white, red, or purple because they have not yet received the chlorophyll that makes them green. To reduce the loss of photosynthetic proteins in the young leaves herbivores eat, some plants do not provide new leaves with chlorophyll or photosynthetic enzymes until the leaves have reached their full size and become tough enough to deter herbivores. **LEFT:** Young red leaves (fig. 120). **BELOW LEFT:** Young red leaves (fig. 121). **BELOW:** Young white leaves (fig. 122).

121 122

stage in a leaf's life. Plants have many ways of reducing the depredations of herbivores on their young leaves.

Graduate students working in both Costa Rica and Panama found that some plants, such as *Croton* and *Inga,* attract ants to defend their young leaves. The bait they offer is nectar, a sugary fluid supplied from glands situated at the leaf base in *Croton* and between each pair of leaflets in *Inga.* When the leaves are young, these glands yield their nectar, which attracts ants. The ants visiting these glands also eat small caterpillars and other pests.

A graduate student of Phyllis Coley's, Mitchell Aide, showed that other plants strive to mature leaves so rapidly that herbivores will not have time to eat much. Coley found that many understory plants with fast-maturing leaves delay stocking their leaves with photosynthetic protein until they are fully grown. If young leaves of such plants are eaten, at least the plant does not lose these proteins. Thus some limp young leaves in the forest understory are white, pink, or blue, rather than green (figs. 120–122).

Coley and Thomas Kursar, now of the University of Utah, found that plants that expand their leaves slowly stock them with a variety of strong antiherbivore poisons. In searching for plants that would yield useful medicines and pesticides, Coley and Kursar found it wisest to focus on slow-growing young leaves. Those leaves are the ones supplied most abundantly with poisons that can be turned against crop pests or human diseases. These poisons, however, are expensive. They divert resources that could otherwise be used to expand the leaf faster.

Aide learned that plants can cut their losses to herbivores by choosing the right time to flush new leaves. Flushing leaves in synchrony with many other plants ensures that there are so many young leaves to share the herbivores' attention that most leaves suffer relatively little. On Barro Colorado, the two main peaks of leaf flush are when the rainy season begins and when the year ends. Aide found that leaves flushed during these peaks suffered less than leaves flushed at other times. Moreover, insects, especially small ones that dry out easily in the hot sun, are less active in the dry season. Aide found that understory leaves flushed in the dry season suffered less than leaves flushed in the middle or latter part of the rainy season. In the deciduous dry forest of southern India, with half of Barro Colorado's annual rainfall and a savage six-month dry season, most forest trees flush new leaves before the rains come, apparently to reduce losses to herbivores.

The Cost of Antiherbivore Defense

Just as military defense is a major item in national budgets, so antiherbivore defense is a major drain on plant resources. Coley observed that the plants with the toughest, longest-lived leaves grow most slowly. In light gaps, species whose leaves live for seven months or less grow in height by an average of eighty-one centimeters a year, whereas those whose leaves live for

twenty-nine months or more grow an average of thirty-seven centimeters a year.

Coley's student Cynthia Sagers measured the cost of defense more precisely. She compared the growth of cuttings from *Psychotria horizontalis* shrubs whose leaves differed in tannin content, protecting some from herbivores and exposing others. Specifically, she took two cuttings from each shrub and grew them in a light gap, one under an antiherbivore screen, the other close by but unprotected. In twenty months, the protected cuttings gained more than five times the weight of their exposed counterparts. Weight gain in exposed cuttings was not affected by their tannin content. True, plants with tannin-rich leaves lost less foliage to herbivores. Plants with less poisonous leaves, however, grow just enough faster to make up their extra losses to herbivores. As one might expect, unnecessary defense is counterproductive. Protected plants with more poisonous leaves grow more slowly. When protected from herbivores, tannin-rich plants grow only a third as fast as protected plants with one-seventh of their tannin content.

Consequently, plants provide good examples of planned obsolescence. If a plant grows fast enough to ensure that a leaf flushed now will be shaded by newer ones in a year, it will protect its leaves just enough to ensure that they are useful for a year.

The Problems of Leaf Eating

There are many signs that leaves are well enough defended to make life difficult for leaf-eaters. Big animals that must eat many kinds of leaves must make sacrifices to do so. Sloths are the only mammals on Barro Colorado that live only on leaves (figs. 23, 112). Sloths digest their food for a week before passing it. Apparently the mature leaves sloths eat are hard to digest; passage time is twenty-four hours for howler monkeys, which eat fruit and young leaves, and four hours for spider monkeys, which eat mainly ripe fruit. Sloths have a singularly reptilian metabolism. Like reptiles, sloths' temperatures fall at night. Thus sloths need to eat fewer of their indigestible leaves to meet their energy requirements (table 3.1). Their reptilian metabolism, however,

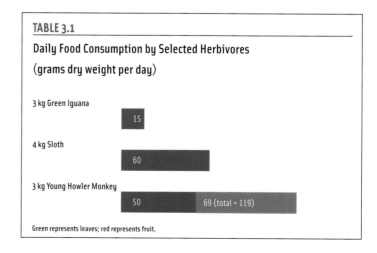

TABLE 3.1

Daily Food Consumption by Selected Herbivores (grams dry weight per day)

3 kg Green Iguana — 15

4 kg Sloth — 60

3 kg Young Howler Monkey — 50 | 69 (total = 119)

Green represents leaves; red represents fruit.

makes them slothful. Sloths are so often still that their resemblance to termite nests or other fixtures on trees allows them to escape the attention of predators. Sloths are so hard to see that even though Barro Colorado shelters thousands of them (we would love to know just how many), a visitor is lucky to see even one.

The other vertebrates on Barro Colorado that live mostly on leaves are green iguanas (fig. 62). Iguanas are cold-blooded reptiles; an iguana does not eat much (see table 3.1). To grow to three kilograms, a wild iguana must eat the same total weight of food that a domestic chicken must eat to attain two kilograms, but, unlike the chicken, which matures in four months, an iguana needs three years to attain three kilograms. Iguanas, like sloths, are often still. Because they are green, they escape predators by being hard to pick out from the leaves around them. Iguanas lack the energy to care for their young; they lay eggs on offshore islands, where mainland predators such as coatis will not eat them. Thus, on Barro Colorado, iguanas are rarely found more than a hundred meters from shore.

A novel form of camouflage: the caterpillar of a swallowtail butterfly *(Papilio thoas)* pretending to be a bird dropping on a *Piper* leaf.

123

Leaf-cutter ants are Barro Colorado's remaining major consumer of leaves. They are the herbivores visitors are most likely to see at work. These ants cannot eat the leaf fragments they cut, although they do suck the leaves' juices. These ants culture a special kind of superfungus that can digest leaves from a huge variety of trees. This fungus digests the leaf fragments the ants cut, and the ants eat the fungus they have cultured. This superfungus is a precious asset; it is what allows these ants to live by harvesting leaves. Each new leaf-cutter queen, flying off to found her own nest, carries a mouthful of her mother's fungus, and, as mentioned earlier, a culture of a particular *Streptomyces* bacterium.

Different plants use different poisons to defend young leaves. An insect that flourishes on young leaves of one kind is usually unsuited to handle the poisons in other kinds. Many sap-sucking insects feed on a variety of plants, but leaves are more distinctive than sap, and generalized leaf-chewers usually grow more slowly than their specialist counterparts. If one finds insects defoliating plants on Barro

Colorado, a careful look usually shows that one kind of plant is suffering most or all of the damage. Another of Coley's graduate students, John Barone, took the trouble to learn what agents were damaging the leaves of eight species of saplings, both near and far from their parents. He found that the majority of the damage on these saplings was inflicted by specialist pests.

Indeed, most plants have specialized pests that can penetrate their defenses. The sticky white latex that oozes from cut fig leaves, like the latex oozing from slashed rubber trees, protects these plants from most insects, but is powerless against their specialists. The poisons that keep most insects off the leaves of the passion vine *Passiflora vitifolia,* whose great red starflowers so many artists have celebrated, make these leaves attractive places for female *Heliconius cydno*—dark blue, almost black butterflies with a white crossbar on each forewing—to lay their eggs. The peppery compounds that make the leaves of *Piper* (shrubs with slender white stalks of minute white flowers or fruits, beloved by some bats) distasteful to most insects are what attract the caterpillars of *Papilio thoas* (fig. 123), a black swallowtail with yellow trim. How do tropical plants escape the pests that specialize on them?

Why Are There So Many Kinds of Tropical Trees?

Barro Colorado has many kinds of trees. On the average, a hectare of its forest includes ninety-one species among 425 trees more than ten centimeters in trunk diameter. In contrast, a hectare of forest in western Maryland has only sixteen species among 279 trees. Moreover, the different kinds of trees on Barro Colorado are well mixed. A tree's nearest adult neighbors seldom belong to its species. To be sure, the mix is far from perfect. A particular kind of tree is far more common in some places than in others. A tree's nearest adult neighbor of the same species is closer than it would be were trees of this species scattered evenly over the island. Considering how few of a tree's seeds are carried far from their parent, however, this mixing is remarkably thorough. Statistical analyses show that Barro Colorado's adult trees are so well mixed because the seeds, seedlings, and saplings closest to their parent are far less likely to succeed than those further away.

The most logical cause of this intermingling is that pests are most likely to kill those young plants closest to their parents, or to other young of their kind. If so, tropical forests have so many kinds of trees at least partly because pests keep each species of tree rare enough to make room for others. A seed or seedling farther from its parents or its fellows is more likely to attain a safe size before it is found by pests specialized to its kind. A tree species' numbers will be driven down by its pests until it is so rare that just enough of the young of this species mature to replace dying adults. Better-defended trees would suffer less herbivory; trees can escape destruction by fighting off their pests as well as by escaping their pests' attention until large enough to survive it.

OVERLEAF: Praying mantises are famous as voracious predators of other insects. Here, a praying mantis devours a katydid (fig. 124).

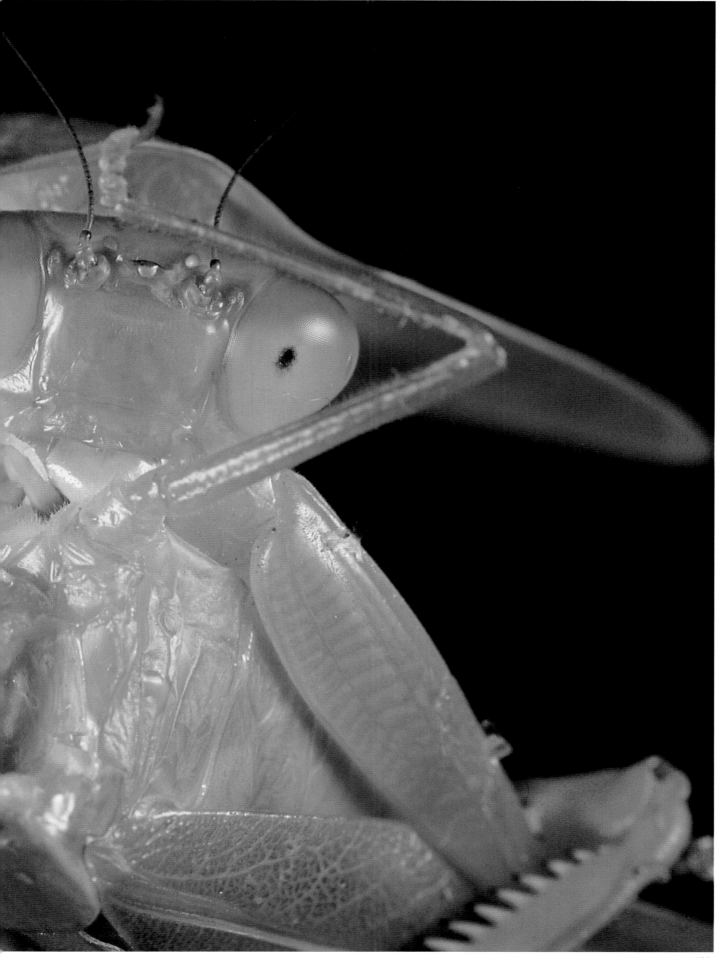

Improved defenses, however, make for a slower-growing sapling; a fast-growing sapling of some rare, less well defended species could outgrow and supplant it.

However, a tree species rare enough to allow some of its young to escape its pests reproduces only because animal pollinators allow pollen to be exchanged among its scattered trees. Before such pollinators evolved, the forest was much less diverse, and its trees survived only by being much more poisonous. In that age, great dinosaurs walked the earth, because huge vats were more effective at digesting—or should one say composting?—such unpromising vegetation.

But why does Panama have so many more kinds of trees than Maryland? Despite being much more poisonous, young Panamanian leaves are eaten far more rapidly than their temperate-zone counterparts. Pest pressure is so much more intense in Panama (and elsewhere in the tropics) than in a northern temperate forest because Panama has no winter to reduce pest populations. Unlike those on Barro Colorado, the pests of everwet forest are spared the inhibiting inconvenience of a dry season. Therefore, pest pressure is even more intense in everwet forests than in seasonal tropical forests such as Barro Colorado's, so everwet forests have even more kinds of trees. One hectare of everwet forest in Ecuador has 307 species among its 693 trees.

A tropical forest's diversity is a crucial aspect of its defense against herbivores. Does this chemical diversity suffice to defend the forest, or do tropical forests depend on predators to help control the forests' herbivores? To answer this question, we must learn something about Barro Colorado's predators.

Predators!

Tropical forests are often depicted as places where beauty and danger are present in equal measure. Sometimes the beauty itself is dangerous, as is the beauty of harpy eagles, venomous snakes such as fer-de-lances and bushmasters, and the great predatory cats. Visitors rarely see such spectacular predators on Barro Colorado, even though many of these animals live or at least occasionally appear there. Yet a multitude of smaller, more visible predators witness to "nature red in tooth and claw" and reveal that, indeed, "it's a jungle out there."

It is hard to walk on Barro Colorado without seeing spiders and the webs they make to snare prey. Praying mantises with sinister faces and deadly forearms often appear on window screens (fig. 124). Small lizards and toads of many sizes lurk on or near the forest floor, waiting to grab insects that come their way. A day's walk often reveals a swarm of army ants spreading over the ground, shredding insects that fail to escape, and pouring down into ant nests to seize the grubs. Likewise, one often happens upon one or more coatis snuffling through the leaflitter for lizards and large beetles, or digging frantically to reach a tarantula in its burrow. Crossing a tree-fall gap, one may find a robberfly or assassin bug (fig. 125) on a sunlit log or leaf, waiting for suitable prey

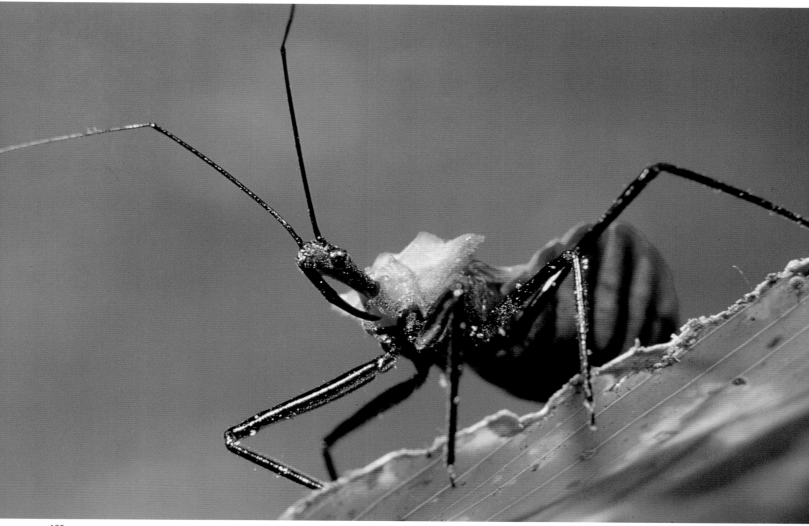

to come by. In the forest, a diffuse flock of birds of several different species may move through, ransacking the foliage for insects. Especially in the dry season, white-faced monkeys may rustle far overhead, searching the forest canopy leaf by leaf for insects big enough to eat.

For every predator we see, many others escape our attention—snakes, hunting wasps, and ant-lions waiting in ambush, predaceous ants and giant damselflies stealing prey from spiderwebs, and a multitude of others. At night, other predators come out—tarantulas, a different set of snakes (fig. 163), insect-eating opossums (figs. 156, 158) and bats (fig. 150), ant-eating frogs and toads (figs. 147, 162), and owls looking for larger prey. We may not see them, but we can see abundant evidence of the defenses they inspire.

Although visitors rarely see the largest predators, these predators have an impact out of all proportion to their visibility. Near the beginning of the year 2000, the Peregrine Fund released a female harpy eagle weighing 8 kilograms on Barro Colorado (fig. 129). With some help from others, Janeene Touchton, an intern for the fund, watched this eagle for 205 days during the following year. This eagle captured an animal of average weight 3.6 kilograms every 4.4 days. At this rate, the eagle would eat 300 kilograms of prey, nearly forty times its own weight, per year. Extrapolating from these 205 days' records, in a year this eagle would eat nine young three-toed sloths, thirty-four adult

Many assassin bugs (family Reduviidae), like the one here, eat other insects, especially caterpillars and beetles. They accordingly help restrict herbivory.

OVERLEAF: Why is the forest still green despite its multitude of herbivores? A forest's chemical defenses do not suffice to control its herbivores; the forest also needs help from the natural enemies of insect herbivores. One powerful source of such help is wasps called parasitoids, whose larvae live in, and on, the larvae or adults of other insects without killing them immediately. Many species of parasitoid are highly specialized, feeding on only a single species of prey. Moreover, some hyperparasitoids specialize in other parasitoids. Here, a hyperparasitoid wasp has just emerged from one of several white cocoons of a braconid wasp whose larvae developed in the caterpillar of a sphinx moth, on whose brown surface the cocoons are resting. (fig. 126)

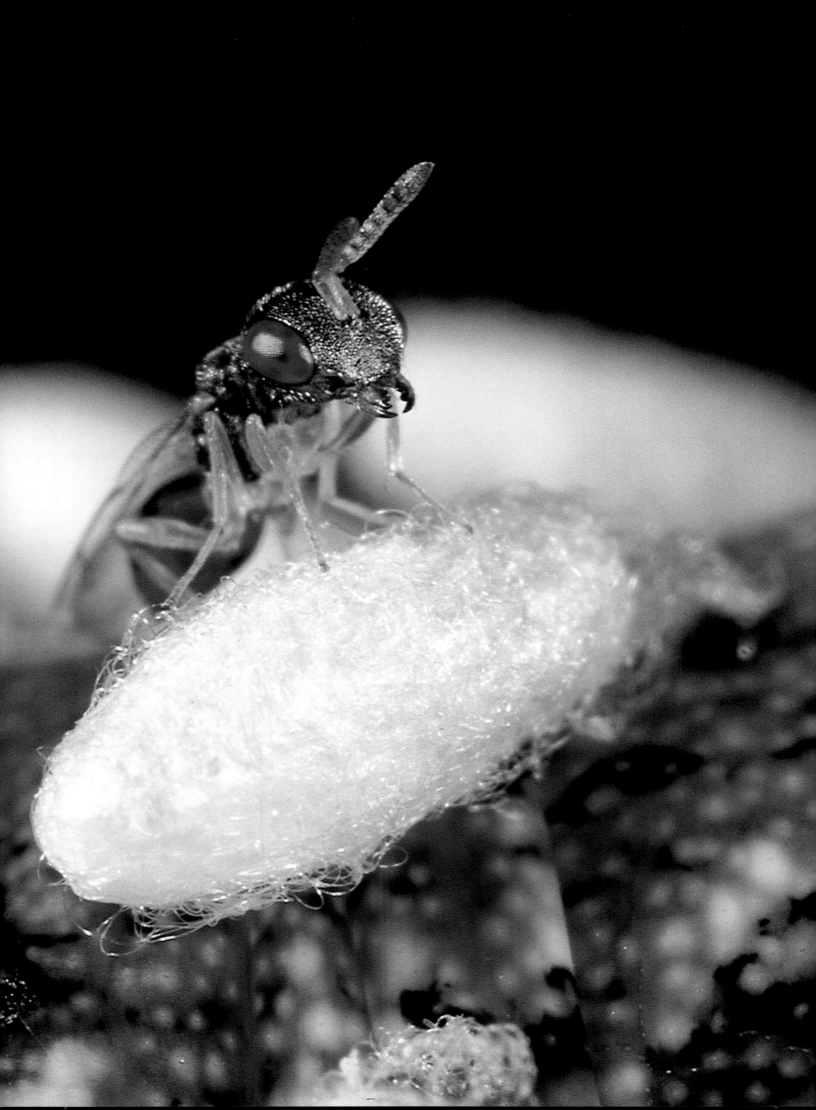

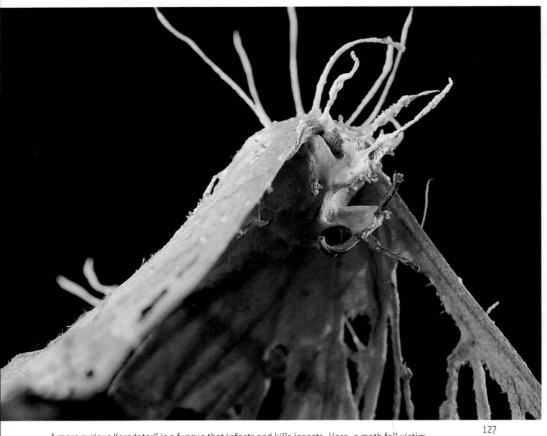

A more curious "predator" is a fungus that infects and kills insects. Here, a moth fell victim to such a fungus, which has now sprouted fruiting bodies that will broadcast spores to infect other insects.

Spiders, such as this jumping spider, are a highly diverse group of predators. They eat a huge variety of insects and even some vertebrates, using many different hunting methods.

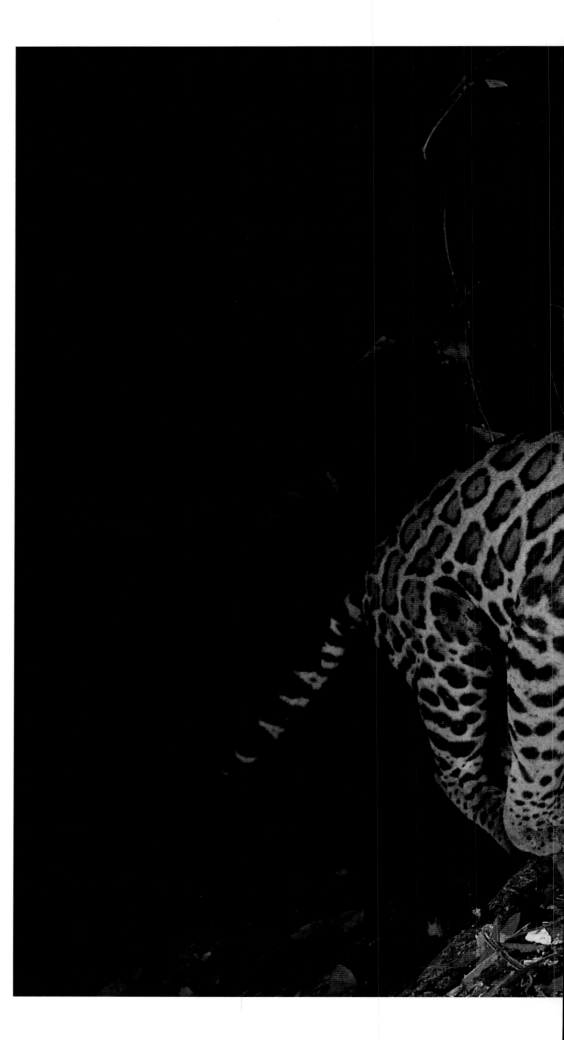

PREVIOUS PAGE: The harpy eagle, *Harpia harpyja*, considered the most powerful raptor in the world, is the largest predaceous bird in the Neotropical forest. Hunting and habitat destruction have greatly reduced this eagle's range. Surviving populations are now scattered from Panama to Brazil. Two harpy eagles have been introduced to Barro Colorado: they both flew away. This captive-bred female was the second one introduced, late in 1999; it left the island for the last time late in 2000 (fig. 129).

Except for occasional pumas and rare visits from jaguars, ocelots (*Felis pardalis*) are Barro Colorado's largest (heaviest) predators. Photographs taken by automatic cameras revealed at least twenty-one ocelots on the island in 2000, and more since. Like all large cats, ocelots are heavily hunted, and their range has been much reduced. Whether ocelots and other large cats play an essential role in protecting tropical forest from vertebrate herbivores is a much-disputed question. They are, however, an essential component of the forest's beauty and romance (fig. 130).

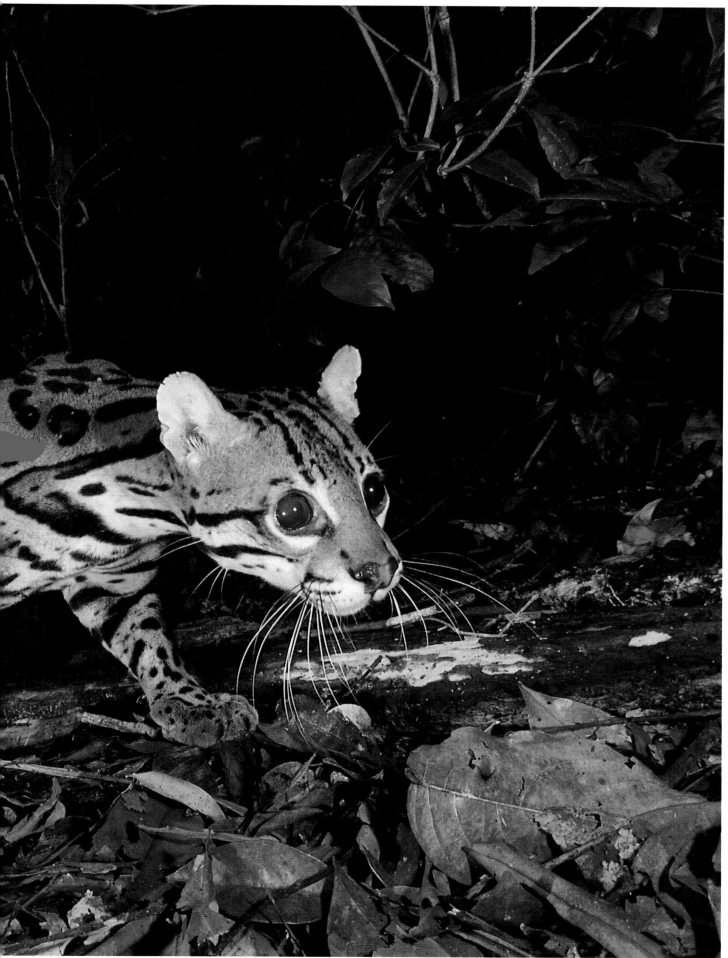

three-toed sloths, two adult two-toed sloths, four young howler monkeys, twenty adult howlers, five adult white-faced monkeys, four green iguanas, two common opossums, two coatis, and a fawn.

Even professional biologists must sometimes think twice to realize how much a big predator eats. Knowing that a pair of eagles raising young might eat three times as much as a lone female, almost a ton of prey each year, some naturalists wondered whether Barro Colorado could afford a breeding pair of harpy eagles. Nonetheless, ocelots (fig. 130) are levying a far heavier tax on Barro Colorado's mammals than a pair of harpy eagles ever would. A ten-kilogram ocelot eats about nine hundred grams of food per day—330 kilograms (a third of a ton) of prey, thirty-three times its own weight, per year. Ricardo Moreno, a student at the University of Panama, identified the contents of forty ocelot scats that he found on Barro Colorado. Judging by their contents, an ocelot's annual take includes twenty-one two-toed sloths, eighteen three-toed sloths, fifteen white-faced monkeys, and eighteen agoutis. Barro Colorado was long thought to have ten resident ocelots. Each ocelot has a unique pattern of spots on its fur, just as each of us has a unique set of fingerprints. Jacalyn Giacalone, of Montclair State University, set up automatic cameras around the island to photograph animals as they passed by. She learned that a Calvin Klein perfume, Obsession, attracts ocelots. In the few months after perfume was spread near her cameras, at least thirty different ocelots were photographed. If all these ocelots were residents, they would be eating ten tons of prey, mostly mammals, per year (the island supports only about sixty-eight tons of mammals). Some of these ocelots may be occasional commuters from the mainland. Nonetheless, the risk of becoming cat food is great enough to make many tree-dwelling mammals wary about coming down to the ground.

Avoiding Predators

The ever-present threat that predators pose reveals itself in many ways. Forest animals are wary. Many have colors designed to hide them against their backgrounds. Small understory birds and large monkeys tend to move in groups, thereby ensuring more eyes to watch for predators. Many wasps live in colonies because a lone female could not go off to look for food without exposing her nest to predators. In Europe, worker honeybees have stingers so that they can help protect their hives from animals that would steal the bees' honey and eat their grubs. In tropical Africa, honeybees face a more diverse and dangerous array of predators, so workers earn the name "killer bees" by going out in aggressive swarms to sting would-be predators. Termite nests are thick-walled fortresses staffed by soldier termites that bite or deploy chemical defenses. Some tropical caterpillars are covered with painfully stinging hairs to ward off predators. Ants and many other animals are distasteful or hard to eat.

Small animals that are dangerous or distasteful advertise these traits. The striking colors of a coral snake, the black-and-yellow livery of many wasps and

bees, the glossy black, blue, or green of others, and the threatening buzz of bees or wasps approached too closely, all warn of danger. The garish colors of many butterflies and their caterpillars, and the tendency of conspicuous caterpillars to collect in even more conspicuous groups, advertise distasteful-ness (fig. 131). The striking black and green colors of Barro Colorado's poison-dart frog, and the brighter colors of such frogs elsewhere in Panama, like the bold black of many ants, advertise both danger and distastefulness.

To help a predator that learns to avoid one to avoid the other, different species of distasteful butterfly mimic one another in the color and shape of their wings, and sometimes even in how they fly (fig. 132). A graduate student, Peng Chai, asked which of the butterflies of southwest Costa Rica's rain forest would be eaten by a jacamar, a butterfly-eating bird. He released the butter-flies one by one into the bird's cage to see which ones it would eat. This bird refused to eat the passion-vine butterflies *Heliconius cydno, H. sapho, H. erato,* and *H. melpomene.* All four of these butterfly species are common on Barro Colorado. There, the first two species are shiny blue-black with a wide white crossbar on each forewing. The two others are jet black, with a bright red crossbar on each forewing and a lemon-yellow leading edge on each hind wing. Working in Panama, the biologist Robert Srygley found that, although *cydno* is most closely related to *melpomene* and *sapho* to *erato, cydno* not only resembles, but flies like, *sapho,* whereas *melpomene* resembles, and flies like, *erato.* The latter two species coexist throughout lowland tropical South Amer-ica. As the Victorian naturalist William Bates traveled up the Amazon, he found sudden changes in the color pattern of this pair every few hundred miles. Both species changed pattern together, so the *erato* and *melpomene* that actually flew together looked alike.

Barro Colorado has many such mimicry rings. In the laboratory clearing one often sees black butterflies with a great red blotch on each hind wing. Usually, each forewing also has a bright spot, white or green. Such a butterfly may be one of several species of *Parides. Parides* are poisonous, because their caterpillars eat pipevines, *Aristolochia,* and incorporate these plants' antiher-bivore poisons into their own bodies. The butterfly could, however, be *Papilio anchisiades,* a "tail-less" swallowtail that does not defend itself with plant poisons but is nonetheless disdained by Peng Chai's jacamar.

Not every advertisement of foul taste or imminent danger is truthful. Harmless flies and edible lacewings seek protection by being colored like, and sometimes buzzing like, stinging bees and wasps. When they have just emerged from their well-insulated nest, made of a natural analogue of styrofoam, many tropical man-tids and peanutheads (odd-looking relatives of cicadas) are colored black like lit-tle ants, and run about in a most repulsively antlike fashion (fig. 133). When touched, many moths, adult peanutheads (fig. 134), and other insects flash their hind wings, revealing the likeness of a pair of glaring owl-eyes. This sight startles some birds just long enough to allow the prey to escape. One forest-floor butterfly, the glasswing satyr, has clear wings, the better to remain unseen, but there is a touch of red on the hind wings so that someone seeing movement focuses on a red spot that looks like a noxious red bug hovering over the ground (fig. 136).

OVERLEAF: Many animals deter would-be predators by being poisonous, distasteful, or dangerous. Such animals advertise their unpleasantness to predators by conspicuous "warning colors," as does this saddle-back caterpillar, defended by poisonous spines (fig. 131).

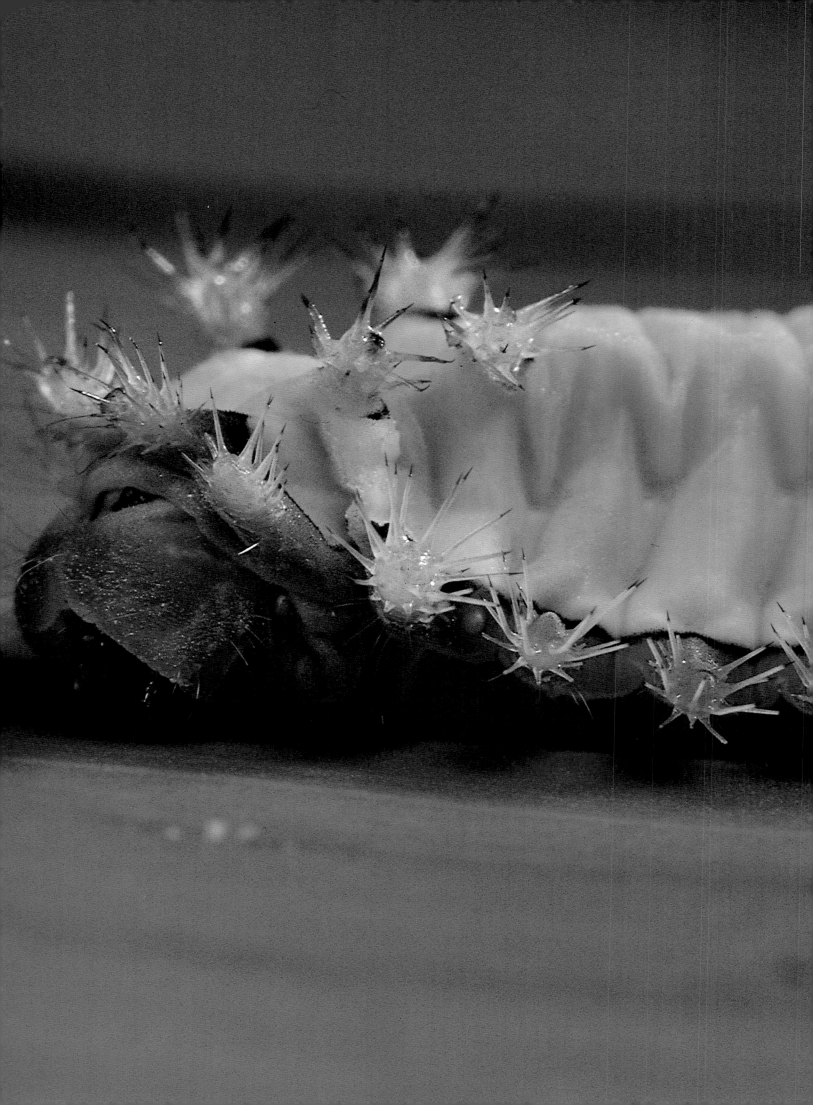

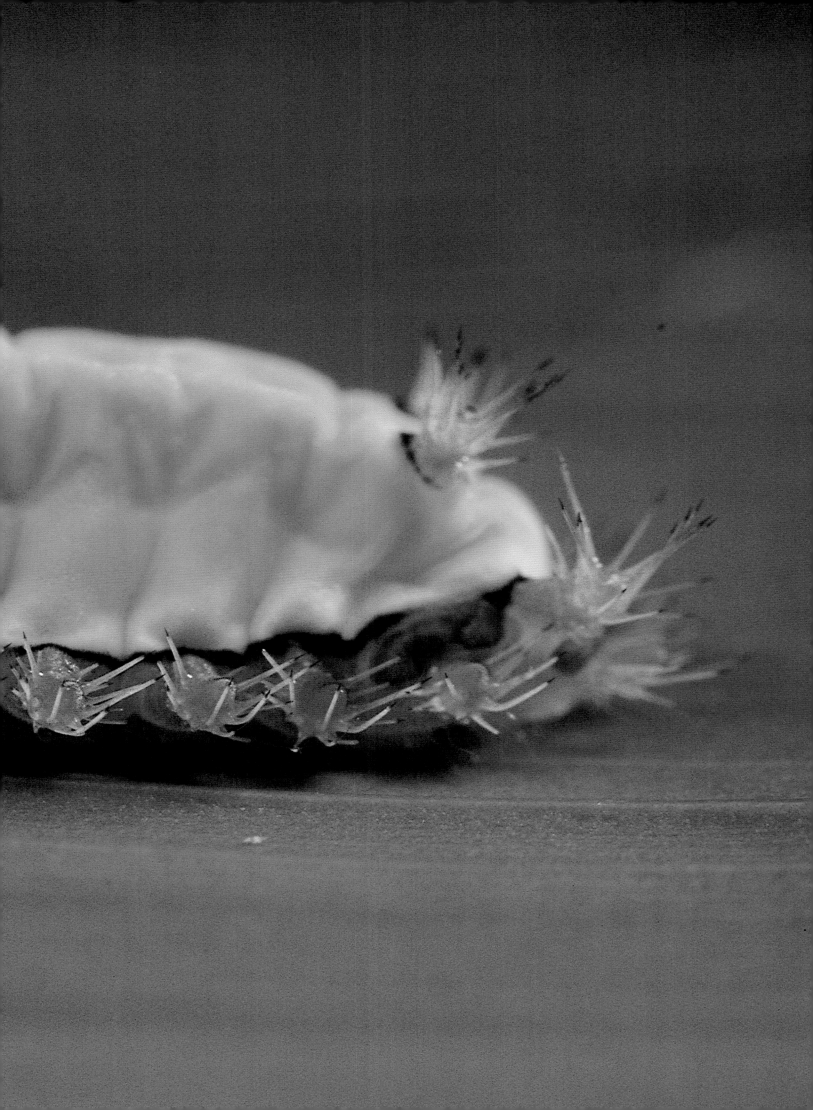

Edible butterflies try to pass themselves off as poisonous by resembling poisonous ones. On Barro Colorado, the milkweed butterfly *Lycorea cleobaea* (fig. 132), related to the monarch, and the ithomiine *Mechanitis polymnia* (fig. 132), jointly advertise their distastefulness by dark orange wings with black bars perpendicular to the body. The tips of their forewings are black speckled with yellow. The much tastier *Dismorphia amphiona* is colored very like *Lycorea cleobaea,* even though *Dismorphia* belongs to the family of sulphurs and cabbage whites familiar in the temperate zone. A mimicry ring composed primarily of small, distasteful butterflies with transparent wings edged with black and white includes a tastier species of *Dismorphia,* the only member of the cabbage white family in Panama with transparent, clear wings. Falsely advertising distastefulness by mimicking poisonous models hurts the models by diminishing the reliability of their wings' message. If such mimics become too common, the models' color pattern no longer protects them.

Another form of false advertising is to look like something predators would never eat, such as a stick or a dead leaf (figs. 137-41). On Barro Colorado, Michael Robinson studied what body parts different animals try to disguise or hide to learn what a predator looks for. Walking sticks are famous for looking like sticks (figs. 137, 138). They go to great lengths to disguise legs, head, and antennae. Robinson found that these appendages attracted the immediate attention of a caged monkey when it was looking for food.

Disguises can be burdensome. Sticks cannot walk, but sometimes walking sticks must walk. Most walking sticks solve the problem by eating at night. When they move by day, they adopt a slow, swaying gait, a bit like a leaf slowly moving in a breeze. Moreover, walking sticks of the same kind cannot be too close together, lest a predator, happening upon one, choose to test all the nearby sticks of the same size. To escape being eaten, common animals must diversify their disguises.

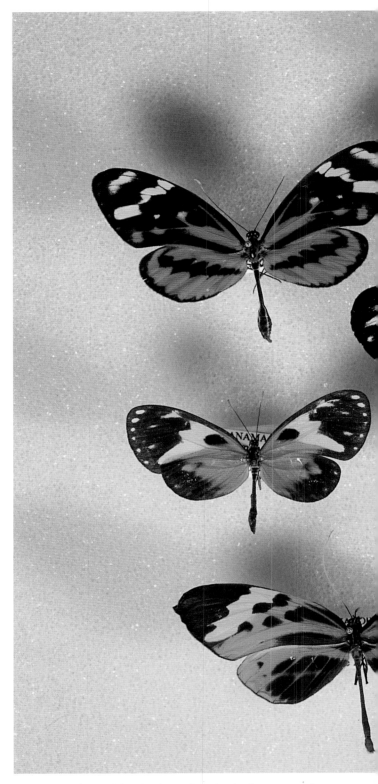

Predators do attack brightly colored prey of species they have not tasted before. Once a brightly colored, distasteful animal has become common enough so that most predators have learned to avoid it, other unpleasant species may imitate this model's color and shape to benefit from predators' familiarity with its distastefulness. In this "Mullerian mimicry," several species assume similar warning colors, unconsciously cooperating to simplify their would-be predators' education and reduce the number of deaths

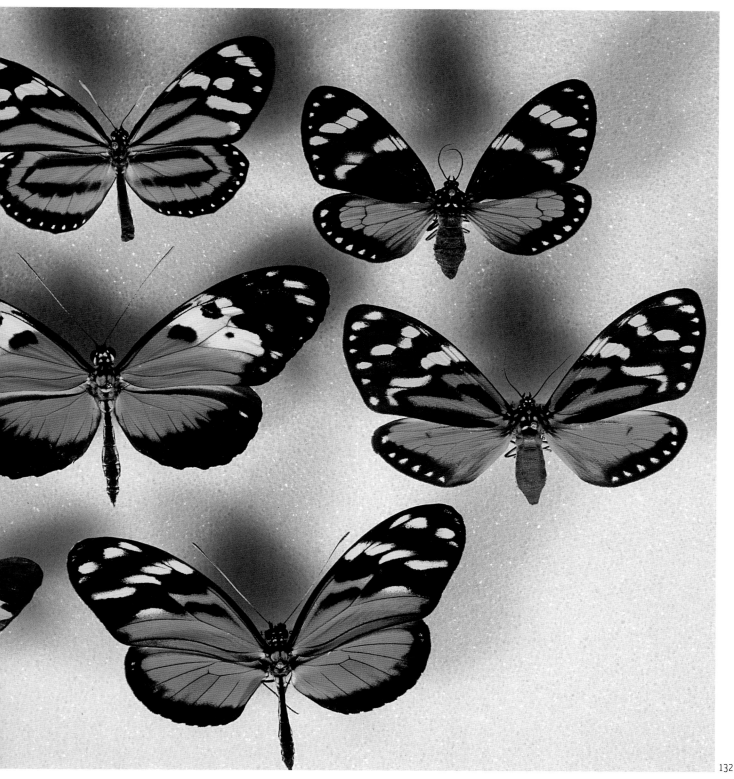

needed to teach predators that they are all distasteful. Other, palatable species also try to escape being eaten by mimicking these warning colors. In effect, these "Batesian mimics" parasitize their models' warning colors. Thus, in the United States, a variety of harmless flies mimics the black and yellow patterns of "yellow jacket" wasps. These six species of butterfly and two species of moth, all of which are distasteful, share a basic color pattern. At the top, from left to right, are the butterflies *Mechanitis polymnia isth-mia* and *Lycorea cleobaea,* which are close mimics, and the arctiid moth *Chetone* sp. In the middle row are two butterflies, *Hypothyris lycaste* and *Heliconius hecale,* which are close mimics, and another arctiid month, *Chetone angulosa.* In the bottom row are the butterflies *Melinaea menophilus* (which lives in Ecuador) and *Heliconius ismenius clarescens,* a close mimic of *Heliconius hecale. Lycorea* belongs to one subfamily, the *Heliconius* to another, and the other three butterflies to a third.

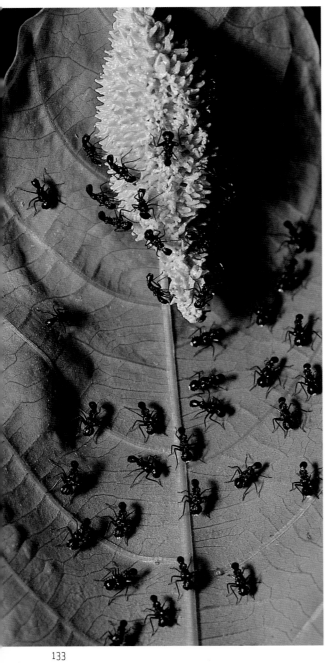

133

134

OPPOSITE PAGE, LEFT: Tasty mimics mimic the behavior as well as the shape and color of their models. Freshly hatched peanutheads, *Fulgora laternaria,* stay in a group close to their empty foam egg case for a few days after they hatch. They look like ants and, when disturbed, they move about in a very antlike way, deterring the many potential predators that dislike ants (fig. 133).

OPPOSITE PAGE, RIGHT: Animals often judge an opponent's size by its eyes; thus, appropriately placed mock eyes send a deceptively scary message. When startled by a potential predator, an animal can gain precious seconds for escape by suddenly displaying a frightening pair of eyes. Here is a cryptically colored peanuthead, *Fulgora laternaria,* an oddly shaped relative of cicadas, with eye spots on its wings (fig. 134).

OVERLEAF: Many butterflies and some other insects use a deceptive trick to escape predators. They fly showing brightly colored wings, and the predator follows the bright colors. When the prey lands, however, the bright colors are folded under or otherwise hidden; the resting insect blends into the background. The predator has no idea what happened to its brightly colored prey. The glasswing butterfly, *Cithaerias menander,* has wings that are transparent except for a red wash on the tips of the hind wings. When the butterfly is flying, it looks like a flying red bug, but if it alights in shade it vanishes (fig. 136).

BELOW: Eyes of a tropical screech owl (*Otus choliba*).

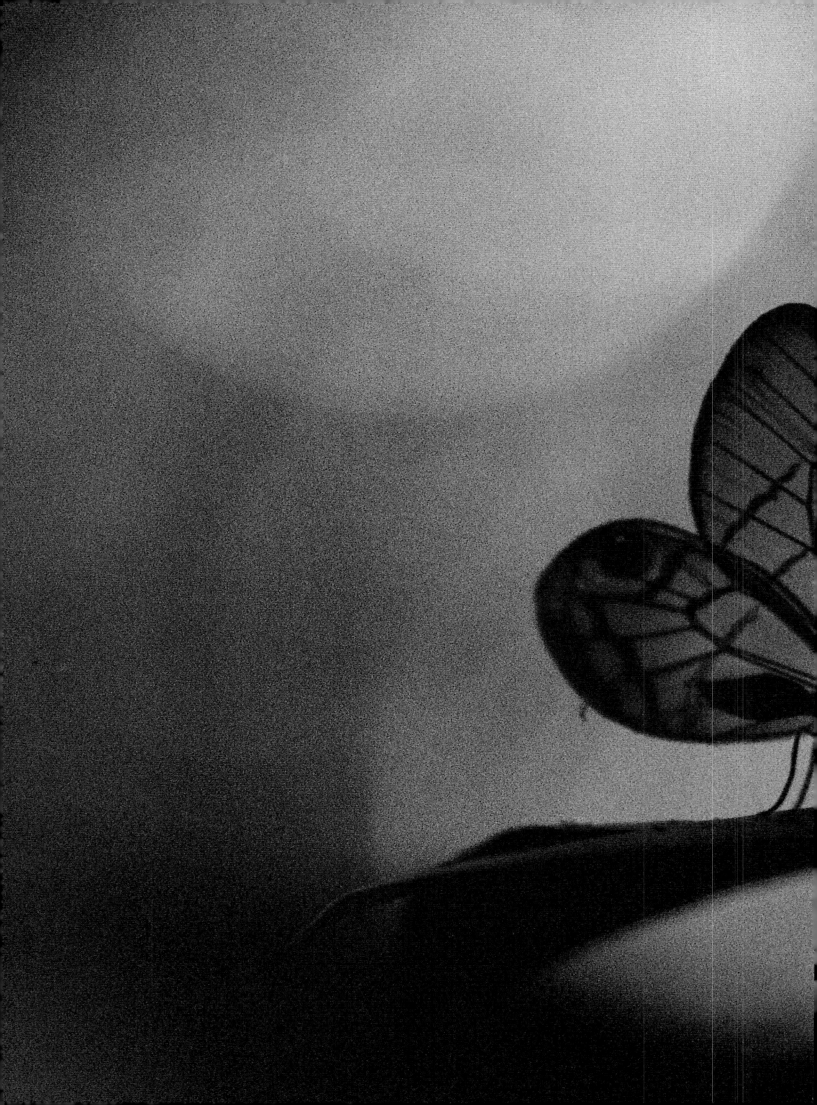

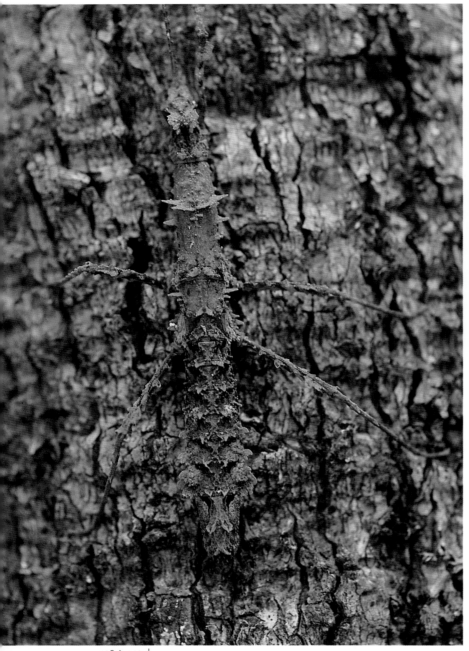

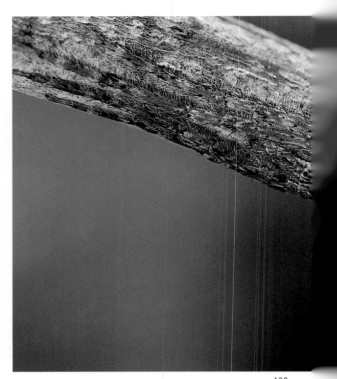

Animals can avoid being eaten by looking like something inedible, such as a stick, or by blending into the background. Walking sticks (figs. 137, 138) are masters of camouflage, as are many other arthropods such as spiders (figs. 128, 139) and katydids (fig. 142).

PREVIOUS PAGE: Walking stick *(Bacteria ploiaria)* (fig. 137).

LEFT: A mossy walking stick *(Autolyca* sp.) (fig. 138); **ABOVE:** a camouflaged spider on a branch (fig. 139); and **ABOVE, RIGHT:** taking off (fig. 141); **BELOW:** A distasteful butterfly, *Helico- nius sara fulgidus,* in the wild (fig. 140); **BOTTOM RIGHT:** Katy- dids of the genus *Mimetica* mimic leaves with small patches of fungus damage (fig. 142).

138 ↑ 140 ↓

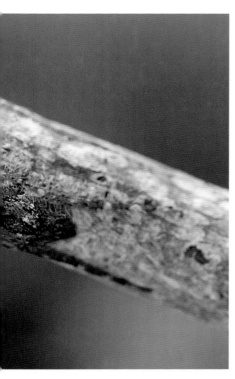
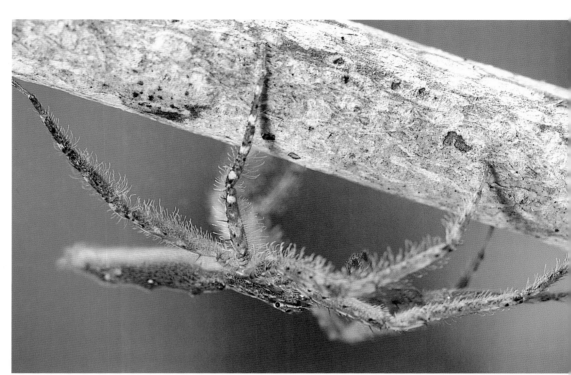

Bufo typhonius, toads that are common on the forest floor at Barro Colorado, look from above like dead, fallen leaves (figs. 143–47). Each dead-leaf mimic, however, differs from the others in color, patterning, and the degree to which the midrib stands out.

Other animals try to blend with their backgrounds and look as if nothing is there. The peanuthead lantern-fly (fig. 134) is colored to blend in with the bark of the guapinol tree, whose sap it sucks. Morpho butterflies, which are a dazzling iridescent blue when flying, look like part of the leafy forest floor when at rest. The lengths to which some animals go to match their backgrounds are among the wonders of tropical natural history. The variety of ways animals deter predators or escape their attention emphasizes the ever-present threat of being eaten.

What Difference Do Predators Make?

Predation is an ever-present danger for most forest animals. Does a tropical forest need predators to help control its herbivores?

Northern forests need wolves and mountain lions to protect them against moose and deer. Now that this protection is gone, their tree species composition is changing inexorably. A multitude of students seeking doctorates have studied the various vertebrate herbivores of Barro Colorado—its squirrels and white-faced monkeys, agoutis, coatis and howler monkeys, seed-eating spiny rats, fruit-eating manakins and fig-eating bats, leaf-eating sloths and iguanas. The students found that the populations of all these herbivores are limited by seasonal shortages of fruit and new leaves. True, predators or parasites often apply the coup de grâce to animals under stress from seasonal shortages of food. When fruit and new leaves are scarce, ocelots finish off young agoutis that must take risks to find food, and botflies and screwworms finish off undernourished howlers (fig. 148). Nonetheless, unlike forests of the north temperate zone, Barro Colorado's forest appears to be able to protect itself from vertebrates without help from big cats or other superpredators.

A tropical forest, however, does need animals to help protect it from insect pests. Phyllis Coley observed that some poorly defended plants of light gaps "outgrow" their pests. What keeps the pests from becoming common enough to block these plants' growth? Coley found that many defensive chemicals do not kill caterpillars; instead, the chemicals slow down the caterpillars' feeding rate and lengthen the time they require to attain adulthood. Why should they do that, unless slower maturation makes it more likely that the caterpillar will be eaten? Coley's assistants have found, moreover, that the death rate of caterpillars from wasps and other predators is quite high.

That tropical forests cannot control insect herbivores unaided is shown most clearly by one-hectare islets recently cut off from the Venezuelan mainland by the rising waters of a reservoir, Lake Guri. John Terborgh and his collaborators discovered that leaf-cutter ants have exploded on these islets. Some islets have five or six colonies in a hectare. These ants severely restrict

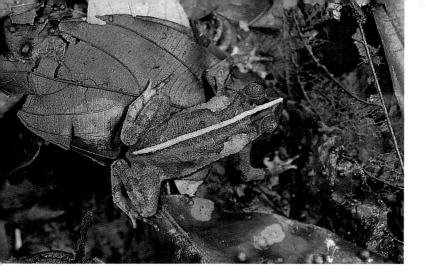

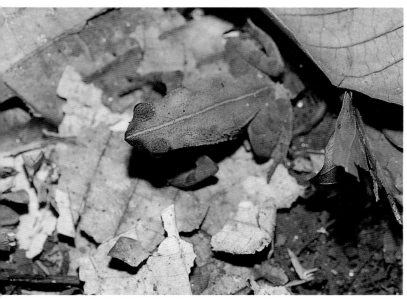

Vertebrates also escape predators by camouflage. The small leaf-backed toad of the forest floor, *Bufo typhonius*, is a master of camouflage. Individuals of this species have different patterns. Each is hard to see unless the toad moves. Moreover, no one "search image" suffices to detect toads of all designs. **TOP TO BOTTOM:** *Bufo typhonius*, design 1 to 4 (figs. 143–146). **OVERLEAF:** *Bufo typhonius*, two individuals (fig. 147).

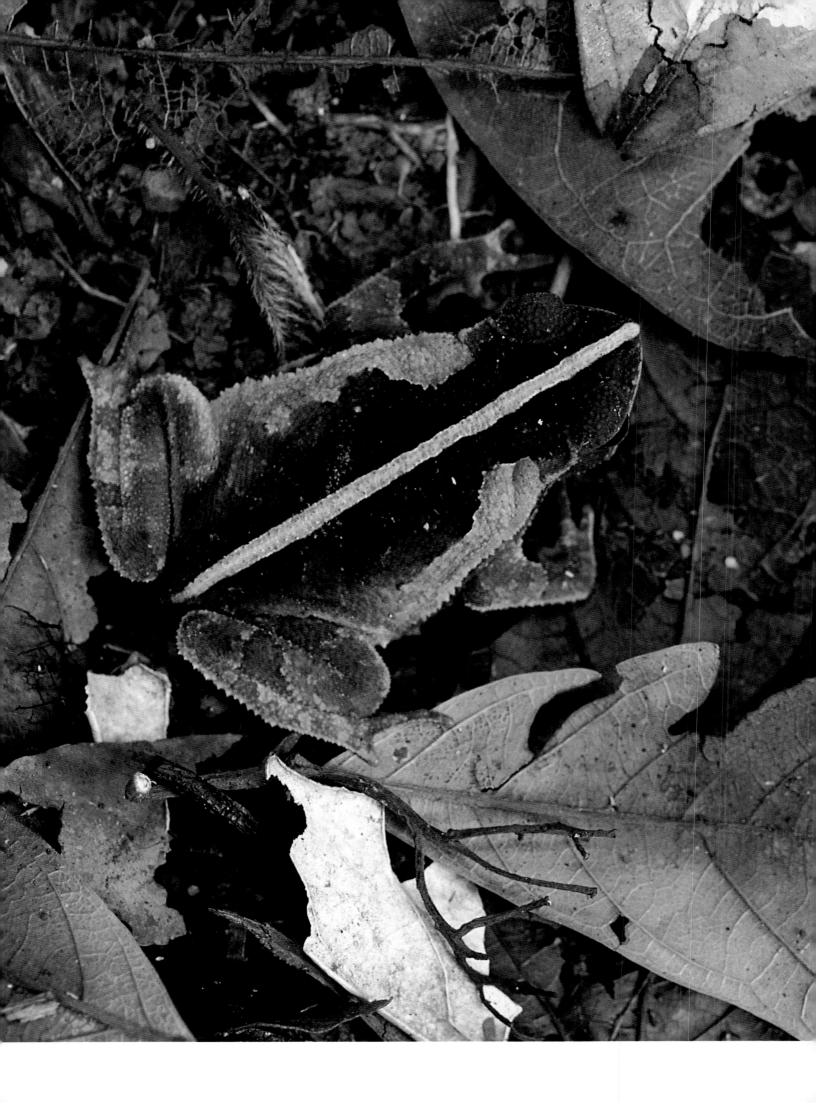

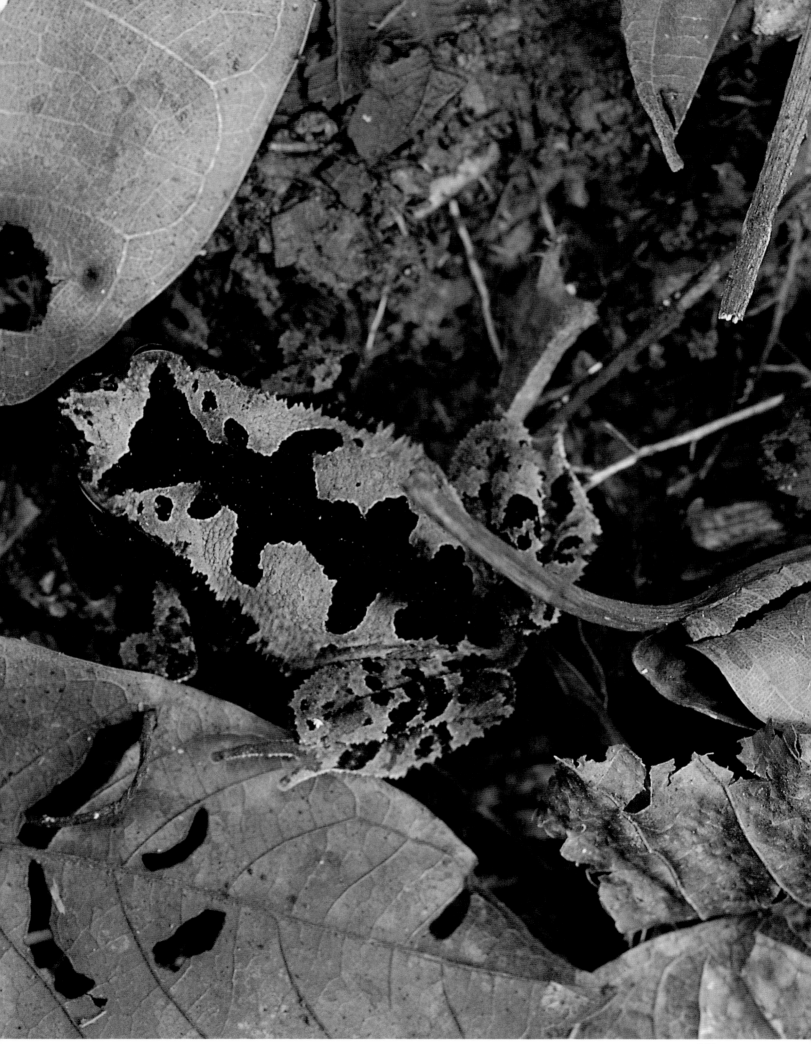

Populations of animals with few predators are limited by seasonal shortages of food. During this season of shortage, they may be vulnerable to disease or parasites. On Barro Colorado, howler monkeys *(Alouatta palliatta)*, which have few predators, are heavily infested by a specialized botfly, *Alouattamyia baeri*. Although the botflies don't kill the monkeys, they render the monkeys more vulnerable to infestation by screwworms, which is fatal. The monkey pictured has many swellings on its neck produced by botfly larvae.

the number and diversity of seedlings sprouting on their islets. Although the mainland offers a steadier, more abundant food supply, leaf-cutter ants are a hundred times less dense there. Some predator that quickly disappeared from the islands must be controlling the mainland populations of leaf-cutter ants. Terborgh's result was a shock; people had thought that leaf-cutter ants, like howler monkeys, were limited by seasonal shortages of new leaves. Other evidence is being assembled, however, that tropical forests need the help of birds, spiders, and wasps to avoid being devoured by insects.

148

 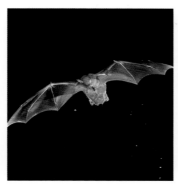 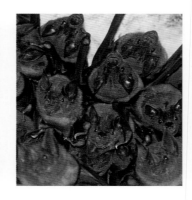 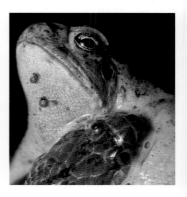

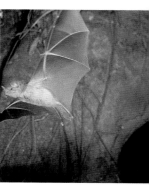

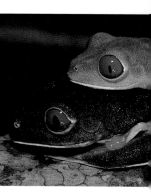

4 Animals

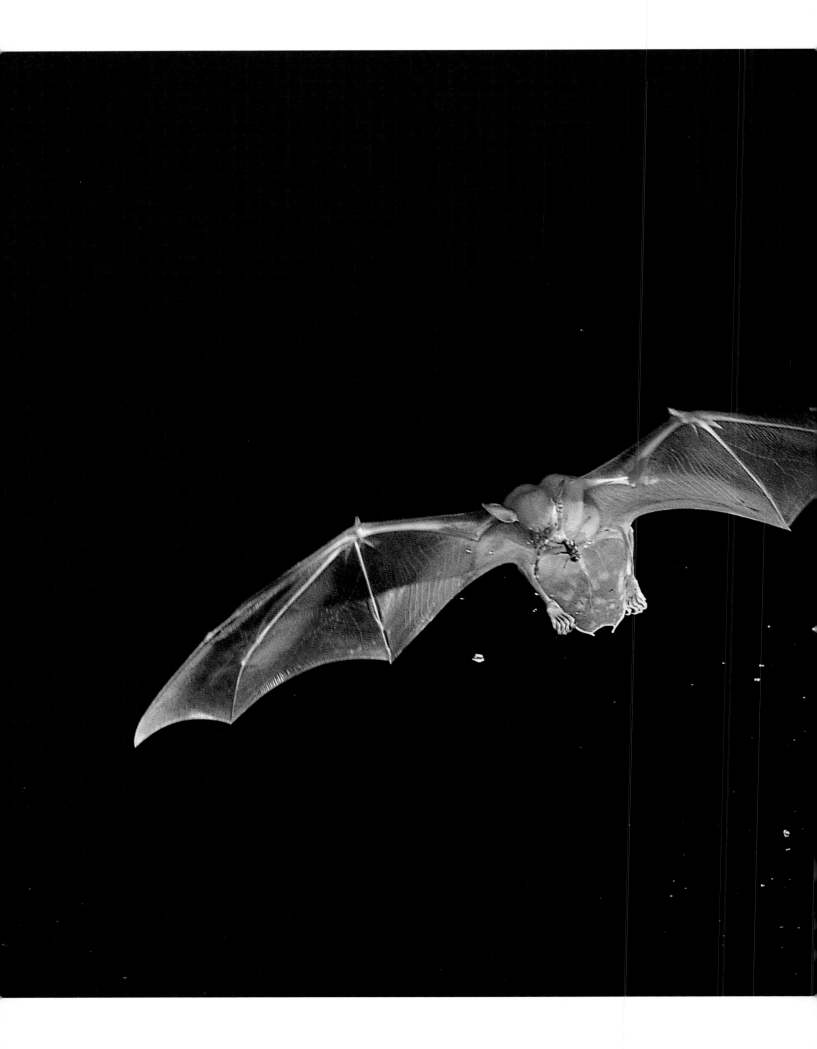

Why Diversify?

Why are there so many kinds of animals? There are so many occupations for human beings because someone experienced in and equipped for a particular task can do it many times more quickly than a person who must deal with many different tasks. Adam Smith begins his *Inquiry into the Nature and Causes of the Wealth of Nations* by showing how division of labor increases the production of wealth. His first example demonstrates that a general blacksmith makes fewer than twenty pins in a day if he does nothing else, while a properly equipped factory with ten workers, each specialized for a different aspect of the task, can produce forty-eight hundred pins per worker in a day.

To be able to do all things well, a human being must have the knowledge, equipment, and experience for each occupation. Human beings are not distinguished for omniscience (least of all those who claim it). As the sum of human knowledge increases, so does the number of different specialties people practice. To be competitive enough to hold good jobs, academics must know their subjects as well as anyone, a circumstance that sometimes limits the range of their subjects in dangerous ways. Outside academia, skill also presupposes experience, and the capacity to do a job well may also demand appropriate equipment. Life is not long enough for us to acquire the experience, or the resources for securing the equipment, needed to do all things well. Thus division of labor is necessary at all levels of a complex society.

Similarly, there are so many kinds of animals because no one animal can do all things well. Like plants, animals face trade-offs. Animals that live on a diet of mature leaves are ill suited to catch, or to digest, animal prey, so forests contain both leaf-eating herbivores and predators. An insect that can derive nourishment or protection

One bat with highly specialized feeding habits is the fishing bat, *Noctilio leporinus*. This bat uses its feet to collect insects fluttering on the surface of the lake surrounding Barro Colorado Island.

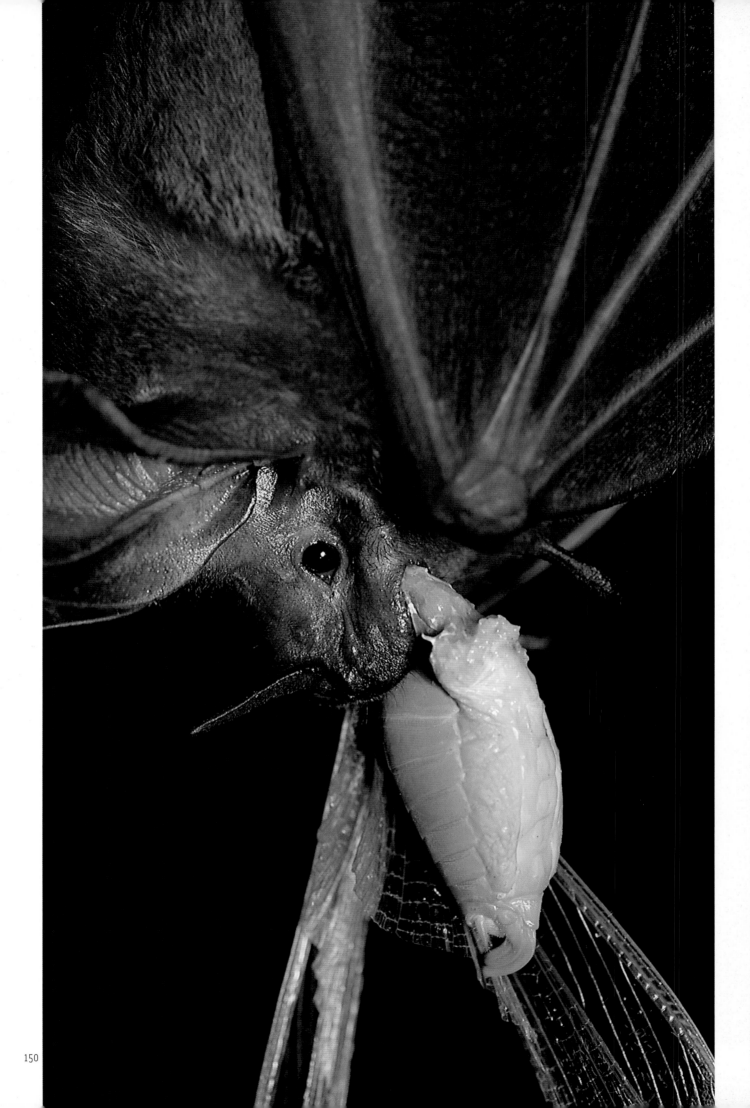

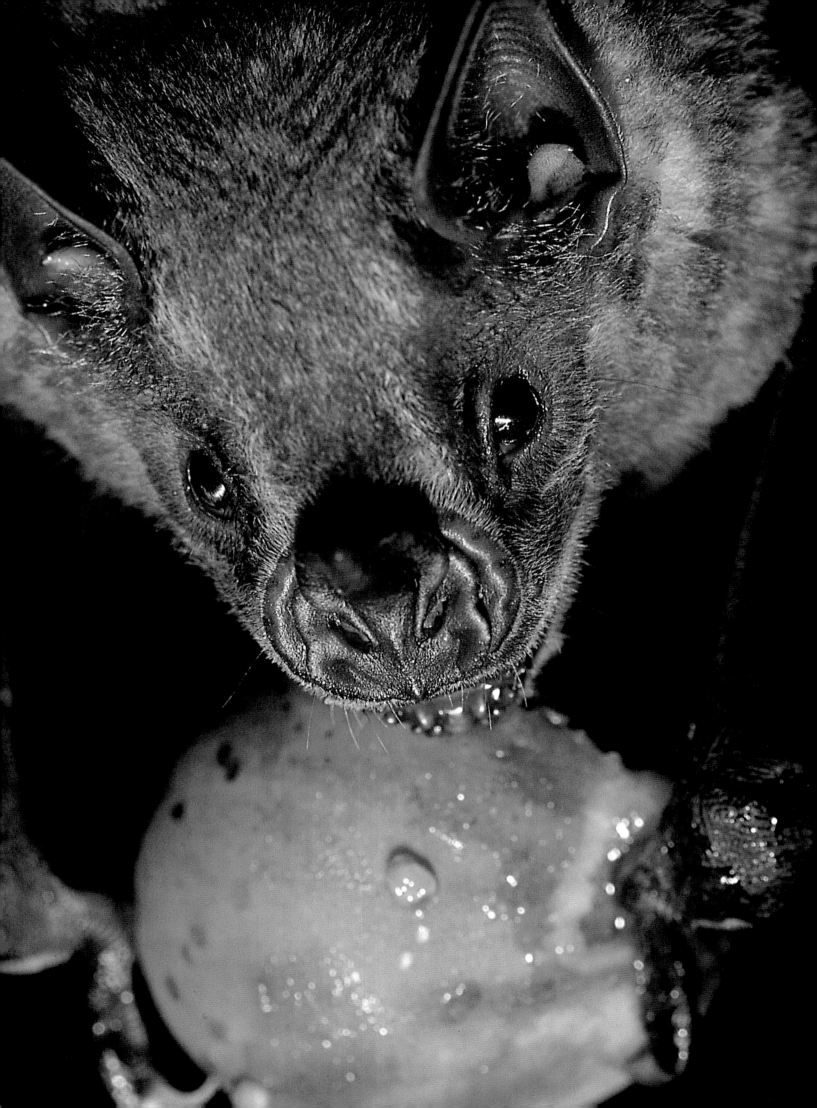

from one plant's poisons cannot parry, much less use, the poisons derived from other plants, so forests harbor an enormous diversity of herbivorous insects. Good fliers are poor walkers, and vice versa; bats, perhaps the forest's best fliers, can hardly walk at all. Therefore a forest contains both flying and walking birds, flying bats, and walking mammals. Animals adapted to kill deer cannot live on midges, while a spider that lives by snaring midges in its web cannot possibly handle a deer. Therefore predators come in many sizes.

Other trade-offs are more subtle. A graduate student from the University of California at Los Angeles working on Barro Colorado, Todd Shelly, found that the physiology that makes a robberfly more effective in light gaps by allowing quick takeoffs and speedy, maneuverable flight once it has warmed up in the sunlight makes it excessively torpid in shady habitats where it cannot stay warm enough. Thus some kinds of robberflies haunt light gaps, while others live in shady places.

A graduate student from Holland's University of Leyden, Jan Sevenster, found a curious trade-off among the fruit flies, *Drosophila,* that live on the fallen fruit rotting on the forest floor on Barro Colorado. These flies must find fallen fruit to lay eggs on, for their larvae can grow only in such fruit. When fruit, and fruit flies, are abundant, those flies do best whose larvae grow quickest and emerge before their competitors can devour their fruit. When fruit is rare, the mother flies that live longest have the best chance of finding fruit on which to lay eggs. As the longest-lived adult flies have the slowest-growing larvae and vice versa, these fruit flies face a trade-off between the competitiveness of their larvae and the longevity of their adults; the species that do best where fruit is abundant do worst where it is rare. As the abundance of fruit varies markedly from season to season and from place to place, this trade-off, like the trade-off plants face between growing fast in high light and surviving in shade, allows several species to coexist.

Wibke Thies, a graduate student from the University of Tübingen, found that fruit-eating bats face a trade-off between feeding on evenly scattered fruit and ranging more widely in search of richer fruit sources. Barro Colorado has two common kinds of bat that live mainly on fruits of the understory shrub *Piper.* She found that their populations were limited by seasonal shortages of food; during the season of fruit shortage, they ate nearly all the available *Piper* fruits as soon as they ripened. Thies placed small radios on these bats to track their movements. She found that the larger species, the twenty-gram *Carollia perspicillata,* ranged farther and fed at two or three different sites such as old tree-fall gaps where suitable fruit was abundant, while the smaller *Carollia castanea,* which weighs thirteen grams, fed mainly on the scattered fruit in a single tract of forest understory. A greater proportion of the larger bat's fruit was taken from plants other than *Piper,* but the large bat fed on a smaller number of *Piper* species. Their differing habits and abilities prevent either species from replacing the other.

Neotropical bats navigate by echolocation (locating obstacles by the echoes from their own calls), as night fighters navigate by the echoes from their radars. Bats that hawk flying insects also find their prey by echolocation. A postdoctoral fellow at the University of Tübingen, Elisabeth Kalko, came to

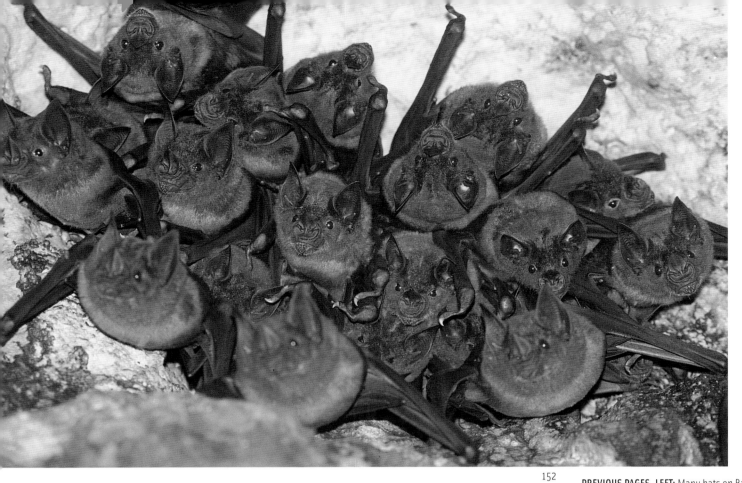

152

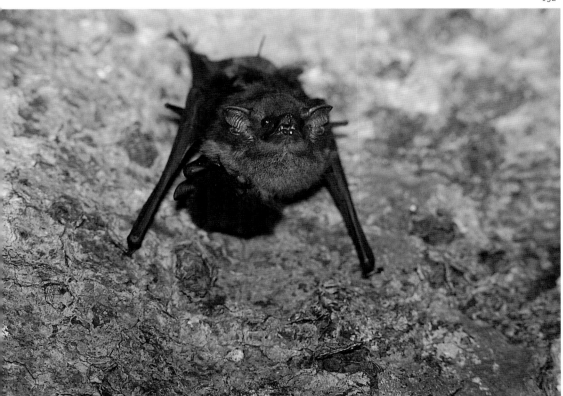

153

PREVIOUS PAGES, LEFT: Many bats on Barro Colorado feed on insects. Some hawk insects flying above the canopy, or in the understory; others glean insects from vegetation. Here, a bat that gleans insects from understory foliage, *Tonatia silvicola,* is eating a katydid (fig. 150). RIGHT: Another major guild of bats eats fruit. *Artibeus jamaicensis,* the common fruit bat, is the most common bat on the island. Here, one eats a fig (fig. 151).

ABOVE: For geological reasons, Barro Colorado has few caves. Where there are caves, some bats will roost in them. In this limestone cave at Bocas del Toro, a group of greater spear-nosed bats, *Phyllostomus hastatus,* has found a safe roost.

LEFT: Some bats roost between the buttresses of a giant tree, such as this female *Saccopteryx leptura* with a baby.

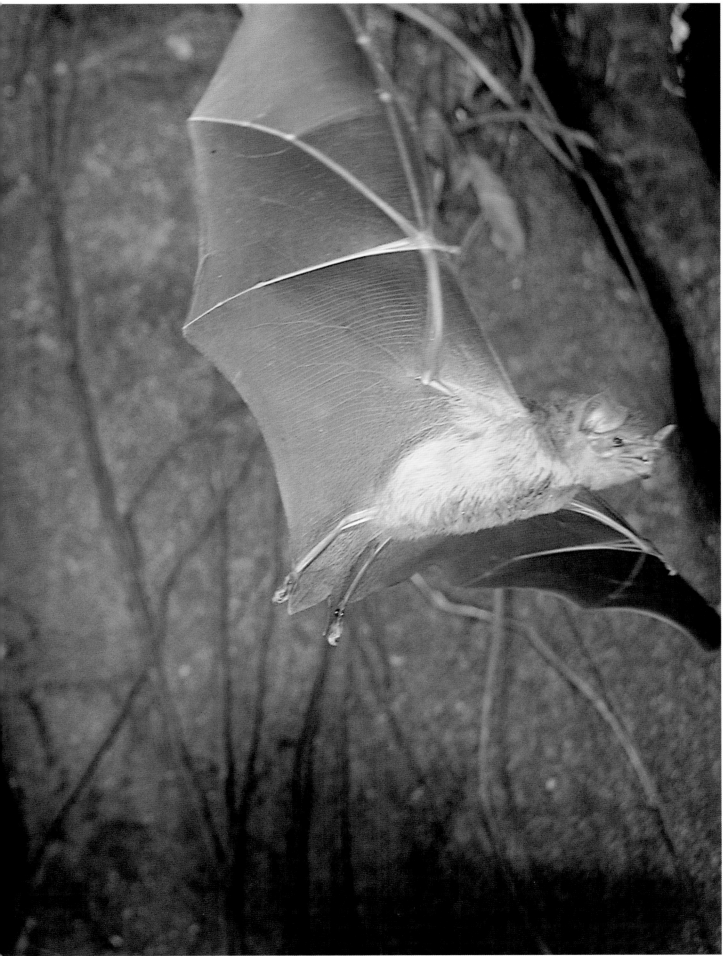

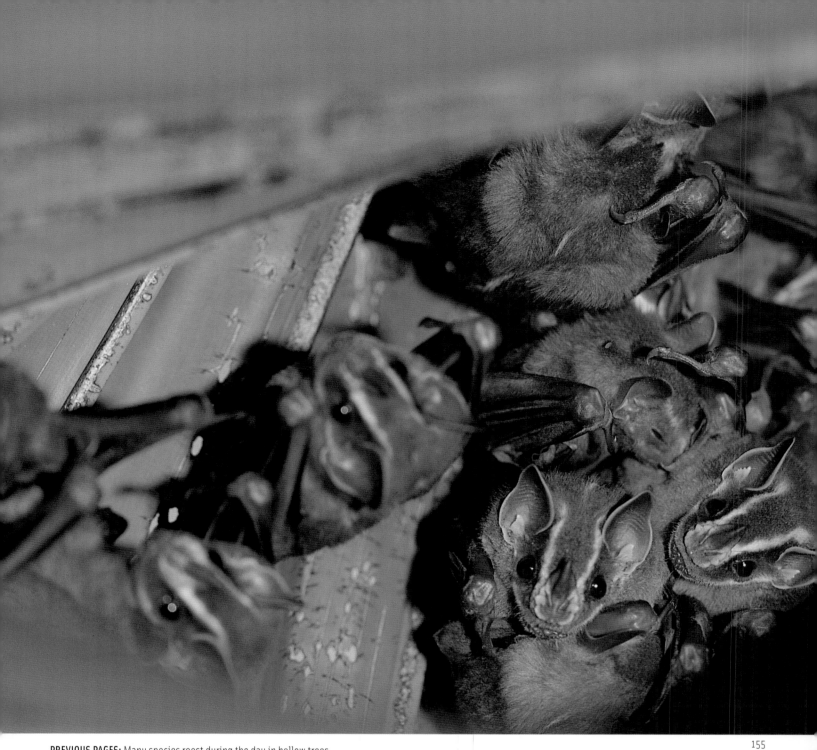

PREVIOUS PAGES: Many species roost during the day in hollow trees—living trees and fallen dead ones. This tree is home to more than five hundred bats of at least three different species. The bat flying out of the hole at the bottom of the tree is *Lampronycteris brachyotis,* a medium-sized insect-eating species (fig. 154).

ABOVE: One group of fruit-eating bats constructs its own shelters. Tent-making bats make incisions in large leaves of heliconias, bananas, palms, and the like, causing them to flop in such a way as to form tents. This huge palm leaf has been transformed into a suitable tent for a large group of the fruit-eating bat *Uroderma bilobatum.*

RIGHT: The woolly oposssum, *Caluromys derbianus,* is one of Barro Colorado's six species of opossum. This one is climbing in a fruiting tree at night.

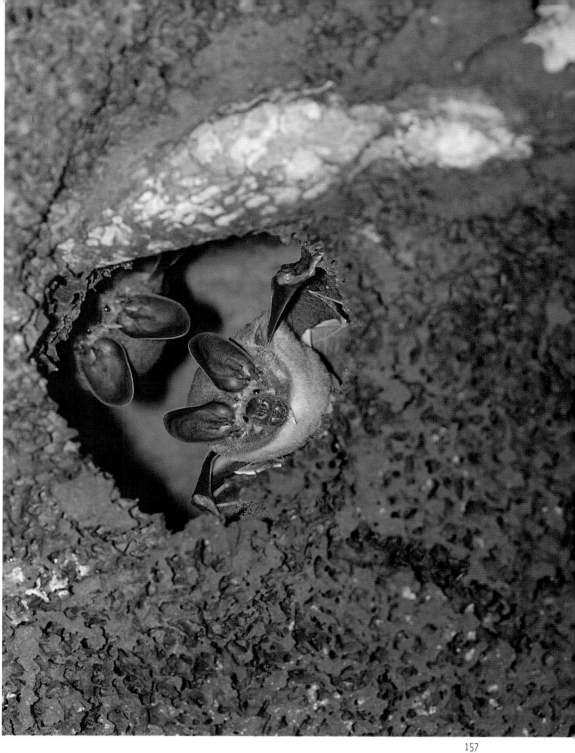

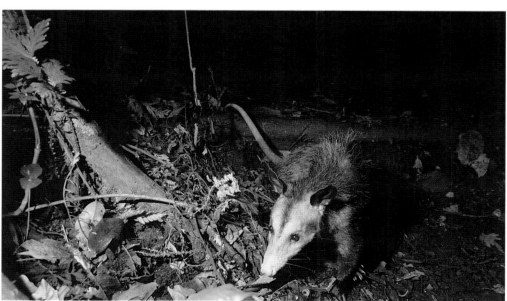

ABOVE: The white-throated round-eared bat, *Tonatia silvicola,* has unusual roosting habits. Bats of this species carve big cavities in arboreal termite nests to make their roosts. Somehow, the bats can carve a niche in a tough termite nest without killing the termite colony or being attacked by the termites.

LEFT: The common opossum, *Didelphis marsupialis,* is usually abundant on the island. It is often seen under fruiting trees.

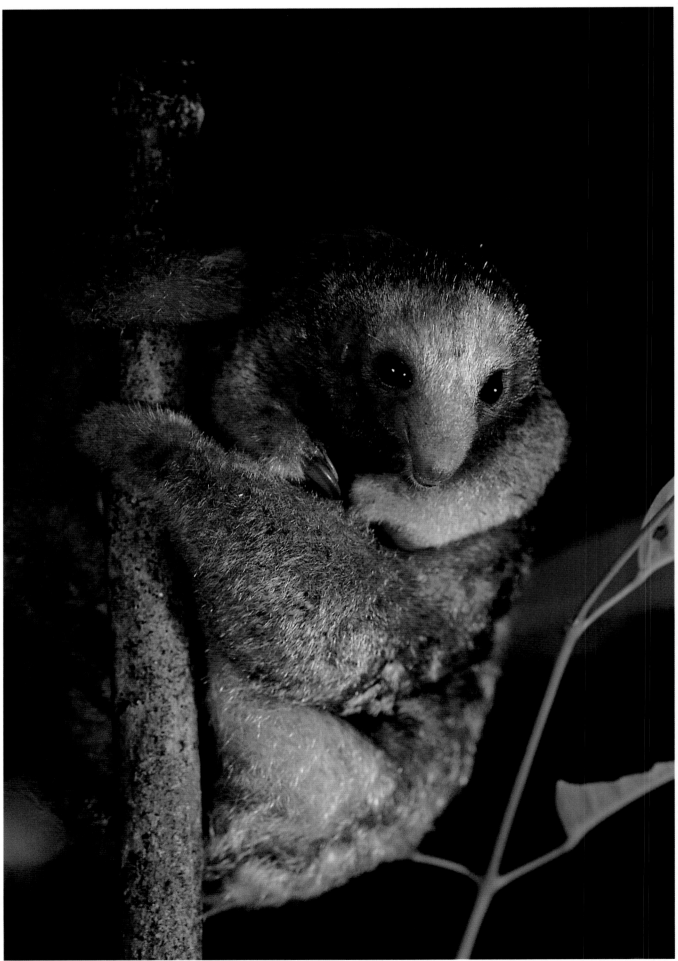

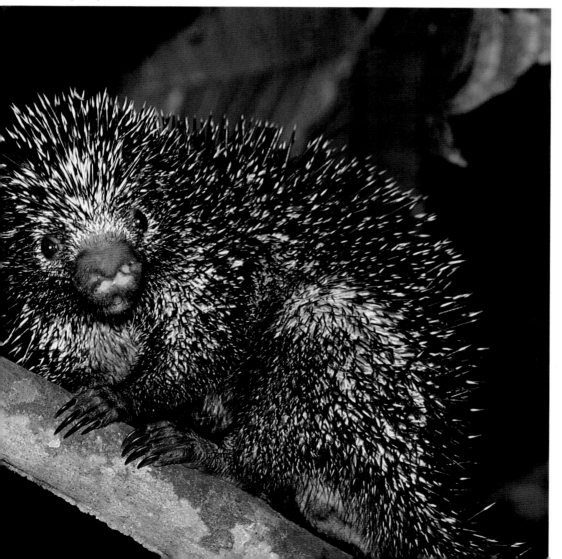

OPPOSITE PAGE: The silky anteater *(Cyclopes didactylus)* has a highly specialized diet consisting of ants nesting in or on twigs (fig. 159).

ABOVE: A rarely seen but interesting nocturnal animal is the kinkajou, *Potos flavus.* Although it belongs to the order Carnivora, it eats hardly anything but fruit. Here, two kinkajous are grooming each other.

LEFT: Another rare sight is the tree porcupine, *Coendou mexicanus,* a nocturnal mammal that lives in the canopy, eating seeds, fruit, and leaves.

Barro Colorado to explore trade-offs between the echolocation calls that work best in different habitats. To learn how bats catch flying insects, Elisabeth rigged a pair of cameras with flashes that fired in rapid sequence while the shutters stayed open. To learn what echolocation calls a bat uses while finding and catching prey, she synchronized the flashes with a tape recording of the photographed bat's echolocation calls. She found that the bats flying above the canopy that use calls to detect insects at long range would be confused by echoes from vegetation were the insects near, say, a tree's crown. Bats looking for insects flying close to foliage need to use other calls. Echolocation usually detects insects in or on foliage only if the insects are fluttering, but different calls are needed for this job. Therefore, one guild of bat species hawks insects above the canopy, another guild hawks insects flying near vegetation, an additional bat species hawks moths fluttering in the vegetation, and another, the fishing bat, skims above the water in search of floating, fluttering insects (fig. 149).

Animals that are active at night need safe, convenient places to sleep during the day. Many bats sleep in caves, where the temperature is stable and never too hot (fig. 152). This habit spares them the high respiration associated with high daytime temperatures. Some forests, however, including Barro Colorado's, lack large caves, and cave-dwelling bats are, at best, rare commuters to Barro Colorado. On that island, many bats sleep in hollow trees; a hollow tree may contain five hundred bats of several different species (fig. 154). Others sleep hidden in dense foliage; yet others make cuts in large leaves so that the leaves flop over to form tents (fig. 155). Some bats sleep in holes that they have dug in active termite nests (fig. 157).

During the season of fruit abundance, many of Barro Colorado's ground-dwelling frugivores—peccaries, deer, paca, agoutis, coatis, and spiny rats—live on fruit. Although peccaries, agoutis, and spiny rats can handle nuts and seeds too hard for the other three species, these animals prefer many of the same kinds of fruit. What keeps some of these species from replacing others? While he was a graduate student at the University of Maryland, N. Smythe showed that, during the season of fruit shortage on Barro Colorado, each of these species has a different fallback specialty that is impractical for the others. Peccaries root and browse more, and sometimes gnaw the bark from a few kinds of trees. Deer eat leaves from both saplings and the leaflitter. Pacas browse seedlings. Agoutis live off seeds they have buried, scattered over their territory during the season of abundance after stripping them of odoriferous flesh. Spiny rats live on seeds hoarded in their burrows. Once we know what these animals do during the season of shortage, we understand how they coexist.

Some trade-offs involve the ability to defend, not just exploit, food sources. Animals eating similar foods often face a trade-off between being large and energetic enough to defend rich sources of food, and being small enough to survive where food is more sparsely scattered. Thus peccaries weighing twenty to thirty kilograms, which can chase off all comers, feed on accumulations of fruit fallen around copiously fruiting trees, while three-kilogram

agoutis live on fruits and seeds too small or widely scattered to support peccaries. In 1960, Edwin Willis, then a graduate student at the University of California, began an eleven-year study of the ant-birds that feed on insects escaping advancing swarms of army ants on Barro Colorado (figs. 32–37). He found that thirty-three-gram bicolored ant-birds (fig. 35) feed at the center of the advancing swarms, where insects are flushed in greatest abundance. They chase eighteen-gram spotted ant-birds (fig. 34) off to marginal sites too unproductive to support the larger bicolored ant-birds. Only the spotted ant-birds, however, can survive on islets without army ants. On the surrounding mainland now, and on Barro Colorado before 1970, fifty-gram ocellated ant-birds (fig. 36) fed at the most productive margins of the largest ant swarms, chasing off their smaller competitors. Ocellated ant-birds, however, cannot feed away from army ants. Willis believes that the short, dry rainy season of 1968 diminished the number of army-ant swarms and the abundance of litter insects, thereby setting Barro Colorado's ocellated ant-birds on the way to extinction. Like the human world, the animal world is competitive. To avoid being put out of business by a superior competitor, an animal must do its job better than others, which means it must specialize in at least some respects, but it must not become specialized to a niche that sometimes disappears.

Indeed, specialization presupposes a degree of environmental stability. Ocellated ant-birds turned out to be too specialized for Barro Colorado; the island was too small to assure them a reliable living. Just as a large, stable, productive economy supports a great diversity of human occupations, so the relatively stable, productive conditions of an extensive tropical forest, where fruit, new leaves, and insects are available all through the year, support the greatest diversity of animals.

The Forest at Night

At night the forest is a hive of activity, one that most visitors never see. A different set of animals emerges while most of the diurnal actors sleep. At night, a fig tree full of ripe fruit attracts bats by the hundred, and a few kinkajous (fig. 160) and woolly opossums (fig. 156) as well, while pacas, spiny rats, and perhaps common opossums (fig. 158) forage below for fallen fruit. By day, this same tree attracts monkeys, especially howlers, guans (dark, long-necked, long-tailed birds with bare, bright-red throats), toucans, with their ungainly and garish long bills, and other birds, while coatis and agoutis dispute the fallen fruit below. At night, a tree flushing new leaves may attract two-toed sloths (fig. 112) and tree porcupines (fig. 161) to eat this bounty, while a silky anteater (fig. 159) may probe its twigs for ant nests within. By day, this same bountiful supply of new leaves may attract howler monkeys or leaf-cutter ants. Three-toed sloths (fig. 23) will eat them by day or night. One of every twenty trees more than ten centimeters in trunk diameter carries a termite nest on its trunk or crown; a tamandua (fig. 100) may attack this nest at any time of day or night.

Thus many animals appear to face a trade-off between being diurnal and being nocturnal. One facet of this trade-off is that during the day, animals can find their way and their food by sight, whereas nocturnal animals must either have large eyes, or, more usually, depend mainly on other senses such as smell or hearing. What have we learned about, and from, the forest's nocturnal actors?

Bats

Visitors seldom see bats. During the day, a group of sac-winged bats, *Saccopteryx leptura* (fig. 153), may be seen hanging on the trunk of a great tree, between two huge buttresses, or a visitor approaching a hollow log may see bats suddenly fly out from the other end. Even residents on Barro Colorado do not see bats often unless they look for them. A resident approaching the island by boat just after sunset may see a multitude of fishing bats skimming low over the water, occasionally snaring insects with their feet. Walking through the forest, or even in the laboratory clearing, at dusk or afterward, one may see a bat suddenly veer off to avoid a collision. Someone who leaves bananas on the back porch and returns to retrieve them after dark may happen upon fruit bats flying about, taking bites out of them. At dusk, lines of free-tailed bats, *Molossus,* fly out from the eaves of houses to search for insects above the canopy. Often a spectacled owl is sitting nearby to catch one for its evening meal.

Yet bats loom large in the life of the forest. Some plants depend on nectar-eating bats to pollinate their flowers; others need fruit-eating bats to disperse their seeds. Bats that hawk flying insects may help keep Barro Colorado free of mosquitoes and other annoying insects, slaying as adults those who, as larvae, escaped the jaws of larval giant damselflies. Indeed, bats have diversified into a wide range of occupations: fruit-eaters (fig. 151), nectar- and pollen-eaters, blood-drinkers, fish-eaters (fig. 149), hawkers of flying insects, bats that glean foliage for insects of all sizes from small roaches to large katydids (fig. 150), and carnivores that eat vertebrates ranging from frogs and small bats to rats. Indeed, the ability to navigate by echolocation has allowed bats to diversify into a wide range of nocturnal occupations.

The bats of Barro Colorado have been particularly well studied. A graduate student from the University of Florida, Frank Bonaccorso, spent parts of 1971 and 1974, and all of 1973, catching bats on Barro Colorado. He gave each a wing band with its own identification number, he recorded where, and how far above ground, he caught bats of different species, and he noted what these bats were eating (as inferred from their feces and the fruit they carried into the net), and when females were pregnant or producing milk for their young. He caught bats with mist nets, nets two meters tall and six meters long of thin black thread that are barely visible when set in the forest understory. Some mist nets were set on the ground, others three to twelve meters above it. He also deployed harp traps, each consisting of a one-meter square strung with

parallel vertical wires just far enough apart for a small bat to fly between them, behind another such square with horizontal wires equally far apart. Harp traps catch bats that hawk insects in flight, such as mustached bats, *Pteronotus,* that usually avoid mist nets. Bonaccorso wanted to learn how bat populations were regulated and how so many species could coexist.

In all, he caught 2,884 bats representing thirty-three species. He found that most female fruit-eating bats bore one young bat near April and another near September, when the forest is particularly full of fruit, whereas a female insect-eater bears one young bat a year, usually in May or June, when the rains have come and insects are most abundant. They all timed their reproduction to bear young when appropriate food was abundant. Finally, he found that bats that ate similar types of food in similar habitats differed in size. He concluded that Barro Colorado's many species of bats coexisted because different species ate different types of food, looked for food in different places, or ate different sizes of food items.

Barro Colorado's most conspicuous bat is the common fruit bat, *Artibeus jamaicensis,* a fifty-gram bat that eats mostly figs (fig. 151). In 1972, another graduate student, Douglas Morrison from Cornell University, came to Barro Colorado on a Smithsonian predoctoral fellowship to learn how these bats find food, how much they eat, and how much is available. He spent 1973 mist-netting the bats, giving each an individually numbered wing band when he first caught it, and recording the place and time of each capture and recapture. He found that adult females of this species bear one young bat in March or April and another in July or August, when fruit is abundant. He also mapped the positions of the fig trees near the laboratory and visited them every fortnight to learn when and how often each tree bears fruit. He found that a fig tree offers abundant ripe fruit for a few days at a time. Different fig trees fruit at different times, following different rhythms. Barro Colorado always has some fig trees in fruit, but how can a common fruit bat find one? To find out, Morrison placed small radios on selected bats to track their movements. A common fruit bat often flew several kilometers in a night. After eating, it usually flew what looked like a search pattern for trees with ripening fruit. He also found that to escape snakes and opossums that lurk among the fruit to catch what eats it, a bat flies twenty-five to four hundred meters from the fruiting tree after plucking a fruit, to a place where it can eat in peace. This behavior allowed Morrison to count "feeding passes." It turns out that a fifty-gram bat eats seventy grams fresh weight, or thirteen grams dry weight, of fruit per night.

In 1976 Charles Handley, of the Smithsonian's Natural History Museum, and many colleagues began a nine-year Bat Project on Barro Colorado to learn what kinds of bats lived there, how many there were of each kind, what these bats ate, and how far they traveled. This project mist-netted thirty-five thousand bats belonging to fifty-six species, marked each bat caught with an individually numbered necklace, and recorded the time and place where each was caught. The only bat this project was able to census was the common fruit bat. Netting was so thorough, and each of these common fruit bats roamed over so

much of the island, that in a few years nearly all of Barro Colorado's adult *Artibeus jamaicensis* were marked. The annual mortality rate of adult females was measured by the annual decline in the proportion of adult females banded by Morrison or Bonaccorso in 1973 among the project's catch of adult females. The survival rate of adult female *Artibeus jamaicensis* was 58 percent per year—76 percent per half year. Counting each female bat marked by the project before January 1981, and calculating the chance that a common fruit bat marked *x* months before January 1981 was still alive then, Handley estimated that Barro Colorado supports sixteen hundred adult female common fruit bats, one per hectare, or about four thousand *Artibeus jamaicensis* in all.

In 1991, Elisabeth Kalko brought "bat detectors," instruments that can record the calls of flying bats, to Barro Colorado. To learn how to identify bats by their calls, as birders tell a bird's species by its song, she traveled with Charles Handley to Venezuela, where she recorded the calls of flying bats, which were then collected by Professor Jesus Molinari from Venezuela's University of Merida and identified by Handley. This trip enabled her to document species of bats on Barro Colorado that never flew into nets. Her bat detector allowed her to find at least ten species of bats on Barro Colorado that had never been recorded there before. Barro Colorado's bat-list now includes seventy-two species.

The fundamental trade-off among Neotropical bats, and the primary basis of their diversification, is the trade-off between hawking flying or fluttering insects, on the one hand, and "gleaning" (looking for food—fruit, nectar, pollen, insects, or vertebrates—in or on vegetation), on the other. Barro Colorado's thirty-two species of hawkers all use echolocation as their primary tool for finding food. The island's forty species of gleaning bats find their food by smell, warmth, or the sounds of moving prey, as well as by echolocation. Thirty-nine of Barro Colorado's forty species of gleaners belong to the great South American family of leaf-nosed bats, the Phyllostomidae, which includes insec-

162

Bufo marinus, the enormous marine toad, is common on Barro Colorado. In the dry season, males form huge choruses to attract females. The male in the picture has just taken its place on the lake shore.

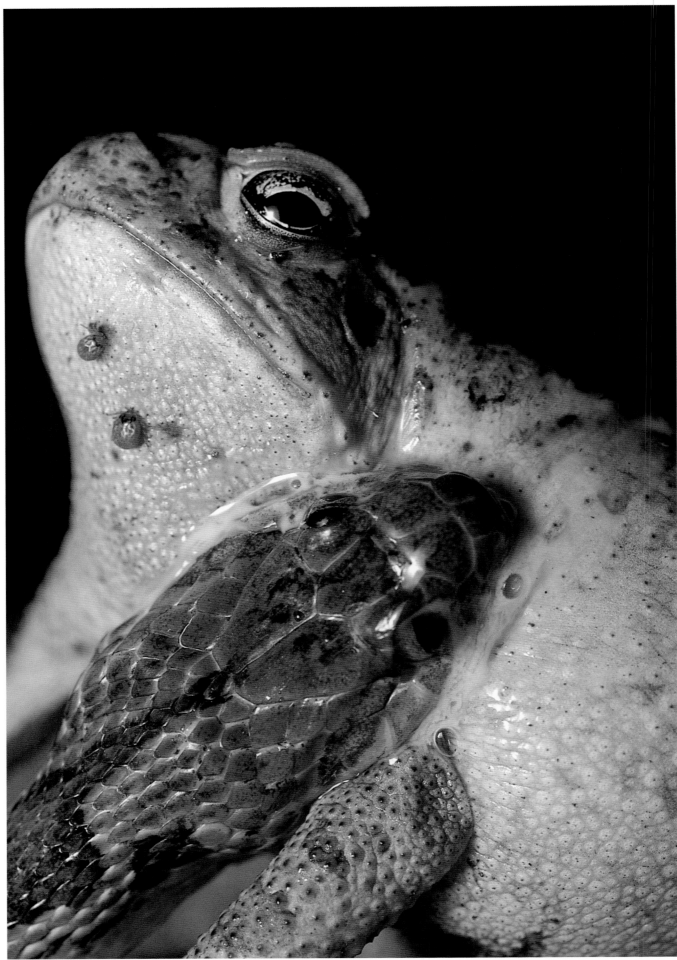

tivores, carnivores, blood-drinking vampires, nectar-eaters, fruit-eaters, and omnivores that eat insects, fruit, and, if the bats are large enough, vertebrates. Barro Colorado's hawkers, on the other hand, are divided among several families, and include no member of the Phyllostomidae.

How do the bat species within a guild coexist? To begin with, larger bats may eat larger food items. As among *Piper*-eating *Carollia,* larger bats may forage at richer food sources. Bats of different kinds may sleep in different types of places during the day. Wibke Thies found this in her *Carollia;* the larger *perspicillata* roosts in hollow trees, often with bats of several other species, while the smaller *castanea* roosts in holes in the earth under washed-out tree roots, along the lake shore, or in the banks of forest streams. Dina Dechmann and Sabine Spehn, graduate students of Elisabeth Kalko now at Germany's University of Ulm, found that the thirty-four-gram *Tonatia sylvicola* (fig. 150) and the thirty-seven-gram *Tonatia saurophila* are both bats that glean large insects from foliage, but *sylvicola* sleep in holes carved in active termite nests whereas *saurophila* sleeps in hollow trees. Elisabeth Kalko found that the nine-gram *Cormura brevirostris* and the seven-gram white-lined bat *Saccopteryx bilineata* both hawk insects near vegetation, *Cormura* just above the canopy, *Saccopteryx* under it. *Cormura,* however, sleep under the trunks and buttresses of fallen trees, while *Saccopteryx bilineata* sleep, rather restlessly, hanging on window screens or on the trunks of large trees, between great buttresses, where people can see them.

The relation between the stability of a food supply and the diversity within the guild this food supports is illustrated by fig trees and the bats that eat their fruit. On Barro Colorado, fourteen species of fig tree have fruit that attracts bats (fig. 151); their fruit ranges in weight from one to eleven grams. All through the year, each fig species must have some trees coming into fruit; otherwise its short-lived pollinating wasps will all die. This steady supply of figs provides more than half the diet of each of ten common bat species, ranging in weight from nine to seventy grams. On the whole, larger bats eat larger fruits. It is clear, however, that these bats do not coexist only by eating different sizes of figs. They do sleep in different places. Douglas Morrison found that adult female *Artibeus jamaicensis* sleep in groups, each sharing a tree hollow with one adult male, while bachelor males sleep hanging in dense foliage well above the ground, shifting their sleeping sites to be close to fruiting figs. Other large fig-eaters sleep in dense foliage several meters above the ground, switching on successive days from one to another of several favored roosts within a hectare of forest, as if to throw off would-be predators. Charles Handley and many later students found that at least some of the smaller fig-eating bats make incisions in large leaves that cause them to flop over and make "tents" in which these bats sleep (fig. 155). In short, fig-eating bats of different kinds sleep in strikingly different places. Whether these differences help maintain the diversity of fig-eating bats, however, is not yet known.

OPPOSITE PAGE: Many of Barro Colorado's snakes eat frogs and toads. Here a cat-eyed snake, *Leptodeira annulata,* is having a young marine toad, *Bufo marinus,* for dinner (fig. 163).

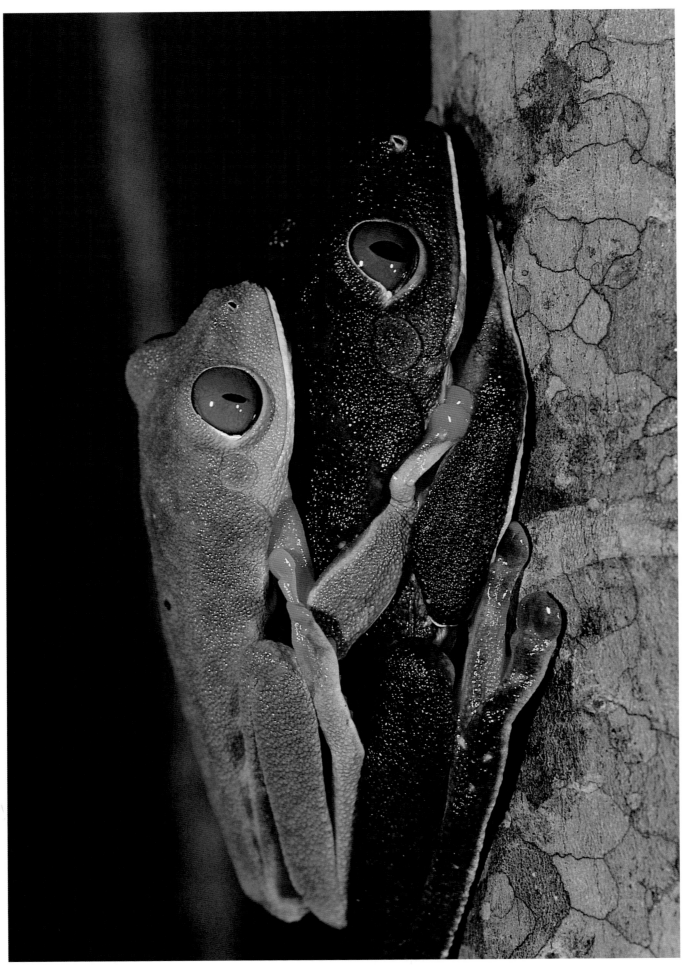

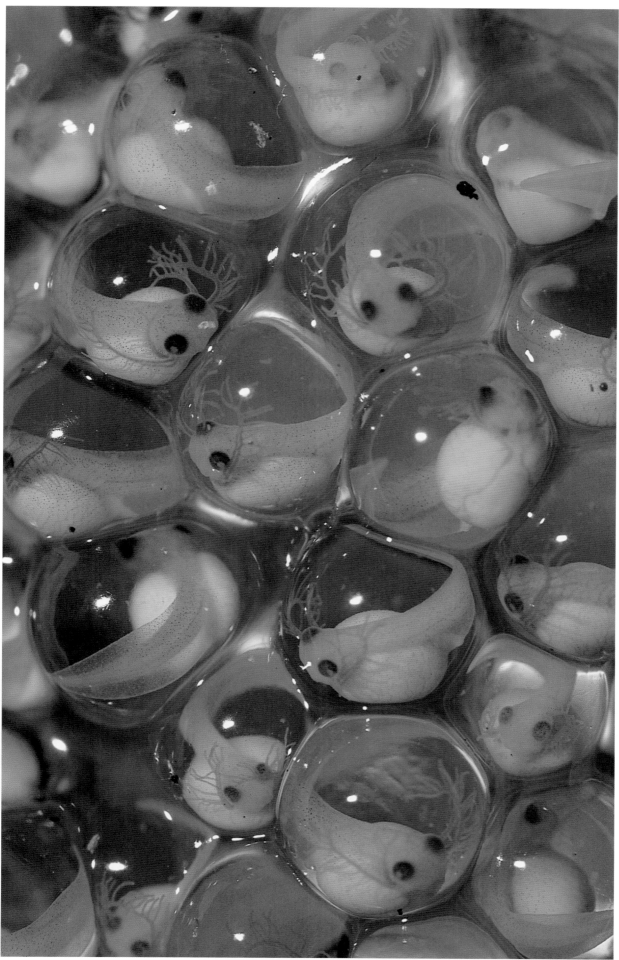

Night Noises and Artificial Ponds

Male frogs usually attract mates at night, by calling. The croaking of bullfrogs, and the higher notes of spring peepers, are familiar to many people in the eastern United States. I can remember the surprise of a classics professor just returned from Greece, who had heard frogs in a marsh there call "brekeke-kex ko-ax, ko-ax," just as the frog chorus does in the *Frogs* of Aristophanes, the greatest comic poet of ancient Athens. Visitors walking in Puerto Rico's mountain forest at night often hear the musical call "ko-kee," the second syllable much higher than the first, although they seldom see the male frogs, *Eleutherodactylus coqui,* that call thus. In Panama, male tungara frogs assemble around a pond or puddle, each repeating about every two seconds a call that sounds like a clear, descending yelp or whine, usually followed by one or more lower-pitched "chucks." A chorus of tungara frogs makes a loud, continuous racket, one of the characteristic night sounds of Panama during the rainy season. Red-eyed tree frogs, mostly bright green aside from their red eyes, assemble in trees over a pond, but their males are much quieter, only making the occasional "chack." The calls of one species of frog differs from those of others living nearby, and females are attracted only by calls from their own species. Indeed, the guide to frogs and toads of central Panama includes a compact disc of their calls, so that we, too, can identify a frog or toad by its call.

What factors influence how a frog calls? To find out, a graduate student from Cornell University, Michael Ryan, came to Barro Colorado in 1978 on a Smithsonian predoctoral fellowship to study sexual selection in frogs. He settled on tungara frogs, *Physalaemus pustulosus*, at Kodak Pond, a small artificial pond in the upper part of Barro Colorado's laboratory clearing. These three-centimeter frogs spend most nights searching the forest floor for insects other than ants, but they assemble at puddles and ponds to breed. He marked males and observed that they left females relatively free to choose their mates. Larger males, however, mated more often. In the laboratory, he confronted female tungara frogs with two speakers, one playing calls without chucks, the other, calls with them; he learned that females usually approached speakers playing calls with chucks. Then he allowed females to choose between speakers playing synthesized calls with identical whines, but with one call's chucks deeper than the other's; they preferred the call with deeper chucks. Larger males, which are more likely to be able to fertilize all of a female's eggs, make calls with deeper chucks; females apparently judge a male's size by his call.

The calls of tungara frogs also attract predators. At Kodak Pond these calls attract marine toads, *Bufo marinus* (fig. 162), Barro Colorado's largest and ugliest toads, and South American bullfrogs, *Leptodactylus pentadactylus,* both of which eat tungara frogs. Cat-eyed snakes (fig. 163) also visit this pond and eat tungara frogs. Merlin Tuttle, a student of bats, then at the Milwaukee Public Museum, came to Barro Colorado to join Ryan in assessing how predators affected courting frogs. Their main field site was the "weir pond," 130 meters into the forest from the upper laboratory clearing.

PREVIOUS PAGES, LEFT: The red-eyed tree frog, *Agalychnis callidryas,* Barro Colorado's most spectacular frog, is a canopy dweller. On moist nights, males and females come down from the tree crowns to meet and mate close to small forest ponds (fig. 164). RIGHT: The red-eyed tree frogs lay their eggs in clutches, which they glue to the underside of leaves overhanging the water. When the tadpoles hatch, they drop into the water below. Recent studies in Panama show that if the eggs are old enough, tadpoles will hatch seconds after a snake or a wasp begins attacking eggs in their clutch (fig. 165).

First, they showed how dangerous mating was for tungara frogs. In fourteen hours, scattered over seven nights, of watching frogs at the weir pond with a night-vision scope that helps users see in the dark, they found that each night, an average of 228 tungara frogs assembled at this pond to breed. Of these 228, fringe-lipped bats, *Trachops cirrhosus,* ate fourteen, South American bullfrogs ate two, and four-eyed opossums, also attracted by the frogs' calls, ate another two. At this pond, moreover, the frogs face another danger. They call while floating in the water, where crabs (fig. 19) living in this pond can grab and eat them. Nonetheless, predation at these ponds has one saving grace. When more tungara frogs assemble to breed at a pond, they do not attract more predators, so each frog has a smaller chance of being eaten. Accordingly, when more males assemble to call, they attract disproportionately many females.

As these frogs' major predator, fringe-lipped bats were singled out for further study. Experiments with recorded calls in flight cages suggested that these bats distinguish frogs by their calls, and avoid those that would make undesirable prey. Tuttle and Ryan had paired speakers in a flight cage simultaneously play calls of different kinds of frog to captive fringe-lipped bats. In this experiment, the bats approached speakers playing tungara frog calls far more often than they approached speakers playing calls of leaf-backed toads, which are poisonous, or South American bullfrogs, which are too big for these bats to eat. To assess the added danger of calls with chucks, Tuttle and Ryan placed paired speakers in the forest, one playing whines only, the other playing whines with chucks. Fringe-lipped bats approached the speakers playing whines with chucks twice as often as they did the speakers playing whines only. When this experiment was repeated in the flight cage, bats approached the speaker playing chucks eight times as often.

Tungara frogs fear fringe-lipped bats. Tuttle and Ryan found that if it is light enough for the frogs at the weir pond to see an approaching fringe-lipped bat, they stop calling for fifteen seconds. The approach of a smaller insect-eating bat causes much less disturbance. The frogs must, however, be able to see the bat's approach in order to respond: on cloudy, moonless nights, when they cannot see, they keep calling when a fringe-lipped bat appears.

Predators eat breeding frogs, and also prey on their young. How do frogs of different species parry these threats? Tungara frogs lay their eggs in foam nests, which protect their eggs from both desiccation and predation. South American bullfrogs, however, also breed at Kodak Pond, and their predaceous tadpoles readily eat tungara tadpoles.

Small (four-centimeter) leaf-mimicking toads, *Bufo typhonius* (figs. 143-47), which spend the day eating ants they find on the forest floor, also breed at Kodak and other nearby pools, but only during the rainy season. While on a Smithsonian postdoctoral fellowship in 1977, Kentwood Wells studied the breeding behavior of these toads and its effect on the safety of their young. He watched their doings at ponds around the laboratory clearing, including Kodak Pond and the weir pond, but he focused primarily on the Animal House Pond, an artificial pond at the edge of the forest, 130

OVERLEAF: Army ants like these from Panama form some of the biggest and most sophisticated ant colonies anywhere in the world. They perform an array of complex behaviors. One is the daily movement of the whole colony, up to a million ants, from one nest site to another during the nomadic phase of their thirty-five-day reproductive cycle. Such nomadic ants cannot construct nests or occupy cavities, as most ants do; instead, they make nests, or bivouacs, of their own workers, with walls of living ants to protect the brood inside. Here is a bivouac of a colony of *Eciton hamatum,* three hundred thousand strong, completely constructed of ants hanging onto each other by their feet. They begin by creating a thin curtain of ants; the curtain's gaps are quickly filled to form a solid wall of living ant bodies. The members of big social insect colonies must live and work together in order to survive. Highly developed networks of communication transform an aggregate of many relatively simple individuals into a complex, effective unit (fig. 166).

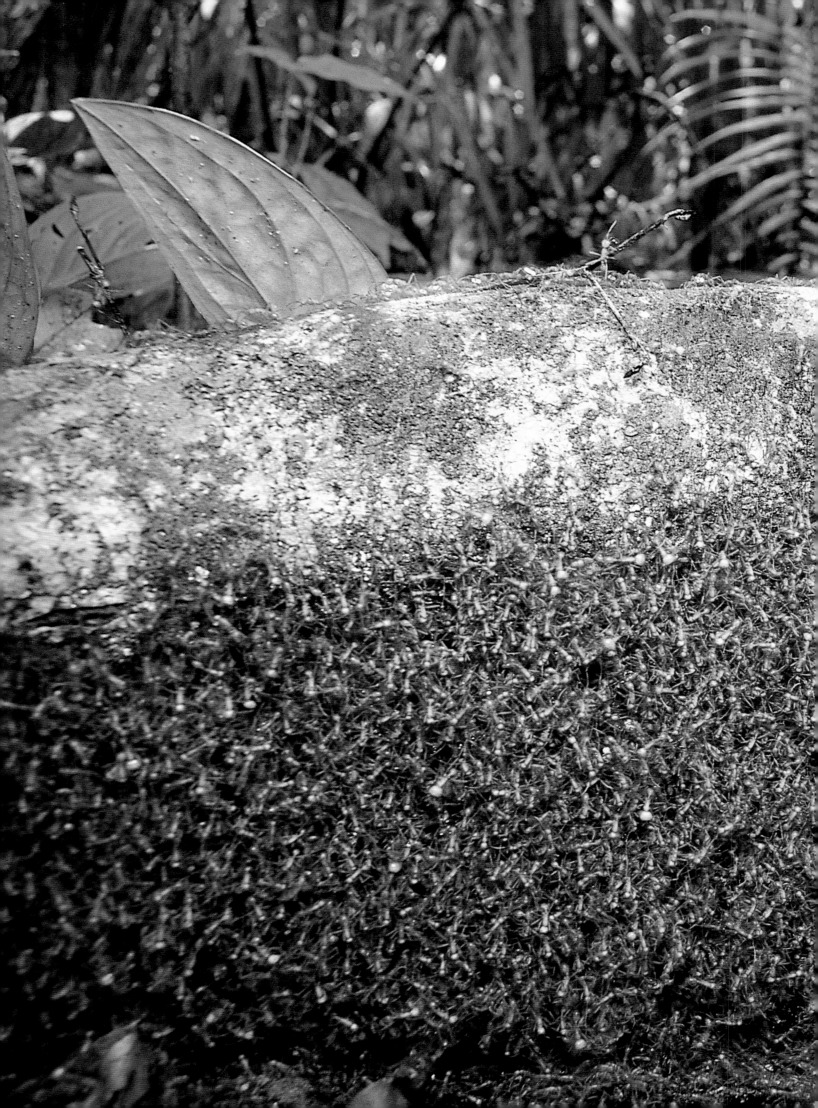

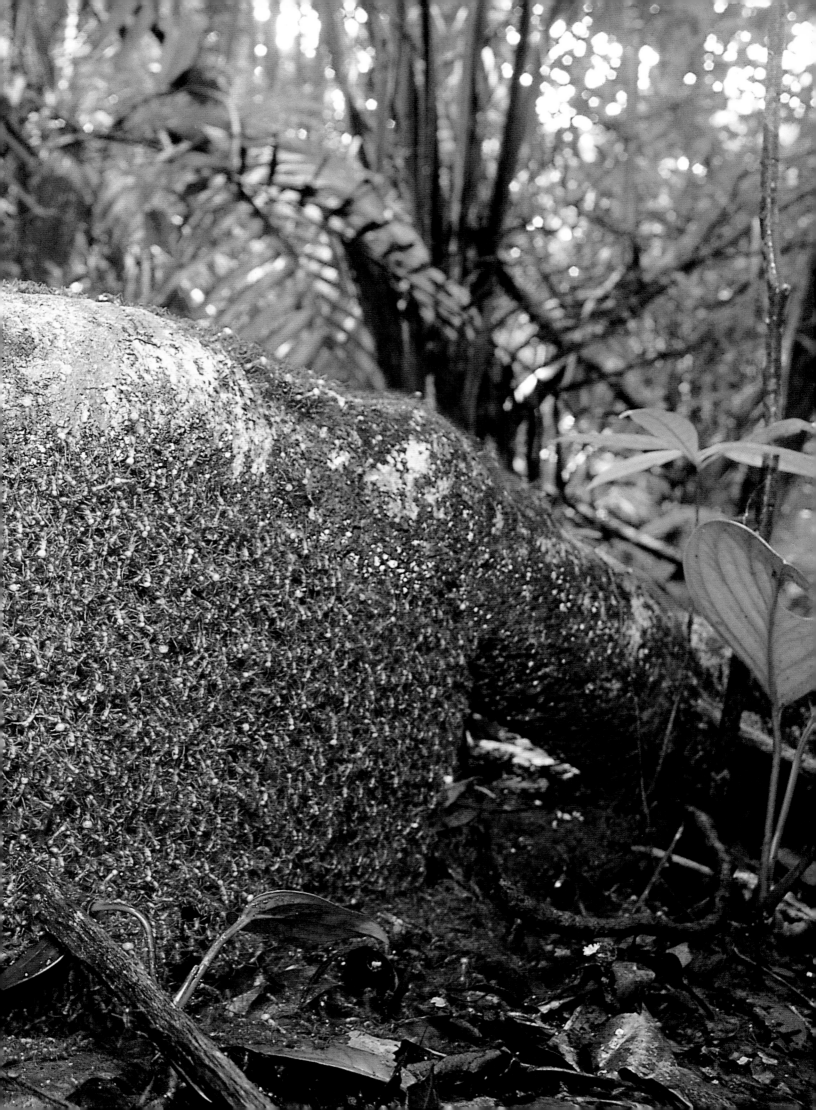

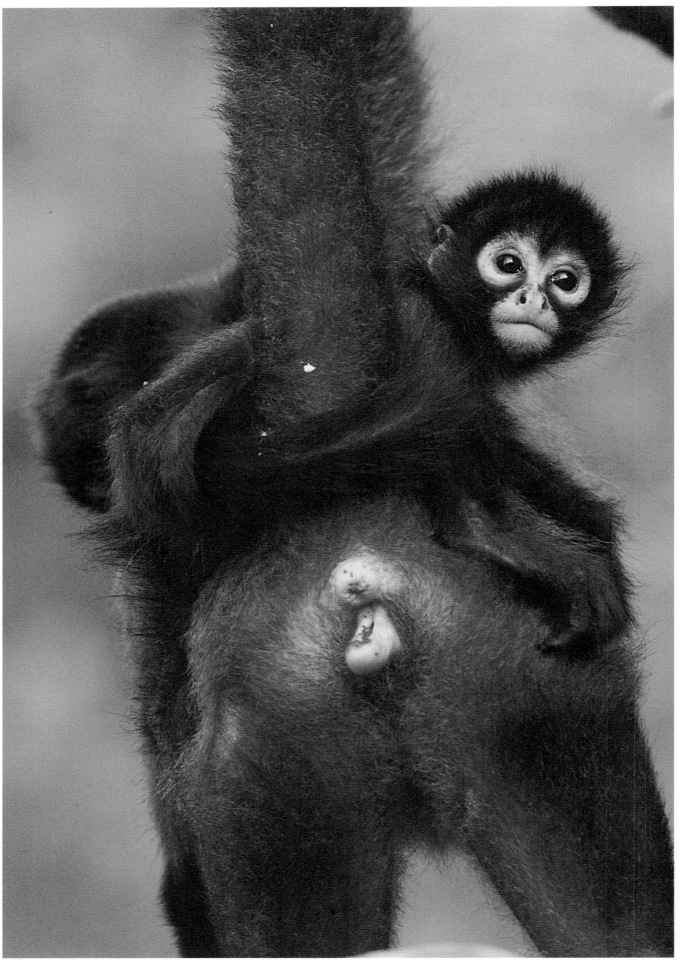

meters from the weir pond. He found that males collected at any given pond to breed only once every three to six weeks. He marked the toads observed at each pond, and found that although toads may breed repeatedly at the same pond, they seldom shift ponds. He found that on a breeding night, these toads assemble in the afternoon, and start calling at 9:00 at night. They compete vigorously for mates, one male often trying to knock another off a female's back. Larger males are more likely to win these fights, so they have better chances of mating. By assembling infrequently in large numbers, these toads probably reduce each individual's risk of being eaten; although fringe-lipped bats consider leaf-backed toads poisonous, marine toads readily eat them. Moreover, by assembling in large numbers, the males attract enough females to lay many more eggs than the South American bullfrog tadpoles can manage to eat. For frog eggs, as well as breeding frogs, there is often safety in numbers.

Red-eyed tree frogs, *Agalychnis callidryas* (fig. 164), mate in the trees overhanging Kodak and Animal House Ponds, where marine toads and South American bullfrogs cannot reach them. Males call ten to twenty meters above the ground, but not frequently. When he came to Barro Colorado for his Ph.D. research, Michael Ryan originally intended to study sexual selection and mate choice among these beautiful frogs, but they called too rarely, and most of the action was far too high in the trees, for him to learn much, and he turned to the easily studied tungara frogs calling at his feet. What we know about the breeding behavior of red-eyed tree frogs was learned in the 1960s by Frank Pyburn, of the University of Texas at Arlington. He worked in a second-growth forest near Veracruz, Mexico, where the frogs call closer to the ground. He released a female full of eggs, which seemed to head for a particular male, passing close by other males on her way. Once a male has mounted a receptive female, he rides on her back down to the water, where she fills her bladder. Then she climbs back to an overhanging leaf, the male still on her back (fig. 164). She lays

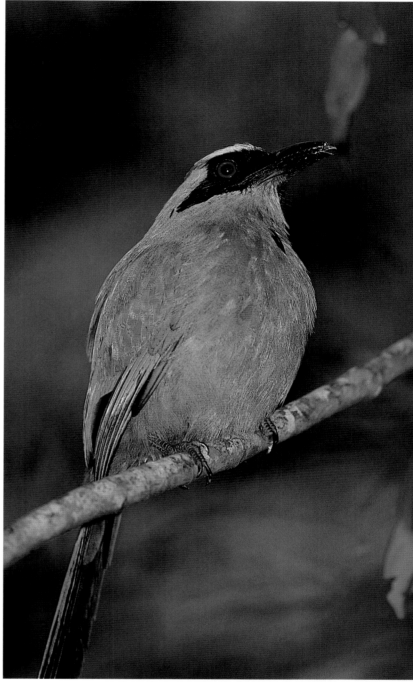

168

OPPOSITE PAGE: The least common of Barro Colorado's four species of monkeys, spider monkeys *(Ateles geoffroyi)*, are highly social primates with complex behavior. A female bears young once every three years. The bonds between mothers and their babies are strong and long-lasting. Juveniles stay in close contact with their mothers, as shown here (fig. 167).

ABOVE: Mixed-bird flocks are found in tropical forests around the world. Birds of different species join in loose groups to forage together, providing more eyes to watch for predators, and giving the birds occasional opportunities to catch insects escaping from flock-mates. The blue-crowned motmot, *Momotus momota conexus,* frequently joins mixed-bird flocks in mainland forests near Barro Colorado, but does not need to be able to join such flocks in order to survive.

a gelatinous mass of eggs on the leaf (fig. 165), which the male fertilizes, and she empties her bladder over them to make sure they stay wet. Then she returns to the pond, still bearing the male, refills her bladder, and climbs to another leaf on which she lays and moistens more eggs. Five such cycles usually empty her of eggs. At any point during these travels, an unmated male may try to replace the one on her back. These attacks rarely succeed, but a female sometimes winds up laying eggs with two males on her back to fertilize them.

If undisturbed, the tadpoles hatch in eight days or so and drop into the water. Cat-eyed tree snakes, however, often eat the eggs of these frogs. A graduate student from the University of Texas, Karen Warkentin, studying these frogs at Costa Rica's Corcovado National Park found that if a cat-eyed snake comes to eat these eggs when they are five or more days old, most of the tadpoles escape by hatching right away and dropping into the water. The earlier they hatch, however, the more vulnerable they are to aquatic predators. Only the immediate presence of a hungry snake makes them hatch early. In short, each of these three species of frogs and toads has a different way of coping with the threat of predators.

Mating Katydids and Their Enemies

Katydids (fig. 12) also call to attract mates. Do their calls attract bats? In 1984, a graduate student at the University of Florida, Jacqueline Belwood, came to Barro Colorado on a Smithsonian predoctoral fellowship to assess the effect of insect-eating bats on the mating behavior of katydids. To learn whether katydid calls attract bats, she set up paired mist nets, one baited with a tape recorder playing katydid calls, the other not. In thirteen one-hour netting sessions, the baited net caught twenty-four foliage-gleaning bats of four species that can eat katydids, while the unbaited net caught none. She also learned that some species of katydid-eating bats return to fixed roosts to eat their prey, where they drop the katydids' wings and other inedible parts. By examining these "bat middens," she found that these bats catch many female katydids, which do not call. She thinks bats hang around near calling males to eat the females they attract.

Belwood also found that katydids that are exposed to bat predation behave differently from those that are not. Katydid-eating bats never venture into the laboratory clearing, and the katydids there call loudly and often. So does a forest katydid that lives among the great saw-toothed, sharply pointed leaves of the ground pineapple *Aechmea,* where no sensible bat would dare to enter. Most male katydids of the forest that sit where bats can reach them, on the other hand, call seldom, in clear tones that are hard to locate. A katydid that calls rarely is harder for a bat to find. In flight cages, round-eared bats, *Tonatia sylvicola* (fig. 150), find katydids that call sixty times a minute in as many seconds as it takes them minutes to find katydids that call less than once a

minute. Instead of calling, a male katydid of the forest vibrates the shrub on which he sits in a complex, species-specific way, and thereby signals his presence and desirability to any females of his species that happen to be on the same shrub. The threat of being eaten by bats makes a profound difference in how a male katydid signals to attract mates.

Why Live in Groups?

Visitors to tropical forests such as Barro Colorado often see animals in groups—a troop of monkeys, a swarm of ants, a nest of wasps, a band of female coatis and their young, a flock of birds, often of many species, foraging together. Some of these animals, such as monkeys, ants, and wasps, have a future only if they are part of a group.

Why do animals live in groups? Sometimes, as among leaf-cutter ants, army ants (fig. 166), and honeybees, the group's members are visibly working as a team; the division of labor among their members makes their group far more competitive than any of its individuals could be if it were living alone. Someone who approaches a bee's or wasp's nest closely enough to be attacked by its occupants may experience this teamwork in a fairly vivid way.

In other groups, however, teamwork becomes obvious only when relatively unusual events occur—two troops of howler monkeys contesting possession of a fruiting tree, members of a bird flock or a white-faced-monkey group calling to one another in alarm about a nearby predator, or, even more rarely, male howlers mobbing a harpy eagle away from the troop. These examples suggest that many animals live in groups because there is safety in numbers—more eyes to watch for predators, more allies to help chase off competitors.

The Fundamental Problem
of Animal Behavior

Nevertheless, why animals live in groups is a puzzle. No animal escapes the competitive test of natural selection. A group's members are each other's closest competitors for food, mates, shelter, and anything else in short supply. What keeps competition among group members from destroying the benefits of group living and undermining the common interest in their group's good? Indeed, why should animals cooperate at all, however briefly? Any time two animals cooperate in sexual reproduction to produce offspring more varied than either could by cloning itself, it is possible for one partner to cheat its mate. Some female spiders and mantises eat the males with which they have just mated. Insectivorous birds and some fish pair off to conceive and raise young. In a bird pair's nest, however, some of the young birds that the male helps feed may have been fathered by other

males. Likewise, a fish of either sex may desert its nest before the young attain independence. Why animals cooperate in a competitive world is thus a fundamental question in animal behavior.

Indeed, destructive competition within groups is a serious threat. A person may derive private advantage in many ways that harm his or her society. The same is true for other animals. One individual may be a freeloader, avoiding its share of the communal work of defense, gathering food, and caring for the young, from which it benefits. Another may hog the benefits of communal labor, making it disadvantageous for others to cooperate.

This fundamental problem of animal behavior has analogues at all levels of biology. For example, the cells of an animal's body normally cooperate fully to form a functional individual. Yet on occasion, a group of cells multiplies wildly, without contributing to their individual's welfare. Such unregulated multiplication creates a cancer that kills the individual on which the cancer cells depend. Indeed, this question is a unifying theme of biology that includes human affairs as well. Plato, Aristotle, and many successors from their day to ours have discussed what organization of human society best aligns an individual's advantage with the society's good—that is, what organization of society makes it most advantageous for individuals to work in ways that benefit it.

Maintaining Harmony in Animal Groups

Wasp, ant, and bee societies began when sisters joined forces to found a nest, thereby avoiding the dangers of nesting alone. Competition for nest cells in which to lay eggs creates winners and losers. Losers often benefit more by helping their relatives reproduce than by facing the dangers of nesting alone. After all, the winner's children are their nieces and nephews. Primitive wasp societies already show a division of labor among an egg-layer, other defenders of the nest, and nonreproducing relatives that find food for the young. Foragers, however, are still capable of reproducing, and they sometimes fight to change roles with the egg-layer. Sometimes the egg-layer or the nest-defenders must force the foragers to work.

In an advanced society of leaf-cutter ants (figs. 11, 41–45), one queen does all the reproducing. By controlling how much the young ants eat, the queen controls their destinies. A few become males. A few become reproductive females, destined to found new nests. Most become sterile workers. Because workers cannot produce young of their own, it is in their common interest to help their queen reproduce. The leaf-cutter queen makes no one work. Yet the leaf-cutter colony is a marvel of smoothly coordinated functions: scouts finding trees with suitable leaves, foragers cutting leaves and bringing the fragments back to the nest, soldiers defending the nest and its ant highways, farmers tending the fungus garden and nourishing it with these fragments, caretakers feeding the young, refuse collectors removing used leaf fragments to the appointed

rubbish dumps. Although an individual leaf-cutter ant's behavior is simple and stereotyped, a leaf-cutter ant colony is remarkably versatile and responsive to its environment, thanks to its extraordinary division of labor. Some biologists presume to use ant colonies as models of how a collection of simple neurons can be combined to yield the intelligence of a human brain.

Monkey societies (fig. 167) work differently. They lack the rigidly programmed hierarchy of a colony of leaf-cutter ants. Monkey groups function because each monkey depends on all the others of its group to help spot predators and to ward off both predators and competitors. A monkey endangers itself if it causes a fellow monkey's death by shirking its role in defense or coordinated escape. Here, each monkey's advantage coincides largely with the common good of its group.

Mixed-bird flocks are associations with no commander (figs. 34-37, 169, 170). Early studies on Barro Colorado showed that a flock's birds feed in ways that reduce competition among the different species present. They do not join together to help each other find food. Rather, these birds forage in flocks because birds in a flock are less likely to be taken unawares by an unnoticed predator. Perhaps it costs a bird (unlike a monkey) nothing to give an alarm call. If a bird spies a predator in time, it can readily escape, and its call tells the predator that it should look elsewhere because it cannot catch the caller. Despite the loose, voluntary nature of the association, birds of a flock join to mob predators. Moreover, the birds joining such flocks have evolved various colors and habits that make flocking more useful to the participants.

Cooperation and the Common Good

Aristotle remarked that those societies that best served their members' common good were least liable to revolutions, because in such societies the fewest people would benefit by overthrowing the social order. An animal joins a group only if it profits by doing so, so animal groups must also serve their members' common good. A queen bee or a queen ant manipulates circumstances to create a common interest among her workers in helping her. The common interest among the monkeys of a group or the birds of a mixed-species flock, however, reflect no such manipulation.

The importance of a truly common interest among collaborators is revealed in the story of a small wasp, *Metapolybia aztecoides.* In a colony of this species, some workers can lay eggs. When their colony has a healthy, fully developed queen, they normally refrain from doing so. If their queen dies, no one worker can lay enough eggs to provide all the workers the colony needs. Therefore, several wasps collaborate to lay as many eggs as the colony needs. A wasp's egg laying, however, improves with practice. When one of the wasps can lay enough eggs to maintain the colony, the collaborators fight for the prize they jointly created. The common interest in cooperation ends when a wasp no longer needs others to help maintain the colony.

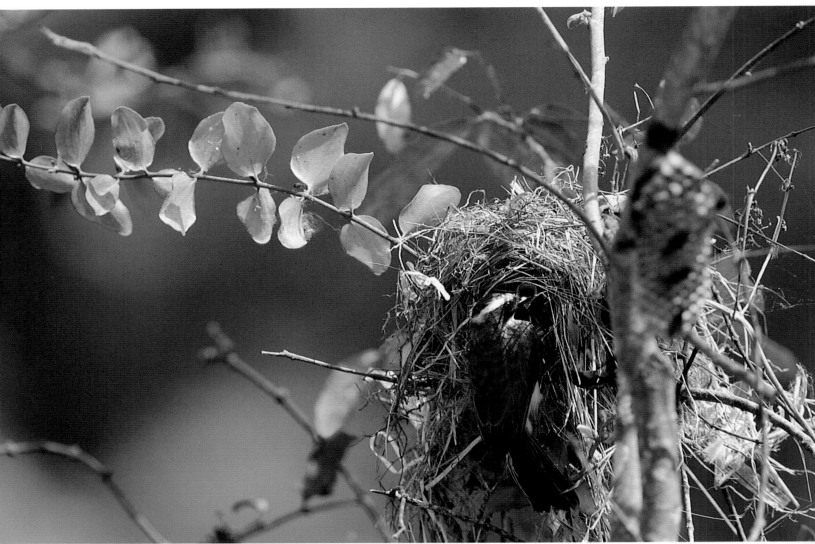

The most elementary forms of social behavior are
sexual reproduction and the rearing of young. Here,
a social flycatcher, *Myiozetetes similis,* feeds its
chicks in a nicely woven nest. These birds are called
social because they are often seen in groups at
concentrations of fruit or insects.

Portrait of a social flycatcher, *Myiozetetes similis*.

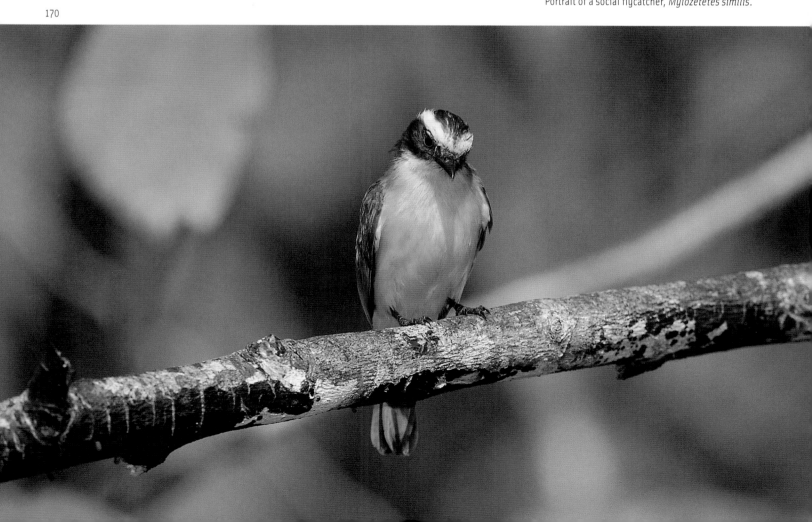

Living in groups is not advantageous for everyone. Eagles are not social animals. They need fear no predators, they do not need help to catch their prey, and they do not want competitors for the prey they can reach. The same is true for jaguars, ocelots, and other cats. At the other end of the spectrum, insects that escape their predators by looking like twigs, leaves, or bird droppings do not want similar neighbors nearby, lest a predator that eats one learn how to spot its fellows nearby.

The Biggest Group of All

The plants and animals of an ecological community—an ecosystem—all depend on other members of their community for food or fertilizer, the habitat they live in, the removal of their wastes and corpses, even for the air they breathe and the carbon dioxide plants use.

Heedless human disturbance usually impairs a natural ecosystem's diversity or its productivity (its total rate of production of vegetable matter and animal flesh). Even the reserves we wish to keep natural suffer from unintended effects of human activity. In North America, songbirds, which help control insect pests, are declining because farms and barren scrub are replacing the tropical forests where the birds spend their winters. Because wolves are gone and mountain lions are rare, the deer these predators once ate are so abundant that only those tree species with the most distasteful seedlings can survive, and the tree species composition of our parks is changing inexorably. River life is poisoned and impoverished when gold miners dump mercury upstream, as often happens in Amazonia. Overfishing in the North Pacific leaves killer whales hungry, so they come near shore to catch sea otters; the sea urchins the otters were eating have accordingly multiplied, and are grazing down the kelps fringing these northern shores, to the great injury of the many animals that lived there and of the harbor seals and bald eagles that lived on this abundance of animals.

A random change in the workings of a watch, a machine designed—organized—to keep time, usually impairs its function. Aristotle inferred that living things were organized to survive and reproduce because mutants, if they differ at all, are usually less effective at these functions than their normal counterparts. Changes wrought in a tropical forest by logging, pollution, or fragmentation into isolated parks and woodlots diminish its diversity, its productivity, or both. Aristotle's argument thus implies that these forests, like other ecosystems, are "commonwealths" organized for a high diversity of members and the high production of food to support them.

What processes organize ecosystems for high productivity and diversity? Adam Smith argued that fair competition among human beings enhances the production of wealth and the diversity of occupations, while society punishes unfair, productivity-reducing competition. Ecosystems illustrate his point better than most human societies do.

The relentless competition for the means to live and reproduce has favored

organisms with new or better ways of generating "wealth." These include photosynthesis, which uses light to make sugars from carbon dioxide and water; respiration, which uses the oxygen released by photosynthesis to extract more energy from food; the use of energy to make the ammonia needed to construct proteins from atmospheric nitrogen; and the combination of organisms with complementary functions that helps each become more competitive. For example, some corals incorporate photosynthetic algae to obtain some of the carbohydrates these algae produce, in return for fertilizing the algae with their own wastes. Likewise, leaf-cutter ants culture a superfungus that they use to digest leaf fragments. The relentless competition for the means to live has also favored organisms that make their livings by recycling others' wastes or corpses in new ways, such as the denitrifying bacteria that derive energy from converting nitrogenous wastes into atmospheric nitrogen; the fungi and termites that derive energy from decomposing dead vegetation; and the burrowing animals that exploit buried carbon, returning it to the pool of accessible resources.

Competition for the means to live and reproduce also favors specialists that are so effective in their occupations that no other living species can replace them. The diversity of specializations is, in effect, a division of labor among the different species of plants and animals, which now depend on each other's functions. Plants depend on decomposers, decomposers depend on plants, grassland grasses depend on grazing animals that keep out tree seedlings, and so on. Even herbivores and predators play their part, enhancing productivity by circulating the resources in the bodies of others more quickly. These animals also have indirect effects: to allow their young to escape the parents' pests, plants employ animals to disperse their seeds and convey their pollen to suitable mates.

Adam Smith considered monopolies among the worst obstacles to the increase of a country's wealth, because they protect inefficient users of resources. Nature's ruthless competition quickly erodes productivity-reducing monopolies. In nature, unexploited and poorly exploited sources of energy always attract more efficient users. This is especially true in tropical climates, where any source of energy finds an organism to use it, as owners of termite-ridden houses, cockroach-eaten books and papers, and fungus-etched lenses know, to their cost.

To be sure, many organisms make their livings in wasteful, hurtful ways, as does the agent of river blindness that ruins a human life through its predilection for optic nerves. Such organisms are part of nature. Yet too exclusive a focus on such organisms misses the central point of more than three billion years of evolution—ecosystems, astoundingly functional commonwealths evolving without intention from the relentless competition among plants and animals for the means to survive and reproduce, in the course of which plants and animals have developed the extraordinary network of mutualisms that make tropical-forest ecosystems productive homes for an extraordinary diversity of living creatures.

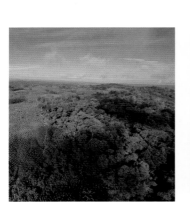

5

Why
Tropical Forests
Matter

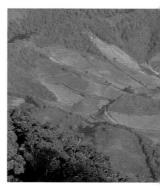

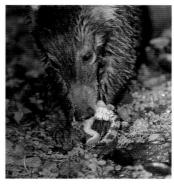

Hundreds of millions of people depend on tropical forests for building materials, firewood, medicines, and some of the things they eat. Hundreds of millions more depend on these forests to make their climate more tolerable, ensure a more reliable water supply, and provide some measure of protection against floods. A growing number of people, both within and outside the tropics, regard tropical forests as some of the most beautiful wonders on this planet, and would consider their world seriously impoverished were such forests destroyed.

The Forest and the Rural Poor

Some tropical peoples—shifting cultivators and hunter-gatherers—depend entirely on tropical forests for their livelihood. Indeed, these peoples have become part of the forest ecosystem, which they manipulate with remarkable skill. Many other peoples of the rural tropics, however, have replaced great tracts of forest with farms, fields, and villages; they have transformed their ecosystem. Nevertheless, many of them still depend on forests for wood to build their houses, furniture, tools, weapons for hunting and defense, and vehicles such as canoes and carts. Forests supply fuel for the fires with which they cook their food and keep warm. Especially in the tropics, forests also serve as sources of medicines prepared from a variety of leaves, flowers, roots, fungi, and resins (fig. 175)—so much so that nowadays ethnobotanists and natural-products chemists are ransacking tropical forests for medically useful compounds (fig. 171). Many tropical farmers depend on forests for palm fronds from which to weave baskets and make roofs, and for a variety of foods they cannot readily grow—particular leaves, fruits, nuts, and mushrooms, as well as the game animals that supplement their protein intake (fig. 172). Many of these items are not only

Chemicals of medical importance are a major rain-forest resource; many of the chemicals plants use to deter herbivores are also effective for treating disease. Considerable effort is devoted to bioprospecting, the search for such chemicals. Of the hundreds of thousands of tropical-plant species, only a small fraction has been thoroughly tested for medically useful chemicals. Here, the Florida-based biologist Dr. John Teen examines the results of his tests of extracts from fresh plant samples for effects on cystic fibrosis.

173 ↑ 174 ↓

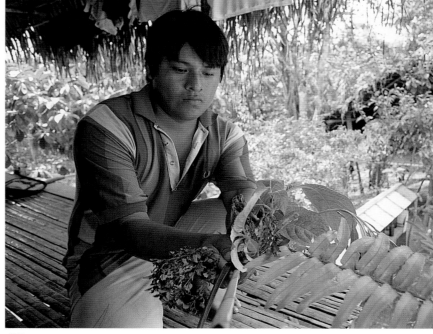

175

ABOVE: Ecotourism is important both as an industry and as a means of education. It makes the tourists appreciate the beauty and importance of tropical rain forests and shows students why it is important to protect the remaining forested areas. It is also a way to generate some income from a forest without destroying it. Panama has high potential for ecotourism if it protects its remaining natural resources carefully. Here, schoolchildren from Panama City, many of whom have never been to the forest before, are standing in front of "Bigtree," a huge kapok tree *(Ceiba pentandra)*. Perhaps twenty years from now, some of these students will be in a position to help protect tropical forests: perhaps what they learned on Barro Colorado and their memories of Bigtree will incline them to do so.

PREVIOUS PAGES

LEFT PAGE: Green iguanas *(Iguana iguana)* are hunted to excess for their tasty meat and their eggs wherever they live. The Panamanian nongovernmental organization Asociación Nacional para la Conservación de la Naturaleza (ANCON) runs an experimental farm to develop inexpensive and easy ways to breed these animals in order to provide farmers an affordable source of protein and at the same time reduce hunting pressure on the wild populations of iguanas. Here, biologist Augusto Gonzales holds a big female from the farm (fig. 172).

RIGHT, PAGE TOP: Another example of the sustainable use of forest products. The palm *Phytelephas* has seeds whose texture and color resemble those of ivory. Here is a collection of carvings from the vegetable ivory for sale as artwork, with nuts like those from which the carvings were made. Behind them is the dark, spiny infrutescence that contains many nuts (fig. 173).

BOTTOM, LEFT: Using strong fibers from leaves of various palms that have been treated and dyed, forest peoples in Panama make baskets and other artwork for their own use and to sell to tourists as souvenirs. This can be a sustainable use of forest resources. Here, an Embara woman makes a basket (fig. 174).

BOTTOM, RIGHT: An Embara Indian living near the Chagres River collected these plants, used for medical purposes in his village (fig. 175).

used locally, but sold or traded to obtain other things their makers cannot grow, gather, or make locally. When tourists or city dwellers provide a suitable market, country people in the tropics also use their forests as sources of precious woods, palm fibers, vegetable ivory (fig. 173), rattans, dyes, and the like from which to make carvings, furniture, decorated baskets (fig. 174), and other artwork for sale.

As a result, most rural landscapes are dotted with woodlots, sacred groves, and other fragments of forest. Some of these fragments are intended to supply needed forest products. Others, set aside for religious reasons, also satisfy many of these needs. Where natural forests have disappeared, traditional farmers in Java, Jamaica, and many other regions plant home gardens that are many-layered forests consisting entirely of useful plants—miniature forest paradises designed to satisfy human needs and desires.

The Forest as a Source of Beauty and Inspiration

A few of the ancient Hebrews viewed untamed nature as something to wonder at, a truly marvelous work that revealed its Creator's splendor, power, and goodness (Job 39-41; Psalm 104). In the past, however, most inhabitants of long-settled landscapes, in both the tropics and the temperate zone, viewed "virgin forests" as places to fear, haunts of wild beasts and perhaps hostile outlaws or aboriginals, places it would be desirable to tame and put to use. A trace of this fear is reflected in J.R.R. Tolkien's description of Mirkwood in *The Hobbit,* and the Old Forest and Fangorn in *The Lord of the Rings.* Appreciation of the beauty of tropical forests and other natural landscapes was rarely expressed in the West until fairly recently. Columbus was unusual among the Iberian conquistadors in his open admiration of the beauty of the Neotropical forests he encountered.

Biologists such as Alexander von Humboldt, Charles Darwin, and Alfred Russel Wallace were moved by the beauty of tropical forests, where wild nature is most wonderful in its gorgeous diversity of plants and animals, the varied ways in which they make their livings, the intricacy of their interrelationships, and the delicate balance of their interdependence. They were astonished at how, as E.J.H. Corner put it, tropical "nature, in her intransigence, brought forth the most beautiful, the most artful, the most destructive."

Tropical forests are also attracting growing numbers of nonscientists. For years, many of the English living in India, the Malay Peninsula, and other tropical regions have visited hill stations to enjoy the cool air and the beauty of montane tropical forest. In 1915, P.F. Fyson published a flora of south India's Nilgiri and Palni hilltops for these "ecotourists." Since then, a host of other guides to wildflowers, birds, butterflies, and mammals has appeared, first for India, Malaysia, and Africa, and more recently for the Neotropics as well. Increasing numbers of tourists are visiting Costa Rica's tropical forests. Closer to home, thousands of students and tourists visit Barro Colorado

Island each year (fig. 176). For those who cannot visit tropical nature in person, many aquaria and zoos in Europe and North America try to recreate the atmosphere of a rain forest, its sights, its sounds, and sometimes its scents, in great halls arranged for the purpose. Television crews come to Barro Colorado and other tropical forests so that people can view some of the more striking scenes of tropical nature in their own living rooms. A century ago, botanical gardens filled great greenhouses with palms and other tropical plants. The painter Henri Rousseau derived his conception of tropical forests from one such greenhouse.

Why this widespread fascination with tropical forests? Some people are attracted by their beauty and strangeness. Others find a spiritual significance in untrammeled nature. A distinguished Muslim scholar, S. H. Nasr, has movingly expressed this significance: "Virgin nature possesses order and harmony. There exists within this vast domain of immediately perceptible reality of nonhuman origin an order, an interrelation of parts, a complementarity of function and roles and an interdependence which, for the mind not paralyzed by the reductionism inherent in the modern scientific worldview, cannot but lead to a sense of wonder and awareness of the spiritual character of that Light that turned chaos into cosmos and which still reveals itself in the natural order."

Tropical Forests and Our Understanding of Nature

Tropical nature not only impressed biologists with its beauty; it posed an intellectual challenge that changed the face of biology. Biologists were confronted with the need to understand why tropical plants and animals found so many different ways to escape their enemies and procure what they needed to survive and reproduce. Darwin and Wallace found answers to these questions in their theory of evolution by natural selection. This theory is the cornerstone of our understanding of biology.

177

Forests influence climate on a local as well as on a regional level. By their abundant transpiration of water vapor, plants provide the clouds for future rain. In a logged area, more rainwater leaves the catchment as runoff rather than returning to the atmosphere as transpiration. About half of Amazonia's rainfall arises from the transpiration of Amazonia's plants.

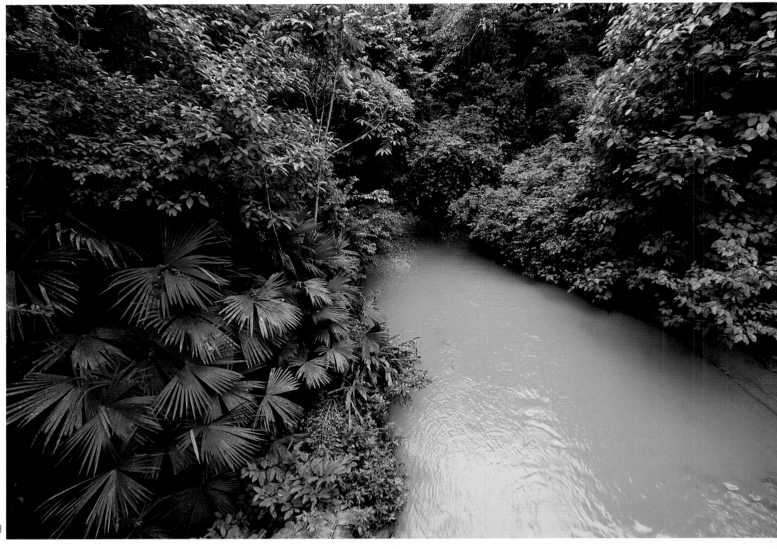

178

Forest cover reduces erosion significantly, whereas soil gets washed away rapidly without forest cover. This sediment-loaded stream drains a deforested area on the mainland.

More recently, tropical nature has prompted biologists to wonder how the competitive process of natural selection could favor the evolution of social behavior in animals, not to mention the many forms of cooperation among plants, animals, fungi, and microorganisms on which the diversity and luxuriance of tropical forests depend. How can tropical biologists make sense of what E.J.H. Corner called "this host of vegetable life which thrives without intention, builds without circulating blood, feels and responds without sense-organs and muscles, summons animals without contriving, and serves in its overproduction their food supply"?

Tropical nature also lends us the perspective to grasp the strangeness of needle-leaf conifers and the normalcy of palms, and to view nature everywhere in a wider, truer context. More and more biologists are coming to the tropics to "discover how modern trees have come about, what tree life really is, what vegeta-

tion can do, and, of course, what it meant to the animals," as E.J H. Corner put it. We have written this book to share with readers the beauty that so attracts us biologists to tropical forests, and to show readers how to look at a tropical forest in a way that reveals the challenges its many and diverse inhabitants face, and how these inhabitants contribute to their forest's luxuriance and beauty.

Tropical Forests and Climate

Alexander von Humboldt observed in 1799 that near Cumaná, Venezuela, "inhabitants have justly noted that aridity has increased all over the province . . . [in part] because it is less forested than before the conquest." Ever since, observers have noted that in tropical regions, deforestation makes the climate hotter and lowers rainfall, especially during the dry season. This observation is poorly documented, and some scholars consider it a myth, yet it rings true. In Amazonia, half the rain that falls returns to the air. This cycle of evaporation and transpiration consumes half the energy the forest receives from the sun and helps keep it cool (fig. 177). Moreover, as remarked above, a tropical forest "through plenteous evaporation engenders its own storms." In areas far from oceans, rainfall will drop when the forest is cleared. Copious rain does regulate tropical climate. In inland Africa it is warmer, especially during the day, and the diurnal range of temperature is much greater, during a long dry season than during the rains.

Forested catchments usually erode less rapidly and suffer fewer landslides. Rivers draining forested catchments tend to be clearer, and are far less likely to be choked by their own sediments than streams draining deforested areas (fig. 178). Its choking overload of sediment is what makes China's Yellow River such a sorrow for those dwelling on the North China plain. Forest soils absorb water more readily, which both lessens the frequency and extent of flooding and increases the amount of water these soils store, which in turn increases stream flow during the dry season. Therefore, wise tropical farmers, such as those of Monteverde, Costa Rica, protect their soil and water supply by keeping their steepest slopes in forest.

Tropical Forests
and the Global Carbon Dioxide Greenhouse

The carbon dioxide content of the earth's atmosphere is rising, which warms the earth by decreasing the proportion of the sun's radiation that returns to space. Deforestation contributes carbon dioxide to the atmosphere. To what extent are tropical forests shields against global warming?

In 1990, the earth's atmosphere contained 2.75 trillion tons of carbon dioxide, and this content was increasing by 12.8 billion tons, or 0.47 percent, per year. To put these huge numbers in perspective, let us compare them with how

Box 5.1 How Much Carbon Entered the Atmosphere Fifty-five Million Years Ago?

Carbon dioxide comes in two forms or isotopes: ^{12}C and the much rarer ^{13}C. Methane clathrates, on the average, contain 6 percent fewer ^{13}C atoms per ^{12}C atom than carbon in the sea or air. Fifty-five million years ago, the proportion of ^{13}C atoms in the biosphere's carbon suddenly dropped by 0.3 percent, as if a great burp of methane had increased the amount of carbon in the sea and air by one-twentieth. The burp may have happened because the world was already warming. Today, colder water, which is heavier, lies at the sea bottom, but when the poles were warmer, the salty water flowing out from shallow tropical lagoons was heavier. If warm lagoon water displaced cooler polar water from the sea bottom, shallower-water clathrates would release their methane. Nearly all this methane's carbon

soon ended up in the atmosphere as surplus CO_2. The metabolic exchange of carbon between air and sea, however, soon made the $^{13}C/^{12}C$ ratio the same in both. Today, there are 1.37 billion cubic kilometers of ocean water. Nearly every liter of seawater (a liter has the volume of a cube 10 centimeters, or 10^{-5} kilometers, on a side) harbors about twenty-eight milligrams of carbon, so the oceans contain thirty-eight trillion tons of carbon. There is no relation between the atmosphere's and the ocean's carbon content. If the oceans contained as much carbon during the methane burp, this burp released 2 trillion tons of carbon, injecting 7.3 trillion tons of CO_2, into the air. But the sea was warmer then. Warmer water holds less CO_2, so the methane burp released somewhat less carbon.

179

ABOVE: Coffee is grown in the highlands of western Panama. Where coffee is grown under shade, some natural-forest trees are kept to shade the coffee. Biological diversity in these areas is significantly lower then in intact cloud forests, but not nearly so low as in clear-cut areas.

OPPOSITE, TOP: Another border: the Baru National Park in the Chiriqui province, with a diverse cloud forest contrasting with intense farming on slopes outside the park. Erosion is extremely rapid on the steep slopes, which receive more than ten feet of rain a year (fig. 180).

OPPOSITE, BOTTOM: An onion field where there was forest only a few years ago. Soil is quickly washed away from steep slopes by the frequent heavy rains (fig. 181).

182

183 ↑ 184 ↓

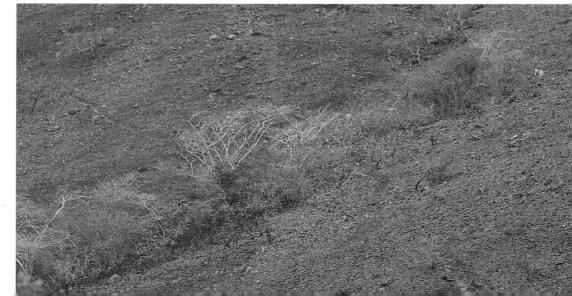

TOP: Large areas on the Pacific side of Central Panama have been deforested for decades or centuries, and now serve only as low-quality pasture (fig. 182).

MIDDLE: Striking erosion patterns in deforested areas in Central Panama. The secondary growth in the annually burned areas cannot hold the soil. Eventually, nothing is left but highly infertile bedrock and washed-out soil (fig. 183).

BOTTOM: A desertlike landscape in Central Panama, the result of frequent burning and severe erosion (fig. 184).

NEXT PAGE: Deforested landscapes are particularly susceptible to invaders that have escaped their natural enemies. The southeast Asian grass *Saccharum spontaneum* escaped into the Panama Canal area about 1970, and has occupied cleared land. In wild parts of its native habitat, elephants and rhinos graze it. In Panama, however, it grows ungrazed, and is burned every dry season, preventing trees from replacing the grassland. This *Saccharum* grassland, with a dead *Cecropia* tree, is close to Gamboa (fig. 185).

185

much carbon dioxide plants use to produce vegetable matter. From satellite-based measurements of the earth's content of chlorophyll, Christopher Field, of the Stanford, California, laboratory of the Carnegie Institute of Washington, and his colleagues found that the world's plants annually produce 260 billion tons dry weight of vegetable matter. In doing so, they use nearly 400 billion tons of carbon dioxide, one-seventh of the atmosphere's total. Most of this is returned to the atmosphere by the respiration of herbivores and decomposers consuming this vegetation.

The earth is clearly warming. In the mountains of Monteverde, Costa Rica, lowland plants and animals are spreading uphill; in the United States, plants and birds of the south are spreading north. The sea is warming and expanding, which makes the sea level rise. Global warming is also melting glaciers, enhancing the rise in sea level. When a marine biologist at STRI, John Cubit, examined sea-level records for the two ends of the Panama Canal, he found that during the past eighty years, sea level has been rising 1.3 millimeters per year on both coasts, which closely matches the average global rise.

How much does an increase in the atmosphere's carbon dioxide content warm the earth? Robert Berner, a geochemist at Yale University, inferred from a study of the fossil record that multiplying the atmosphere's carbon dioxide content by a factor R increases average global temperature by $6 \ln R$ degrees Celsius. Here, "ln" denotes the natural logarithm, the logarithm to the base

e = 2.718. . . . If so, an increase of 0.47 percent per year in the atmosphere's carbon dioxide content increases the global mean temperature by 0.028 degrees Celsius per year. The change is imperceptible over a politician's term of office, but becomes unpleasantly evident after a century, especially if enough ice melts to cause a sharp rise in sea level. Global warming demands long-term thinking; the perspective of geologists is needed to evaluate the phenomenon, and the willingness to think generations ahead is needed to deal with it.

Perhaps the best test of Berner's equation was provided fifty-five million years ago by a sudden, catastrophic release of methane from "methane clathrates" buried on the continental shelves. Methane clathrates are crystals, each unit of which is a molecule of methane enclosed in a cage of water molecules. At -1.5 degrees Celsius, they are stable in sediments under more than 250 meters of water; at 15 degrees Celsius, they are stable only in sediments under 1,460 meters of water. In cores from the sea bottom, methane clathrates are revealed by an explosive derangement caused by the escape of methane gas when "decomposed" by being brought to the surface, or by the lens of fresh water left behind by the escaped methane (methane clathrates contain no salt). Data from sea-bottom cores around the world suggest that today, methane clathrates contain between ten and twenty times as much carbon as the atmosphere.

According to Richard Norris of the Woods Hole Oceanographic Institution and Ursula Röhl of Germany's University of Bremen, the methane released fifty-five million years ago increased the atmosphere's carbon dioxide content by about six trillion tons (box 5.1, p. 244), raising it from five to eleven trillion tons. This increase, which amounts to five hundred years' accumulation at today's rate of twelve billion tons a year, caused the average global temperature to rise about five degrees Celsius, as Berner's equation would predict, from sixteen to twenty-one degrees Celsius. When the weather is warmer and more carbon dioxide is available, plants produce more vegetable matter; how much of this increase is buried undecomposed? Santo Bains of Oxford University, Richard Norris, and two collaborators found that after the methane-induced temperature increase, more organic matter fell incompletely decomposed to the ocean floor and was buried. Nevertheless, it took sixty thousand years for the imbalance between production and decomposition to withdraw this surplus six trillion tons of carbon dioxide from the atmosphere—a withdrawal rate of one hundred million tons of carbon dioxide a year, less than 1 percent of its current rate of increase.

What factors set the atmosphere's increase of carbon dioxide at thirteen billion tons a year? People inject twenty billion tons of carbon dioxide per year into the atmosphere by burning coal and oil. Deforestation is supposed to inject another six billion tons per year, but this number is uncertain. What happens to the carbon dioxide that does not remain in the atmosphere? The ocean is thought to absorb about seven billion tons of surplus carbon dioxide per year, but this number, too, is uncertain. Robert Stallard has calculated that, worldwide, landslides and other eroded sediments bury 0.6 to 1.5 billion tons of veg-

etable carbon per year beyond the reach of decomposers. The burial of this carbon prevents between two and five billion tons of carbon dioxide from returning to the atmosphere. Is the atmosphere's higher carbon dioxide content increasing the excess of plant productivity over consumption and decomposition enough to account for the remaining surplus? Judging from the global-warming event fifty-five million years ago, the excess of production over consumption and decomposition is unlikely to account for more than a hundred million tons of carbon dioxide per year, far from enough to explain today's restrained increase of atmospheric carbon dioxide.

How much will protecting tropical forests restrain global warming? Amazonia contains five million square kilometers, or five hundred million hectares, of tropical forest—more than half the world's total. If this forest contains 120 tons of combustible carbon per hectare, burning it would produce 440 tons of carbon dioxide per hectare. If all of Amazonia were burned, or consumed by termites and fungi, at one go, 220 billion tons of carbon dioxide would enter the atmosphere—slightly more than the carbon dioxide all the land plants of the world use for a year's production of vegetable matter. According to Berner's equation, these 220 billion tons of carbon dioxide would increase the average global temperature by 0.46 degrees Celsius, less than the coal and oil we have burned have already done. Moreover, the fossil record has told us that increased forest production induced by warmer weather and more carbon dioxide cannot do much to mitigate current rates of global warming. Tropical forests benefit humanity in many ways, but they are not the cure for global warming.

A teak plantation close to the Barro Colorado Nature Monument.

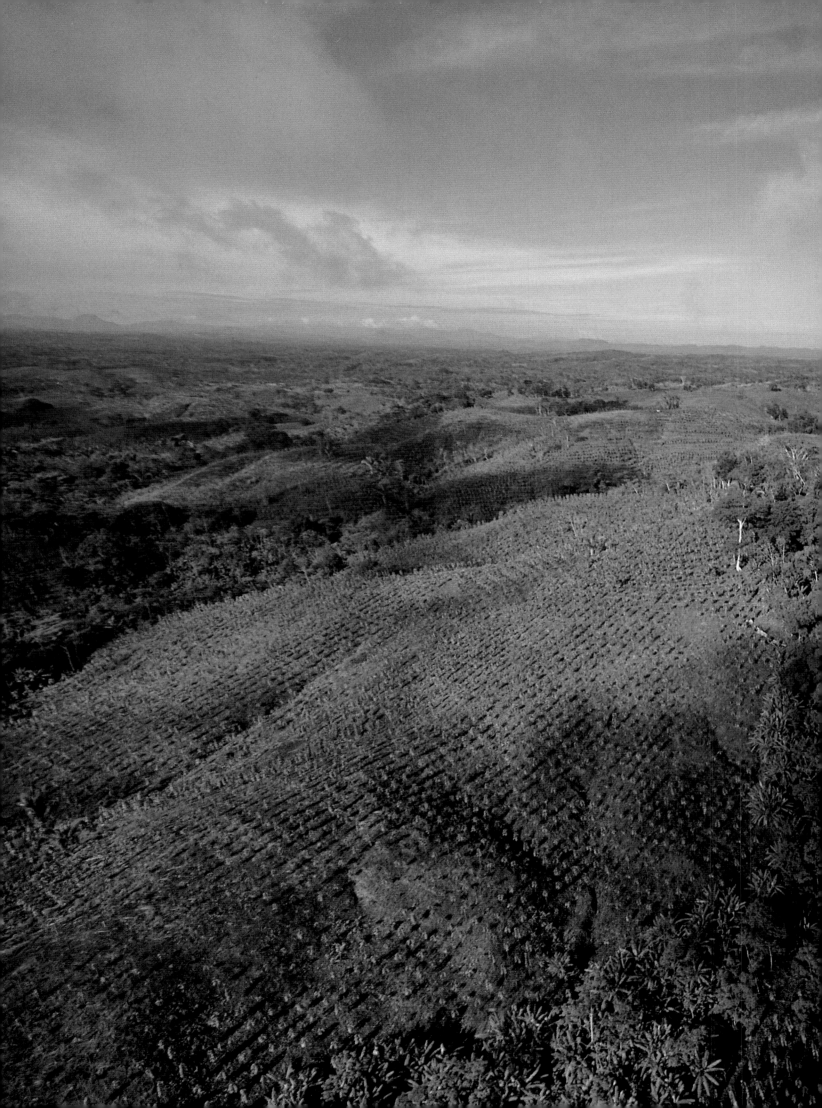

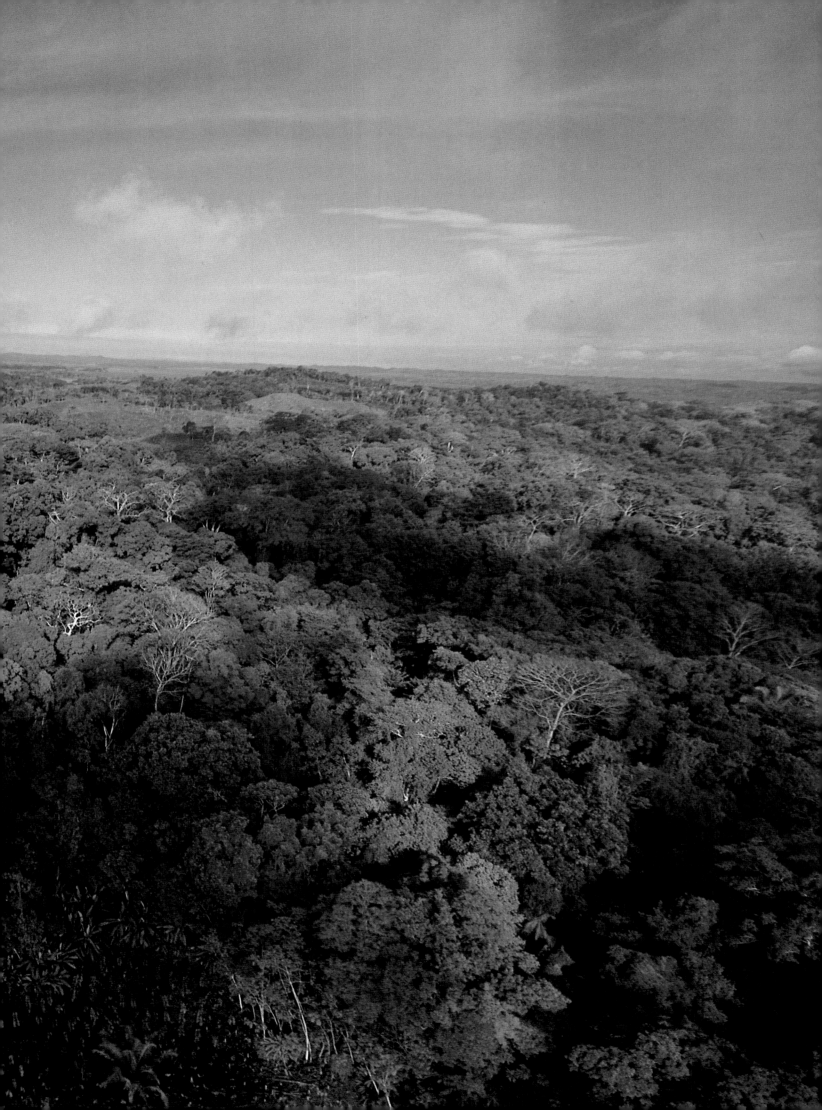

The Fragmentation
and Destruction of Tropical Forests

Tropical forests are being degraded and destroyed in many ways. Between 1981 and 1990, an average of 0.8 percent of the total area of lowland tropical forest was being cleared each year (fig. 180). An additional 0.3 percent per year was logged for the first time, most in an unnecessarily destructive and wasteful fashion. In recent years, most of the land adjoining the southern border of the Barro Colorado Nature Monument has had its original forest removed. In years of El Niño drought, escaped fires burn large tracts of forest in Brazil and Indonesia, creating enough smoke to threaten human health and close the airports of major cities. In Brazil, gold miners are hunting the animals forest trees need to disperse their seeds, and poisoning forest rivers with the mercury they use to extract gold from the rock. The progressive subdivision of the tropical forest into fragments is disrupting forest ecosystems in many ways.

Deforestation and Waste

The most striking feature of the destruction of tropical forests is the enormous waste involved. Usually, tropical forests are destroyed not to institute settled, productive agriculture or agroforestry, but for activities that cannot be sustained for long, many of which leave the land an unproductive wasteland (figs. 182, 183, 184).

The clearing of tropical forests for agriculture need not increase erosion rates or the frequency of flooding, reduce river flow in the dry season, or ruin the land. Indigenous shifting cultivators have long lived in balance with tropical forests in Africa and South America: shifting agriculture threatens the integrity of tropical forest only when too many cultivators are confined to too small an area. The Kofyar tribe of Nigeria has long been farming permanent smallholdings sustainably, causing minimal erosion, without any advice from agricultural extension services. Traditional rice growers of southern and eastern Asia have long provided models of sustainable land use. Nevertheless, deforestation usually damages more than just the forest. Across the Panama Canal from Barro Colorado, Robert Stallard has compared two adjacent catchments with similar bedrock and topography. A third of one catchment is pasture that is burned each year; another 13 percent is pasture that has already been abandoned. The other catchment is entirely forested. The partially cleared catchment has soil that is more compacted and less easily penetrated by rainwater; it suffers heavier, more sudden floods, and has lower flow in the dry season than its forested counterpart. Abandoned pastures and fields near a village adjoining the Barro Colorado Nature Monument have been taken over by sterile grass of a single species, *Saccharum spontaneum* (fig. 185). This paja grassland cannot be redeemed for production without great labor. These events have counterparts not only in Panama

PREVIOUS PAGE: An island of forest in a sea of monotony. This aerial photograph shows the border of the Barro Colorado Nature Monument and monotonous plantations of teak trees beyond. Biological diversity is drastically reduced in such monocultures (fig. 187).

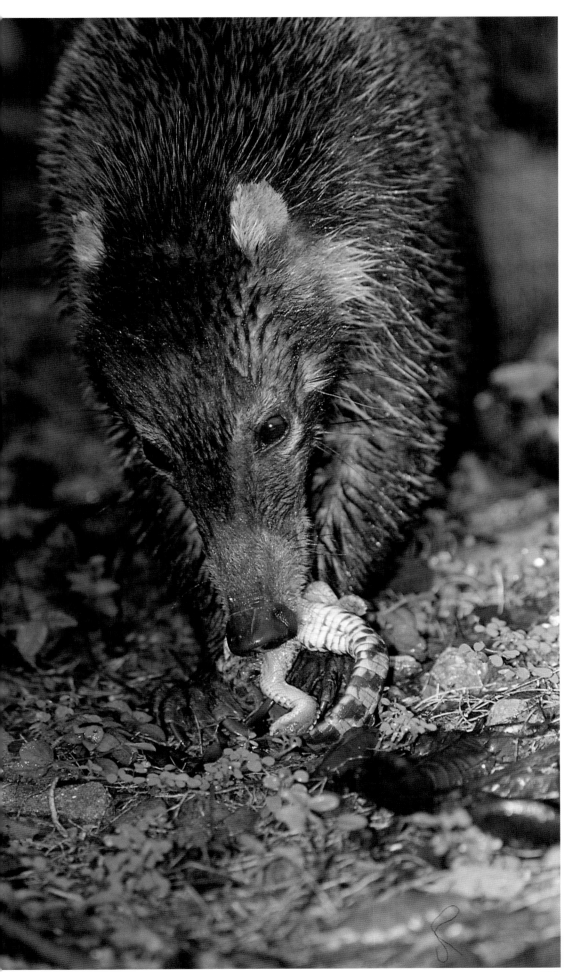

Island effect? Barro Colorado has more coatis (*Nasua narica*) per hectare than comparable forests with more big cats. Coatis have been blamed for causing the disappearance of several species of ground-nesting understory birds now absent from Barro Colorado, but this accusation currently appears to be unjust. This coati is feeding on a crocodile egg that it dug up shortly before the egg was due to hatch.

but in other tropical countries ranging from Puerto Rico to Brazil and from Java to Madagascar.

Logging likewise tends to be heedlessly wasteful. Logging usually destroys 60 percent of a forest to obtain 10 percent of its timber. Advance planning about where to make trees fall, cutting lianas beforehand to keep the trees to be felled from pulling down others, and care in removing the felled trees increase the amount of useful timber extracted while leaving 65 percent, rather than 40 percent, of the forest intact. These techniques for "reduced-impact logging" have been known for more than a century. Most loggers consider them too costly and troublesome to employ, although the belief that reduced-impact logging reduces immediate profits may be a delusion.

Moreover, the means for removing logs cause damage. The heavy machinery by which the logs are taken away compacts the soil. During storms, much of the rainfall cannot penetrate the compacted soil and so runs off on the surface, aggravating erosion and making flooding more likely. The hastily bulldozed and carelessly placed logging roads, surfaced merely by the mud the bulldozers expose, become rapidly deepening channels of erosion. These effects of logging can be mitigated with proper care, but this care is rarely shown.

In sum, most clearing and logging of tropical forests involve practices that sacrifice the interests of neighbors downstream and of future generations to immediate profit and convenience.

Why This Heedless Waste?

Ways to mitigate the detrimental effects of deforestation and make more enduringly profitable use of cleared land have long been known. Because wasting cleared land begets more deforestation to clear more land to waste, it behooves us to ask why newly cleared land is not used more carefully.

Many people consider the Hebrew scriptures hostile to nature because their primary emphasis is on human beings, and in particular on our need to show love of God and neighbor by maintaining social harmony and responsibly using the land that God has given us. Yet these scriptures claim that social injustice injures nature. The prophet Isaiah blames failed harvests on social injustice, warning "Shame on you! You who join house to house and field to field, until not an acre remains, and you are left alone in the land. The Lord of Hosts has sworn in my hearing: . . . Five acres of vineyard shall yield only a gallon, and ten bushels of seed return only a peck"(Isaiah 5:8-10, New English Bible). The prophet Hosea warns, moreover, that human injustice also injures wild nature: "Hear the word of the Lord, O Israel; for the Lord has a charge to bring against the people of the land. There is no good faith or mutual trust, no knowledge of God in the land, oaths are imposed and broken, they kill and rob; there is nothing but adultery and licence, one deed of blood after another. Therefore the land shall be dried up, and all who live in it shall pine away, and with them the wild beasts and the birds of the air; even the fish shall be swept

ABOVE: Small islands or forest fragments have reduced plant diversity. One picture taken on Barro Colorado shows a dozen species of seedlings . . .

BELOW: . . . whereas the other, taken of the same area of forest floor on a nearby islet in Gatun Lake, shows only one species.

from the sea" (Hosea 3:1-3, New English Bible). This message gets to the heart of the environmental crisis. The greatest threat facing tropical rain forests is not biological ignorance but social injustice, both within and among nations.

The wastefulness of tropical deforestation reflects social indifference and social conflict. Modern loggers, strangers to the communities where they log, show no more understanding of or concern about how their activities might affect rainforest peoples than the settlers of America's Great Plains showed for the needs and fears of their nomadic predecessors. Meanwhile, distrust of foreign loggers leads tropical governments to lease logging concessions for periods too short to give loggers any incentive to think beyond their first harvest, which reinforces the vicious circle of distrust and waste.

Tropical forests also suffer because tropical governments are far more likely to be overthrown by urban riots than by rural unrest. These governments accordingly seek to keep food prices low enough to prevent such riots. Therefore, even honest politicians are more interested in current income from the "national forestry estate" than in the effect of logging practices on country people. The food prices thus subsidized are often too low to allow farmers to mobilize the resources needed for settled agriculture. Similarly, tropical governments often promote the buyout and subsequent displacement of small farms by large agrobusinesses that grow taxable export crops—not always sustainably. Especially in countries where agrobusiness has preempted the best land, population growth often forces people to farm land that should be left forested, aggravating erosion and flooding. The urgency of repaying debts increases the pressure on tropical countries to generate exports however they can, often at the expense of the rain forest and in ways that aggravate social injustice.

Worse yet, the attempts of tropical governments to arrest the environmental crisis often backfire. Poorly worded incentives for reforestation encourage landowners to clear natural forest in order to "reforest" their land with teak or some other exotic tree. Campaigns promoting the virtues of smaller families often become another engine of social conflict. Children are the only "social security" a poor family may have. Moreover, many societies view children, not unreasonably, as gifts of God, to be prized as such. Birth rates tend to drop only when the education of women opens new opportunities for them, or when economic conditions improve enough to diminish child mortality and make it worthwhile to prepare a few children well for life, rather than many more poorly.

A rooted prejudice that bigger is always better, held by politicians and granting agencies alike, makes it more difficult to develop the sort of settled agriculture that reduces pressure on the forest. Robert Netting, an anthropologist at the University of Arizona, found that sustainable agriculture is most likely to be practiced by traditional smallholders with heritable land tenure under rules that ensure that farmers derive most of the benefit from improving their farms or discovering better ways to cultivate them. Among such smallholders, family farms and the techniques for their cultivation are the

parents' primary bequests to their children. When the farm is the family's future, it will be well cared for if the family knows how.

Smallholder agriculture, however, faces many obstacles. Some countries lack a tradition of sustainable agriculture. In Panama, colonists settled a land that disease and slavery had largely emptied of its former inhabitants. The poorer colonists, at least, practiced shifting agriculture because it takes so much less work, and demands so much less money, than the sustained variety. Fields abandoned by shifting cultivators were taken over by cattle ranchers rather than left to be reclaimed by the forest. Now population growth, and increasing concern for the remaining forest, entails too frequent reuse of the available land; shifting agriculture is no longer sustainable. Yet much of Panama's rural society is still organized around the clearing of new land. In lowland Panama, developing a traditional smallholder agriculture is so traumatic that various forms of agro-industry are preempting much of the usable land in the meantime (fig. 186).

Rising expectations lead some smallholders to scorn their land and their occupation as unable to support the life they want. Once the land becomes merely a vehicle to a better life elsewhere, it is treated less carefully. Farmland is most at risk when social change is rapid; during times of slower change, people emigrate and the remaining farms expand until they become economically viable.

In sum, smallholders farm sustainably if farming meets their expectations of life and if they know and love their land and understand their crops, know and trust their neighbors, have secure tenure, and can profit from their innovations. Scarcity of land, civil disorder, and the lure of economic opportunity, however, are uprooting more and more people from their networks of social relationships and pitching them into other lands and other societies that they do not know or understand, among people to whom they feel little responsibility. Many governments are promoting the settlement of "empty" lands by farmers whose previous experience gives them no idea how to cultivate the land they are given. Thanks to the social gulf between the rich and the rural poor, some businesspeople do not realize, or do not heed, the effects on their poorer neighbors of polluting the water or the air, just as some large landowners are happy to arrange the invalidation of the land titles of nearby smallholders to create a pool of cheap labor for their own estates.

Forest Fragmentation

Deforestation for agriculture, however careful it may be, leaves remnant patches of forest—private or communal woodlots, and sometimes even tracts of forest preserved in remembrance of bygone splendor. The damming of rivers to make reservoirs also creates forest fragments in the form of islanded hilltops. Barro Colorado is one such fragment.

Fragmentation causes change. Big as it is, Barro Colorado is too small to support a herd of white-lipped peccaries, which normally contains a hundred

animals or more. No white-lipped peccary herd has been seen there since the 1940s. About eight other species of mammals became extinct from Barro Colorado after it became an island. Four of them disappeared because clearings were overgrown or because secondary forest matured. Barro Colorado has also lost the large ocellated ant-bird, which, unlike its smaller counterparts, depends exclusively on insects flushed by army ants. Barro Colorado is apparently too small to ensure that, even in a bad year, a hungry ant-bird can always find a large swarm of army ants flushing insects. Unreliable food supply, however, is not the only cause of extinction on Barro Colorado. Of the 121 species of birds breeding in Barro Colorado's older forest in 1921, 25 were gone by 1996. Most of the bird species that died out nested or foraged on the ground. Douglas Robinson of Auburn University finds that birds on Barro Colorado that nest near the ground lose more eggs and nestlings to predators than do counterparts of the same species on the mainland. He is now trying to discover what predators are responsible, and why these predators are more common on Barro Colorado than on the mainland.

Indeed, many people now claim that Barro Colorado's isolation has irretrievably changed its ecology. The primary charge is that Barro Colorado lacks big cats—pumas and jaguars. Therefore the coatis (fig. 188) and opossums they should have eaten are so common that they have extinguished many bird species nesting near the ground by eating so many of their eggs and nestlings. In truth, Barro Colorado has never been noted for its abundance of jaguars, but it is full of ocelots, and is now regularly visited by pumas. Pumas were still common there shortly after 1945. Nonetheless, in 1948 coatis were still so common on Barro Colorado, despite all those pumas, that a postage stamp honoring the island's twenty-fifth year as a reserve featured a coati. More generally, just how isolation is affecting Barro Colorado remains a mystery.

On smaller fragments, the forest is more severely disrupted and its community more obviously impoverished. One-hectare islets near Barro Colorado in Gatun Lake support no resident mammals. More than half of an islet's trees may belong to its most common species, a circumstance unheard of for a hectare plot on Barro Colorado (figs. 189, 190). Wind sweeping across the lake tears at the edges of these islets' forests, overthrowing big trees. The fallen giants are replaced by dense thickets of shorter trees. Compared to Barro Colorado, even forty-hectare islands have few kinds of mammals, and their abundance and diversity of birds are also low. Forest fragments surrounded by pasture often suffer more; they are liable not only to windthrow but to invasion by fires, cows, and weeds. In some places, to be sure, such as near the Malay Peninsula's Pasoh Reserve, wind is rare and the countryside is too well kept to threaten its forest fragments with fire or invasive weeds or animals. Under these benign conditions, trees die slowly and the forest in the fragments appears little changed. These fragments, however, are too small to support the mammals and birds that disperse their trees' seeds. Many of the birds and larger insects that pollinate flowers must also be absent. When the old trees die, will trees of only a few species replace them? Even a large fragment is

unlikely to retain indefinitely the splendid diversity of the forest of which it was once a part.

A forest newly fragmented by a reservoir is, however, an opportunity as well as a tragedy. Some animals disappear from the newly formed islets; others, safe from predators or competitors, multiply. What differences do all these changes make? One-hectare islets near Barro Colorado lack agoutis, which bury tree seeds. Four tree species are taking over these islets, all with large seeds that are safe from insect attack during at least the latter part of their fruiting season. These species can replace themselves even where there are no agoutis to bury their seeds. Are other tree species disappearing from these islets because insects destroy their seeds when there are no agoutis to bury them?

With many collaborators, John Terborgh of Duke University is studying changes on islets recently formed by a fifty-meter rise in the water level of Venezuela's Guri Reservoir. For Terborgh, fragmentation is a "natural experiment" that reveals what factors maintain the balance of nature on the nearby mainland.

On the one-hectare islets in Lake Guri, herbivores burgeoned. Howler monkeys were trapped on some islets, and survived there at densities four times that on Barro Colorado. Dispersal of their young regulates the populations of mainland howlers, which must not only survive the season of food shortage, but be strong enough to fend off competing troops. On these islets, howlers have nowhere to go, and no competing troops to face, so they can maintain amazingly high numbers per hectare, at least for a while.

Worse yet, a one-hectare islet in Lake Guri can have six full-grown colonies of leaf-cutter ants—enough to eat 25 percent of the islet's leaf production. Terborgh and his colleagues found no leaf-cutter ant colonies on a twenty-hectare plot of mainland forest. Something on the mainland, absent from the islets, must control leaf-cutter ant populations. Army ants destroy young ant colonies of all kinds, including leaf-cutters. Army ants, however, cannot survive on islands of fewer than 150 hectares. Are army ants the agents that keep down the numbers of leaf-cutters on the mainland?

Terborgh and his colleagues found that this superabundance of herbivores on Lake Guri's islets severely limits the number of seedlings that survive there. Moreover, few species of seedlings—presumably the most distasteful or poisonous—can sprout there. In diverse rain forests, plants can afford to grow fast because others of their species are far off, making it hard for specialist pests, which are the most destructive, to pass from one plant to another of the same species. Scattered plants can therefore spend more on growth than on defense against pests. Plant diversity, however, depends on animals—pollinators and seed dispersers—that allow a species of plant to survive even when made rare by its pests. Fragmentation of the forest disrupts visits from pollinators and seed dispersers and removes controls on herbivores. Consequently, on forest fragments a far less diverse, better-defended, slower-growing vegetation, less dependent on animals for pollination and seed dispersal, is replacing the luxuriant diversity of unbroken tropical forest. The

last 150 million years of plant evolution replaced tropical forests of a rela-tively few well-defended, slow-growing plants (conifers, cycads, ferns, and the like) with the baroque diversity of flowering plants, which feed and employ so great a multitude of animals. Forest fragmentation has suddenly thrown this process into reverse, and a marvelous world is passing away.

Social injustice arising from unconcern for other human beings is degrad-ing the elaborate mutualism of human civilization. The degredation of civi-lization, in turn, is unraveling another equally elaborate mutualism, the one by which the pollinators, seed dispersers, carnivores, and insectivores of trop-ical forests maintain the diversity and make possible the productivity of their trees and other plants. Careless, wasteful land use, an implicit denial of responsibility to and relationship with other human beings, sometimes ends by creating a single-species grassland, in Panama as in Indonesia. This grass-land is a living denial of relationship with animals and other plants; it uses the wind to carry its pollen and disperse its seeds, and depends on fire to sup-press its competitors and extend its borders. This grassland is the ultimate in choking monopoly, a grim contrast to the beauty and diversity of tropical rain forests, and a mirror of the absence of relationship among human beings.

Preserving Tropical Forests

Tropical forest parks and reserves face many threats. Especially where other land is scarce, some people want to farm in these areas, or let domestic ani-mals feed there. Others want the timber. Oil lies under some rain forests, gold under others, attracting miners; the extraction of either entails damage, sometimes catastrophic, to tropical forest ecosystems and their peoples. In some rain forest reserves, overcollection by nearby villagers endangers medicinal plants. Above all, rain forest reserves attract hunters, who seek meat to eat, and increasingly often, to sell (fig. 191).

Protecting Barro Colorado

Barro Colorado is fortunate. No miners are eying it. No one has tried to poach timber, or clear a garden, on either Barro Colorado or the surrounding penin-sulas of the Barro Colorado Nature Monument after they were declared reserves.

Hunters, however, plagued Barro Colorado Island until the Smithsonian Tropical Research Institute could afford enough game wardens to keep them out. In 1932, a sudden surge of poaching caused Barro Colorado's populations of cats and tapirs to plummet. In 1969, hunters were visiting Barro Colorado so freely that litter traps—green tubs a foot across placed in the forest by Robin Foster to measure the fall of leaves, flowers, and fruit—had to be replaced until the villagers nearby had as many as they wanted. By 1985, poaching on Barro Colorado had ended. STRI had put one of its scientists,

OPPOSITE: Game wardens with a confiscated boat full of iguanas that were poached for sale as "bush meat" (fig. 191).

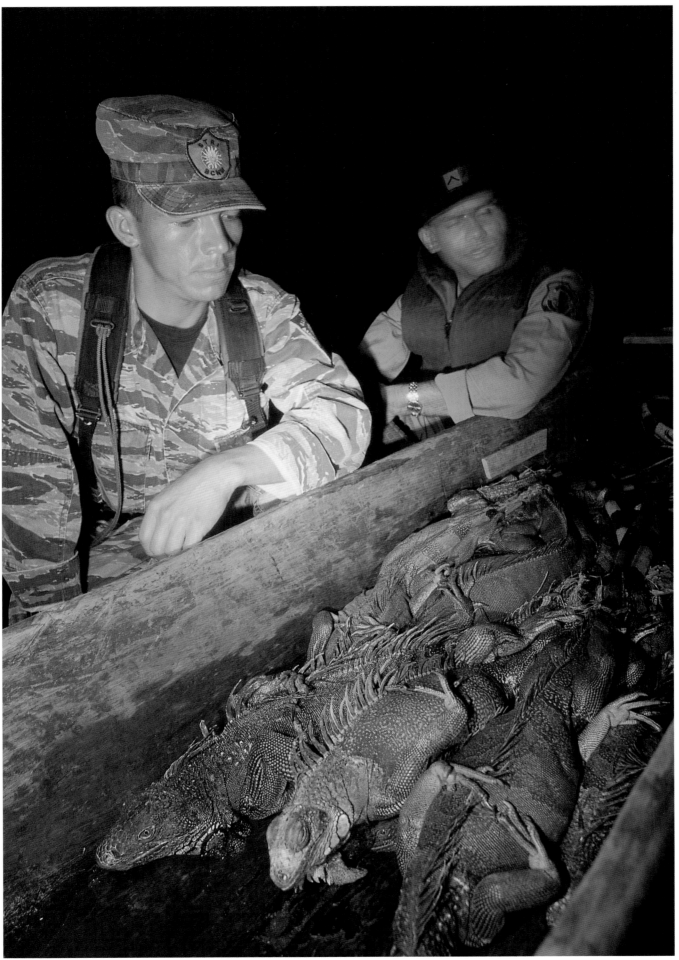

S. Joseph Wright, in charge of the game wardens (fig. 192); he took an interest in them, listened to their advice, changed the schedule of patrols frequently and unpredictably, and organized ambushes where poaching was most frequent. His plan worked.

Barro Colorado is too small to maintain its full diversity. To provide habitat enough to maintain animals willing to fly or swim to the mainland, STRI acquired five nearby forested mainland peninsulas to form the Barro Colorado Nature Monument (BCNM), protecting fifty-five hundred hectares of forest. In turn, the BCNM shares a border with Panama's twenty-two-thousand-hectare Parque Nacional Soberanía. Together, they protect more than twenty-seven thousand hectares of forest.

The protection of these peninsulas, however, caused resentment among nearby villagers who were newly excluded from forests in which they used to hunt. The resentment was the greater because there was little other forest where they could hunt. They accordingly felt no compunction about hunting in these peninsulas and helping others do so. One angry poacher shot a Panamanian police officer patrolling with STRI game wardens (the poacher was caught and punished). STRI's wardens have had their work cut out for them to keep poaching on these peninsulas down to a dull roar. They are succeeding; mammals of all kinds are more common there now than in 1979, and not much less common than on Barro Colorado Island. STRI's efforts to mend fences with the villagers have been less successful. Most of STRI's representatives there, including all of its game wardens, are college graduates, most of whom are not at their best with country people. More generally, simply keeping people out of reserves never assures a stable future for conservation.

The Threats Game Wardens Cannot Cope With

Currently, however, the Barro Colorado Nature Monument faces threats more ominous than upset villagers. Although the monument is part of nearly thirty thousand hectares of protected forest, even this tract is not big enough to preserve the forest ecosystem intact. A few kinds of birds that used to migrate seasonally from the Parque Soberanía to the forested slopes of the upper Río Chagres disappeared from the park when the forest connecting the park to the mountains was cleared away. Barro Colorado is a wintering ground or a travel route for many migrant birds that breed in North America. Some of Barro Colorado's plants time their fruiting to employ these migrant birds as seed dispersers. Adverse developments in North America or along the flyways could cause these birds to stop visiting Barro Colorado.

Several kinds of bats live on Barro Colorado only in certain seasons. Some of its insect populations die out or move elsewhere every year, to be replaced later by migrants from the mainland. Many of Barro Colorado's butterflies migrate en masse during certain seasons. We do not know

PREVIOUS PAGES: Game wardens leaving the laboratory cove to go out on a night patrol (fig. 192).

where any of these animals go when they leave the island, or how safe their flyways and their other homes are.

Game wardens are likewise unable to protect Barro Colorado from the changes in climate resulting from the atmosphere's increasing load of carbon dioxide, or from increase through air pollution in the supply of nitrates and nitrites from the atmosphere to the forest canopy. Winds transport dust from the Sahara, and pollutants created by burning forest and scrub south of the Sahara, to the Caribbean and Central America. These pollutants include viable spores of bacterial and fungal pathogens. Die-offs of corals around certain Caribbean islands have been caused by the soil fungus *Aspergillus,* whose spores are among the pollutants blowing in from Africa. Although water separates Barro Colorado from the mainland, this island is not immune to the effects of events on the Panamanian mainland or in far distant parts of the world.

Building a National Consensus for Conservation

The Smithsonian Tropical Research Institute has been fortunate to enjoy the favor of successive governments of Panama and of Panamanian opinion at large. Most Panamanians do not view conservation as a ploy of First World interests to block national development. Nor do most Panamanians view conservation as a cover for reserving large tracts of virgin land for the exclusive enjoyment of rich foreign tourists and the further enrichment of a few wealthy city dwellers, local or foreign.

Indeed, Panamanians are becoming increasingly aware that preserving the forest that remains in areas draining into the Panama Canal reduces the rate at which the canal fills with sediment. They are also showing a growing appreciation of tropical nature. Panama has several active conservation organizations. When a toll highway was built through a forest park bordering Panama City, there was a storm of protest—not enough to stop the highway, but enough to show that in Panama, tropical nature has many advocates.

STRI has promoted conservation much more successfully to the Panamanian public at large than to its immediate neighbors. Panamanian students have gained research experience at STRI that enabled some to complete graduate work in the United States or elsewhere and others to find more satisfying jobs in Panama. Many of them are now working in the cause of conservation. A growing program for day visits to Barro Colorado with Spanish-speaking guides is spreading the word about the beauty of the tropical forest. STRI's efforts to communicate the results of its research on tropical nature—in popular books, newspaper articles, and television programs—have also helped.

A true consensus for conservation, however, is a long way off in Panama, as it is in the United States. Panama's most powerful conservation organizations are the least competent in convincing country people of the benefits of con-

servation. Urban sprawl proceeds apace, with its attendant air pollution. The Panama Canal catchment has 150,000 people in it: 90,000 of them live within 2.6 kilometers of the highway crossing the isthmus. Yet Barro Colorado, with its fifty residents, has one of the catchment's only two sewage treatment plants. (The other serves a resort hotel.) The influx of sewage into the catchment's streams fertilizes great expanses of water lettuce in the lower Río Chagres, which is sometimes flushed into the Panama Canal after heavy rains.

Monteverde: A Conservation Success

Few conservation efforts are initiated by local communities in the tropics, yet conservation programs initiated and controlled by local communities are likely to be the most successful. Near Barro Colorado, the most famous achievement of community-level conservation is the work at Monteverde, a mountain community in Costa Rica where Quaker dairy farmers from Alabama settled in 1951. To protect their watershed, these settlers set aside a reserve of 554 hectares of ridge-top forest from the more than 1,400 hectares of land they had originally purchased. Thanks to local initiative, this original reserve has since mushroomed into an array of contiguous reserves protecting tens of thousands of hectares of montane forest. How did this happen?

A just economic system helped. When the Quakers arrived, 175 people were living on farms in the Monteverde area. Major social inequality had not yet developed. The Quakers decided that the dairy product most easily transported over the area's rough roads was cheese, so they started a cheese factory. Following the Quaker habit of fair dealing with all comers, they offered fair prices for everyone's milk. As a result, most people in the area became well enough off that they could afford to plan for the future.

Indeed, the Quakers' social ethics and religious beliefs favored conservation in many ways. As Wolf Guindon, one of the original Quaker settlers, put it, Monteverde was to be a "community that sought the good of every one of its members and experimented in ways of living that would naturally lead to peace in the world. To reach solutions through group decision-making, allowing time for all views to be presented and considered, was challenging. The basic belief in the visible and invisible power of creation, and the interrelatedness of all life, and the desire to live simply and close to nature were among the common values that strengthened the community. There was always a concern for the wise use of our natural resources and for the protection of our watershed."

In accordance with these aims, the Quakers took care of their land and its watershed, as befitted their intention to stay indefinitely, rather than use the land as a disposable vehicle to a better life elsewhere. Moreover, the Quakers sought the consensus of the whole community, not just themselves. Community wide consultation over concerns expressed by any member, and the proliferation of organizations of mutual assistance, greatly strengthened Monteverde's sense of community.

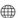

The Quakers were originally more careful of their land than of wild animals, but their belief in the goodness of creation made them receptive to the views of the biologists they sheltered on the virtues of wild nature as a whole, animals and all. Thus, when the biologists sought to extend the boundaries of the reserve to protect quetzals, tapirs, and other wide-ranging animals, the Quakers offered full and effective support.

The Quakers, who valued education, provided a good school. Its graduates were intellectually equipped to understand issues of community responsibility, sustainable land use, and appropriate ways to achieve conservation. When biologists and their Quaker supporters applied to international organizations for money to buy additional land for their reserves and to hire people to protect and manage them, these organizations were delighted to oblige that rarest of all rarities, a rural community in the tropics with forest worth preserving, a shared will to preserve it, and knowledge of how to do so effectively.

The Quakers entrusted the management of their original 554-hectare preserve to San José's Tropical Science Center. The center decided to invite paying tourists to the reserve to finance its maintenance and protection. Tourists liked what they saw, and told their friends. In due time, inhabitants of Monteverde were building hotels and eating places to serve these tourists. Biologists at Monteverde wrote guidebooks and trained nature guides to show the visitors the cloud forest. Thanks to local initiative, the ecotourist boom began, and because the boom involved local enterprises, it developed in accord with community norms. As tourist traffic grew, new commercial cloud-forest preserves were created to meet the growing demand. The whole community profited, giving all a stake in the integrity of the cloud forests, which was an ideal basis for their conservation.

Earlier, we saw how the way tropical forests are destroyed often reflects the lack of concern shown by human beings for their fellows. Conversely, the conservation miracle at Monteverde was made possible by the Quaker penchant for neighborliness and social justice, which restored some measure of mutual concern and social harmony among those living in the Monteverde area. Can a sense of community among human beings spread fast enough to provide enduring, satisfying livings for people and suitable homes for plants and other animals throughout the tropics?

WHERE TO LEARN MORE

Introduction

There are several readable books in which one can learn more about tropical forests. E. J. H. Corner gives a compelling account of tropical forest in *The Life of Plants* (World Press, 1964). This book recounts plant evolution from the microscopic algae of the open ocean to trees, and celebrates tropical forest as the climax of plant evolution. Other brief introductions to tropical forest are T. C. Whitmore, *An Introduction to Tropical Rain Forests*, 2d ed. (Oxford University Press, 1998), and John Terborgh, *Diversity and the Tropical Rain Forest* (Scientific American Library, 1992). Most biologists of the writer's generation first learned about rain forest from P. W. Richards, *The Tropical Rain Forest* (Cambridge University Press, 1952); a much enlarged second edition appeared in 1996 from the same press. A more detailed account of the forest of Barro Colorado, and some of its animals, is provided by E. G. Leigh, Jr., A. S. Rand, and D. M. Windsor, eds., *The Ecology of a Tropical Forest* (Smithsonian Institution Press, 1996). E. G. Leigh, Jr., considers the forest on Barro Colorado from a worldwide perspective in *Tropical Forest Ecology* (Oxford University Press, 1999). That work, hereinafter referred to only by its title, is the primary source of information for this book. We have also drawn data and ideas from many other sources, as detailed below. When an article is cited only for statistics on a particular page, its title will not be given.

Chapter 1
The Enormous Variety of Tropical Organisms

Why there are so many kinds of tropical trees, and why plants and animals come in many different kinds, are discussed in chapter 8 of *Tropical Forest Ecology*. Why the tropics shelter so many more kinds of animals than the temperate zone is discussed by Robert MacArthur in *Geographical Ecology* (Harper and Row, 1972).

The numbers of trees and tree species in a 120-by-80-meter rectangle of forest in Brunei are given in S. J. Davies and P. Becker, *Journal of Tropical Forest Science,* vol. 8 (1996), p. 544. Data for other sites are from table 8.5 of *Tropical Forest Ecology.*

Data in table 1.1A for Indiana are from *Tropical Forest Ecology*, p. 203; data for the tropical sites are from the Center for Tropical Forest Science, an organ of the Smithsonian Tropical Research Institute that coordinates the inventory and recensus of trees and saplings on Forest Dynamics Plots in tropical forests around the world. See, for example, J. Plotkin et al., "Predicting Species Diversity in Tropical Forests," *Proceedings of the National Academy of Sciences, USA,* vol. 97 (2000), pp. 10850-54. In table 1.1B, data for Europe and the eastern United States are from R. E. Latham and R. E. Ricklefs in *Species Diversity in Ecological Communities,* ed. R. E. Ricklefs and D. Schluter (University of Chicago Press, 1993), p. 296; data for Panama and Malaysia are from R. Condit et al., *Journal of Ecology,* vol. 84 (1996), p. 559.

Data on bat diversity in table 1.2 for Indiana and eastern Germany are from tables 4.1 and 4.2 in James Findley, *Bats* (Cambridge University Press, 1993). Data for Panama are from E. K. V. Kalko in *Tropical Biodiversity and Systematics,* ed. H. Ulrich (Zoologisches Forschungsinstitut and Museum Alexander Koenig, Bonn, 1997), pp. 24-27, supplemented by a personal communication from Kalko.

The impact of a sudden global warming fifty-four million years ago on the vegetation of southern Wyoming is described in P. Wilf and C. C. Labandeira, "Response of Plant-Insect Associations to Paleocene-Eocene Warming," *Science,* vol. 284 (1999), pp. 2153-56.

Data in table 1.3 for Santa Rosa, Costa Rica, are from R. J. Burnham, *Biotropica,* vol. 29 (1997), p.

388; the remaining data are from table 8.6 of *Tropical Forest Ecology.*

Table 1.4 is based on A. H. Gentry's table VIII in *Evolutionary Biology,* vol. 15 (1982), p. 38.

Sexual selection and its role in speciation are described by William Eberhard in two books, *Sexual Selection and Animal Genitalia* (Harvard University Press, 1985), and *Female Control* (Princeton University Press, 1996). An example of the role played by sexual selection in the division of one butterfly species into two is given by Christopher Jiggins et al., "Reproductive Isolation Caused by Color Pattern Mimicry," *Nature,* vol. 411 (2001), pp. 302-5. Sexual selection among giant damselflies is described in two papers by Ola Fincke, "Consequences of Larval Ecology for Territoriality and Reproductive Success of a Neotropical Damselfly," *Ecology,* vol. 73 (1992), pp. 449-62, and "Interspecific Competition for Tree Holes: Consequences for Mating Systems and Coexistence in Neotropical Damselflies," *American Naturalist,* vol. 139 (1992), pp. 80-101.

The quotation from Martin Moynihan is found in *Journal of Theoretical Biology,* vol. 29 (1970), p. 103.

Rapid speciation involving divergent sexual selection in the fishes of Lake Victoria, where hundreds of species have diversified from a common ancestor, perhaps in just fifteen thousand years, is discussed in Ole Seehausen, J. J. M. van Alphen, and F. Witte, "Cichlid Fish Diversity Threatened by Eutrophication That Curbs Sexual Selection," *Science,* vol. 277 (1997), pp. 1808-11; O. Seehausen and J. J. M. van Alphen, "Can Sympatric Speciation by Disruptive Sexual Selection Explain Rapid Evolution of Cichlid Diversity in Lake Victoria?" *Ecology Letters,* vol. 2 (1999), pp. 262-71; and O. Seehausen, J. J. M. van Alphen, and R. Lande, "Color Polymorphism and Sex Ratio Distortion in a Cichlid Fish as an Incipient Stage in Sympatric Speciation by Sexual Selection," *Ecology Letters,* vol. 2 (1999), pp. 367-78. Geoffrey Fryer questions whether Lake Victoria's cichlids diversified so rapidly in "On the Age and Origin of the Species Flock of Haplochromine Cichlid Fishes of Lake Victoria," *Proceedings of the Royal Society of London,* series B, vol. 268 (2001), pp. 1147-52.

Interdependence: The Many Ways Different Species Depend on One Another

The role of mutualism in tropical forest is discussed in chapter 9 of *Tropical Forest Ecology.* Darwin's last book is *The Formation of Vegetable Mould through the Action of Worms* (John Murray, 1881; reprint, University of Chicago Press, 1985).

Philip DeVries describes the subversion of ant-plant mutualisms in "Singing Caterpillars, Ants, and Symbiosis," *Scientific American,* October 1992, pp. 76-82.

Barro Colorado's most common leaf-cutters, *Atta colombica,* make dumps. Leaf-cutters of other species bury their garbage; one spots their nests by areas several meters wide where ants have cleared away all the low vegetation. The measures leaf-cutter ants take to preserve their leaf-digesting fungus from contamination are described in C. R. Currie et al., "Fungus-Growing Ants Use Antibiotic-Producing Bacteria to Control Garden Parasites," *Nature,* vol. 398 (1999), pp. 701-4, and C. R. Currie and A. E. Stuart, "Weeding and Grooming of Pathogens in Agriculture by Ants," *Proceedings of the Royal Society of London,* series B, vol. 268 (2001), pp. 1033-39.

How the inflorescences of one species of aroid heat up to spread an odor attracting pollinators without cooking them is described in R. S. Seymour, G. A. Bartholomew, and M. C. Barnhart, "Respiration and Heat Production by the Inflorescence of *Philodendron selloum* Koch," *Planta,* vol. 157 (1983), pp. 336-43.

In table 1.5, on the area from which a fig tree can call pollinating wasps, data for *Ficus obtusifolia* are from figure 2A in J. D. Nason, E. A. Herre, and J. L. Hamrick, *Journal of Biogeography,* vol. 23 (1996), p. 506. The data for *Ficus dugandii,* and an explanation of the project, are given in J. D. Nason, E. A. Herre, and J. L. Hamrick, "The Breeding Structure of a Tropical Keystone Plant Resource," *Nature,* vol. 391 (1998), pp. 685-87.

The story of how human overhunting changed the area around the Bering Strait from grassland into moss tundra is told in S. A. Zimov et al.,

"Steppe-Tundra Transition: A Herbivore-Driven Biome Shift at the End of the Pleistocene," *American Naturalist,* vol. 146 (1995), pp. 765-94.

How forestry can be improved by imitating nature is outlined by E. F. Bruenig in chapter 6 of *Conservation and Management of Tropical Rainforests* (CAB International, 1996), and by Jerry Franklin et al., "Alternative Sylvicultural Approaches to Timber Harvesting: Variable Retention Harvest Systems," in *Creating a Forestry for the Twenty-First Century,* ed. Kathryn Kohm and Jerry Franklin, pp. 111-39 (Island Press, 1997).

Chapter 2

Klaus Winter, a plant physiologist, opened his job seminar at the Smithsonian Tropical Research Institute with the remark that we, and all other organisms on this planet, are the guests of its green plants. He got the job.

A forest's leaf area, light interception, and photosynthesis are described in chapter 6 of *Tropical Forest Ecology.* How much water forests use, and how a forest functions as a giant air conditioner, are described in chapter 3 of the same book. How the evolution of forests caused global cooling is described in Gregory Retallack, "Early Forest Soils and Their Role in Devonian Global Change," *Science,* vol. 276 (1997), pp. 583-85.

Table 2.1 is based on table 3.10 of *Tropical Forest Ecology.*

The quotation about evapotranspiration is from Corner, *Life of Plants,* p. 107.

Finding Light

How much wood a forest uses to carry its leaves, and how rapidly a forest renews its wood, are discussed in chapter 6 of *Tropical Forest Ecology.* Death rates for trees of different sizes on Barro Colorado's fifty-hectare Forest Dynamics Plot are given in table A.1.

TABLE A.1

Trees of Different Sizes (*N*), in Different Years, and Death Rate (*m*), in Intervening Intervals

Diameter Class	N, 1985	m, 1985–90	N, 1990	m, 1990–95	N, 1995
5 ≤ 10 cm	24,490	1.97	29,024	1.98	28,906
10 ≤ 20 cm	12,745	1.97	13,154	1.92	13,307
20 ≤ 40 cm	5,277	1.96	5,333	1.83	5,415
40 ≤ 80 cm	2,012	2.12	1,971	2.08	1,968
80 + cm	323	1.45	368	1.19	370

Contrasting ways of being an epiphyte are described in José Luis Andrade and Park Nobel, "Microhabitats and Water Relations of Epiphytic Cacti and Ferns in a Lowland Neotropical Forest," *Biotropica,* vol. 29 (1997), pp. 261-70. The load of epiphytes in a Bornean rain forest is given in table 2 of T. Yamakura et al., *Southeast Asian Studies,* vol. 23 (1986), p. 464.

The habits of strangler figs, other hemi-epiphytes, and lianas are discussed in N. M. Holbrook and F. E. Putz, "Physiology of Tropical Vines and Hemiepiphytes: Plants That Climb Up and Plants That Climb Down," in *Tropical Forest Plant Ecophysiology,* ed. S. S. Mulkey, R. L. Chazdon, and A. P. Smith (Chapman and Hall, 1996), pp. 363-94.

Lianas are discussed in *Tropical Forest Ecology,* pp. 134-35. F. E. Putz describes the different ways of being a liana in "The Natural History of Lianas on Barro Colorado Island, Panama," *Ecology,* vol. 65 (1984), pp. 1713-24.

TABLE A.2

Leaf Area of Trees and Lianas, and the Amount of Wood Required to Support a Square Meter of Each, in Selected Forests

Site	Plot Size	Tree Leaf Area per Hectare	Kg Wood per m² Tree Leaves	Liana Leaf Area per Hectare	Kg Wood per m² Liana Leaves
Pasoh, Malaysia	1/5 hectare	71,000 m²	6.45 kg/m²	6,600 m²	1.38 kg/m²
Sebulu, Borneo	1/8 hectare	68,460 m²	12.47 kg/m²	8,400 m²	1.30 kg/m²
San Carlos, Venezuela	Not applicable	52,000 m²	6.44 kg/m²	12,000 m²	1.31 kg/m²

Table A.2 compares the leaf and wood content of a forest's lianas with its trees. Data for Pasoh, Malaysia, are from T. Kira's table 24.1 in *Tropical Trees as Living Systems,* ed. P. B. Tomlinson and M. H. Zimmermann (Cambridge University Press,

1978), p. 569. Figures for Sebulu, Borneo, are from table 2 in T. Yamakura et al., *Southeast Asian Studies,* vol. 23 (1986), p. 464. Figures for San Carlos de Rio Negro, Venezuela, are from F. E. Putz, *Biotropica,* vol. 15 (1983), table 2, p. 187.

The contrast between canopy and understory leaf arrangements, and other aspects of plant form, are discussed in chapter 5 of *Tropical Forest Ecology,* pp. 94-98.

The physiological contrasts between saplings of canopy and understory species of the same size, growing in the same conditions, are described in S. C. Thomas and F. A. Bazzaz, "Asymptotic Height as a Predictor of Photosynthetic Characteristics in Malaysian Rain Forest Trees," *Ecology,* vol. 80 (1999), pp. 1607-22. Different ways of life as a shade-tolerant species are described in T. A. Kursar and P. D. Coley, "Photosynthetic Induction Times in Shade-Tolerant Species with Long- and Short-Lived Leaves," *Oecologia,* vol. 93 (1993), pp. 165-70.

The trade-off between fast growth in high light and survival in shade is described in chapter 8 of *Tropical Forest Ecology,* p. 188. Further information on this subject is supplied in David King, "Influence of Light Level on the Growth and Mortality of Saplings in a Panamanian Forest," *American Journal of Botany,* vol. 81 (1994), pp. 948-57, and in K. Kitajima, "Relative Importance of Photosynthetic Traits and Allocation Patterns as Correlates of Seedling Shade Tolerance of Thirteen Tropical Trees," *Oecologia,* vol. 98 (1994), pp. 419-28. The data for table 2.2 are from N. V. L. Brokaw, *Journal of Ecology,* vol. 75 (1987), p. 9.

Procuring Nutrients and Water

Some visible evidence of competition for nutrients is discussed in Nalini Nadkarni, "Canopy Roots: Convergent Evolution in Rainforest Nutrient Cycles," *Science,* vol. 214 (1981), pp. 1023-24.

What factors influence the apportionment of energy by plants among root making, leaf making, and stem growth, and how to assess this

apportionment, are discussed in chapter 6 of *Tropical Forest Ecology.* Tables 2.3 and 2.4 are based on tables 6.6 and 6.17, respectively, in *Tropical Forest Ecology.*

The depth of soil from which different trees draw their water is discussed in Paula C. Jackson et al., "Partitioning of Water Resources among Plants of a Lowland Tropical Forest," *Oecologia,* vol. 101 (1995), pp. 197-203, and Frederick Meinzer et al., "Partitioning of Soil Water among Canopy Trees in a Seasonally Dry Tropical Forest," *Oecologia,* vol. 121 (1999), pp. 293-301.

Decomposition and recycling of nutrients are discussed in Corner, *Life of Plants.* M. J. Swift, O. W. Heal, and J. M. Anderson discuss the community of decomposers in *Decomposition in Terrestrial Ecosystems* (Blackwell Scientific, 1979). Decomposers of tropical forests are presented more briefly in T. C. Whitmore, *An Introduction to Tropical Rain Forests,* 2d ed. (Oxford University Press, 1998), pp. 162-64, and Whitmore, *Tropical Rain Forests of the Far East* (Oxford University Press, 1984), pp. 131-34. The army ants of Barro Colorado are discussed by Nigel Franks in "Ecology and Population Regulation in the Army Ant *Eciton burchelli,*" in *Ecology of a Tropical Forest,* ed. E. G. Leigh et al. (Smithsonian Institution Press, 1996), pp. 389-95.

Nutrient cycling and soil formation are discussed in chapters by I. C. Baillie, C. P. Burnham, P. Sollins, and L. A. Bruijnzeel in *Mineral Nutrients in Forest and Savanna Ecosystems,* ed. J. Proctor (Blackwell Scientific, 1989), and chapters by P. Sollins et al. and G. G. Parker in *La Selva: Ecology and Natural History of a Neotropical Rain Forest,* ed. Lucinda McDade et al. (University of Chicago Press, 1994). The quotation from Bruenig about soil organic matter is from his book *Conservation and Management of Tropical Rainforests* (CAB International, 1996), pp. 17-19. Erosion and soil formation are discussed in chapter 4 of *Tropical Forest Ecology.* Landslide data for table 2.5 are from a chapter by Matthew Larsen and Abigail Santiago Roman in *Geomorphic Processes and Riverine Habitat,* ed. J. M.

Dorava, F. Fitzpatrick, and B. B. Palcsak (American Geophysical Monographs, 2001); sediment export is from Matthew Larsen and Robert Stallard, *United States Geological Survey Fact Sheet,* no. 163-99 (2000). Robert Stallard supplied the data for tables 2.6-2.8.

Trees that ruin the soil are described by Eberhard Bruenig in *Conservation and Management of Tropical Rainforests* (CAB International, 1996), p. 23; the question of whether natural selection favors trees that kill their neighbors is discussed in William Bond and Jeremy Midgley, "Kill Thy Neighbor: An Individualistic Argument for the Evolution of Flammability," *Oikos,* vol. 73 (1995), pp. 79-85.

Seasonal Rhythms and Odd Years

The severity of Barro Colorado's dry season is discussed at the beginning of chapter 3 of *Tropical Forest Ecology.*

How different plants cope with the dry season is discussed in *Tropical Forest Ecology,* pp. 188-89. S. J. Wright and others show how severe El Niño droughts affect Barro Colorado's forest in "The El Niño Southern Oscillation, Variable Fruit Production, and Famine in a Tropical Forest," *Ecology,* vol. 80 (1999), pp. 1632-47.

The role of the seasonal shortage of fruit and new leaves in limiting animal populations, and how different plants know when to flower or flush leaves, are described in chapter 7 of *Tropical Forest Ecology.* According to K. A. Nagy, "Field Metabolic Rate and Food Requirement Scaling in Mammals and Birds," *Ecological Monographs,* vol. 57 (1987), pp. 111-28, a "typical" mammal weighing x grams eats $0.235x^{0.822}$ grams dry weight of food per day. The mammal counts and weights given in *Tropical Forest Ecology,* p. 172, thus allow us to calculate how much food these animals need.

G. Rivera and R. Borchert present evidence that, in Costa Rica, *Cochlospermum vitifolium* and some other plants flower in response to the shortening days of September, October, and November in "Induction of Flowering in Tropical Trees by a Thirty-Minute Reduction in Photoperiod: Evidence from Field Observations and Herbarium Specimens," *Tree Physiology,* vol. 21 (2001), pp. 201-12.

Chapter 3
Herbivory

Phyllis Coley compares herbivory and antiherbivore defenses in young and mature leaves of different plant species in "Herbivory and Defensive Characteristics of Tree Species in a Lowland Tropical Forest," *Ecological Monographs,* vol. 53 (1983), pp. 209-33.

T. Mitchell Aide discusses how plants might time production of young leaves in order to reduce herbivory in "Patterns of Leaf Development and Herbivory in a Tropical Understory Community," *Ecology,* vol. 74 (1993), pp. 455-66.

Phyllis Coley and Thomas Kursar discuss different ways young leaves can avoid being eaten in "Anti-Herbivore Defenses of Young Tropical Leaves: Physiological Constraints and Ecological Trade-offs," in *Tropical Forest Plant Ecophysiology,* ed. S. S. Mulkey, R. L. Chazdon, and A. P. Smith (Chapman and Hall, 1996), pp. 305-36.

Data for calculating average growth rates of plants with long- and short-lived leaves are from Coley, "Herbivory and Defensive Characteristics," pp. 230-31.

The costs of defending leaves of *Psychotria horizontalis* are analyzed in Cynthia Sagers and Phyllis Coley, "Benefits and Costs of Defense in a Neotropical Shrub," *Ecology,* vol. 76 (1995), pp. 1835-43.

In table 3.1, the feeding rate of iguanas is calculated from K. A. Nagy's equation 44 in *Iguanas of the World,* ed. G. M. Burghardt and A. S. Rand (Noyes Publications, 1982), p. 57. According to this equation, a typical iguanid weighing x grams eats $0.024x^{0.80}$ grams dry weight of food per day. The feeding rate of sloths is from K. A. Nagy and

G. G. Montgomery, "Field Metabolic Rate, Water Flux, and Food Consumption in Three-Toed Sloths *(Bradypus variegatus),*" *Journal of Mammalogy,* vol. 61 (1980), pp. 465-72; and the feeding rate of howler monkeys is from K. A. Nagy and K. Milton, "Energy Metabolism and Food Consumption by Wild Howler Monkeys *(Alouatta palliatta),*" *Ecology,* vol. 60 (1979), pp. 475-80.

Leaf-cutter ants are discussed in *Tropical Forest Ecology,* pp. 36-37.

Why plant-eating insects specialize, and how their specialization enhances the diversity of tropical plants, are outlined in *Tropical Forest Ecology,* pp. 190-94.

The number of trees and tree species in a hectare of old-growth forest in western Maryland is given by Brian McCarthy and Donald Bailey in *Bulletin of the Torrey Botanical Club,* vol. 123 (1996), p. 354.

Predators!

Data on what a female harpy eagle ate during its stay on Barro Colorado were collected by Janeene Touchton, and occasional assistants, on behalf of the Peregrine Fund.

Louise Emmons discusses how much predatory cats eat in "Comparative Feeding Ecology of Felids in a Neotropical Rainforest," *Behavioral Ecology and Sociobiology,* vol. 20 (1987), pp. 276-77. To calculate how many sloths and other animals an ocelot eats in a year, I started with Ricardo Moreno's observation that prey weighing 2.5 kilograms or more were represented in twenty-five scats of the forty examined, and assumed they made up five-eighths of the total prey consumption. I also assumed that each ocelot produces one scat a day, and that an animal weighing 2.5 kilograms or more (white-faced monkeys, agoutis, and sloths) would be represented in three scats, so that the appearance of such a species in one scat represented one-third of an animal. Eight of these scats had two-toed-sloth remains. These represented 2.7 two-toed sloths. An ocelot drops one scat daily, or 365 per year, so an ocelot eats 9 times 2.7, or 24, two-toed sloths in a year.

Lincoln Brower discusses the evolution of distastefulness and warning colors in "Chemical Defenses in Butterflies," in *The Biology of Butterflies,* ed. R. I. Vane-Wright and P. R. Ackerly (Academic Press, 1984), pp. 109-34, and J. R. G. Turner discusses warning colors in "Mimicry: The Palatability Spectrum and Its Consequences," pp. 141-61 of the same volume.

Peng Chai compares the reaction of his captive jacamar to different butterflies in "Field Observations and Feeding Experiments on the Response of Rufous-Tailed Jacamars *(Galbula ruficauda)* to Free-Flying Butterflies in a Tropical Rainforest," *Biological Journal of the Linnean Society,* vol. 29 (1986), pp. 161-89. Robert Srygley and C. P. Ellington show how distasteful butterflies mimic each other in how they fly, as well as in wing color, in "Discrimination of Flying Mimetic, Passion-Vine Butterflies *Heliconius,*" *Proceedings of the Royal Society of London,* series B, vol. 266 (1999), pp. 2137-40.

M. H. Robinson describes the different ways insects disguise or misrepresent themselves to avoid being eaten in "Defenses against Visually Hunting Predators," *Evolutionary Biology,* vol. 3 (1969), pp. 225-59.

The role of predators in protecting Barro Colorado's forest from herbivores is discussed in *Tropical Forest Ecology,* pp. 158-59, 167-68.

The explosion of leaf-cutter ants and other herbivores on newly created islets, and the impact of these herbivores on their islets' vegetation, are described by John Terborgh et al., "Ecological Meltdown in Predator-Free Forest Fragments," *Science,* vol. 294 (2001), pp. 1923-26.

Chapter 4
Why Diversify?

The advantages of specializing to a particular occupation or way of life are sketched in *Tropical Forest Ecology,* pp. 187-89.

The trade-off robberflies face between seeking food in sunlit areas and seeking it in shade is described by Todd Shelly in "Comparative Forag-

ing Behavior of Neotropical Robber Flies (Diptera: Asilidae)," *Oecologia,* vol. 62 (1984), pp. 188-95.

The trade-off fruit flies face between the competitiveness of their larvae and the longevity of their adults is described by Jan Sevenster and Jacques J. M. van Alphen in "A Life History Trade-off in *Drosophila* Species and Community Structure in Variable Environments," *Journal of Animal Ecology,* vol. 62 (1993), pp. 720-36.

The trade-offs involved in different modes of echolocation are described by Hans-Ulrich Schnitzler and Elisabeth Kalko in "Echolocation by Insect-Eating Bats," *BioScience,* vol. 51 (2001), pp. 557-69.

The relations among frugivorous mammals of different species during the season of fruit shortage are described in *Tropical Forest Ecology,* pp. 160-61.

Edwin Willis shows how the smallest ant-following ant-birds are the least competitive at ant swarms but the best able to survive away from ant swarms in *The Behavior of Spotted Antbirds,* Ornithological Monographs no. 10 (American Ornithological Union, 1972), especially pp. 109-23. He discusses the extinction from Barro Colorado of ocellated ant-birds in "Populations and Local Extinctions of Birds on Barro Colorado Island, Panamá," *Ecological Monographs,* vol. 44 (1974), pp. 153-69.

The Forest at Night

How so many bat species coexist on Barro Colorado and the trade-offs they face are described in Frank Bonaccorso, "Foraging and Reproductive Ecology in a Panamanian Bat Community," *Bulletin of the Florida State Museum, Biological Sciences,* vol. 24 (1979), pp. 359-408, and Elisabeth Kalko, Charles Handley, and Darelyn Handley, "Organization, Diversity, and Long-Term Dynamics of a Neotropical Bat Community," in *Long-Term Studies of Vertebrate Communities,* ed. M. L. Cody and J. A. Smallwood (Academic Press, 1996), pp. 503-53. Charles Handley, Don

Wilson, and Alfred Gardner summarize our understanding of common fruit bats in "Demography and Natural History of the Common Fruit Bat, *Artibeus jamaicensis,* on Barro Colorado Island, Panamá," *Smithsonian Contributions to Zoology,* no. 511 (1991), pp. 1-173. Elisabeth Kalko, E. Allen Herre, and Charles Handley describe the guild of fig-eating bats and their food supply in "Relation of Fig Fruit Characteristics to Fruit-Eating Bats in the New and Old World Tropics," *Journal of Biogeography,* vol. 23 (1996), pp. 565-76.

Roberto Ibáñez, A. Stanley Rand, and César Jaramillo wrote a bilingual guide to the frogs, toads, and other amphibians of central Panama, complete with a compact disc of their mating calls: *The Amphibians of Barro Colorado Nature Monument, Soberanía National Park, and Adjacent Areas* (Smithsonian Tropical Research Institute, 1999).

Michael Ryan wrote the book on tungara frogs—how females choose mates, how males attract females, and the risks they run to do so—in *The Tungara Frog* (University of Chicago Press, 1985).

Kentwood Wells describes the mating habits of *Bufo typhonius* in "Reproductive Behavior and Male Mating Success in a Neotropical Toad, *Bufo typhonius,*" *Biotropica,* vol. 11 (1979), pp. 301-7. William Pyburn describes the mating habits of red-eyed tree frogs in Mexico in "Breeding Behavior of the Leaf-Frogs *Phyllomedusa callidryas* and *Phyllomedusa dacnicolor* in Mexico," *Copeia 1970* (1970), pp. 209-18.

Karen Warkentin describes the extraordinary behavior of the eggs of red-eyed tree frogs when attacked by predators, in "Adaptive Plasticity in Hatching Age: A Response to Predation Risk Trade-offs," *Proceedings of the National Academy of Sciences, USA,* vol. 92 (1995), pp. 3507-10.

Jacqueline Belwood and Glenn Morris describe the risks forest-dwelling katydids face from bats in "Bat Predation and Its Influence on Calling Behavior in Neotropical Katydids," *Science,* vol. 238 (1987), pp. 64-67.

Why Live in Groups?

The advantages of living in groups are discussed in chapter 9 of *Tropical Forest Ecology.* Egbert Leigh discusses the fundamental problem of animal behavior in "Levels of Selection, Potential Conflicts, and Their Resolution: The Role of the 'Common Good,'" in *Levels of Selection in Evolution,* ed. Laurent Keller (Princeton University Press, 1999), pp. 15-30.

Nigel Franks describes army ants as a model of the human mind in "Army Ants: A Collective Intelligence," *American Scientist,* vol. 77 (1989), pp. 138-45.

Mary Jane West Eberhard tells the story of *Metapolybia aztecoides* in "Temporary Queens in *Metapolybia* wasps: Nonreproductive Helpers without Altruism?" *Science,* vol. 200 (1978), pp. 441-43.

Egbert Leigh and Geerat Vermeij discuss how the struggle for life among plants and animals has created productive, diverse ecological communities in "Does Natural Selection Organize Ecosystems for the Maintenance of High Productivity and Diversity?" scheduled to appear in *Philosophical Transactions of the Royal Society of London,* series B, vol. 357 (2002).

Chapter 5
How Rain Forests Benefit Rich and Poor

The relationships between peoples of the tropical forest and the forests they live in are outlined in Serge Bahuchet et al., *Tropical Forest Peoples Today,* vol. 1, *Tropical Forests, Human Forests: An Overview* (Avenir des Peuples des Forêts Tropicales, 2001). The ways tropical forests matter to all the rural poor are explored in a large volume, *Tropical Forests, People, and Food,* ed. C. M. Hladik et al. (UNESCO and Parthenon, 1993).

The quotation on nature's intransigence is from Corner, *Life of Plants,* p. 113.

How tropical forests and other manifestations of untrammeled nature serve as a source of beauty and inspiration is described by S. H. Nasr on pp. 119-20 of chapter 8 in his book *The Need for a Sacred Science* (State University of New York Press, 1993).

The quotation on "this host of vegetable life" is from Corner, *Life of Plants,* p. 1, and the quotation about discovering how modern trees have come about is from p. 141 of the same book.

Alexander von Humboldt is quoted from *Personal Narrative of a Journey to the Equinoctial Regions of the New Continent* (reprint: Penguin, 1995), p. 82.

The effect of tropical forests on climate is described in *Tropical Forest Ecology,* pp. 56-59. The effect of rainfall on climate in tropical Africa is illustrated by table 6.3, whose data are from M. J. Müller, *Selected Climatic Data for a Global Set of Standard Stations for Vegetation Science* (W. Junk, 1982).

TABLE A.3

Mean Rainfall (mm), Mean Daily Temperature Maximum (T), and Mean Daily Temperature Minimum (t), in Degrees Celsius, at Three African Sites

		Jan	Feb	Mar	Apr	May	Jun	Jul	Aug	Sep	Oct	Nov	Dec
Yangambi,	P	85	99	148	150	177	126	146	170	180	241	180	126
Zaire	T	30	31	31	30	30	30	29	28	29	29	29	29
	t	20	19	20	20	20	20	19	20	19	20	20	20
Bria,	P	10	10	104	117	206	173	251	277	208	211	66	3
Central	T	35	36	35	33	32	30	29	29	30	31	32	33
African													
Republic	t	15	17	20	20	21	19	19	19	19	19	17	14
Birao,	P	0	0	2	19	97	112	217	204	171	37	1	0
Central	T	35	37	39	39	37	34	31	30	32	34	35	35
African													
Republic	t	12	15	19	21	23	22	21	21	21	20	14	12

David Montgomery and others show in an unusually careful study that clear-cutting steep slopes in the temperate-zone rain forests of Oregon greatly increases landslides in "Forest Clearing and Regional Landsliding," *Geology,* vol. 28 (2000), pp. 311-14, just as deforestation enhances landslide frequency in Puerto Rico.

Helaine Markewich and others assess how much carbon dioxide the atmosphere contains, how much carbon dioxide is released by deforestation and by burning coal and oil, and where this carbon dioxide goes, in *United States Geological Survey Fact Sheet,* no. 137-97 (1997).

Christopher Field and others assess how much organic matter the earth produces in "Primary Production of the Biosphere: Integrating Terrestrial and Oceanic Components," *Science,* vol. 281 (1998), pp. 237-40.

J. A. Pounds, M. P. L. Fogden, and J. H. Campbell document how various plants and animals are spreading uphill at Monteverde, Costa Rica, in response to global warming, in "Biological Response to Climate Change on a Tropical Mountain," *Nature,* vol. 398 (1999), pp. 611-15. John Cubit estimates the rate of rise of sea level in "Possible Effects of Recent Changes in Sea Level on the Biota of a Caribbean Reef Flat and Predicted Effects of Rising Sea Levels," *Proceedings of the Fifth International Coral Reef Congress, Tahiti,* vol. 3 (1985), pp. 111-18.

Robert Berner discusses the temperature increase caused by adding a given amount to the atmosphere's carbon dioxide in "Paleozoic Atmospheric CO_2: Importance of Solar Radiation and Plant Evolution," *Science,* vol. 261 (1993), pp. 68-70. Gregory Retallack shows one way to measure long-ago temperatures in "A Three-Hundred-Million-Year Record of Atmospheric Carbon Dioxide from Fossil Plant Cuticles," *Nature,* vol. 411 (2001), pp. 287-90.

The great methane "burp" fifty-five million years ago, its impact on global climate, and the time required for atmospheric carbon dioxide content to return to "normal" are discussed in Richard Norris and Ursula Röhl, "Carbon Cycling and Chronology of Climate Warming during the Paleocene/Eocene Transition," *Nature,* vol. 401 (1999), pp. 775-78, and in Santo Bains et al., "Termination of Global Warmth at the Paleocene/Eocene Boundary through Productivity Feedback," *Nature,* vol. 407 (2000), pp. 171-74. Gerald Dickens et al. calculate the amount of methane that would have to be released into the atmosphere to reduce the ratio of ^{13}C to ^{12}C by 0.3% in "Dissociation of Oceanic Methane Hydrate as a Cause of the Carbon Isotope Excursion at the End of the Paleocene," *Paleoceanography,* vol. 10 (1995), pp. 965-71. Other evidence that extra carbon dioxide does little to help

forests slow our atmosphere's increase in carbon dioxide content is provided in John Casperson et al., "Contributions of Land-Use History to Carbon Accumulation in U.S. Forests," *Science,* vol. 290 (2000), pp. 1148-51. They show that forests of the same age produced as much wood per hectare in the 1930s as in the 1980s.

Robert Stallard estimates how much carbon is buried worldwide in eroded sediments in "Terrestrial Sedimentation and the Carbon Cycle: Coupling Weathering and Erosion to Carbon Burial," *Global Biogeochemical Cycles,* vol. 12 (1998), pp. 231-57.

The Fragmentation and Destruction of Tropical Forests

T. C. Whitmore estimates the area of tropical moist forest on different continents in 1990, and how fast it is being cleared or logged, in *An Introduction to Tropical Rain Forests,* 2d ed. (Oxford University Press, 1998), pp. 207-9. William Laurance describes the various modes by which the tropical forest of Amazonia is now being degraded, and the wastefulness of land use there, in "A Crisis in the Making: Responses of Amazonian Forests to Land Use and Climate Change," *Trends in Ecology and Evolution,* vol. 13 (1998), pp. 411-15.

Tropical land can be farmed sustainably. Why smallholders with heritable land tenure, either landowners or payers of a fixed rent, farm most productively is outlined on the basis of European experience by Adam Smith in *The Wealth of Nations* (Modern Library, 1937), book 3, chapter 2. Why such smallholders, whether in the tropics or in the temperate zone, are most likely to farm sustainably, and the various threats to smallholder farming, are discussed by Robert Netting in *Smallholders, Householders* (Stanford University Press, 1993).

My figures for typical damage caused by logging are from fig. 19.6 of T. C. Whitmore, *Tropical Rain Forests of the Far East,* 2d ed. (Oxford University Press, 1984), p. 271. Damage caused by

logging, how to reduce this damage, and how much it can be reduced are discussed by Whitmore in *Introduction to Tropical Rain Forests*, pp. 132-39, and by E. F. Bruenig in *Conservation and Management of Tropical Rainforests* (CAB International, 1996), pp. 105-24. E. F. Bruenig describes some of the causes of the heedless and unnecessary wastefulness of most logging in tropical countries in the same book.

In "How Wide Is a Road? The Association of Roads and Mass-Wasting in a Forested Montane Environment," *Earth Surface Processes and Landforms*, vol. 22 (1997), pp. 835-48, Matthew Larsen and John Parks show that, in hilly rain forest, landslides are five times as frequent within eighty-five meters of a highway as elsewhere in the forest.

The social and ecological consequences often occasioned when agrobusiness displaces tropical smallholders are discussed in William Durham, *Scarcity and Survival in Central America* (Stanford University Press, 1979). The damage caused by transplanting farmers to regions previously left uncultivated because of their poor soils is sketched by Whitmore in *Tropical Rain Forests of the Far East*, pp. 171-72.

The fragmentation of tropical forest and its consequences are considered in *Tropical Forest Remnants*, ed. William Laurance and Richard Bierregaard, Jr. (University of Chicago Press, 1997).

William Glanz lists mammals that have become extinct on Barro Colorado in table 16.1 of *Four Neotropical Rainforests*, ed. A. H. Gentry (Yale University Press, 1990), p. 289. I have excluded the three largest animals on the list, because tapirs may never have disappeared and the two big cats are simply commuters. Moreover, spider monkeys were almost certainly extinct before Barro Colorado became an island. The decline of bird diversity since Barro Colorado became an island is described by Edwin Willis (who inquires into the causes of the extinction of ocellated ant-birds) in "Populations and Local Extinctions of Birds on Barro Colorado Island, Panamá," *Ecological Monographs*, vol. 44 (1974),

pp. 153-69, and by W. D. Robinson in "Long-Term Changes in the Avifauna of Barro Colorado Island, Panama, a Tropical Forest Isolate," *Conservation Biology*, vol. 13 (1999), pp. 85-97. Whether the absence of big cats has caused serious ecological imbalance on Barro Colorado is discussed in *Tropical Forest Ecology*, pp. 158-59.

The loss of diversity on islets of various sizes that were formed when Gatun Lake was created in 1914 is discussed in S. J. Wright, "Competition between Insectivorous Lizards and Birds in Central Panama," *American Zoologist*, vol. 19 (1979), pp. 1145-56, and in Egbert Leigh et al., "The Decline of Tree Diversity on Newly Isolated Tropical Islands: A Test of a Null Hypothesis and Some Implications," *Evolutionary Ecology*, vol. 7 (1993), pp. 76-102.

What we learn when new reservoirs cut off forested islets from the mainland is outlined in John Terborgh et al., "Transitory States in Relaxing Systems of Land Bridge Islands," in Laurance and Bierregaard, *Tropical Forest Remnants*, pp. 256-74, and "Ecological Meltdown in Predator-Free Forest Fragments," *Science*, vol. 294 (2001), pp. 1923-26.

Preserving Tropical Forests

The surge of poaching on Barro Colorado in 1932 and its impact on populations of predatory cats and large herbivores are outlined in R. K. Enders, "Changes Observed in the Mammal Fauna of Barro Colorado Island, 1929-1937," *Ecology*, vol. 20 (1939), pp. 104-6.

How ecological damage in one part of the world causes trouble elsewhere is highlighted in Robert Stallard, "Possible Environmental Factors Underlying Amphibian Decline in Eastern Puerto Rico: Analysis of U.S. Government Data Archives," *Conservation Biology*, vol. 15 (2001), pp. 943-53: dust blown from deforested zones in Africa may cause epizootics and other damage in the Neotropics.

The successes and challenges of nature conservation near the Panama Canal are outlined by

Richard Condit et al., "The Status of the Panama Canal Watershed and Its Biodiversity at the Beginning of the Twenty-First Century," *Bio-Science,* vol. 51 (2001), pp. 389-98, and described more fully in *La Cuenca del Canal: Deforestación, Urbanización, y Contaminación,* ed. Stanley Heckadon-Moreno, Roberto Ibáñez, and Richard Condit (Smithsonian Tropical Research Institute, 1999).

The conservation achievement at Monteverde, Costa Rica, is described in *Monteverde,* a large book edited by Nalini Nadkarni and Nathaniel Wheelwright (Oxford University Press, 1999). Egbert Leigh summarized this story in a review of their book in *Environmental Practice,* vol. 3 (2001), pp. 65-67.

NOTES ON THE PHOTOGRAPHY

Planning

A large part of my photographic work—long before I touch a camera at all—is planning. Egbert and I first sat down and sketched a table of contents, covering processes and phenomena we thought it important to mention. I then began thinking about photographs that would represent the different groups of organisms and the ecological concepts we wanted to present.

The hummingbird not only is a pretty example of an unusual pollinator but also tells the story of a whole feeding guild that exists only in the tropics, thus contributing to the higher diversity found in tropical forests. The bruchid beetle represents many thousands of other specialized seed pests that help maintain tree diversity. Most of the animals and plants in this book are symbols and ambassadors that represent many, sometimes thousands of, other organisms playing similar roles.

Rain Forests and Photography

Rain forests are fantastic places. Life is everywhere—an overwhelming composition of colors, shapes, sounds, smells, and humidity. Rain forests are also subtle places; animals are quiet and hide from visitors. For a long time, you don't realize how many creatures you are walking among. If you close your eyes, you can sense the presence of abundant life around you.

From a photographer's point of view, rain forests are a challenging environment for several reasons. One is the extreme climate: heat and moisture may cause the equipment to fail or the photographer to give up. Several of my lenses fell victim to moisture and fungus; several cameras stopped working; a camera with a flash got chewed up by a crocodile.

Two biological facts have severe implications for the photography. One of them is that only about 1 percent of the light that hits the canopy ever reaches the forest ground. This results in a permanent lack of light where a photographer needs it. The second is that, due to the enormous number of species, pretty much any animal one is looking for will be rare and hard to find.

The forest is good at hiding its treasures. Even if you see something, often enough it is not possible to get a decent image of it. But then there are the moments when magic happens. Suddenly the bird comes by; suddenly the sun shines on the right spot and offers you the chance to take one or two images before everything starts to fall apart again. Small windows in time and space in which the forest is willing to share its secrets are what the photography is all about.

Working Methods:
Biological Knowledge, Patience, and Luck

Only a few of the images in this book are the result of chance encounters and spontaneous shots. Most of them took quite some preparation; I had to know how and where to find the organism in the first place, and then figure out ways to get the situation and perspective in which I wanted to show it. It took me nearly two weeks (with the help of an ornithologist) to track down the nest of a motmot. During another two weeks hidden in a blind near the nest, I gradually moved the camera setup with a remote control closer every day without disturbing the birds. Eventually I was able to position the camera comfortably in front of the nest entrance, where I could get the intimate perspective of the parent bird coming back to feed its young.

I used a photographic trap to capture images of ocelots. I developed and improved my system (learning a painful lesson in getting the system watertight; I lost three flashes in the process) and followed track patterns to set up the camera in promising spots. Eleven weeks and more than

forty rolls of film later, which produced great images of rain, opossums (there are many, many opossums out there), bats, and other curiosities, I finally got my first ocelot shot.

I chose these two examples to illustrate that there is more to nature photography than seeing an animal and pushing a button. Knowledge of the organisms, the development of a feeling for the behavior of animals and what they will tolerate, patience, and luck are as crucial as knowledge about technique—perhaps even more so.

All the images in this book were taken of wild animals, most of them on Barro Colorado Island, some in surrounding areas, and a few for the last chapter in Western Panama.

Equipment

For the most part I used the Canon EOS System with lenses from 14 to 500 millimeters. For certain situations, I worked with a manual Canon camera (a T 90), and for landscapes sometimes with a Pentax 67. A flash was used in most of the images. The film material was mainly Fuji Velvia, Fuji Astia, and Kodak E 200, pushed to 800 ISO. A tripod was necessary for many of the images. In some cases, special devices such as remote controls and high-speed infrared triggers were used to get the shots without bothering the animals too much. In many cases, I worked out of blinds. For macro shots I either photographed the animal in a studio or, more often, built up a field studio with multiple flashes to balance natural with artificial light.

ACKNOWLEDGMENTS

This project has been long and exciting, and many people have contributed in different ways for which I am thankful. My parents, Christa-Anita Ziegler and Hans-Walter Ziegler, always trusted me and supported my work. Without their help none of this could have happened, and I am very grateful to them. I also want to thank my brother, Johannes Ziegler, for his support.

I want to thank Dr. Ira Rubinoff, the director of the Smithsonian Tropical Research Institute (STRI), for his trust in this project, and Dr. Cristian Samper for his support.

I learned a lot of what I know about tropical ecology at the University of Wuerzburg in Germany from Professor Karl-Eduard Linsenmair and Dr. Gerhard Zotz. They helped provide a scientific basis for my fascination with the tropics.

I am grateful to Janeene Touchton, with whom I have been happily sharing my life and who has supported me with her warmth, love, and spirit.

Thanks are due to my friends and colleagues on Barro Colorado Island for a wonderful time and for our talks about science and life. Other people came to visit me on "my island" and gave me the feeling that I had not been forgotten at home. All of them were generous in sharing their knowledge of the organisms they studied, which improved the pictures a lot. Living on a forested island for fifteen months generates a need for good friends. The following list is far from complete (I hope the people I have forgotten understand how easily that can happen, and know I am still thankful): Dora Alvarez, Jennie Bee, Juergen Berger, Christiane Broeker, Chrissy Campbell, Stelios Chatzimanolis, Ellie Clark, Sandra Correa, Cameron Currie, Dina Dechmann, Dr. Robert Dudley, Dr. Bettina Engelbrecht, Amy Faivre, David Galvez, Jacalyn Giacalone, Rachel Goeriz, Victor Gonzalez, Denise Hardesty, Dr. Michaela Hau, Dr. Hubert Herz, Margaretta Kalka, Dr. Elisabeth Kalko, Dr. Roland Kays, Andreas Kompa, Alexander Lang, Stefan Laube, Johanna Marxer, Ricardo Moreno, Jay Nelson, Timothy Pearson, Matthias Pestel, Scott Powell, Dr. Carl Rettenmayer, Ghislain Rompre, Tara Sackett, Lauren Schachner, Gerold Schmidt, Stefan Schnitzer, Steffen Schultz, Kirsten Silvius, Sabine Spehn, Annie St. Amand, Sabine Stuntz, Jens-Christian Svenning, Dr. Edmund Tanner, Dr. John Teen, Ingeborg Teppner, Katja Ueberschaer, Julia von Puttkamer, Martina Wagner, Elan Wang, Paige Wickner, Dr. Martin Wikelski, and Dr. Rainer Wirth.

The STRI staff on Barro Colorado Island made sure the island ran smoothly; Oris Acevedo, in particular, achieved the seemingly impossible. The boat mechanics, especially Ricardo Cajar, fixed my poor boat many times. The cooks Juan Dutari, Gary Oses, and Edward Robinson supplied me with good food. The game wardens did their difficult job all the time, protecting the monument. They also helped me locate animals. Others I need to mention here are Rafael Batista, Victor Perez, and José Sanchez.

I am grateful to the following people in the STRI administration and at the STRI photo lab, who helped develop the insane amount of film I exposed: Laura Flores, Nelli Flores, Marcos Guerra, Beth King, Maria Leone, Gloria Maggiori, Raineldo Urriola, and Jorge Ventocilla. Among the researchers at STRI who helped me with their knowledge were Dr. Annette Aiello, who identified insects; Dr. George Angehr, who provided information on birds; Dr. Phyllis Coley and Dr. Thomas Kursar, who shared interesting stories about plants and caterpillars; Dr. Allen Herre and Adalberto Gomez, who helped me find and understand figs and their pollinators; Dr. William Laurence, who informed me about fragmentation; Dr. Stanley Rand and Dr. Karen Warkentin, who taught me about frogs; Dr. William Wcislo and Dr. Donald Windsor, who offered me information on bees and beetles; and Dr. Joseph Wright, who answered plant-related questions.

I want to thank Augusto Gonzales at the Asociación Nacional para la Conservación de la Nat-

uraleza (ANCON), who showed me the experimental iguana farm. In Germany, Matthias Pestel helped me with laboratory questions and organization.

I am grateful to the following people for their constructive critique and their trust in my photographic work: Ruth Eichhorn, Annette Hasselmann, Venita Kaleps, Frans Lanting, and Rosamund Kidman-Cox.

Last but not least, I want to thank Frans Lanting more generally for his help with my photographic career as well as this project. He gave me inspiration and encouragement at a crucial time and has been supportive ever since. He enabled me to become a professional nature photographer, and without him this book would never have been started.

INDEX